OPERA'S SECOND DEATH

OPERA'S SECOND DEATH

Slavoj Žižek and Mladen Dolar

ROUTLEDGE
NEW YORK • LONDON

Published in 2002 by
Routledge
29 West 35th Street
New York, NY 10001

Published in Great Britain by
Routledge
11 New Fetter Lane
London EC4P 4EE

Routledge is an imprint of the Taylor & Francis Group.

Printed on acid-free, 250-year-life paper.
Manufactured in the United States of America.

10 9 8 7 6 5 4 3 2 1

Library of Congress Cataloging-in-Publication Data

Žižek, Slavoj.
 Opera's second death / Slavoj Žižek and Mladen Dolar.
 p. cm.
 Includes bibliographical references (p.) and index.
 ISBN 0-415-93016-2 — ISBN 0-415-93017-0 (pbk.)
 1. Opera. 2. Mozart, Wolfgang Amadeus, 1756–1791—Themes, motives.
3. Mozart, Wolfgang Amadeus, 1756–1791. Operas. 4. Wagner, Richard,
1813–1883—Themes, motives. 5. Wagner, Richard, 1813–1883. Operas.
6. Operas—Analysis, appreciation. I. Dolar, Mladen. II. Title.

ML3858.Z59 2001
782.1'092'2—dc21 2001019949

CONTENTS

INTRODUCTION:
FOR THE LOVE OF OPERA

In recent times, the psychoanalytic approach to opera has deservedly enjoyed a bad press; what we usually get is a deconstructionist reading of the libretto or, perhaps even worse, a rather primitive Freudian denunciation of its (patriarchal, anti-Semitic, and/or antifeminist) biases. The contention of this book is that opera deserves something better. The very historical connection between opera and psychoanalysis is thought-provoking; the moment of the birth of psychoanalysis (the beginning of the twentieth century) is also generally perceived as the moment of opera's death—as if, after psychoanalysis, opera, at least in its traditional form, was no longer possible. No wonder, then, that Freudian resonances abound in most of the pretenders to the title of the last opera (say, Berg's *Lulu*).

However, the awareness of this historical connection does not equal the historicist contextualization permeating today's cultural studies. In a famous passage from the introduction to his *Grundrisse* manuscript, Marx mentions how easy it is to explain Homer's poetry from its unique historical context—it is much more difficult to explain its universal appeal, that is, why it continues to give us artistic pleasure long after its historical context has disappeared. If we reduce a great work of art or science to its historical context, we miss its universal dimension; apropos of Freud, it is also easy to describe his roots in the fin de siècle Vienna—much more difficult is demonstrating

how this very specific situation enabled him to formulate universal theoretical insights. Such historicizing is especially problematic in the case of Wagner. It is easy to show how *Parsifal* grew out of timperial, anti-modernist anti-Semitism—to enumerate all the painful and tasteless details of Wagner's ideological engagements in the last years of his life (his obsessions with the purity of the blood and vegetarianism, Gobineau and Houston Chamberlain, and so on). However, to grasp the true greatness of *Parsifal*, one should absolutely abstract ideas from these particular circumstances; only in this way can one discern how and why *Parsifal* still exerts such a power today. So, paradoxically, the context *obfuscates* Wagner's true achievement.

The underlying idea of this book, an exercise in Lacanian reading, is simply that Mozart and Wagner are the two key figures in the history of opera and that each of them follows at a different level the same trajectory from the work, which, as it were, postulates the composer's basic matrix (Mozart's *Seraglio*, Wagner's *The Flying Dutchman*) through the series of variations that attain their apex in a work of lethal despair (*Così fan tutte, Tristan*) to the reversal into an ambiguous fairy-tale bliss in their final work (*The Magic Flute, Parsifal*). In both composers, the elementary constituent of their universe is the gesture of *entreaty* (the plea to the master in Mozart, to which the master answers with grace; the Wagnerian hero's death wish, which is granted at the opera's end); each of the book's two parts focuses on the work that marks the lowest point of despair (*Così, Tristan*). The first part (written by Mladen Dolar) thus culminates in a detailed analysis of why the ending of *Così fan tutte* is so ambiguous—not only as to its narrative content but also in purely musical terms—lacking the clear resolution and reconciliation of his other operas, whereas the second part (written by Slavoj Žižek) is centered on a close reading of what is arguably Wagner's greatest musicodramatical achievement, Act III of *Tristan*, with Tristan's long-postponed peace in death.

Why, then, for the love of opera? To put it somewhat bluntly: Because, from its very beginning, opera was dead, a stillborn child of musical art. One of the standard complaints about opera today is that it is obsolete, no longer really alive, and furthermore (another aspect of the same reproach) that it is no longer a fully autonomous art—it always has to rely in a parasitic way on other arts (on pure music, on theater). Instead of denying the charge, one should undermine it by radicalizing it: opera *never* was in accord with its time—from its very beginnings, it was perceived as something outdated, as a retroactive solution to a certain inherent crisis in music and as an impure

art. To put it in Hegelese, opera is outdated in its very concept. How, then, can one not love it?

One of the members of the Vienna Philharmonic reports on a strange incident that occurred sometime in the early 1950s, when the orchestra was practicing under a mediocre conductor. All of a sudden, inexplicably, the orchestra started to play much better; surprised, the musician looked around and noticed that Wilhelm Furtwaengler (*the* conductor of the twentieth century) had entered the hall from a side entrance—when players registered his presence, they spontaneously put a much greater effort in their playing so as not to disappoint him. The two authors entertain an immodest hope that a similar effect will be discernible in the present book: that the love of its subject did leave at least some traces in its writing.

IF MUSIC BE THE FOOD OF LOVE

MLADEN DOLAR

Philosophers did not go to the opera very often. Opera's glamor—the splendor of court spectacles, the pomp of national myths, the sentimental melodramas—seemed highly removed from their activities and from their vantage point, opera may have looked rather pitiable. Dr. Johnson's famous dictum that opera was "an exotic and irrational entertainment" set the general tone, along with Schelling's claim that the opera was the lowest caricature of the highest form of art, the Greek theater.[1] For three centuries, opera strove to fascinate, to ensnare by means of the imaginary, to bewitch with fantasies. Philosophy's task was rather the disenchantment—the deconstruction—of this fascination and glamor. How ironic that opera and modern philosophy coincide chronologically, spanning the period from the seventeenth to the twentieth century.

If opera is alien to philosophers, then Rousseau, Kierkegaard, and Nietzsche are exceptions that prove the rule. Rousseau, a man with two souls in one breast, even wrote an opera himself: His *Le Devin du Village* is still performed occasionally today. Kierkegaard let himself be totally spellbound by the enchantment of the opera so that for him it became a paradigm of aesthetic sensual fascination—but only to overcome it all the better by rising to the ethical and the religious. And for some time, Nietzsche actually saw the realization of his philosophical project in Wagner's operas only to reject

this error all the more spectacularly (and relying on another kind of opera, Bizet's *Carmen*).

The opera is, at any rate, a bizarre subject for philosophical scrutiny. Its glamor is perhaps connected to its strange temporality. Opera represents a corpus that is historically closed, finished. As a musical genre, it has its beginning, its rise, and its fall, so it can be delimited and discussed as a self-contained entity. The notion of opera's having a distinct beginning and end may not be self-evident, for the idea of combining a narrative with music is, I suppose, as old as mankind. And its end does not seem to be in sight because opera has experienced something like a renaissance during the past few decades. Almost all the founding fathers of modern music have at some point succumbed to the irresistible appeal of crowning their careers with a work of opera. One can think of Stockhausen, Berio, Ligeti, Penderecki, and even Cage and Messiaen, not to mention the older attempts by Henze, Zimmermann, Kagel, Nono and many others. Sooner or later they could not resist the overwhelming temptation to test their hand at this ultimate musical genre.

Nevertheless, I share the view held by many that the opera is emphatically finished. Several candidates for the date of its death exist, and if the genre's grand, melodramatic finale is to match the grandeur of its ascendancy, then the favorite of these is no doubt April 26, 1926, the first performance of Puccini's *Turandot*, when Toscanini's famous gesture—interrupting the performance at the point where Puccini's work was terminated by his death, and leaving the podium in tears—also suspended the majestic tradition of opera and marked its demise. A more intimate burial had occurred a few years earlier: Schönberg's *Erwartung*, written in 1909, was first performed in June 1924, by the strangest coincidence as a kind of requiem for Kafka.[2] To be sure, there are other suitable candidates for "the last of the operas": Strauss's *Daphne* (1938) offers a nicely symmetrical exit, its subject repeating that of the first opera, Peri's *Dafne* (1597–1598)—a satisfying conclusion for a genre so obsessed with the problem of a satisfying conclusion.[3] Berg's *Lulu*, first produced posthumously in truncated form in 1937 and in a completed version not until 1979, is another major contender since it brings the diva, the true goddess of the opera, to a most spectacular death. In the course of opera's long life, it may well have seemed that the spectacular death was a diva's main business and that after undergoing it for so many times in so many works, she was immune to death. But Lulu's demise was the death of the death itself; no more divas

would draw their last breaths to the sobs of the audience after that. Lulu is the anti-Turandot. But perhaps it is best not to argue about the various candidate's merits and to retain an ecumenical stance; it is important to place developments after that time in a different horizon, a context determined by the awareness that the great tradition of the opera—along with its presuppositions, the social and cultural conditions that formed the pillars of the genre for three centuries and made opera a coherent whole despite the myriad individual manifestations—is irretrievably gone.

If opera were simply over, however, it could be assigned a neat place in cultural archaeology and thus properly buried. The astounding thing is the enormous operatic institution's stubborn, zombielike existence after its demise; it not only is kept alive but is also growing steadily. At present, opera is larger and more complex than it ever was during its lifetime. The more opera is dead, the more it flourishes: New opera houses are being built, and performances are becoming increasingly costly and sophisticated, accompanied by lavish TV broadcasts and by video, CD, and DVD industries, so that the scale and technological advancement of it all dwarf anything that went before. Opera enjoys a glamorous star system comparable to that of the movie world, pop music, or sports. The glamor of the opera maintains the ever-changing new elites. The crème de la crème meet at Scala or the Met, just as in the times of Louis XIV, but the mass media make that glamor accessible to everybody and transmit it directly into our living rooms. Yet the core repertory of the modern opera house is very limited, comprising about fifty operas from Gluck to Puccini. The works created before and afterwards, as well as the lesser-known works and composers of the classic era, still stand out as curiosities even if this attitude has changed considerably in the past years.[4] Opera remains a huge relic, an enormous anachronism, a persistent revival of a lost past, a reflection of the lost aura, a true postmodern subject par excellence.

The secret of this posthumous success and increasing popularity may well lie in something one could call a redoubled or mediated fantasy. Throughout three centuries, the opera was the privileged place for enacting the fantasy of a mythical community, and by virtue of this presentation, the "imagined community" (to use Benedict Anderson's term) spilled over into the "real" community, as it were: first as the supporting fantasy of the absolute monarchy and then as the foundational myth of the nation-state—the court opera evolved into the "state opera."[5] Mythical community was

able to offer the grain of fantasy needed to constitute the real community—
not merely as its substitute or its mythical reflex but as its mover. The
operas were always set in distant, legendary times and distant mythical
places (if, rather exceptionally, they dealt with the present, then it had to un-
dergo a process of a subtle double mythification, where, for example, the op-
eratic life of Spanish workers in the tobacco industry turns out to be more
removed from everyday life than the intrigues of the Olympian gods). To be
sure, today no one believes in this mythological foundation of community,
but one does believe in the times when people still believed in it; one does
believe in the heroic golden times of the rise of the bourgeois order, when
myths still had their standing and their sway, presented at the peak of their
splendor by the opera. It is not so much our own fascination that is now at
stake as it is the fascination of our ancestors who, supposedly, took opera
with the utmost seriousness it deserves, who were interpellated into sub-
jects by it and formed a community relying on it. So we are caught precisely
by this mediated and delegated—and, hence, all the more stubborn—fasci-
nation. Obviously, if opera were measured by realistic standards (whatever
one chooses to mean by that), then it would look totally absurd, but the more
absurd it appears, the more this proves its authenticity.[6] Whereas anthro-
pologists have to travel to the primeval forests of South America and to the
islands of the Pacific to find relics of ancient social rituals, we merely need
to go to the opera. It is there that our own weird rites, the mythical begin-
nings of our society, its lost but still persistent origins are presented and re-
enacted, in both their highest and their most trivial form. (For triviality, one
only needs to think of the Three Tenors: However much one is inclined to
loathe this distasteful phenomenon, it is nevertheless in tune with a certain
part of operatic history, which thrived on kitschy pomp and show-off.) The
more they are lost and purely mythical, the more they persist and the more
lavish and extravagant their compulsory repetition. The moment we enter
the opera, we start acting as our own aboriginal population.[7] Opera thus
retroactively recreates the mythical past that nobody believes in but yet is
dearly needed and piously re-created.

So when we enter the opera, we have to deal with something too silly
and ridiculous for philosophy to tackle but something that psychoanalysis
has put on the agenda: the logic of a fantasy. And perhaps it is no coincidence
that the fall of the opera coincides with the advent of psychoanalysis.

Mozart will be taken as a paradigmatic figure here: paradigmatic because
he represents the pinnacle and the culmination of the first two hundred years

of opera, its first great epoch—an epoch to a large extent passed into obliv-
ion in the present standard repertoires (despite some exceptions). A massive
amnesia has set in where Verdi—alas!—won big against Monteverdi.[8] Mozart
sets up the terminal point of this tradition by bringing together its presup-
positions and extending its consequences. By doing this, he, at the same time
and within the same gesture, inaugurates the second great epoch of the op-
eratic tradition, one crowned with fame and associated with its greatest
glamor. He stands at the point of intersection between two worlds, two (so-
cial, historical, philosophical, and musical) epochs, and presents perhaps the
most exalted playground of fantasies and their shifts.

The Birth of Opera from the Spirit of Absolutism

To be able to discuss Mozart's operas and to discern their underlying philo-
sophical program, we will proceed by determining—in the good old manner
of philosophers or in their bad manner, whichever one prefers—what opera
is according to its concept. It may be possible to trace Mozart's operas back
to the very origin, or definition of opera, to its minimal structural terms, in
order to show to what extent they are true to this concept or rather to what
extent this concept had to be shifted by drawing some extended implications
of these structural traits. One could say that these operas' loyalty to tradition
is proven by the fact that ultimately they turned this tradition upside down.

Textbooks unequivocally state that opera began with *Dafne*, composed
by Jacopo Peri, even if the year of its first performance is not quite certain
(probably 1597 or 1598). Although opera had numerous predecessors and rel-
atives—medieval mystery plays, liturgical and pastoral dramas of the Re-
naissance, madrigal comedies, musical intermedi in different plays, and so
on—none of these ever had a consistency adequate for the formation of a suf-
ficiently strong structure. This only came about at the turn of the seven-
teenth century with the Camerata, a society of Florentine musicians, poets,
philosophers, and scholarly members of the nobility, which—in the spirit of
the times—sought to recreate antique tragedy in its original form, on the
supposition that the ancient Greek drama was sung from the beginning to
the end. The reliance on the original format provided the vast panoply of an-
tique motifs along with the background of the classical dramatic structure.
A new style of music developed from this idea—monody, whose program
was summed up by the slogan *parlar cantando* or *recitativo* (with many var-
iations—for a list, see Sternfeld 1993: 38–40), "singing speech," a "musical

recitation" of the solo voice with harmonic support from the accompaniment (the Baroque *basso continuo* evolved from this). As the slogan states, the musical line was to be firmly linked to the text, which should lead the way, and music was to enrich its expressive powers; a new style developed, called *stile recitativo, stile rappresentivo,* or *stile espressivo* or *parlando.* The monodic action was at suitable points interrupted by instrumental ritornellos and choruses, which mostly took the form of orchestral introductions and choral finales. Barely a decade after these first steps, opera found its first great master in Claudio Monteverdi and its first paradigm in his *L'Orfeo,* first performed in 1607. With this work, opera started out with the highest possible import and a standard that all later works were hard put to attain.

The concept of the supposed rebirth of antique tragedy is a paradox in itself. The humanistic idea of returning to the antique ideal as a means of renewing the present was caught up in the dialectics of historical repetition. For if one wants to recreate the assumed past standard and ideal, if one wants to repeat something long gone, one can achieve this only by creating something altogether new. The rule of thumb: The greatest conservatives are the greatest revolutionaries. The original that was to be repeated was missing anyway—there were only assumptions that the antique tragedies were sung or at least performed with melodic declamation. So to reconstruct them, a new style had to be invented that produced a break with the counterpoint and madrigal tradition of Renaissance music. Already at its very origin, opera was caught between the demand for a rebirth of a mythical past, the loyalty to an ideal standard, and the need for innovation required by this rebirth.[9] These dialectics largely influenced the whole history of opera: On one hand, it presents a fabulous past transcending time, beyond time, a past raised to the temporality of the fantasy; on the other hand, it invents new forms by means of which the myth can find a dramatic realization and a corresponding new social function and hence, in its very above-time nature, introduce new temporality.[10]

The turn of the century coinciding with the birth of opera also stands for a most dramatic transition between two epochs. The difference between the Renaissance and Baroque styles of music and art in general may seem a rather minor matter in comparison, for this was the time of Galileo and Descartes (Galileo's father, by the way, Vincenzo Galileo, was a musician and one of the founders of monody, a co-author of the idea of the rebirth of the antique tragedy), the time of the birth of modern science, of the rise of

fundamental structures of modern subjectivity, and of a concentrated and emphatic beginning and rise of bourgeois society, the elements of which had begun to form some centuries before. The opera offered a new fantasy support to this fresh epoch, and it did not take long before all became aware of its tremendous power. The fantasy mechanism of the theater, powerful in its own simplicity (for what is stage but the minimal gesture of forming a frame for what Lacan called the "window of the fantasy"), is greatly enhanced by the element of music, the element of direct elevation into a transmundane world, to a place of transcendence and utopian reconciliation. Music, the most time-bound of all arts, is at the same time "a machine to suppress time," as Lévi-Strauss has written, just like the myth (Lévi-Strauss 1964: 24). If, to cut the long story short, we take Lévi-Strauss as witness on this point— the link between myth and music—then we can see that the opera, as the marriage between the two, was indeed a marriage made in heaven.

Yet opera's emergence at this dramatic moment does not mean that it represented the mounting new order, a herald of the break with the old and of the ascendancy of the new. On the contrary, the rise of the opera is entirely linked to the paradoxical period of absolutism; two hundred years would have to pass before the French Revolution. Operas were performed at courts, and it is only gradually that they gained a broader audience; at their core, their primary addressee was the aristocracy, in the last instance the king, who by himself constituted the ideal audience: "The King, at one and the same time, is the privileged viewer and the central hero in the tragedy" (Salazar 1980: 29). The opera became the privileged place of presenting and showing the conditions of power; at the time of its birth, nobles and monarchs rocked its cradle. It grew up by imbuing absolutism, and thus it is a miniature model of it, its homegrown fantasy.

The paradox of absolutism—to put it briefly and in simplified terms— is that it is a compromise formation caught in the contradiction between form and content. As far as its form is concerned, absolutism embodied the last flourishing of the feudal world—grand rulers enter the stage, giving the impression that they are the only true personifications of the feudal master, coupling the sun and the state in the same divine emissary. This was the time of court chivalry and magnificent pomp, as if the fading feudal world had wanted to show itself in its most fascinating light before its decline and death. It is the grandeur and the luxury of a mortally wounded universe. As to content, this epoch coincides with the time of the Enlightenment,

characterized by the rise of autonomous subjectivity along with the un-
stoppable ascent of the bourgeois order, the formation of all bourgeois social,
economic, and cultural structures. The revolution occurring two centuries
later will only have to discard the form, to cast away the shell, since the ac-
tual battle had already been won within the very brilliance of the absolutist
state. "Then 'one fine morning it gives its comrade a shove with the elbow,
and bang! crash! the idol lies on the floor,'" as Hegel (1977: 332) quotes
Diderot's *Nephew of Rameau.*

Feudal form and bourgeois contents—in this contradiction, opera, at the
time of its emergence, stood on the side of form. Above all it provided a sup-
port for this form, the legitimization of the feudal frame, its ideological basis
and fantasy representation.

Now, what makes up the core of this fantasy?

Acheronta movebo

There is general agreement that the first great opera on the level of its con-
cept was Monteverdi's *Orfeo.* Even though it was written barely a decade
after opera's official birth, Monteverdi was already the third composer to
have used this myth to create a work in the new genre. He was preceded by
Jacopo Peri and Giulio Caccini, who had both used Rinuccini's libretto for
two operas called *Euridice* in 1600 (not counting Agazzari's *Eumelio,* pro-
duced in 1606 in Rome, a version of the same myth adapted for an all-male
cast in a Jesuit seminary). And this was but a beginning: One can list no fewer
than twenty operas based on Orpheus in the seventeenth century alone (refer
to the list in Sternfeld 1993: 2). The evidence is rather overwhelming that a
special affinity exists between the myth of Orpheus and the newly created
operatic structure.

One can see at first glance that as an opera topic, the Orpheus myth has
a lot to recommend itself, because the music is not only there to illustrate
the plot but is an immediate mover of the dramatic action. Staging this myth
involves not only setting a story to music, but the music itself becoming the
moving force behind the events. Orpheus descends to the underworld to gain
back his beloved Eurydice, and he has only one tool, one instrument to
achieve this goal: his music. *Music is what moves the deity to yield, music
can defy death itself.* The mysterious power of music is shown exemplarily
when it becomes *pianto, lamento*—lament, entreaty, imploration, beseech-
ing, humility, supplication, prayer. In one of Monteverdi's programmatic

texts, one finds the formula *humiltà o supplicatione*, which for him defines one of the basic stances to be expressed by music (quoted in Nagel 1985: 9, 57–58). Thus, music is turned into an appeal to the divine Other; it directs its pleas and laments to the Other, and ultimately, the Other cannot resist— it must give in and show mercy. This minimal dispositive provides a simple paradigm of the operatic aria: an appeal to the Other, an attempt to make it yield. In this dispositive the Other is inherently of a different rank than the subject—it is omnipotent, a deity, or as a monarch, the worldly representative of divine power. The gesture of the Other responding to the subject's appeal is a gesture of mercy—*grazia, clemenza, pietà*. In Orpheus's story, Pluto, god of the underworld, yields to the singer's lament and supplication; he shows mercy and reawakens Eurydice from death.

Another motif, which is also an essential part of Orpheus iconography, shows the power of music at its most spectacular: Through the irresistible charm of his song, Orpheus can tame wild beasts and nature.[11] Monteverdi does not use this motif directly (although the relationship between music and nature is present all along, with the dances and songs of the nymphs and shepherds, the ode to the sun, and so on), but it appears in many other versions, and its sway is such that it still reemerged triumphantly almost two centuries later in Mozart's *The Magic Flute*, the last classical embodiment of the Orpheus myth.[12] Just like Orpheus, Tamino has to save his beloved from captivity, and the magic on which he can rely for help is that of music (although, quite significantly, Mozart replaces the lyre, the instrument of Apollo, with the flute, the instrument of Dionysus).[13] The power of music, the moving force of the opera, is such that it transcends the boundaries of society, either over and above its upper limit to reach gods and monarchs or below its lower limit to stir nature. The appeal of music, being the highest cultural product, is unstoppable, and its suprasocietal message is irresistible. Orpheus forces nature and the gods to yield; with his music he can even overcome death, he can bend heaven and hell—his motto is like the one placed by Freud on the first page of *The Interpretation of Dreams: Acheronta movebo*.[14]

In the opera, this sublime power of music enters the stage—quite literally in Monteverdi's *Orfeo*. In the prologue, a personification of music introduces itself, speaking in the first person in a sort of naive immediacy no longer possible later:

> Io la Musica son, ch'ai dolci accenti
> So far tranquillo ogni turbato core,

Et or di nobil ira et or d'amore
Poss'infiammar le più gelate menti.

=====

I am Music, who in sweet accents
can calm each troubled heart,
and now with noble anger, now with love,
can kindle the most frigid minds.
 (translated by Lionel Salter)

This music, which enters the stage so emphatically in the first act of the first great opera—as a motto to all later operas—confronts the whole subsequent operatic tradition with a most difficult task: If the opera is to achieve its objective, it may neither be "a concert in costumes" nor a theater play with musical accompaniment; rather, it must stage the power of music itself, and the music must form the inner principle and motive of its revelation. Music, in opera, stands in a self-reflective relationship—it performs its own representation, it stages its own power and its effects. To represent the power of music, opera must stage the plea in all its force as well as the response to this plea, the act of mercy, clemency, grace, the effect that is the measure of its force. By putting its own power and its effect musically on the stage, it becomes apparent how it exceeds beyond social and rational structures. It structures the nonstructurable and represents the nonrepresentable (which is the Kantian definition of the sublime).

The structure underlying *Orfeo* can provisionally be taken as the basic paradigm of opera. This paradigm is based on two primeval, perhaps original, functions of music that defined most of its fate throughout its entire history: the religious and the erotic. In both instances the music acts as an appeal to the Other, as the best means and the best strategy for attaining mercy, softening the Other's heart, bending the Other's resistance. Music is ascribed the power of being able to attain God's mercy and win the heart of one's beloved, and this is also the place of its ineradicable ambiguity—music is at one and the same time the epitome of transcendence and of sensuality and eroticism. Trying to seduce deity or to seduce the beloved can weigh very differently on the scales of culture and religion, and this is where the religious music always had problems with music's link with sensuality and sin (for a lot more on this, see Dolar 1996).[15] But in both cases music is supposedly endowed with power to bring about something that cannot be achieved

by any rational means: It can awaken love. Music is the only strategy left where all strategies fail, defeated by the impossibility of the task (making people fall in love is what even Aladdin's jinnee, despite his omnipotence, cannot do). "*A muover gl'animi all'amore*" (to move the souls to love), says Vincenzo in his *Discorso*.[16] To awaken love, and hence mercy, in deities and monarchs—for mercy is their only way to show love to humans—and to awaken the love of a beautiful woman: The whole history of opera is there, the simple clue to all its plots and scenarios. In its minimal dispositive the opera not only enacts this appeal but also simultaneously stages its effect: It enacts the response of the Other, the act of mercy and love—that is the sublime moment toward which opera strives, the true object of the opera. The musical plea is irresistible, and its sublimity can be matched only by the sublimity of mercy that it elicits. The effect of music can be measured only by and through music; the equivalent of musical power can be given only in musical currency. By and large, this paradigm will, in the first place and in the first great period of its history, serve as the model for the great operatic tradition characterized by *opera seria*.

The first operatic version of Orpheus, Peri's *Euridice*, was produced for the wedding of Henry IV and Maria de Medici (the same Henry IV who a couple of years earlier, in 1598, had signed the Edict of Nantes, thus finishing the religious wars and massacres by an act of mercy—but the historic coincidences are too many to be noted). Given the nature of the occasion, the libretto, without any scruples and considerations, provided the story with a *lieto fine*, a happy ending: Orpheus enters the underworld and by the persuasive powers of his music and his entreaties obtains from Pluto, the god of the Underworld, permission for Eurydice to return to earth—and they live happily ever after. One may well wonder how the learned members of the Camerata, who were officially striving to revive the great heritage of antiquity, could take such liberties with that same heritage without so much as blinking.

Monteverdi (with the libretto writer Striggio), however, endeavored to follow the original myth: Orpheus loses the mercy bestowed upon him by ignoring the condition set by the god and turning back to see if Eurydice is following behind, and so, when he sets his eyes upon her, she is gone forever. His lamentation, his appeal to the Other (*"Possento spirito"*), is the central moment of the opera, quite literally placed in its exact middle, but it is also curiously displaced. The song is addressed to Charon, the boatman of the dead on the river leading to Hades, and this all-powerful music eventually

lulls him to sleep so that Orpheus can sneak by into the Underworld. Once there, he does not confront the god at all (so that the treatment of the hero's lament, the centerpiece of the whole, may even be seen as ironic); it is Proserpina, Pluto's wife, who makes her irresistible entreaty on Orpheus's behalf before Pluto, and she succeeds in softening the god's heart only by employing all her feminine charms. God yields, but with a condition—and if Orpheus was able to tame wild beasts and gods, he was not able to tame his heart, his own nature. He responds to the gesture of mercy with an ambiguous gesture of subjectivation—he violates the divine command, he succumbs to his own humanity—or to another, higher deity?—and turns back, thus losing god's mercy. The same god of love, under whose auspices he made the plea to bring his beloved back from the dead, now makes the hero lose her.

> Ciò che vieta Pluton, commanda Amore.
> A nume più possente,
> Che vince uomini e dei,
> Ben ubbidir dovrei.

===

> What Pluto forbids, Love commands.
> I must obey
> a more powerful divinity
> who conquers both men and gods.

Eurydice is lost: "*Così per troppo amor dunque mi perdi?*" (Thus, then, through excess of love you lose me?) The excess of love that gained her is what loses her. And what is left to the bereaved singer but yet another lament? The lament has to be repeated, it must be echoed, and indeed, the fifth act opens with the famous "echo lament": The last parts of verses are echoed, producing an effect which was very popular in the seventeenth century music. This lament echoes the previous one, and the echo replies to the singer as both repetition and anticipation of an answer (the echoes imply that lament is always answered).[17] The repeated lament tries to elicit the repeated response from the Other, the reiteration of the god's mercy, and indeed, in Monteverdi's work Orpheus is answered through Apollo,[18] who descends from heaven, the very prototype of deus ex machina. "*Apollo discende in una nuvola cantando*" (Apollo descends in a cloud, singing) the stage directions say. He cannot return to Orpheus the beloved Eurydice, but he prom-

ises immortality instead, a place in heaven above this world full of sorrow where he will be able to see Eurydice again, to "cherish her fair features in the sun and stars." So Orpheus ascends with his divine father to heaven in perfect happiness to enjoy celestial honors while the final chorus celebrates divine grace, *grazia*, as the last line of libretto states. The ascent to heaven is the reward for the descent into hell, and the final apotheosis is above all the apotheosis of Orpheus's art, that is, of the power of music itself, the mover of the plot. There is a happy ending, but not of the simple kind favored by Rinuccini and Peri—*lieto fine* is here underpinned by the whole Neoplatonic panoply of the Renaissance. This reading has a long pedigree, stretching back to Hyginus in the second century and Boethius in the sixth (Sternfeld 1993: 13, 19ff), and the gist of it is a progression leading from the love for a beautiful woman to the love of divine beauty, the renunciation of human love and apotheosis of art. (If this sounds too seventeenth century to you, then you need only think of the most famous twentieth-century version, Stravinsky's ballet *Orpheus* (1948), which reinstates precisely the apotheosis finale, celebrating the victory of artist over time and the immortality of music.)

Gluck's opera, created one and a half centuries later (1762)—the operatic version of the Orpheus myth that is performed most frequently today—goes back to Rinuccini's solution, to the happy reunion of the couple, but with a shift: After the second loss of Eurydice, the hero's repeated lament (the famous *"Che farò senza Euridice"*) is heard by the gods once again, and his beloved is restored to life.[19] The changed sensibilities of the eighteenth-century audience would hardly take a Neoplatonic answer for an answer.[20]

The oscillations in the plot are telling and show very well why this scenario was so appropriate for the opera. The power of music elicits mercy, the power of music is the only thing that equals the power of love, music is another word for love and its irresistible force, and with a force like this, the *lieto fine* cannot fail; it can either take the form of the praise of love with the happy reunion of the couple, love defeating death; the praise of divine mercy, the gesture of love shown by gods as the counterpart of the appeal of music; or finally the praise of music and its power and hence the apotheosis of the singer, the art, and the love for immortal beauty. Or it could take all three forms at the same time, with variations of accent. It is the equation love = mercy = music that rules supreme and guarantees a happy end. One can see the same constellation still ruling *The Magic Flute*, where the power of music helps the couple through the trials and brings about the victory over

death and the triumph of love. The power of the flute and its music is not
just a means, it is *"power itself*—a subtle power, without violence—of
which Tamino is but a servant and by which he lets himself be guided. What
the ultimate trial *represents* is not just the triumph of love: it is the triumph
of music and of the musician" (Starobinski 1979: 149).

The equivalence of love and music, which is at the bottom of this (mercy
being divine love for humans), implies that music is the only equivalent of
love and that love can be adequately expressed only by music. Food of love
indeed,[21] but this is not going far enough in the equivalence, hence Shelley's
footnote to Shakespeare:

> No, Music, thou art not the 'food of love',
> > Unless love feeds upon its own sweet self,
> > Till it becomes all Music murmurs of.
> > > *(Fragment, "To Music")*[22]

The equation can be made—given a certain idea of music and certain
idea of love—because it seems that only music corresponds to both the tran-
scendent, sublime, Platonic part of love as well as to its sensuous and cor-
poreal component, which it presents at its most delicate and at the same
time its most persistent and obstinate. A certain idea of music and certain
idea of love: The opera establishes both and brings them together in a very
precise historical moment. And we will have to follow the avatars of both
sides of the equation.

We can see that the lament forms the central structural point of the
opera; it is the place where the supreme power of music is displayed and
tested. A year after *Orfeo*, Monteverdi would produce its truly paradigmatic
form in his next opera, *Arianna*, of which only the central part, the famous
lament of Arianna—*"Lamento d'Arianna"*—has survived. During the first
performance in May 1608, the audience was moved to tears[23] (and we can
still see why), and with this opera Monteverdi achieved instant fame and
found numerous imitators stretching to the end of the century.[24] Arianna's
situation is exemplary: Out of love for Theseus she left her home, her father,
and the kingdom where she was a princess—only to be left by Theseus on
the first island on the way, thus losing him as well. In the name of love she
lost everything, and then she lost Theseus' love as well. All she can do in
this situation of total loss and despair is to offer the only thing she has left,

her own life, so her adamant appeal, repeated obsessively throughout, is *"Lasciatemi morire"* (Let me die). Her situation is strangely inverse to that of Orpheus, sounding as it does like an impossible appeal of Eurydice (and Eurydice is a rather minor figure in *Orfeo*): *"Volgiti, Teseo mio"* (Turn around, my Theseus), but he does not. Arianna's lament remains like a lonely cry cut off from the rest of the opera, presenting an emblematic figure: A subjectivity completely distraught and destroyed, deprived of all that was hers in life, whose only recourse in this extreme position is the power of music, the last refuge for those who have lost everything else. And what a tremendous recourse it is! Music is the power of the powerless, and its power is all the greater the more the subject has lost the last vestiges of any other power. The lament of the annihilated subject who has lost all succeeds in staging the music at its most sublime. It says: I have no power whatsoever over you, except music — and this is what makes it irresistible.

One can see that the sexual division can easily be grafted upon this dispositive: The lament at its most poignant is an affair of women. It is as though only a woman can truly represent the entirely powerless subject, only a woman can be totally distraught. Because the reason for lament is mostly the loss of the beloved person, only a woman, the creature entirely dependent on love, can thereby lose everything. Even Orpheus, totally bereaved by the loss of Eurydice, can finally achieve his apotheosis without her, by being immortalized for his art, by finding in his art the compensation for his loss of human love, as it were. The beloved may be lost, but love is immortalized through art. For the true embodiment of the power of music, Orpheus must lose his status of master-singer and turn into a woman. With Arianna another paradigmatic subject enters the operatic stage: She is the first in the great series of distraught divas who will rule operatic history — Diva, the goddess of the opera whose status depends on being in total despair, the goddess deprived of all power and hence the most powerful. The moment of her greatest weakness is the moment of her overwhelming strength. In the early period of the opera, Ovid, whose *Metamorphoses* were the main source for plots (Sternfeld counted some fifty-five opera scenarios based on them), also provided another source with *Heroides*, epistles by eighteen unhappy heroines tormented by love. Penelope, Dido, Ariadne, Andromeda, Daphne, Echo... a gallery of ladies in the grip of harsh despair as if waiting for centuries for the discovery of a proper genre in which their voice could be, finally and quite literally, heard.

The structural consequence of the lament is the happy ending. If the power of music is such, it must ultimately elicit the mercy for which it strives and awaken love, at least allegorically if not literally. How could Arianna's plea and supplication possibly remain unanswered? Just at the point of the greatest despair, there is redemption: Another deus ex machina descends from the sky, this time not Apollo but his counterpart Bacchus. The lament is accompanied by its natural and necessary companion piece, the *lieto fine*. We are thus confronted with a most extraordinary phenomenon: the project of bringing antique theater back to authentic life by means of the opera, which cannot produce or even bear a tragedy. The first extant opera, Peri's *Eurydice*, is still opened by a prologue sung by Tragedia, but this is just going through the motions, given the ridiculously happy outcome, and the prologue will be quickly supplanted by *Musica* in Monteverdi, as we have seen. The first two hundred years of opera contain virtually no unhappy endings. The tragic stories from mythology had to be bent toward a *lieto fine*, with various gods descending from heaven, showing mercy, bringing the dead back to life, making love triumph over all... The exceptions are few, the most famous being Purcell's *Dido and Aeneas*. And if there were no tragedies, there were strangely no real comedies either. The one genre that prevailed was the pastoral, the tragicomedy, the *fabula satyrica*—a genre that was more often than not set in the midst of nature populated by shepherds and nymphs, relying on another antique tradition that stretches back to the *Eclogues* and *Georgics* of Virgil and that provided a backdrop to the love dramas of heroes and gods. This genre occupies a sort of middle ground between tragedy and comedy, with its basic formula "from sorrow to joy," from tears to laughter, from despair to the happy end. The *lieto fine*, joined in the eighteenth century by the *buffa* comedies, ruled supreme in the two hundred years from Monteverdi to Mozart—precisely through the period of operatic history that has today largely passed into oblivion, some exceptions notwithstanding.

What has ultimately become known as the paradigm of the opera, based on its grand flourishing in the nineteenth century, is the very opposite: opera as the grand catastrophe. The divas thrust themselves into fire (*Norma, Götterdämmerung, Khovanshchina*); children are thrown into fire (*Il Trovatore*); divas are stabbed (*Rigoletto, Carmen*), strangled (*Otello*), buried alive (*Aida*), commit suicide (*Madame Butterfly*), throw themselves from castles (*Tosca*), die of tuberculosis (*La Traviata, La Bohème*), die of love (...), and a lot more along these lines.[25] The heroes, although always only the second best in the

opera, do not fare much better. The once-celebrated monarchs are revealed as criminals and die a lonely death (*Boris Godunov*), and when the gods appear on scene, rather massively and spectacularly with Wagner, it is to meet their twilight. The individual catastrophe is extended to cataclysmic proportions. To be sure, there are exceptions, but the catastrophe rules supreme, and if one goes to the opera, it is rather to accomplish the reverse journey, from deceptive joy to tears and despair—and the ability to evoke a good sob becomes the trademark of a good opera.

The examples may have been chosen with bias, but they nevertheless show well enough that we have to deal with what appears as two very different worlds. It is as if mercy, which held all early opera in sway in the first universe for two centuries, disappeared in the second one, suddenly and irretrievably gone. It is as if the music lost its power to elicit mercy and love and to bring about a *lieto fine* however much it tried—and try it did. The music became much louder, given the great expansion of the romantic orchestra and chorus; it became much longer, actually took gigantic proportions (think of Wagner) and grew much more convoluted (again, Wagner, and many others); it disposed of far greater technical resources—but however much it tried, the mercy would not appear. Opera found itself in a merciless world—though neither is it quite a tragic one. It seems as if the capacity for tragedy had also gone along with mercy.

So what happened? How did we get from the one world to the other? The answer, at least the operatic one, is very simple: Mozart. And this means that the answer is also very complicated. In what follows I attempt to trace the steps of this transition through Mozart's operas.

Some brief comments may be necessary on the development of the opera up to Mozart. Monteverdi's greatest musical achievement (not his alone, because it belongs to the whole generation, but he was its greatest master) was the invention of monody, *stile rappresentativo, recitativo, parlar cantando*, whatever name one chooses. In this new style, the text attained a musical power previously unknown. Monteverdi was a great adept of *primo le parole*, but the text is continuously shifted by the music; it gains inner tension, it appears in a completely unexpected light, the nicely flowing verses are fragmented by the voice of passion, the careful meter (relying on the complex science of versification in Renaissance) is constantly interrupted by syncopes and dissonances, and at one and the same time the text is illustrated and refuted. Monteverdi occupied a privileged place in a period of extraordinary musical freedom between two musical epochs, the Renaissance and

Baroque—he was the last Renaissance composer, the last great master of the madrigal, and at the same time, he paved the way for the Baroque as the inventor of its elementary forms (including *basso continuo*). Monteverdi enjoyed a rare and privileged point in time when one convention, that of Renaissance polyphony, had already faded away, and the other one, the codification of Baroque style, had not yet been established. His elementary force and incredible boldness, which soon would not be possible and which were only rediscovered during the twentieth century, can in many ways be attributed to this circumstance.[26] It is as if, in a rare moment in music history, the door was left a bit ajar so that we could catch a glimpse of something usually glossed over in convention.

And to be sure, convention was quick to follow. In the hundred years after *Orfeo* opera was standardized, operatic conventions were firmly established. This occurred simultaneously with a forceful upswing and opulence in opera, which gradually became a central social event. The main pattern of this convention (canonized by Metastasio's scheme of operatic construction) was formed by generally separating the operatic texture into recitatives and arias. The dramatic action, the plot, is explained and acted out in the recitatives; the arias are the points of rest that add emotional commentary, the musical expression of subjective stances, treatises on hopes, fears, and despair—emotions that can be catalogued and can appear as "set pieces."[27] The dividing line between recitatives and arias was not yet clearly demarcated in Monteverdi's works, and even his strophic arias, such as "*Possente spirito*," can hardly be perceived as strophic or as arias in any later sense of the words. The paradoxical shift brought about by the Metastasian convention was that the recitative became completely stereotypical; it moved within utterly conventional patterns with minimal *continuo* accompaniment, whereas the music was entirely relegated to the arias. The aria as well became codified, it became a *da capo* aria, but this form allows for all musical and psychological complexities and had its grand heyday and its grand masters. The paradox is that all dramatic action, which is, after all, the moving force of the opera, was completely divorced from the musical action, which was reserved for the arias, and expelled into the undramatic and in musical terms mostly uninteresting stereotypical recitative. Consequently, opera became fragmented into individual musical arias, occasionally interspersed with some choruses and duets, linked by the recitative. When music held the stage, it was to form a break, a caesura in the dramatic action. Just as the text imparted the information in the recitative, so the aria's informa-

tional content was reduced to a minimum, to the purely lyrical. The recitative maintained some dignity and expressiveness only as *recitativo accompagnato*, usually a prologue to an aria accompanied by the orchestra, as opposed to the *recitativo secco*, which was accompanied only by harpsichord and in which the main tribulations of the plot were briefly told. This dividing line (which was not yet present in Monteverdi's works and was not given up until Wagner's time) allowed opera to present its greatest object of fascination in its purest form: the voice. It was granted an exclusive position in the arias while being reduced to a minimal frame in recitatives. The aria could present the voice beyond meaning, the object of fascination beyond content; it could aim at enjoyment beyond the signifier, at the immediate fascination with a senseless object, and here the prima donna could eventually take up her position as the central operatic figure, supported by the fantasy of the woman who holds the enigmatic object of enjoyment and proves, through her formidable voice and her desperation, that the Woman exists after all. Yet the prima donna was only the second best to occupy this place; she was preceded by the castrato, who held the whole operatic world in sway for almost two centuries. But this is another and very fascinating story that cannot detain us here (for some more on all this, see Dolar 1996).

This scheme was extremely clear-cut and effective; indeed, it could present an ideal solution to "the problem of the opera," as Kivy (1999) claims, the perfect correlation of the musical form, the text, and the underlying psychology. Yet the relationship between music and drama was lost, the construction of the whole became a series of separate passages, the numbers (what in German became known as *die Nummeroper*, "the number opera"). The French *opéra comique* and the German *Singspiel* were able to use spoken dialogue instead of the recitative, without altering the basic scheme. This scheme was used until Mozart, who inherited it and kept it up but only to give it a shift, to situate it in a completely different perspective. The fantasy dispositive of the aria became complemented and overshadowed by another dispositive, the ensemble, which brought with it a construction of community unlike anything that had appeared in opera before and which gave rise to a new whole.

The Logic of Mercy

Now we can skip some 170 or 180 years up to the creation of the seven great operas that Mozart composed during the last decade of his life. These are

provisionally listed as follows by the year of their first performance: *Idomeneo*, 1781; *Die Entführung aus dem Serail* (*The Escape from the Harem*), 1782; *Le nozze di Figaro* (*The Marriage of Figaro*), 1786; *Don Giovanni*, 1787; *Così fan tutte* (*Women Are Like That*), 1790; *La clemenza di Tito* (*The Clemency of Titus*), 1791; *Die Zauberflöte* (*The Magic Flute*), 1791.[28]

If we take a brief glimpse of the two of these seven operas that follow the tradition of *opera seria*, then it soon becomes obvious that the same paradigm that underlies *Orfeo* is still in place—the structure of the music will be discussed later. In *Idomeneo*, Idomeneus, the king of Crete, promises the gods that in return for deliverance from death in a terrible storm, he will sacrifice the first person he meets when he sets foot on the coast of Crete. Naturally, the first person he encounters is his son Idamantes, and when Idamantes, after many attempts to evade the vow in some way, is willing to sacrifice himself (at the same time that his beloved Ilia wants to sacrifice herself in his place with the same selflessness), the god takes pity and shows mercy in the face of his noble-mindedness, thus allowing a happy ending. The other opera, *La clemenza di Tito*, is about a conspiracy against the Roman Emperor Titus prepared by Vitellia, the daughter of the deposed Roman emperor, and Sextus, who is in love with her. After the plan fails, the conspirators confess their guilt, throwing themselves at the emperor's feet, and he responds with a sublime act of mercy and forgiveness. Instead of punishing them, he shows magnanimity.[29] In both operas the instance of the Other is decisive, be it the deity or the monarch. The Other to whom the heroes and heroines address their appeal is of a different status than the community of heroes and heroines. The opera can come to a conclusion when the Other shows its sublime status through its act of mercy, thereby allowing reconciliation.

The act of mercy has its own inner economy that can be provisionally summed up by the following formula: the divine in man in exchange for the human in the deity, or in its earthly representative, the monarch. The subject proves that it deserves mercy, that it can surpass its own subjectivity, that it is willing to risk it or to sacrifice it unquestioningly, ultimately to offer its own death; in return, the Other is ready to yield and to show a human touch, as it were.

The act of mercy has to be understood against the background of the law, as a violation of or an act beyond the law. In the oldest surviving libretto for *Orfeo*, written by Rinuccini, Pluto at first does not give in to Orpheus's lament precisely in the name of the law:

> …ma troppo dura legge,
> legge scolpita in rigido diamante,
> contrasta a'preghi tuoi, misero amante.

<p style="text-align:center">≡</p>

> …but the harsh law,
> the law engraved in hard diamond,
> is opposed to your entreaties, poor lover.

Hence, the deity's conflict is that he must not violate the laws that he himself set down and that he safeguards—the laws that (if they are to be effective) should be firm and clear-cut, as if engraved in a diamond.

> Romper le proprie leggi e vil possanza…

<p style="text-align:center">≡</p>

> To break one's own laws is [a sign of] bad power…

The power that violates its own laws is pitiable, claims Pluto—through this it would reveal the weakness of its rule and admit its own inconsistency. How could it expect its subjects to obey the laws when it does not abide by them itself? Nevertheless, the deity cannot but yield to the lamentation and humility, to *pianto* and *supplicatione:*

> Trionfi oggi la pietà ne' campi inferni,
> e sia la gloria e 'l vanto
> de le lagrime tue, del tuo bel canto.

<p style="text-align:center">≡</p>

> Let the mercy triumph today in infernal regions
> and let the glory and the praise
> belong to your tears and your beautiful song.
> 　　　　　　*(Quoted from Nagel 1985: 59)*[30]

At least for one moment mercy may triumph over the law; this time the exception may dominate for once.

We can appreciate the difficult position in which the god finds himself here: On the one hand, being the Other, he is the guarantor for the laws and,

hence, also subject to them; on the other hand, he is also the creator of the laws and hence above them. His position as a deity allows him to violate his own laws—and that is what makes him a true Other in the first place. The same holds true for a monarch. Thus, it is the distinction between the law on the one hand and the deity/monarch who establishes the law on the other that is decisive for mercy—the distinction between the Other of the law and the Other beyond law. Therefore, the Other is truly Other provided he is the Other of the Other—the Other of the whim, not the Other of the law.

Montesquieu was well aware of this constellation when he developed his political model. In his argument in favor of a separation of judicial and royal powers, he claims that the king, if he were to be the head of the judiciary, would lose "the grandest attribute of his sovereignty, namely that he can show mercy" (faire grâce, "grant pardon") (Montesquieu 1961:85). In the section "De la clémence du prince," he maintains, for instance, that "monarchs can gain so much by showing mercy, that mercy is accompanied by such love, through mercy they gain such fame, that they almost always consider an opportunity to show mercy a most happy circumstance" (101). According to Montesquieu, the monarch should not be the highest judge, but he should retain the privilege of being the true Other and beyond comparison: the privilege of granting pardon. The judiciary can only work on the basis of the law; the monarch, however, is a last instance located at a point above the law. He is in a position of exception, which is also why he can make exceptions. That is the sublime moment toward which opera seria strives, the moment that opens up the dimension of love: The act of mercy is the proof of love beyond the law, it demands love in return, and the true medium of love is music.

This logic entails that just as the deity truly shows its divinity insofar it can show its humanity, the monarch is a true monarch only when he is grand and noble as a man. Or, as Schink claimed in his Dramaturgische Fragmente in 1781: "A monarch who . . . despite so many opportunities, allowing him to forget so easily that he is human, still remains a man and is superior to other men only as a man, such a man is the most attractive image an artist can invoke" (quoted from Nagel 1985: 67). Hence, depicting the act of mercy, extolling it to the point of taking it for the main subject of the opera, undoubtedly contains flattery of the monarch (and after all, Mozart did write La clemenza di Tito for the coronation of Leopold II in Prague, in a political context where this coronation was used by the most conservative forces which opposed the Josephine reforms and hoped to get the upper hand after Joseph's death, that is, used by aristocracy which wouldn't be deprived of its

privileges).[31] Consequently, the illusion is produced that the monarch attains his authority from his human traits—from being a more noble man than other men, a superior man—and not from the position that he holds, that he is the monarch by virtue of his characteristics and not by his being and position. His true humanity can come to the fore only if he is a sovereign and not a tyrant, insofar as he is a just and noble ruler and not the capricious Other, insofar as his superior justice surpasses the dead letter of the law. The customary treatment of aristocracy, the etiquette and the very forms of address, pertains to this illusion and upholds it: People of noble birth should act nobly and are to be addressed as "Your Grace" to show not only that they are aristocrats by the grace of God but also that they can prove themselves worthy of this position only by showing grace. But this flattery is double edged and may show its dangerous reverse side very quickly. If, for instance, a monarch lacks human greatness, then the implication is not far that he doesn't deserve to be a monarch; a nobleman who is actually not noble is denigrating his function and illegitimately holding on to his status.

Mercy is ambiguous in another and more fundamental respect: It is nothing but the positive, reverse side of another form of the Other, both more familiar and more terrifying—the Other's whim and caprice. The idea of a capricious God was then ubiquitous—this was, after all, the century of counter-Reform and of Jansenism—an obscure, sinister, unpredictable God, a God who left his subjects in complete uncertainty as to their redemption. This God is one with whom no deals can be made; salvation depends on his mercy, and his mercy cannot be bought or elicited but depends on his whim alone. The subject may sacrifice itself as much as it can and be highly noble and virtuous, but nonetheless it is up to God to show mercy or not—that is the God of Protestantism and Jansenism, with the question of predestination looming large. Opera, however, is in its origin and by its basic outfit an Italian, that is, Catholic genre, entirely constructed on the premises of mercy, love, and reconciliation. The principle underlying its economy is "renunciation for renunciation, sacrifice for sacrifice"; once the subject has shown the unconditional readiness to sacrifice his/her life without reservation, God, or monarch, grants him his/her life. Protestantism found its great composer in Bach, who, despite all the complexity and the enormous size of his many-faceted oeuvre, one of the greatest in musical history, never came upon the idea of composing an opera.[32]

In view of this exchange between the hero's divinity and the Other's humanity, the act of reconciliation between the subject and the Other seems

to lessen the gap between them but only to highlight all the more their insurmountable distance. The subject remains subject, the sovereign remains sovereign, the deity remains deity. The Other, despite his or her humanity, or rather precisely because of it, is irrevocably Other. Through the reconciliation, the inequality of the two poles is strengthened and legitimized precisely through their mutual acknowledgment. The subject has to prove that she deserves mercy, but mercy is an act of noble and free judgment of the Other, who has the power of granting it or refusing it—and because he deigned to grant it out of his own magnanimity, the subject can respond only with boundless gratitude and love.

The mechanism of mercy, so central to the early opera, displays an image of the Other beyond the law, a sublime image that glosses over and conceals another face of the Other of whim, the face of cruelty, inscrutability, and malice in deities and monarchs. There is another, much less sublime, psychoanalytic name for this mechanism of mercy: the superego. The logic of mercy relies on and engenders the logic of superego, the other side of the law. If music be the food of superego, play on? Is there another logic of love, in this equation with music, that could escape this framework?

Anyway, the ideological core of the fantasy that supported the opera during its first heyday is contained in this logic of mercy, which was also the link of *opera seria* to the horizon of absolutism.

Opera buffa

Opera seria was only one of the great operatic traditions used by Mozart. There was another and quite different one, *opera buffa*. The opposition between the two characterized much of the eighteenth century, and given that this was an era in which opera inspired great passions and ideological wars, the most famous one of those was actually *la querelle des bouffons*, one of the most heated debates of the mid-eighteenth century that opposed the Enlightenment generation of *Encyclopédie* to the conservatives. *Opera buffa* was initially a comedy created as an entertaining and relaxing interlude between the acts of the *opera seria* (one may recall that *seria* developed from the Renaissance *intermedi*). These initially short diversions followed from the tradition of the commedia dell'arte, a popular style of theater whose primary place of performance was not the courts of the aristocracy but rather the marketplaces with their shows and burlesques put on to entertain the people.

Opera buffa also had its typical minimal plot, which can best be described as "troubles on the way to marriage." Despite many difficulties and entanglements, the couple in love will come together. The obstacles on the way often appear in the form of old aristocrats defending their privileges and who are not, as persons, in keeping with the status they represent. Here as well music is present as an instrument, the best means to elicit love and to help the lovers to the happy ending. But there is a huge difference: Marriage can take place only between two people of the same status, and if their status is initially different, marriage is the great equalizer. *Buffa* aims at the abolition of distance and overcoming differences in status. Whereas *opera seria* strove for transcendence, *opera buffa* was based on the structure of immanence (see Nagel 1985: 40).

The force of love, sustained by music, can defeat any initial inequality. However, this is not the fatal love that can find its completion only as transgression in some *Liebestod* or other; it is the love-toward-marriage. Pergolesi's *La serva padrona (The Maid Turned Mistress)* became the paradigm of *opera buffa*, an operatic style that was immensely successful and gained tremendous popularity immediately after its first performance in 1733 as an intermezzo in an *opera seria*, while its first performance in Paris in 1752 actually triggered off the famous *querelle* in which Rousseau led the party of the proponents (his opera, *Le devin du village*, was also composed as a weapon in the fight, and it curiously later served as a model for Mozart's first opera, *Bastien und Bastienne*). The story of the maid who turns mistress is very simple: She marries the master and thus attains noble status. The master is stupid and helpless, the maid cunning and clever—she deserves her promotion owing to her own shrewdness and skills, as a prize for her capabilities, as it were. The privilege is earned and achieved. And it follows already from this simple description that *opera buffa* is a democratic genre that strives for social promotion, equality of social standing, and overcoming class differences, and in the final instance, it ultimately offers the perspective of a common humanity or a human community.

Besides the couple in love, which has to come together after surmounting all kinds of obstacles, another couple is equally important in *opera buffa:* the master and the servant. This couple is no less passionate, (almost) no less intimately linked, and even more intriguing as the couple of lovers. Whereas the first pair is based on equality through love and marriage, the second one stands for insuperable differences in social standing. Nonetheless, it is precisely the instructiveness of the relationship between master and servant,

and the transformations this relationship undergoes, that defines the inner tension of *opera buffa* and its democratic potential.

The elegance of the first model, *La serva padrona*, can be attributed to the fact that the two couples (man/woman, master/servant) directly coincide so that the whole scope of *opera buffa* is already there, condensed and abbreviated in its initial figure. The inequality between the two actors prior to their marriage pertains to the first model of the master/servant pair: Their social status is in an inverse relationship to their capabilities—the rather stupid master has as his counterpart the clever servant (one can think of numerous literary models: *Don Quijote*, Diderot's *Jacques le fataliste*, and so on). In this model the clever servant usually sees to it that the master's wishes are fulfilled, so the servant's ingenuity evens out the master's inability. The servant is master of know-how and hence master over the reality principle, whereas the master is there merely in name and image and hence is the real servant. In Pergolesi's *coup de force*, the maid sees to her master's desire by making herself the object of it; the feeble-minded master doesn't even know what he wants (or rather, he particularly doesn't know that). The maid makes him realize what he wants, namely her, and at the same time she makes certain that his desires come true. Rossini's opera *Il barbiere di Siviglia*, which is the beginning of the Figaro story and of the Almaviva family saga,[33] follows the same model: Figaro, by cunning and deceit and, of course, for appropriate remuneration, helps the Count Almaviva win the heart of his beloved and poor Rosina.

Although this model maintains a distance between the two (the master remains the master, the servant remains the servant), there is ample space for social tension and criticism: The master does not live up to his position. What was a source of seriousness in *opera seria*, that is, the proper behavior according to the status, becomes a source of comedy in *opera buffa*, with the glaring disproportion between the form of domination and human triviality of the master. To avoid immediate criticism, *opera buffa* frequently resorts to naturalizing the conflict that appears to reside in a contrast between youth and old age; the opposition is placed between a young nobleman, full of humanity, courage, and magnanimity, and an old nobleman, who is concerned only with retaining the privileges of his status along with debauchery, greed, and so on.

In the sequel of the Figaro story in Mozart's opera, Count Almaviva turns from the category of the "young" nobleman who had all the sympathy of the audience (even if he lacked Figaro's shrewdness) into the category of the "old" defender of privileges, keen on secretly retaining the most repulsive of them all, *ius primae noctis*; Figaro, on the other hand, turns from the servant who

fulfills his master's desires to the master's chief antagonist. Although both are now shrewd, skilled plotters, it is the servant who triumphs over the cunning but corrupt master. The social criticism is outspoken and reaches the limits of social acceptability (hence the initial prohibition of Beaumarchais's play, the difficulties with Da Ponte's libretto for Mozart, and so on).

This paradigm is reversed in the relationship between Don Giovanni and Leporello, and a third model is presented: The servant may be quite clever in the economy of survival and seeing to his own interests, but he is a coward, the representative of common sense, received opinion, and the defender of current social norms. In the greatest contrast to this, the master is courageous and fearlessly prepared to defy and breach any social norms. In this relationship, with the figure of the cowardly, greedy, and corrupt servant (*Leporello* means "hare") that falls back on the old model of the commedia dell'arte, it is now the master who functions as the carrier of an ambiguous and extensive social criticism. The shifts and the vicissitudes of the master-servant relationship in *opera buffa* present the most instructive laboratory situations for the shifts of social and philosophical paradigms. We will get back to this in more detail.

The two operatic traditions, *seria* and *buffa*, already had a long history before Mozart. *Buffa* was the much younger sister but very quick and efficient so that the opposition between the two was seen as pivotal when Mozart began to use them in his own special way. They are based on different presuppositions: *Opera seria* is built on a distance between the subject and the Other, between the social and its transcendence; the opera takes place in the space of a symbolic exchange between the two and ends in the sublime safeguarding of this distance by the act of mercy. As a democratic genre, *opera buffa* provides a perspective of equality within the limits of the common humanity; its weapon is to ridicule those whose human qualities don't correspond to their social status, those who do not prove worthy of participating in the common humanity. This is, to be sure, only a rough and schematic description of the opposition, and the moment we try to interpret some specific examples from both quite ramified traditions, things inevitably get muddled. We would soon run into numerous crossbreeds and additional elements (for example, the somewhat different French traditions of vaudeville, *tragédie lyrique*, and *opéra comique*; elaborations of fairy tales with magical interventions; frequent inclusion of Oriental motifs; and so on). Nevertheless, this opposition is paradigmatic, despite all possible supplements and specifications, and the confrontation of the two currents is crucial for understanding

the operatic dispositive. And in respect to our initial assumptions about the historic emergence of the opera, one could say that the contradiction between the form of the absolutist state—its spectacular gloss of the dying ancien régime—and its contents—the rise of the bourgeois order—was translated into musical terms as the opposition between *seria* and *buffa.*

A third tradition has to be added to these two if we are to account for the state of the art as Mozart found it: the German *Singspiel.* This tradition was the weakest, had only a short history, and never was able to develop a coherent paradigm with clear-cut structural definitions. The *Singspiel*'s defining trait was that it was written in German, as opposed to the hegemonic Italian, and as such it was intended primarily for a wider audience, which also largely defined its choice of topics: It was more of a commercial enterprise, aiming at more immediate effectiveness. Its main formal distinction was the spoken text that carried the plot, which was occasionally interrupted by musical passages (as in the French *opéra comique*). For this reason, the musicality of the *Singspiel* usually was considerably less sophisticated than that of real opera; for a long time it was customary to choose actors who were also able to sing (and not, as in the opera, singers who could also put on an act of acting). As a popular genre, the *Singspiel* presented a spectrum of topics that extended mostly from farce to fairy tales.

Syntax

Now that we have finally come to Mozart, let me first quote a fragment from his diary (or more precisely, from notes he wrote in his sister's diary) dated August 26, 1780:

> post prandium la sig'ra Catherine chés uns. wir habemus joués colle carte di Tarock. Á sept heur siamo andati spatzieren in den horto aulico. faceva la plus pluchra tempestas von der Welt.[34] *(quoted from Böttinger 1991: 9)*

The irresistible humor and charm of this fragment stems from the simple fact that in every sentence virtually every word comes from a different language: German, Italian, French, and Latin. Although Mozart had no formal education, he was fluent in three languages and could play with them masterfully, with an incredible ease and feeling that was surpassed only by his musical capacities.

The point of this quote is a tentative claim that Mozart's music in general and his operas in particular should be interpreted in the same way as this fragment: as a combination and intertwining of different and heterogeneous traditions—Italian opera, German *Singspiel*, French gallantry, and Latin church music. But that is not all—it could also be claimed that the connection between the disparate elements is just like the one in the diary fragment—even if every element has a separate linguistic origin, the connection is still completely logical, flowing, and comprehensible. We know very well what he is saying; all the sentences have structural consistency and make sense. This is achieved through the syntax that holds them together, gives them transparency, and combines them into one structure.

Mozart was able to draw on distinctly variant musical traditions owing to the strength of the new syntactic structures that he used, which were based on the classical style (best described and explained by the justly famous work by Charles Rosen [1971], a "classical" book if there ever was one). Mozart was well aware of the far-reaching implications of this style and its syntactic advantages; he realized the great possibilities and knew how to apply them directly to operatic structure. The quintessence of this style, its strongest tool and weapon, was the sonata form, which is already by its very nature drama proper. Technically, it is a certain way of treating musical themes and elaborating of motifs that is based on a strategy of creating and resolving harmonic tension. But its basic structure (exposition—development—recapitulation) is much like that of a drama, and thus the sonata is best expressed in dramatic terms. The symphony, based on the extended use of the sonata form, is in itself already an opera, as it were; all it lacks are the vocal parts and a tangible dramatic plot. The drama inherent in the sonata had only to be linked to the drama of the operatic plot, the libretto; the inner relationship between the two had to be found, with both sharing a buildup of tension and its resolution in the denouement. At this point opera grew out of its early Metastasian scheme of a sequence of musical numbers and recitatives to gain the architecture and grand design of a drama-made-music[35] and of music coinciding with drama.

This use of the sonata as an internal principle of dramatic action and its unfolding cannot be overestimated. To quote Rosen:

> Mozart's achievement was revolutionary: for the first time on the operatic stage, the music could follow the dramatic movement while still arriving at a form that could justify itself, at least in its essen-

tials, on purely musical grounds. Before Mozart... a musical drama had always been so arranged that the more formally organized music was reserved for the expression of feelings—generally one sentiment at a time—in an aria or duet, while the action was left to be conveyed in recitative. This meant that except in so far as the music had values of its own unrelated to the drama, it remained essentially an illustration and expression of the words; it could only be combined with the action in the most primitive way and in the least interesting fashion. (1971: 173)

And there is more: The change in the musical form went along with the change in the underlying philosophical assumptions and psychology. If *opera seria* was largely based on Cartesian assumptions about the nature and the classification of human emotions, then the classical sonata, with its shifting dramatic focus and its volatility, implicitly relied on another view of human nature, based more on what can be called the associationist ideas stemming from the empiricist tradition and developed by people such as Francis Hutcheson, John Gay, David Hartley, Charles Avison, Alexander Gerard, Johann Georg Sulzer, and so on:

Where the Cartesian emotions are innate, those of the associationist school are acquired; where the Cartesian are hard-edged and discrete, the associationist are blurred and continuous; where the Cartesian are finite and fixed, the associationist are infinite and proliferating; where the Cartesian suggest a static, stable emotive life, the associationist suggest a fluid, evanescent one, of rapid and perhaps violent change. (Kivy 1999: 188)

With the sonata principle we are entering a new musical world as well as a new political one—and both will become hard to distinguish. Sonata is not only drama-made-music but also music-made-politics.

Mozart's seven operas can of course be roughly placed in the previously discussed standard categories: The three operas created together with the libretto writer Da Ponte—*Le nozze di Figaro, Don Giovanni,* and *Così fan tutte*—are *opera buffa; Idomeneo* and *La clemenza di Tito,* as already mentioned, are *opera seria;* and *Die Entführung aus dem Serail* and *Die Zauberflöte* represent the German *Singspiel.* Yet this classification does not say much, because it doesn't account for Mozart's shifts in relation to tradition;

the conventions are upheld, yet everything has changed, with the genres interweaving into surprising new entities. Despite the apparent diversity of genres, it is nevertheless obvious that one of them stands out as paradigmatic: the *buffa*, which was the instrument and the weapon of the classical style. It embodied its new dramatic thinking, just as *opera seria* was tailor-made for the Baroque style. The gradual predominance of *opera buffa* over *opera seria* in the eighteenth century was also one of the signs that the classical style had triumphed over the Baroque. Mozart elaborated this confrontation of different traditions as well as their ideological and structural preconditions in every individual opera separately. And the most indicative aspect to envisage the change is the final moment of the opera, the finale. It is the place of the confrontation of the two logics.

Mozart's finales are beyond comparison to anything hitherto offered in operatic tradition. They seem to be small operas in themselves: at the end all protagonists come together to confront one another, the plot is intensified, the tempo increases, and yet all characters are given their own identity and clear identifiability in the midst of the events as they hasten toward the end. The mechanism allowing such a finale was the ensemble.

Music attains a new function in Mozart's ensembles. It is no longer an aria sung as a lamentation addressed to the Other or the moment of emotional expression, the suspension of action; it is neither a doubled aria as in previous duets (or rare terzettos and quartets) nor the choir as a general resonator, the agent of the community beyond the individual. The invention of the ensemble brought about a new community where all could retain their individuality, their own motivic identity, their rhythmic and melodic line, and still be integrated as such in the whole. The individual retains his/her particularity: s/he confronts the others in the ensemble and enters into conflicts with them, but at the same time s/he can solve these conflicts only through the ensemble, with the consistency of the whole being maintained. A utopian moment of community grows from individuals and their particularities, where individuals are not submerged and engulfed by the community but sustained and promoted. This community is kept alive through conflicts and by solving them; in the ensemble community can disintegrate and be put back together again. Mozart's ensemble is the utopia of the positive side of bourgeois society, the community growing from particular interests and inclinations and combining them to form a common harmony, without having to sacrifice them—the community as a "non-totalitarian totality" (Nagel 1985: 41). It is a society of con-

flicting interests that still form common harmony through the conflicts and their resolutions.

The emergence of the ensemble as a structural operatic element very effectively eclipsed the predominant opposition between recitatives and arias. To be sure, Mozart retained this convention. His operas abound in recitatives and arias, and the dividing line between the plot and expression remains in place but loses its privileged position through the use of the ensemble. Like the aria, the ensemble is a musical number, but it outshines the aria by its complexity of musical means and forms. Most importantly, the ensemble, like the recitative, carries the plot and much more: The key dramatic events are developed in the ensembles, and the recitatives are relegated to the minor part of conveying information and filling the periods between the arias. Hence, the traditional opposition loses its prevailing importance so that both arias and recitatives more and more frequently pave the way for the ensembles. Being both carriers of the plot and expressions of feelings, they tend to become the space of the key shifts: they modify, intensify, and resolve the relations between the subjects, and their end is usually different from their starting point. This also entailed the economy of means; a plot that would require, for example, three recitatives and three arias in the classic form now calls for only one single ensemble.

One can quickly illustrate this point on the basis of the sextet 3.19, "Riconosci in questo amplesso," from Figaro (the sextet that Mozart liked most of the whole opera). It begins with the resolution of the conflict and the creation of the harmonic community: The trial against Figaro is adjourned because it is discovered that Marcellina, whom Figaro would have had to marry for unpaid debts, actually is his mother, and her accessory, Don Bartolo, is his father. The parents and their long-lost son embrace joyfully, much to the dismay of the count (and his helper, the notary Don Curzio), whose plans have gone awry. Hence, a community is established, but this is done in such a way that the count and Don Curzio are given the melodic line of expressing their dissatisfaction in the background. The situation is reversed when Susanna arrives. She knows nothing about the new turn of events and tries to settle the case with borrowed money. Thus, she completely misinterprets Figaro's embrace of Marcellina and is overcome by blind rage that culminates by her slapping Figaro. But the conflict is quickly resolved, Susanna is told about the new situation and an idyllic community is reestablished, naturally against the background of the contrasting grumbling of the count and Don

Curzio. The musical elegance of this part stems from Mozart's direct manner of using the sonata form to present the plot. The sextet starts in F major, with several blocks of motivic material. The modulation to the dominant— that is, the manner in which conflict and tension are harmonically created in the exposition of the sonata—coincides with Susanna's arrival. The musical conflict, inherent in the sonata form, coincides with the emergence of the conflict in the dramatic plot. Susanna expresses her anger in C major and C minor, and the culmination of the conflict coincides with the end of the exposition, with the cadence in C, that is, with the point that also represents the highest tension musically. The recapitulation, the easing of the conflict, begins with the return to the tonic and the repetition of the initial motivic material—that is precisely the moment when the situation is explained to Susanna and the community begins to take on its initial harmony again. Thus, the sonata model with its inner musical drama (even if here the sonata form is treated somewhat loosely, as a guiding principle and not as a pattern) is used directly as an interpretation of a part of the dramatic plot, the creation and resolution of the conflict. The musical form develops from the logic of the dramatic plot, and the dramatic plot is embodied directly in the musical logic.[36]

The second aspect that will guide us in this brief survey of Mozart's finales is the way Mozart solved the conflicting prerequisites posed by tradition. Mozart's oeuvre obviously belongs to the Enlightenment, and so does the subject of *opera buffa*. Its logic stands in full contrast to that which had its origins in the sublime act of mercy from above and was based on the transcendent instance beyond the community. Consequently, this unique historical and musical moment represents the encounter and confrontation of two philosophies, two social theories, even "two ontologies" (Nagel 1985: 12). The individual already is an (enlightened) subject, although the framework of mercy is still maintained as a general frame of reference. Is then mercy the limit of the new subjectivity, its Other? Can transcendence and immanence be maintained? Can one hold both ends at one and the same time? How should their conflict be conceived and solved?

Die Entführung aus dem Serail

The two operas belonging to the tradition of *opera seria*, *Idomeneo* and *La clemenza di Tito*, cannot be discussed in detail here, even if they illustrate

important and interesting shifts and transpositions. Thus, for example, Mozart put to music Metastasio's fifty-year-old libretto in *La clemenza di Tito*, a libretto that already had been used for numerous operas before. Mozart wasn't happy at all with it and demanded some important changes—and the changes made by Mazzolà went in the two opposite directions of considerably shortening the whole thing and of substantially amplifying the ensemble. To Metastasio's original three duets were added three trios, one quintet (the finale of the first act), and a sextet (finale of the second act) (see Einstein 1979: 424). Apparently Mozart also wanted to apply his new knowledge and weapons to *opera seria*; he wanted to dismember it as a mere series of arias, and he wanted the musical constitution of a new community. The result is that Titus does stay monarch and magnanimously proves his mercy at the end, but at the same time he must sing together with others in ensembles, that is, he must enter into a musical community with them (as opposed to *Idomeneo*, where only Neptune's short oracular utterance is reserved for the act of mercy). In short, the monarch must justify his actions to and in the presence of the others. He must subjectivize himself—the old frame is maintained, but it is thoroughly shifted and reformed. And this begs the question of whether this can work and whether, in the final analysis, this is not an unsuccessful attempt at bringing together the incompatible.

Die Entführung aus dem Serail, Mozart's first great opera—technically a *Singspiel* with musical numbers connected by spoken prose dialogues—ends with the monarch's act of mercy: Belmonte wants to free his beloved Constanze from captivity in the Turkish harem. When the attempted escape eventually fails, Belmonte and Constanze, along with their servants Pedrillo and Blonde, who helped them, have to throw themselves at Pasha Selim's feet and beg for mercy. As if this wasn't bad enough, it turns out that Belmonte is the son of the Pasha's greatest enemy, but the Pasha wants to outdo his enemy in magnanimity and noble-mindedness and shows clemency, granting freedom to the four prisoners. In the greatest departure from the model on which it was based (Bretzner's *Belmonte und Constanze*), Belmonte is not revealed to be Pasha's long-lost son—leading to one of those sentimental reunions that densely populate the happy endings of Western literature—but the son of his archenemy. This leads immediately to the logic of mercy: Pasha is a true monarch when he is able to overcome his own passion for revenge—the despotic passion par excellence—and show regal generosity.

The subject of this opera is a topic that can be traced throughout the entire seventeenth and eighteenth centuries: the fantasy of Oriental despotism,

both as an image of unspeakable cruelty and tyranny and as one of alluring, exotic, sensuous attraction (or are the two one and the same?). Here we are given the positive version, as it were: The Oriental despot is not a ruler because of his cruel capriciousness or his supposed infinite enjoyment, whose center is the harem; rather, he is a ruler because of his noble spirit, which distinguishes him above all others. The despot who can reject despotism is no longer a despot but a sovereign—like Joseph II, whom the opera was intended to impress? On the other hand, the four protagonists are subjects with certain rights and dignity who are trying to master their own destiny through actions and cleverness. They can ultimately fall back on the right to love without constraint, a right that can elicit mercy. The monarch must yield to this right, and he proves his humanity through his realization that he cannot win Constanze's love by force.

The despot and the vizier, Pasha Selim and Osmin, respectively, are two extreme poles of despotism and form a couple that frames the four protagonists. The dramaturgical tour de force is undoubtedly that Selim is a spoken part: On the one hand, the act of mercy could no longer be credibly sung as in the grand tradition of *opera seria*, which was now coming to its end.[37] A year before *Die Entführung*, "singing mercy" was reduced to the smallest possible measure in *Idomeneo*, with the brief intervention of Neptune's oracle, and in *La clemenza di Tito* it would later lead to structural difficulties. On the other hand, the monarch retains his unique status precisely through the fact of being excluded from music. He can well be unique, but at the price of no longer being part of the musical community when it becomes guided by the Enlightenment ideal of community based on universal human reconciliation (the whole human race being one family, as the famous dictum of Lessing's goes). Harnancourt's Viennese production in the early 1980s sharpened this line to the extreme: At the end Selim appears like a broken man, forcing himself to the act of mercy with barely concealed anger, and throughout the remaining finale he remains a sad and lonely figure, excluded from the newly formed community that sings in praise of his generosity. His monarchic position is his deficiency and his curse, no longer a privilege. The original intention may well have been the flattery of the enlightened monarch, but it ambiguously entails his exclusion.

The despot and vizier have to be interpreted together as a double entity, and their maximum distance cannot disguise a structural complementarity. Whereas the despot makes reconciliation possible through his act of mercy while being himself excluded from it, the vizier excludes himself by refus-

ing to accept the reconciliation. He remains vengeful and implacable, unable to acknowledge the continuity with the others. Osmin's rage is the reverse side of mercy, the suppressed fury of the despot; the vizier sings in place of the despot, as his dark shadow and his caricature. The despot is the speaking part, so Osmin has to sing for two, and indeed his part—next to that of Constanze—is musically the most elaborated and the most individualized.

Mozart's finale shows this constellation with utmost brilliance: It takes the form of vaudeville, a simple musical form where each of the protagonists sings the single strophes while the chorus is sung by all. When it is Osmin's turn, he at first picks up the general tune of the solo verses for a few measures, but then the tempo is increased and Osmin falls out of the rhythm and tonality, suddenly seized by a wild rage (with the return of the A minor and the motif from his opening aria). His proverbial statement *"erst geköpft, dann gehangen"* (first beheaded, then hanged) demonstrates the reverse side of reconciliation and mercy. The elegance of the musical solution is that the simple vaudeville form—the individual verses and the joint refrain—is broken at a certain point, but this diffraction actually complements and rounds off the form. It is only through this infraction that the last refrain is so convincing. Vaudeville as a form cannot be the ideal of Mozart's ensembles, for the individuality of the figures is entirely stereotypical, and this particular one attains its dramatic power and the convincing transition to resolution precisely through Osmin's infraction.

So the finale displays the transcendence of the despot, his nonmusical uniqueness, as well as the inner exclusion of the vizier, the despot's suppressed musical representative and shadow self; hence, the community is healed by excluding both extremes. The concluding finale is thus the counterpart and the response to the finale of the second act, its inversion, for the second act finale presents the inner tensions of the community itself. The master couple and the servant couple are finally reunited in the second act when the two men join the two women in captivity to save them, but in the quartet that concludes the second act, both couples, after the initial bliss, break apart and are then eventually reconciled. The trouble starts because of the jealousy awakened in Belmonte and Pedrillo precisely by Pasha Selim and Osmin. The despot hopes to win Constanze's love, and Osmin tries to win over Blonde, the servant, and the result is that Constanze's constancy is suspected as well as the servant girl's so that here Pasha and Osmin represent the inner danger, the internal split of the happy community. Have the

two women been constant, given the cruelty and the allure of this paramount Oriental place, the harem? Here we can see a grand example of Mozart's ensemble: At the beginning the harmony reigns in view of the newly attained happiness; then there is a rift, a breakup due to the pangs of male jealousy; and finally the suspicions are dissipated and there is a happy reunification. And in the process, the quartet passes through a wide spectrum of moods, styles, tonalities, and tempi. And not by coincidence, the moment of reconciliation and forgiveness is on the side of the women, who were unjustly accused of faithlessness.

Here is a feature that we will discover to even a larger extent in *Figaro* and *Die Zauberflöte* and that seems to permeate all Mozart's operas: *Die Entführung*, both dramaturgically and musically, is slanted toward the women. One can see it on many levels. To Osmin's seducement, Blonde responds with something that sounds like a feminist manifesto:

Mädchen sind keine Ware zu verschenken! Ich bin eine Engländerin, zur Freiheit geboren und trotz jemanden, der mich zu etwas zwingen will!

=

Girls are not a commodity to be given away. I am an English woman, born for freedom, and I oppose anyone who wants to force me into anything.

Blonde is given one of the most popular hits of the opera *("Welche Wonne, welche Lust")*. But it is Constanze who primarily carries the drama, and she overshadows all others as the central musical and human figure. She is given the greatest aria placed in the exact middle of the opera *("Martern aller Arten,"* 2.11). When the end seems inescapable, when they are all facing death, she is the one willing to lead her presumable savior through death—just as Pamina will lead her savior Tamino. In the duet 3.20 she outdoes him, both in musical and human respects; she is transfigured from a passive and suffering victim into a figure of redeeming power. Compared with her, Belmonte emerges as a mere weakling, anticipating Don Ottavio.

Obviously, Mozart's feminism—if paper can bear such an oxymoron—is a highly ambiguous affair. One side of it relies on the most conservative eighteenth-century fears and concerns about feminine constancy and fidelity.

Constanze is the woman whose fidelity is put to test and who remains constant in the face of great allures and adversities, preferring death to infamy, the model of faithfulness against the proverbial fickleness of feminine nature. In her great aria she swears to her constancy by eagerly anticipating all kinds of tortures that she will have to undergo in preserving it, extolling the joys of martyrdom in a strange mixture of pleasure and defiance. Yet there is another side, apart from the immediate conservative readings—Constanze is a victim who turns into a redeemer, anticipating Pamina and Leonore (in Beethoven's *Fidelio*)[38] in a movement where the way to universality—the common humanity—is paved by femininity. The feminine universality (another oxymoron?) is the image of the Enlightenment universality for Mozart, and hence all the obvious, traditional assumptions and conservative cliché images of women at the same time touch upon something that makes them function as their opposite, the way to emancipation.

Mozart's letters (for example, the letter to his father dated September 26, 1781) show that neither the architecture of the whole nor the minute details were left to chance, despite the obvious weaknesses of the plot. Mozart demanded great changes in the libretto, both in the general design (the division into three acts instead of the two then customary for a work of this genre) and in the fine points, all based on his great theatrical sensitivity and dramaturgical instincts. General meaning is never discussed but only the technical details of theatrical presentation and musical effectiveness—only the mechanisms producing meaning (see Einstein 1979: 398–400, 471–475).

Figaro

The set-up in *Figaro* comprises again the standard two couples—the master pair and the servant pair. However, the difference in social status was at all points explicit and clearly delimited in *Entführung* (not only toward the inside but also toward the outside through the liaisons of Constanze and Pasha and of Blonde and Osmin), with the servants wanting only to wholeheartedly help their master or mistress; the entire plot in *Figaro* circles around the infringement of this explicit dividing line.

The count is placed in a double position. On the one hand, he wants to publicly and officially suspend his privileges—including the *ius primae noctis*, the mother of all privileges that grants him the despotic right to a harem—so as to legitimize himself through an act of mercy and magnanimity. In the first act, a choir of grateful subjects actually thanks him for

his generosity. On the other hand, he wants to secretly maintain the privilege—to combine public mercy with private debauchery, to be a feudal *and* enlightened master at the same time. Figaro, being his antagonist, may well be of a lower social rank, but in the end he will triumph over the master precisely in his function as servant. Reconciliation can be attained only through an equalization of status, that is, in such a way that the master has to reduce himself to human size, as it were—he must become a miniaturized master, a *Signor contino*, as he is addressed in Figaro's famous cavatina. The count's plans are eventually revealed through the ruse of disguise (by the countess and Susanna, mistress and servant, exchanging their clothes), which paves the way for the reconciliation in the finale, the most sublime moment of the opera.

Yet most significantly, the final reconciliation is not achieved through the classic act of mercy. Its mechanism is radically transformed, virtually turned upside down. It no longer concerns the *grazia* (mercy) granted by gods or the *clemenza* (clemency, magnanimity) shown by monarchs and aristocrats or the *pietà* (pity, mercy) implored by the subjects but rather *perdono* (pardon, forgiveness) (see Nagel 1985: 39). Forgiveness is human mercy that no longer requires that the distance be maintained; it is based on establishing continuity, on affirming immanence. Forgiveness is secularized mercy, the mercy shown by a human to another human. It is through forgiveness that the community becomes a community of equals.

In the finale, the count falls for the ruse and, because of the disguises, he is convinced that his wife (actually Susanna disguised as the countess) is betraying him with his servant Figaro. Susanna, in the outfit of the countess, begs him for forgiveness, all the others join her in her plea, but the count refuses to give in. The deceived husband, the threatened and shattered master, can retain his status only through a resolute "No!" that he repeats six times, by affirming his own discontinuity. The turning moment occurs when the countess appears disguised as Susanna, whom he tried to seduce just shortly before without knowing that it was actually his wife—when it becomes evident that the alleged victim was actually the greatest deceiver. The count, being the one who has the power of granting mercy, must now plead for that mercy he just refused the others. A moment ago the community knelt before him; now he must fall to his knees before the countess—and also before the community that is on her side. Now the power to grant mercy lies with the countess and, consequently, also the power to heal the community, to establish its continuity.

This sublime moment is extremely simple, both in text and in music:

CONTE: Contessa, perdono.
CONTESSA: Più docile io sono
 E dico di sì.
TUTTI: Ah! Tutti contenti
 Saremo così.

≡≡≡

COUNT: Countess, forgive me.
COUNTESS: My kindness prevails,
 And I consent to forgive you.
ALL: Ah! Everyone will be happy now.

Mozart seems to have looked to sacral music for this moment, to the ar-
chaic form of an exchange between the soloist and the chorus. The choir
takes over the countess's motif and, hence, the community becomes the sub-
ject of the act of forgiveness and is established precisely through that act[39]—
a community in which the count can now sing *"Tutti contenti saremo così"*
together with the others. Mozart's finales proceed according to a logic of in-
creased tempo, with the events following in quick succession; but just be-
fore the matter is finished quickly in a short final chorus, there is a moment
of sudden standstill in this scene of pardon, a moment in which dramatic
and musical time is suspended in a sublime instant evoking eternity.[40]

Tutti contenti saremo così—that is the emphatically condensed utopian
moment of the bourgeois community, the moment of reconciliation and
equality, the moment of *liberté, égalité, fraternité*. The revolution already
has taken place, the master already has fallen to his knees to eventually be-
come part of the community when the countess disguised as the servant
grants him pardon. Three years later, the French Revolution merely has to
dispose of the masters' empty shells. The master had already died on stage
for everybody to see, and he died all the more for not being killed but for
being pardoned. And the Bastille had already fallen.[41] No wonder that
Napoleon said, *"Le mariage de Figaro, c'est déjà la révolution en action"*
(Figaro's wedding is already revolution in action) and swore that under his
rule Beaumarchais would finish in prison.

Speaking of philosophy in the opera, here is a paramount example of it:
this moment of forgiveness finds its parallel par excellence in Hegel's *Phe-*

nomenology of Spirit, in the chapter about the spirit, the central chapter of this work, which ends with the section "Conscience. The 'beautiful soul,' evil and its forgiveness." Here forgiveness is taken to be the highest manifestation of spirit, its culmination. Hegel attributes to forgiveness the power of *Ungeschehenmachen*, "making [something] as if [it] had never happened" (Hegel 1977: 406) and, hence, "the wounds of the spirit heal, and leave no scars behind" (407). The dialectics of continuity and discontinuity of the community that can be raised to a new continuity precisely through forgiveness—the philosophical terms I use sporadically here—can be traced back to that page in Hegel, which, in the finale of *Figaro*, is set to music in a magisterial way.

To fully appreciate this ending, one must also bear in mind that the most significant moment of the first finale (the finale of the second act, the end of the first part of the opera) is structurally repeated in the second finale. The first one is equally concerned with the act of forgiveness—the count asks for pardon because he unjustly suspected the countess, and he is granted it. The economy of the situation is the same: the unyielding stance of the count, his refusal to forgive (*"Non ascolto!"* [I am not listening!]) is contrasted with the gentleness of the countess, who is willing to pardon him after a short lesson (*"Perdono non merta chi agli altri non dà"* [Who doesn't grant pardon to the others doesn't deserve it himself]). Yet it is a false act of reconciliation, an inadequate and deceptive forgiveness; the countess knows that she was not accused unjustly, that she has not told the count the whole truth, even though she was ultimately innocent. (Was she? Not by Beaumarchais's reckoning, judging by the sequel of this story in *La mère coupable*.)

At the same time, the short bravura final chorus quotes the motif from the finale of the third act (*"Amanti constanti"*; see Noske 1977: 14). There the subjects vowed love and loyalty, presenting an ideal image of the wise master and grateful subjects when the real situation was far from that. The final reconciliation has to cancel precisely this maximum distance between the reality and the illusion of the subjects by this transposed quote.

It has been often claimed that Mozart's and Da Ponte's *Figaro* is much less radical than Beaumarchais's original. Explicit and politically dangerous stings had to be omitted, and it was necessary to make concessions to the censorship so that the work could be performed at all. The most obvious example of this is the omission of Figaro's monologue in the last act, which, being a sharp manifesto of social critique, was the most significant stumbling

block and for a long time prevented performance of the piece in France. In his monologue, Figaro expressly accuses the count that his only merit was that of being born *("Vous vous êtes donné la peine de naître, et rien de plus")*, and he presents himself in contrast as a self-made man solely deserving for his own success. In this place in the opera we find only Figaro's lamentation about women's infidelity *("Aprite un po' quegli occhi")*, a cliché fitting perfectly into the convention of the eighteenth century. A extreme view in this direction is offered by Noske, for example:

> Even if the social tensions are clearly expressed in the opera, we should not let ourselves come to the conclusion that the composer wanted to disclose the suppression of the lower classes by the ruthless aristocracy in this way. *Le nozze di Figaro* has no message; it does not strive for reform of the social order nor for revolution. Anyone who can see and listen has to admit that Mozart merely illustrated the social climate at that time, without taking sides. His count isn't a monster, and Figaro is no national hero. (1977: 37)

This opinion, however, stands alone, because anyone who can see and listen can quickly realize that the whole opera is so strongly tinged with social criticism that the omission of this or that bit is irrelevant. The story of the count's usurpation, the despair and the forgiveness of the countess, the extraordinary human link with her maid, the enlightened and rebellious servant, and so on is no stuff for an innocuous Rococo intrigue, and this certainly was not Mozart's intention. Let us take, for example, *Figaro's* famous cavatina 1.3 *("Se vuol ballare, signor Contino"):* Just the fact that the count can be addressed in this way, with such nonchalance, already means that the count is lost, that he is subject to ridicule that cannot be compensated by any amount of social conformity. No matter what he does, he cannot hold onto his status after the cavatina, even though the opera has barely begun. And this is not to mention that the text at this point is much sharper and more sarcastic than in Beaumarchais's version, and as regards the music, Mozart presents a disparaging parody of the minuet as an aristocratic dance par excellence. One hundred and twelve years later, on a summer afternoon in 1898, Freud, in an extremely revolutionary mood, would hum precisely this cavatina on the platform of the Westbahnhof in Vienna after a chance encounter with Baron Thun (the minister president of Austria at that time, who was traveling to the emperor's summer residence from the same train

station): "Now all kinds of insolent and revolutionary ideas were going through my head, in keeping with Figaro's words" (Freud 1976: 300). Later that night, in an uncomfortable compartment, he was to have his most revolutionary dream (299–311, 561–564).

If we look at the operatic cast, *Figaro* shows another most extraordinary feature in the arrangement of the voices: there is no tenor. The two antagonists, the count and Figaro, are baritones (or bass-baritones), with Figaro being given greater musical weight—he is the only one who gets to sing three arias (1.3, 1.10, and 4.27), and these count among the most famous hits of the opera. The only tenors are Don Basilio and Don Curzio, cast in two completely minor roles, and the only tenor aria (Basilio's *"In quegli anni,"* 4.26) is practically always omitted in view of its musical and dramaturgical insignificance. Hence, no part has been given to the tenor hero, who always had taken center stage in both *opera seria* and *opera buffa*[42] (that is, when he has taken over this position from the castrato who dominated a great deal of the seventeenth and eighteenth centuries). There is no classical hero, no ideal lover who always is willing to sacrifice himself. This role cannot be assumed either by the count or Figaro, and it is already by this outward sign that we can see the great shift in the structure of the community created by the opera.

Until now we have looked at only one axis of *Figaro*, the opposition of the master-servant pair, the dispute between the count and Figaro. But there is another one, the gender axis, which brings up the problem of sexual economy and politics in Mozart's operas (keeping in mind that in Mozart's operas, all politics is sexual politics; they are developed against the background of the romantic intrigues that intersect with relationships of dominance). The count and Figaro may well be the main antagonists, but the resolution is only possible through the second axis, which hinges on the relationship between the countess and Susanna. When studied more closely, it becomes evident immediately that Figaro's plan against the count has no success—his ruse (disguise of the page, and so on) pitifully fails in the second act, and the women have to take things in their hands. In his position as the count's opponent, Figaro is just as blind as the count, and the two are united through their common blindness. Already in the first act, Figaro does not understand the meaning of the arrangement of the rooms, and it is up to Susanna to enlighten him—the count generously assigns him a room, into which the count will be able to slip without hindrance during Figaro's absence to see Susanna. In the general imbroglio of the last act, Figaro again is blinded. Although his aria begins with *"Aprite un po' quegli occhi, uomini incauti e schiocchi"* (Open your eyes a little, you

foolish deluded men), he is blind precisely at the moment at which he appeals
to men to see. Ultimately, it is the women who pull all the strings. Both mu-
sically and dramaturgically, Mozart's heart is on the side of the women. The
countess is not merely the subject of the sublime act of forgiveness; she is also
the one who at all points retains great dignity, without ever recurring to the
stereotypes of operatic despair. Susanna is presented with the greatest sympa-
thy. The count and Figaro are treated objectively, while Mozart's affection is
reserved for the female figures—women truly are the better halves here. This
is the stance that could already be found in *Die Entführung,* and it turns out
to be ubiquitous in virtually all of Mozart's operas: How much closer do we
feel toward Constanze and Blonde than Belmonte and Pedrillo? How much
closer do we feel toward Donna Anna and Zerlina than Don Ottavio and
Masetto? How much closer do we feel toward Pamina than Tamino, as she is
the true subject of the second half of *Die Zauberflöte,* the carrier of the drama?

Figaro's finale also makes the point that the act of reconciliation and the
fall of the master can only be achieved through the female pole—the mas-
ter's ruin was brought about not by the notoriously clever rebellious servant
but only by women. Hence, Susanna stands at the center, as servant and
woman. The community can be created only when the female element forms
the general ether that as a particularity gives the tone to the whole. The bond
between the countess and Susanna is the prerequisite for the general recon-
ciliation (and in this regard the duet 3.21, *"Che soave zefiretto,"* is the de-
cisive moment). "In musical respects there actually is almost no class dis-
tinction between the countess and Susanna" (Noske 1977: 21).[43] The
reconciliation between Figaro and Susanna (*"Pace, pace, mio dolce tesoro"*)
directly prefigures the reconciliation between the count and the countess.
The difference between the male and female poles is characterized by an-
other important social dividing line: Contrary to the men, the women are
subject to a certain social mobility in the course of the plot. When they ex-
change their clothing, the countess and Susanna also exchange their posi-
tions. Marcellina and Barbarina achieve their social advancement through
marriage; the men remain in their positions. One of the main factors allow-
ing reconciliation in the final moment, allowing social differences to lose
their relevance, is precisely this female mobility.

The sexual economy of the whole is complicated by the figure of Cheru-
bino. Given that we have a square with two couples (with the couple Bartolo-
Marcellina to round them off), the question arises as to the purpose of Cheru-
bino in this square, this completely unnecessary and yet central character

around whom the whole intrigue revolves. Cherubino always appears where he should not be—in the first act, the count discovers him hiding in the armchair where he must have heard the count's seductive words to Susanna (just as he discovered him the previous day at Barbarina's place, whom the count visited with the same intentions); the whole second act turns around Cherubino, his disguise, his hiding place in the closet, the escape through the window, the count's suspicions and the grudge he bears him due to his supposed affair with the countess; in the last act, he appears in the least appropriate moment and spoils the entire game; and so on. Thus, on the one hand, Cherubino appears as—to speak in Freud's terms—*Störer der Liebe* (an intruder upon love), an annoying element that thwarts romantic plans. On the other hand, he is the image of Cupid and Amor, the representative of sexuality par excellence. He courts the countess as well as Susanna and Barbarina in an equal way, and his undifferentiated sexual desires are oriented toward femininity as such (Kierkegaard will see in him "the portrait of Don Juan as a young man"); he is standing at the threshold of childhood and adulthood, entering into sexuality, but he is also standing on the border between masculinity and femininity. Not only was his role written for a female voice—what in German is called *Hosenrolle* (a woman in trousers)—but the main twist of the intrigue consists of his disguise in a female costume—a woman playing a man being cross-dressed as a woman, like an eighteenth century version of *Victor/Victoria*. His character represents a strange condensation of Cupid and cherub (fondly used in the diminutive Cherubino); thus, the sexless angel coincides with the representative of sexuality as such, just as sexual desire in him coincides with his absolute narcissism (Figaro, in his most famous aria, compares him to Narcissus and Adonis).[44] He is a walking series of fetish condensations: the awakening sexuality, the mythical origin of sexuality, the limit between sex and sexlessness and between male and female, while at the same time he embodies sexuality per se, the very essence of sexuality as well as the stumbling block, the obstacle to sexuality that prevents the seductive exploits of the master.[45] If one adds to this the element of disguise, then one has everything needed to define the phallic element in psychoanalysis.[46]

Don Giovanni

Figaro finishes on the happy note of an utopian community and reconciliation, and nothing seems quite to prepare us for what is to follow: *Don Giovanni*, which shows the reverse side of this utopia, its hidden prerequisites.

There is a direct connection between Don Giovanni and Figaro, which brings about an inversion of the whole by extending and radicalizing the motifs. Don Giovanni is everything the count wants but is too scared to be—he is the realized count. There is no longer a dividing line between public virtues and private sins. Don Giovanni is the declared libertine who does not hide his immorality under the guise of morals and mercy but rather sets it up as his program. Strangely and perhaps surprisingly, they have in common their failed efforts at seduction: The count is not able to seduce the servant, and Don Giovanni cannot win over the peasant woman Zerlina—he may be an expert lover, but on the stage he experiences failure right before our eyes. The count mistakes his own wife for a lover, and so does Don Giovanni, who doesn't recognize Donna Elvira.

The most important inversion, however, takes place in the relationship between the master and the servant. As mentioned previously, Leporello, being a coward, glutton, and egoist, is the representative of the economics of survival, both as regards his cunning in looking after his private interests and his subordination to prevailing norms and opinions. He is, to put it simply, the representative of the reality principle, which is for Freud but an extension of the pleasure principle; thus, he is our own representative, who, while waiting before the house in which his master attempts his seduction, introduces the opera, thereby setting our perspective. On the other hand, Don Giovanni, being a fearless master who won't renounce any desire and wants nothing less than all women, stands for the moment beyond the pleasure principle. That is his paradox: By following so uncompromisingly the pleasure principle that he refuses to renounce, he takes this principle to an extreme, to an ethical attitude in whose name he finally is willing to die (see Žižek 1991: 115–116). This ethical attitude indicates an absolute autonomy of the subject in rebellion against the existing order, its moral principles and religious arguments (traditionally, Don Juan was presented not only as a womanizer, which wouldn't have been the worst, but also as an atheist). Not only does he violate human moral laws and God's commandments, but also "the divine law" in Antigone's sense of the term—that is, he violates the law prescribing the burial of the dead, their untouchability, their holiness, he violates the space symbolically assigned to them. The violation of precisely this law is his undoing; the usual excesses would not have been enough. After all, he killed the Commandatore, Donna Anna's father, in a duel; his true violation is that he disturbed his peace after death and infringed upon the symbolic place allotted to the dead.

Yet Don Giovanni takes an ethical stance that could be read in accordance with Lacan's slogan *"ne pas céder sur son désir"* (not to give way as to one's desire—something that Kierkegaard already knew, as we shall see later). The disturbing thing about him is not that he has vast quantities of women—all aristocrats are assumed to do that—but that he raises pursuing pleasure to the level of an ethical principle for which he would rather die than renounce.

For Don Giovanni there is no reconciliation and no mercy. Compared to the finale in *Figaro*, the situation is reversed. Mozart quotes himself twice: At the beginning of the finale he parodies himself and, with seeming innocence, throws in the famous melody from *Figaro* as entertainment during the banquet. That, however, merely serves to announce another more important quotation—just like the count, Don Giovanni also says "No" six times—not in refusal to dispense mercy and forgiveness (like the count) but in refusal of pleading for and obtaining it for himself. The statue of the Commandatore challenges him to repent and attain redemption, to save his soul and gain continuity with the community. The call for remorse, *"Pentiti,"* is repeated four times, urging him to take the attitude of *"humiltà o supplicatione"*—the attitude of which Monteverdi spoke, the attitude of humility, imploration, and lamentation that alone can bring about mercy (see Nagel 1985: 52). Don Giovanni is not a master whose status would depend on granting mercy, on showing *clemenza*; he abides solely by the law of his desire. He is the merciless master, and that is why no mercy can be bestowed upon him. Both granting mercy as well as begging for mercy would require him to give way as to his desire.

Consequently, Don Giovanni is a condensation of two things. On the one hand, he is the very quintessence of the old order—just like the count but without disguise and pushed to the extreme. He demands for himself absolute privilege, not the *ius primae noctis* but the right to all nights. He appears as the archaic image of the real master as opposed to the master who has to hide behind mercy and magnanimity or, even worse, who is forced to ask for forgiveness. Thus, he embodies the old order of absolute privilege against which the Enlightenment's crusade is directed. On the other hand, he embodies the autonomous subject which is the cornerstone of the Enlightenment. He is his own legislator, obedient only to his own desire, and in the end he rebels against the old order in a much more radical way than any bourgeois subject would ever dare to do. Whereas *Figaro* ends in the spirit of *liberté, égalité, fraternité*, for Don Giovanni *liberté* is placed beyond and

in opposition to *égalité* and *fraternité*, in a zone where pure liberty coincides with pure evil.

This condensation can also be seen as follows: Whereas the count was a father figure (a corrupt father, but nevertheless, or all the more, a father), Don Giovanni is a figure of the son.[47] As the embodiment of the master par excellence, he can paradoxically only be a son, a rebellious son who claims for himself all of the father's privileges in a much more radical way than the father would ever dare. The figure of the father returns as the living statue of the dead father, who eventually celebrates an ambiguous victory—the son is damned and goes to hell, unwilling to repent and compromise, which also shows that the father can no longer be master in view of the son's autonomy.

Don Giovanni, this paradoxical condensation, stands at the center of the opera. He is omnipresent, the driving force behind the whole action. At the same time, he cannot be caught, evading every trap set for him until he voluntarily extends his hand to the statue of the Commandatore, keeping his word for the first and the last time, honoring the binding nature of his invitation. But he is ungraspable not only with respect to the plot but also in that he lacks a musical identity. Contrary to common operatic convention, he has no introducing aria in which he would explain his attitude and intentions. His famous "Champagne aria," a presto lasting barely one and a half minutes, is indeed like champagne—mere bubbles of a dashing trance. He sings the other two arias, the serenade *"Deh, vieni alla finestra"* (Come here to your window [2.17]) and *"Metà di voi quà vadano"* (Half of you go this way [2.18]), in disguise as Leporello. The first aria is a parody of seduction, and the second is an "action aria," that is, not an aria in the strict sense but rather instructions for action. In the ensembles, too, he constantly changes his identity, musical styles, and forms. Several musicologists already have pointed this out: Noske (1977) showed that all protagonists present a circumspectly elaborated musical characterization—except for Don Giovanni.

> The kaleidoscopic image of Don Giovanni is merely a negative application of the principle of individual characterization. Our hero does not have the homogeneity of the others, simply because he subtly adapts to every situation. Sometimes he even transforms himself within one and the same scene, as in the quartet in the first act. Flexibility is his most important weapon in his struggle for power. Consequently, a consistent Don Giovanni would not be able to dominate

his opponents or to convince us, his audience." (Noske 1977: 41; see also 85–86, 320)[48]

This lack of identity in the dramaturgical and musical center of the opera allows everything to revolve around him while at the same time situating him outside the community and its codified relations. This also entails that he can form the point of contact for different segments of the community: With his *"È aperto a tutti quanti, Viva la libertà!"* (This ballroom is open to all; you're at liberty to enter), representatives from all social ranks and classes join in the banquet at the end of the first act, people who would hardly have been able to celebrate together otherwise (their simultaneous presence is brilliantly represented by three orchestras that play three dances at the same time—minuet, allemande, and contredanse), just as women of all natural and social categories can be found in his list of women. He occupies a position of the edge of the community, beyond rank and class.

His discontinuity with the community is insurmountable; he cannot be incorporated. Rather, the community, over and beyond the differences in status, enters into an allegiance against him, in the very strange alliance among Donna Anna, Donna Elvira, Don Ottavio, Zerlina, Masetto, and finally, even Leporello. They were able to join forces and become equals only in their effort to confront Don Giovanni, in their attempt to exclude him. And he can be excluded only by the old order, the order based on the authority of transcendence and the authority of the father—it is precisely the dead father, who returns as transcendence and takes care of moral sanctions, who kills him. The punishment for the rebel who took autonomy too seriously is finally dispensed on behalf of the new community, which joins forces with the emblem of the old order, the living dead of the statue. The upcoming new and waning old order enter into a coalition against the common enemy. But even that cannot reconcile the community, which, in the last scene, remains alone after Don Giovanni's fall with a parody of the happy ending that cannot conceal the uneasiness. They were a community only in their opposition against Don Giovanni, so without him they lose their ground.[49]

If the count in *Figaro* had had the courage to go to the limit, then he would have been Don Giovanni; if the enlightened autonomous subject had the courage to go to the limit, then it would be Don Giovanni, too. Both coincide in him. On the one hand, he embodies the power of the new subjectivity, which paradoxically takes the form of the last real aristocrat; Don Gio-

vanni is its destructive face, pure autonomy without the mask of equality and fraternity. On the other hand, transcendence appears in the form of the guest of stone without the mask of mercy, as the force of revenge, the alliance of heaven and hell. All of this turns *Don Giovanni* into the most ambiguous of Mozart's operas.

The Opera in Philosophy: Mozart and Kierkegaard

Today it is commonplace to consider Don Juan a modern myth.[50] Tirso di Molina created its first version in 1630, at the time of Galileo and Descartes and the emergence of opera as a genre. Molina called his work *El Burladór de Sevilla*—the mocker, joker, swindler, womanizer from Sevilla (he who plays tricks—in short, the "Barber of Sevilla"). This version is followed by innumerable others that—as we have learned from Lévi-Strauss—should be taken together as so many transformations of the same myth, so one has to find their "matrix of permutation" and not look for a supposed original or privileged embodiment. Molina's version may be the beginning but not the original—he merely combined elements that had been present before in Castilian folktales, medieval morality plays, and so on. Nonetheless, the origins of the myth are placed in a precise historical moment so that its spreading and its fascination accompanies the emergence of modern subjectivity as a sort of metaphysical parable about its status and limits.

This myth had to wait for a devout Christian such as Kierkegaard to be taken as seriously as it deserves. Kierkegaard is of interest to us above all because he considered Mozart's *Don Giovanni* as the absolute, privileged, and only true version of the myth and tried to integrate the myth itself in a simultaneous historical and metaphysical horizon. Writing another Don Juan after Mozart is like wanting to write a post-Homerian Iliad—Mozart's version is final and unsurpassable, achieving complete harmony between contents and form (Kierkegaard 1992: 50). Never before or after has any opera undergone such comprehensive philosophical reflection—Kierkegaard dedicated something like 150 pages of his work *Either/Or* to it alone, and his poetic soul cannot resist lyrical outpourings:

> Immortal Mozart! You, to whom I owe everything, to whom I owe the loss of my reason, the wonder that overwhelmed my soul, the fear that gripped my inmost being; you, who are the reason I did not go through life without there being something that could make me

tremble; you, whom I thank for the fact that I shall not have died without having loved, even though my love was unhappy.... Yes, to take him away, to efface his name, would be to overturn the only pillar that hitherto has prevented everything collapsing for me into a boundless chaos, into a fearful nothingness." (51)

One must understand that Don Juan is a Christian hero par excellence:

Since sensuality in general is what is negated, it first comes into view, is first posited, through the act that excludes it by positing the opposite, positive principle. As a principle, a power, a system in itself, sensuality was first posited with Christianity.... However, if one wishes properly to understand the proposition that Christianity has introduced sensuality to the world, it must be understood identically with its opposite, that it is Christianity that has chased sensuality out, kept it out of the world." (64–65)

In ancient Greece, sensuality was not a problem to the extent that that culture "posited sensuality under the category of spirit"; for the Greeks, "spiritually defined sensuality" (65), and they strove to achieve harmony between sensuality and spirit. Gods and humans could meet in the sphere of Eros, and Eros himself was a god, a spirit. Don Juan could never have been a hero of antiquity. But Christianity, by forcefully asserting the spiritual principle, brought forth its opposite as the consequence—something that it excluded but that "first comes into existence through its exclusion" (65). It is only exclusion that provides existence in an emphatic meaning.

Don Juan is a figure of sensual genius, the embodiment of that opposite principle. As an embodiment of a principle, he belongs in the Middle Ages; as an emblematic "sinner as a matter of principle," he can be placed in the same category as other allegorical figures such as the Knight, the Dame, Mammon, Everyman, and the like. The emergence of such allegorical figures is a product of the historical enforcement of the Christian spiritual principle. But one had to wait for the end of the Middle Ages for his birth, because medieval sensuality was still held captive by the eroticism of chivalry, minnesongs, and the aesthetics of courtly love; this was a deferred sensuality. This love was too spiritual, too close to Hellenic love, and only its decline made pure sensuality possible. Still, the Middle Ages gave birth to the myth of the mount of Venus[51] as a place of unrestrained debauchery, where

"language has no home, nor thought's sobriety, nor the laborious business of reflection. All one hears there is the elemental voice of passion, the play of the appetites, the wild din of intoxication; indulgence, only, in an eternal tumult. The first-born of this kingdom is Don Juan." (Kierkegaard 1992: 96). Following the demise of the medieval universe, the hero of pure demonic sensuality could enter the stage.

This principle can be expressed only in music:

> This is where the significance of music is revealed in its full validity, and in a stricter sense it also reveals itself as a Christian art, or rather as the art which Christianity posits by shutting it out, as the medium for what Christianity shuts out and thereby posits. In other words, music is the demonic. In the erotic sensual genius, music has its absolute object." (68)

Only in developed Christianity can music unfold its full powers—as Christianity's opposite and antithesis, as the sphere of sensuality and pleasure. The Greeks could not have known either sensuality, pleasure, or music, for they did not yet know sin.

Music is a sphere beyond language; music defines the limitations of language. Language as the sphere of spirit, ideas, and reflection tries to reduce its sensual materiality to the minimum, to mere means and tools. Poetry is aware of this materiality and raises language to music as its upper limit, but music is at the same time also the lower limit of language, its disintegration to voices. "Wherever language comes to an end, I run into the musical" (73). If music is the upper and lower limit of language, its beginning and its end, this is because "music always expresses the immediate in its immediacy. . . . In language there is reflection and therefore language cannot express the immediate" (74). Sensual immediacy is necessarily lost in language and can only find itself in music, only music can refer to the "absolute object"—and we can see Kierkegaard joining hands with Hegel, his great antagonist, his perfect opponent. The only difference is that Kierkegaard interprets Hegel's dialectics of sense-certainty, as expressed in the opening chapter of the *Phenomenology of Spirit*, as a treatise on music, developing the very same thesis. Whereof one cannot speak, thereof one can make music.

Can music be a medium of the spirit? Where does its unique role in Christian rituals and its powerful impetus on church music come from? For Kierkegaard there is no doubt and no compromise: "The stronger the reli-

giosity, the more one renounces music and stresses the word" (77). Music can be the counterpart of undeveloped religious sentiment that is still caught in sensuality, that is, a non-Christian religious sentiment. The Presbyterians are well aware of that, as they "regard the organ as the devil's bagpipes which lull serious reflection to sleep, just as dance benumbs good intentions" (77).

Hence, there is an inherent relationship between music and sensuality and, by extension, between the essence of music and the essence of Don Juan; the idea of music attains its completion in the idea of Don Juan. Thus, no other version can compete with that of Mozart, and no other opera by Mozart can truly achieve its telos. The inherently erotic quality of music is seductive and ephemeral as sensuality and, by virtue of this, absolute: "In the particular, desire has its absolute object, it desires the particular absolutely" (90). It can exist only within a moment and for the moment, but then it is absolute. For this reason, Don Giovanni cannot be individualized—Don Giovanni is not an individual:

> "When he is interpreted in music, on the other hand, I do not have a particular individual, I have the power of nature, the demonic, which as little tires of seducing" (99). "Love from the soul is a continuation in time, sensual love a disappearance in time, but the medium which expresses this is precisely music" (102). "For his life is the sum of mutually repellent moments that lack any coherence" (103).

As sensuality, Don Giovanni is the pure principle of nonidentity—only language is able to grasp identity, giving it continuance at the price of losing the momentary and the sensual, and from then on one can speak about spirit and morals. As a demonic force of sensuality, Don Giovanni is inherently not identical with himself; his only identity is eternal transformation, in purely negative determination—his only loyalty is the ceaseless repetition of disloyalty. He strives for the object that is always transient and transformable yet precisely because of this always identical and absolute. All women are the same for him—they are always different, to be sure, but they embody the same absolute and elusive object. Don Giovanni has no existence of his own; he is always on the run from himself. If Kierkegaard had praised Mozart as the only pillar that alone would protect him against chaos and nothingness, then this pillar appears to stand here at its very closest to chaos and nothingness, beyond the limits of identity—the musical embodiment of that which cannot be embodied.

So Kierkegaard seems to be in unusual agreement with the previously mentioned musicological opinions that Don Giovanni does not possess a musical identity and, consequently, is present only as a relentless musical force through the effect he has on others. "Don Giovanni's own life is the principle of life in them" (Kierkegaard 1992: 128). He is their common denominator. They are defined through him; he holds them together and establishes a community, just as dark planets receive their light from the sun (133). When, for example, Donna Elvira sings, the audience does not have to see Don Giovanni; they are to hear him in Elvira because it is he who is singing through her (131). He is the music that holds everyone spellbound; they cannot break out of his circle by virtue of the power of music which coincides with him.

Should Don Giovanni be condemned as a womanizer, as a demonic sinner? Kierkegaard's answer is paradoxical: He stands above any ethics or morals; he is their absolute limit, that which is inherently excluded from the ethical. Ethics can apply only when the elusiveness of the sensual is fixed, pinned down in an identity and permanence. To designate him as seducer already is too much—seduction calls for a strategy, a reflection, a plan; it takes place primarily in the sphere of words. "A seducer should therefore be in possession of a power which Don Giovanni does not have, however well equipped he is otherwise—the power of speech.... The power of such a seducer is speech, that is to say, lies" (106).[52] But Don Giovanni seduces only through the force of desire—he desires and that is enough—and the fact that he doesn't give way as to his desire makes him unstoppable. The reflective seducer, the counterpart to Don Giovanni, obtained the paradigmatic and emphatic embodiment in Kierkegaard's "The Seducer's Diary" (which is included as a special part in *Either/Or*)—there we see a seducer who draws up detailed plans, thinks at great length about proper strategies, and finds aesthetic enjoyment at every step in the process through the very deferral of the sensual consummation. His enjoyment lies in reflecting on pleasure, in postponement (when Cornelia finally gives herself to him, she loses all attraction for him, and he can discard her—the aesthetic appeal lay only in deferment). This literary seducer works his charms on only one single girl, whereas his musical colleague seduces 2,065 (if Leporello's list is correct). Although his irresistible and inexpressible[53] power makes the girls unhappy and actually destroys them, "it was a foolish girl who did not want to be unlucky in order just once to have been lucky with Don Giovanni" (108)—she wouldn't really be a woman. And where is the young man who wouldn't give

half his fortune or lifetime to be Don Juan for one single year—he, too, wouldn't really be a man—and only a profoundly devout Christian could have written something like that.

In its essence the idea of music is the idea of Don Juan; however, the idea of music can only attain its full deployment within the opera, and only the opera can embody its essence. If Don Giovanni's power resides only in his effect—the effect for which one cannot fathom a graspable cause (that is the reason for his lack of identity)—then this effect calls for staging the performance. The immediacy cannot be shown directly, but its representation in the performance already is a form of mediation and thus its loss. Through the performance it is already betrayed, reflected, echoed. Don Juan, however, is "an inward specification and so cannot become visible in this way or reveal himself in bodily forms and their movements" (Kierkegaard 1992: 114). If sensuality is to be on the level of its definition, it must be invisible sensuality, because eyes spoil sensuality and reduce it to something merely external. Kierkegaard listened to music with his eyes closed, and although he at first tried to find a seat close to the stage, he gradually moved further and further away and found that the greater his distance from the performers, the better he understood the music: "I stand outside in the corridor; I lean up against the partition separating me from the auditorium and then the impression is most powerful; it is a world by itself, apart from me, I can see nothing, but am near enough to hear and yet so infinitely far away" (129).

The absolute object of sensuality can only be the inward object. Having an actor play the role of Don Giovanni on the stage is already too much, because the actor bestows upon him the consistency of a figure and a form. The true correlate of sensuality is the music; all else betrays through positive features. "Mozart constantly interprets [Don Giovanni] ideally, as life, as power, but ideally in opposition to reality" (144). Opera, thus being the only true space of music, is also the space of an impossible representation, the evocation of the impossible object.

How can Don Giovanni be stopped? Where is his limit? No worldly or profane power can touch him; his limit is spirit alone: "A spirit, a ghost, is a reproduction; this is the mystery in the return; but Don Giovanni can do everything, can put up with anything, except the reproduction of life, precisely because he is sensual life in its immediacy, the negation of which is spirit" (121).

The spirit is not worldly; it is transcendent, suprasensual, and as such it can be embodied only in stone, in the element of permanence. "The spirit

is a bone," says Hegel (1977: 260), and "The spirit is stone," claims Kierkegaard. As a double of life, it is the reproduction of its transitoriness qua permanence; it is life paralyzed and mortified. The spirit cannot be pierced, just as the stone cannot be pierced, a dead person cannot be murdered, and a ghost cannot be killed. The spirit as stone is absolute stagnation, eternalized identity confronting the demonic force of nonidentity. The nonmaterial materiality of sensuality stumbles against the material nonmateriality of the stony spirit; nonsensual sensuality reaches its limit in sensual transcendence. If, however, the spirit is stone, then it also is a stone that is moving and still alive—and that precisely makes it transcendent sensuality—the spirit is death that cannot die, that continues to live as stone. The elusive and intangible object of music and sensuality meets its negative reverse side here—the object of fixation, stagnation, the realm between two deaths.

Kierkegaard never stops to confound us by his eagerness to draw extreme consequences.[54] His Don Giovanni stands beyond language and the signifier,[55] in the realm of enjoyment, which—here he agrees with Lacan—is not accessible to the signifier as such. He is constantly chasing after this impossible object, the always same and always different object, and he at the same time becomes this object for the others, the promise of enjoyment. That he refuses to give way as to his desire turns him into the elusive object of desire. Not giving way as to one's desire in the final instance turns desire into drive, to a pure compulsion to repeat. Enjoyment turns into a mechanical repetition—what cannot be put into words, repeats itself; what is unique (that is, sensual) can only be repeated. The drive circles around its object, it can find satisfaction only in infinite repetition, and desire brought to this extreme point spellbinds the observers. Thus, lust for pleasure is transformed to an ethical attitude beyond the pleasure principle. Ethics are based on permanence and identity and, hence, an economics of renunciation, through which it finally serves the pleasure principle in a roundabout way. Don Giovanni represents an ethical attitude beyond these ethics, a pure repetition beyond identity. The limit of this repetition circling around the elusive object is finally the object itself, in its fixity as its determination in its opposite: When the object is found, it is lethal.

Kierkegaard is important for our project in several respects. He, too, tried to trace Mozart from the definition of music and, hence, from the definition of opera. We started from the assumption that in the opera, music attains its own self-reflective presentation, and thus, by staging and performing its own

power, it reflects that which is transcended by this allegedly irresistible power. One takes recourse to music when all other means and strategies fail—it is only by music that one can bend the Other, obtain mercy, and produce love; only music can reach beyond the social to nature and the gods. But if in the operatic tradition up to Mozart, this power of music immediately translated into the redeeming power of love, which found its expression in the final act of mercy or in the final act of marriage, then music, in Kierkegaard's view, primarily is the demonic power of sensuality, the sphere excluded from the spirit and love, the sphere beyond mercy. Kierkegaard also believed that the power of music oversteps every structure and rational reasoning, but this transgression for him occurs in a radically opposite direction. The question is not whether it extends to gods and to nature, as in Orpheus; on the contrary, as far as it extends to nature by presenting pure, natural motive force and sensuality, it is the farthest away from God. The truth of love and mercy is Don Giovanni, the being beyond love and mercy as a true embodiment of music. Ultimately, mercy and love are only a mask of the demonic nature of music, its deceptive disguise. But this subjects music—and, hence, the opera as its true embodiment—to a radical ambiguity, a fundamental ambivalence: The highest force of love and mercy coincides with its excluded opposite, with the lowest demonic force of sensuality, with radical evil. It seemed that music would reach to God as well as bring love and reconciliation to the community; but it turns out that it may be nothing else but the most sublime invention of its demonic counterpart. Does music stem from the Devil? If it has the power to make the Other yield not because of its sublimity but rather because of its sensual and erotic nature, then it is able to bend the Other only by allying itself with the demonic power in order to seduce the Other. The music is not the sublime power capable of taming nature; rather, it stands for the triumph of sensual nature over spirit. Here Orpheus's *"Acheronta movebo"* attains its opposite, its Freudian ambiguity. The annihilated subject who lost everything in its attitude of *humiltà o supplicazione,* in its lament directed to the Other, has not really lost everything and only seemed to be annihilated—it retained the voice, the music, and thus the most subtle connection to demonic sensuality, its quintessence.

Like Bach, Kierkegaard stems from a Protestant background; unlike Bach, who simply dismissed or avoided the opera, Kierkegaard raised it to a paradoxical privileged position, to the position of the paradigmatic antipode of ethics and religion—but whoever cannot give himself completely to the

fascination of opera should also remain silent with respect to ethics and re-
ligion.

And coming back to philosophy, one could say that opera also stands be-
yond philosophy, and philosophy, like Christianity, must exclude it as sen-
sual fascination to constitute its concepts at all. Yet, by the same gesture, it
also brings forth and evokes its impossible object. Philosophy, too, creates
that which it excludes. To paraphrase Kierkegaard, the modern philosophy
has introduced the opera into the world.

La femme machine

The finale in *Figaro* promises *"Tutti contenti saremo così,"* presenting a
utopian and happy point of departure for the bourgeois order, the demise of the
master, the French Revolution in music, the reconciliation of a new commu-
nity. A bright future is on the horizon. But barely a year later, the finale of *Don
Giovanni* shows a new face: There can be no reconciliation with the rake who
embodies all privileges of the old order; for him there is no mercy and no for-
giveness. There can be no reconciliation with the moment of his absolute au-
tonomy, his radical calling into question of the basic social values, his ethical
stance. He unites in him the old libertinism and the moment of Jacobin radi-
calism; the community can be redeemed only through the return of transcen-
dence, the resurrection of the patriarchic authority of the father figure and re-
venge from the Beyond. The conclusion is more destructive than redeeming
for the community; a dark shadow falls over the bright future.

Così fan tutte,[56] Mozart's next opera, is undoubtedly the strangest of all.
During the past two centuries, it has never ceased to provoke uneasiness.
The connoisseurs of classical music would generally agree about the supreme
quality of its music, but one could hardly reach unanimity when judging its
contents, which continue to appear rather questionable and bizarre. Should
one simply take the stance that operatic librettos are generally of a rather
mediocre quality anyway and should not be judged on their own merit, so
let us forget about it and concentrate on the music? Or should one insist that
the opera only makes sense as a *Gesamtkunstwerk*, that it is by its nature
something very different from a concert in costumes, so that a questionable
libretto necessarily ruins the required unity? Can one turn a blind eye to the
dubious ideology of the plot that permeates the whole? Neither attitude can
quite do away with the problem that underlies *Così*.

Così was the third and last opera that Mozart wrote in collaboration
with Da Ponte, and if we take it as the conclusion of a triad, a synthesis, as
it were, it certainly provides a most bizarre ending to the series that started
with *Figaro* and continued with *Don Giovanni.* More peculiar still, it was
written in the very year of the revolution and first performed in January 1790,
thus presenting a rather odd historical counterpoint. If *Figaro* could be seen
as a direct precursor of the revolution and if *Don Giovanni* entertained a very
strong though ambiguous link with its historical moment, then nothing
could be more remote from it than the rococo facetiousness and artificiality
of *Così*, a wrong piece at a wrong time. *Figaro* and *Don Giovanni* soon be-
came the objects of universal and unalloyed admiration, featured among the
highest achievements of human spirit. The nineteenth century found fasci-
nation with the heroic new beginning in the former and satisfied its thirst
for the demonic in the latter (remember Byron, Kierkegaard, Pushkin, Hoff-
mann) while *Così* sank into oblivion. Mozart's first two biographers,
Niemetschek and Nissen, were also the first to deplore the discrepancy be-
tween the music and the plot:[57] "One must wonder how Mozart could sink
so low that he wasted his divine melodies on such a miserable bungle" (Nis-
sen, quoted by Gülke 1991: 254), and thus opened the century-long season
of lamentations.[58] To save the music, there were several proposals for a dif-
ferent libretto (the most famous attempt was based on *Love's Labour Lost*,
another was tried with Calderón's *Dame duende*, and so on) or at least to
modify the plot in such a way that the two ladies see through the intrigue
halfway through and only feign to be taken in to play a trick on their fiancés
(see Hughes 1972: 187–188). It has taken the authority of Gustav Mahler to
rehabilitate the original version after a hundred years and to start its revival
through our century, though the uneasiness has never quite subsided.

The reasons for doubt are easy to see. The first one is the work's obvi-
ous lack of psychological credibility and tendentious artificial construction.
The two ladies may well be rather dumb and vain, but it is a bit too much
to assume that they would throw themselves, in the space of a few hours,
into the embrace of the first Albanians who happen to come along and to fall
for the clumsiest tricks. The plot is obviously constructed to prove a thesis,
regardless of the likelihood. The protagonists lack personality; the philoso-
pher may well try to persuade the youngsters that their high idols are women
in flesh and blood, but the plot rather proves the contrary—that they are
mere puppets. It is quite true that in the opera we are prepared to swallow

all kinds of colossal improbabilities and that opera is itself an absurd under-
taking when measured with the minimal realistic standards, but here the ab-
surdity is even greater, given the contrast with the realistic setting. *Così* is
actually one of the very few operas (particularly in the early period) that is
not set in some conveniently distant mythological time and place, and nei-
ther do any deities and monarchs appear on the stage—it is entirely con-
temporary. The action takes place in the bourgeois setting of Neapolitan
flats, gardens, and cafés, and the audience can for once watch people like
themselves. The impression of artificiality is reinforced by the symmetry of
both couples and the symmetrical constructions of the whole—the second
act mirrors the first one, scene by scene, and both share the same internal
organization (see Mezzocapo de Cenzo and MacGabham 1991: 283–284, for
a detailed overview).

The second source of reticence was the obvious immorality of the story.
If *Figaro* and *Don Giovanni* condemned and punished the frivolous libertines,
at least on the face of it, then *Così* seems to condone rather questionable be-
havior. The thesis it tries to prove puts into question the high, untouchable
values of love, virtue, and fidelity. It shows how little is needed to under-
mine those ideals and unmask them as illusions. Beethoven was horrified
that Mozart could accept such a dubious and unethical libretto, and Wagner
deemed that trivial contents could not yield anything else but trivial music
and that Mozart's genius had failed him for once. But Wagner was one of the
very few who disputed the quality of the music[59] (and one could not expect
anything less from a believer in *Gesamtkunstwerk*).

The third stumbling block is more recent and probably did not cause so
many problems in those times. *Così* is imbued with an antifeminist attitude
that views women as naturally prone to infidelity and of dubious virtue. They
are perceived as easily corruptible: Words do not bind them, they lack super-
ego, and one would be foolish to put trust in their faithfulness. And all this
stems from the traditional perspective that self-evidently takes women to
represent nature as opposed to culture, emotion as opposed to reason, to em-
body the unstable and corruptible part of human nature.

As a reaction against general reticence, our century saw a wave of ar-
dent admirers who tried to make virtue out of its very flaws and to take its
seemingly archaic features as a token of its modernity. The opinion started
to circulate that *Così* was the most Mozartean of all Mozart's operas and
could thus serve as a watermark of true connoisseurs, as a proof of fidelity—
the real Mozart lovers would not succumb, like Fiordiligi and Dorabella, to

the tricks of the seducers and their easy criticism. Nevertheless, the misgivings did not vanish, and whereas *Figaro* and *Don Giovanni* continue to possess an immediately universal appeal, *Così* seems to need interpretation, an excuse, a justification, a reference to its historical background, and thus an admission of its limited nature.

Machine in Love

Let us take a provisional starting point in *Die Entführung*, the first of the great Mozart operas and the one with the most transparent structure. It is easy to see some parallels between it and *Così* on the formal level: In both operas we have two couples, which, in *Die Entführung*, are framed by Pasha Selim and Osmin, the despot and the vizier, marking the lower and the upper social edge, whereas in *Così*, they are framed by the philosopher Don Alfonso and Despina, the maid. On the background of this abstract framework, the differences are soon obvious: The two couples in *Die Entführung* were unequal—there was a natural difference between the couple of masters (Belmonte-Constanze) and the couple of servants (Pedrillo-Blonde)—a structure that would reappear later in *The Magic Flute* with Pamina-Tamino and Papageno-Papagena, where Sarastro and Monostatos present new incarnations of Selim and Osmin, and also to some extent in *Figaro* and *Don Giovanni*, which display more complicated sexual structures. Pasha, accordingly, tries to seduce the lady and Osmin the maid. In *Così*, however, the two couples are equal in their status and thus interchangeable. There are no monarchs or aristocrats in this utterly bourgeois setting—the only trace of them being the anecdote that the idea for the story came from nobody less than Joseph II, who was supposedly inspired by a real event. Although the story was never authenticated, it persists as a myth throughout the literature on *Così*.[60]

The outer couple, the philosopher and the maid, differs in status from the two inner couples, though the difference is of a very different kind compared with *Die Entführung*.[61] The special status of the philosopher is based on his alleged knowledge about human nature: He is an agent of universal laws reigning over the human heart, the big Other in which the Enlightenment continually sought its support—the knowledge about the principles of human nature that will lead to the foundation of a new social order. This is what makes possible his alliance with the maid as the representative of common sense, the spontaneous *lumen naturale*—the philosopher speaks about *"necessità del core"* (necessity of the heart); the maid, about *"legge di*

natura" (the law of nature). Common sense can match the philosopher's view because it has always doubted the high ideals, the solemn and virtuous words, and put its faith in more earthly matters. Though the two standpoints differ considerably, they can nevertheless form an odd couple[62] and establish a coalition of both a theoretical and material nature.

Despina stands firmly on the ground of the pleasure principle and general hedonism. A wise woman knows how to take pleasures and does not fool herself with illusions of virtue. She knows where the devil has his tail and has already fooled a thousand (could she be a match for Don Giovanni who boasted of a thousand and three?). The philosopher, on the other hand, sees beyond simple hedonism and is much more firmly footed in the materialist and deterministic side of eighteenth-century philosophy, as emblematically represented by La Mettrie's *L'homme-machine.* The reverse side of freedom is determinism. Behind the highly acclaimed autonomy lurks an inanimate mechanism; the most sublime feelings can be mechanically produced, experimentally and synthetically provoked. It might seem very paradoxical that the century that so emphatically glorified freedom could not resist an utter fascination with the mechanical at the same time—starting with Descartes's automata covered with hats and Pascal's automaton that unwittingly carries along the spirit and moving on to La Mettrie and Vaucanson and finally Hoffmann's Olympia, to mention just a few. The mechanical doll is a metaphor of, and counterpoint to, autonomous subjectivity; autonomous self-determination and the automaton seem to go hand in hand. *Le mort saisit le vif* (the dead seizes the living)—this junction appears to exemplify the paradox of the Enlightenment. And the most frequent and recurring criticism of *Così fan tutte* throughout the last two centuries was precisely that its protagonists were mere puppets.[63]

The interpreters have found a legion of precursors of *Così* in the traditional genre of trial of fidelity. The list starts with Ovid's *Metamorphoses* (book 7);[64] continues with Apuleius, Boccaccio (*Decameron* 2.9 and 8.8), Ariosto's *Orlando furioso* (43, where the protagonists are actually called Doralice and Fiordespina), Cervantes, and Tirso di Molina; and finishes with the immediate forerunners, the operas by Grétry (*Céphale et Procris,* 1773) and Salieri (*La grotta di Trofonio,* 1785; libretto by Casti), with some significant parallels also to be drawn with Laclos's *Les liaisons dangereuses* (1782). But if one had to choose just one author who with an invisible hand pulled the strings of *Così,* it would undoubtedly be Marivaux. The libretto seemed to stem directly from his pen, as it logically continues his themes and ob-

sessions in very similar plays (*Le jeu de l'amour et du hasard, L'épreuve, Le triomphe de l'amour*, and so on). To pick out just one for our present purpose, we could take the one-act *La dispute* (1744), in which we see an aristocratic gathering trying to resolve the controversy about who was first to be unfaithful, man or woman. They make up a wager and decide on an experiment: Two boys and two girls are to be educated far from society, left ignorant as to sexual differences, and then confronted on the verge of maturity. The dispute, the wager, the experiment—and finally the gaze of aristocracy, for whom the spectacle is performed—the structural roots in *Così* are the same.

Così fan tutte radicalizes the message which with Marivaux tended to remain ambiguous: Love does not finally and triumphantly defeat all but rather is itself easily defeated. It takes very little to manipulate it: a speck of jealousy; a grain of doubt; a confession of love, which is so difficult to resist; a smidgen of flattery; a fake sacrifice. When the two officers feign suicide attempts because of unrequited love at the end of the first act, the two ladies, in a sort of parody of mercy, cannot respond otherwise than with pity, and then they are lost. There is something in love that is more like a machine than a mere set of unpredictable emotions; there is a mechanical predictability in its emergence that can be experimentally induced. Women, proverbially unstable and unpredictable, are yet the best embodiment of this mechanical part, *les femmes machines*, the puppets.

True, men are unfaithful as well, as Despina does not tire of pointing out: "*In uomini, in soldati / sperare fedeltà?... Di pasta simile / son tutti quanti*" (You look for fidelity / in men, in soldiers?... All of them / are made of the same stuff [1.12]). Despina believes in *Così fan tutti*, justification enough for women "to suit our convenience and our vanity." Yet the corruptibility of men appears to be of a different nature—they are free agents, free, supposedly, to take their pleasures, and in this particular case free to put women to test. If women are like mechanical devices, then men construct them. The story cannot but contradict itself and prove the reverse of what it proclaims as well: The first infidelity was committed by men, they have thrown the first stone, their virtue could be easily swayed by the dubious alibi of a scientific experiment, and their lament over feminine nature can only be hypocrisy. They were the designers.

But there is a mechanical side to men as well that our heroes are bound to discover. The design had to be paid for; they constructed a device that they could not control and in which they got caught. Here is another great

Enlightenment theme: the critique of amour propre, self-love, a topic with a long pedigree starting with Pascal and La Rochefoucauld. Amour propre has to undergo something that could in modern terms be called a blow to one's narcissism. One has to do away with spontaneous self-deception to truly grasp human nature. Love is another disguise for this self-deception, and the antifeminist perspective shows its reverse side: The two young men can prove women's infidelity only at the price of disrupting their own narcissism, of inflicting a wound to their own egos. They experience how little is needed for their own status as idols and privileged love objects to crumble. The rococo intrigue suddenly winds up in pain and deception.

There is a sublime moment at the beginning of the second finale, just preceding the burlesque wedding ceremony and the ensuing disclosures. It is the famous toast *"E nel tuo, nel mio bicchiero"* written in the form of canon, where the new couples celebrate their new happiness: "In your glass and mine / may every care be drowned, / and let no memory of the past / remain in our hearts." Fiordiligi, Ferrando, and Dorabella consecutively join in that moment of exaltation and oblivion, whereas Guglielmo, when his turn comes, cannot join the party and vents his bitter disappointment and fury: *"Ah, bevessero del tossico, / Queste volpi senza onor!"* (Would that they were drinking poison, / the dishonorable jades!). The first three voices strictly follow the highly codified canonic form, repeating the same melody, but the fourth one breaks the symmetry and comes as a background counterpoint. Canon, with its identity and exchangeability of voices, could be taken as a metaphor of this highly organized, symmetrical, and codified play, counterbalanced by the excluded fourth voice in the background that resumes the latent pain of all.

There is a comparable sublime moment in the finale of *Figaro*, the moment of final reconciliation when the count asks for and is granted forgiveness by the countess, and the community, along with the count, resumes the countess's melody, *"Tutti contenti saremo così,"* in a utopian promise of a healed community of equals. The sublimity is produced by an extreme simplicity of musical means, an archaic-sounding incantation, and by a slowing down of musical time, a sort of suspension of temporality that points to an elevation beyond time into timelessness, an eternity of happiness. It is a moment of a standstill in that finale, where events occur with breakneck speed. In *Così*, the sublimity of the moment is brought about by similar musical features: the archaic form of canon, the simplest and most codified of all,[65] and a suspension of musical time—the tempo is larghetto, the slowest

among the numerous changes of tempo in the finale and one of the slowest in the whole opera.[66] But the short-lived magic is suddenly dispersed with the abrupt transition into allegro and a passage from the dark A-flat major into the harmonically distant and light E major, which announces the grotesque following scene with the notary. In *Figaro*, the moment of sublime standstill was the conclusion of the opera, its denouement, with only a quick bravura ending after that. The opera ended on a note of reconciliation and utopian promise, the erasure and undoing of all past conflicts. In *Così*, the finale has only just started, and there remains a good deal of entanglements and explaining to do. The utopian moment crumbles bit by bit, and the story eventually winds up in a very ambiguous reconciliation deprived of sublimity. The oblivion, the elevation, and the suspension of time were possible only in a moment of highest deception, where beauty became indistinguishable from lies.

Figaro offers a final perspective of equality where the community is reconciled with itself. Nobody has to be sent to hell, as in *Don Giovanni*, to seal the new togetherness. Nobody retains the superior status of exception to generously grant the mercy to the others, as in *Die Entführung* or in *Clemenza di Tito*. The villain is forgiven and integrated. But the slogan of equality receives an unexpected corollary in *Così:* Equality is interchangeability, with one woman equaling the other, and one man equaling the other as well.[67] Everybody is replaceable; there is no privileged subjectivity, no privileged object of love. *"Uno val l'altro, perchè nessun val nulla,"* says Despina—one is as good as the other because neither is worth a thing.

A Philosopher in the Opera

Così fan tutte presents a new version of the popular comedy of errors and mistaken identities based on disguise, which persistently fascinated eighteenth-century audiences. One can again recall Marivaux, as the grand master of disguise.[68] One can recall the disguise in the final act of *Figaro* and in the second act of *Don Giovanni*. Behind this ubiquitous imbroglio, there was a consistent Enlightenment concept, a reevaluation of values: It is enough for the master and the servant to exchange their clothes to also exchange their social status. Clothes make the man—the alienated social order takes the image for the measure, not the intrinsic value; it judges by sight, not by merit. We worship the masters' clothes, and the clothes are enough for domination to work. This is one of the big motifs of the Enlightenment: to see through

the imaginary deception that perpetuates the old order and to reach behind it to the true status of subjectivity on which to found a new order. This idea could best be conveyed with the exchange of clothes between master and servant[69] (Marivaux's *Le jeu de l'amour et du hasard* is a paramount example): Don Giovanni exchanged clothes with Leporello; the countess, with Susanna. But with *Così*, the situation changes—the switch takes place between two subjects of equal status.[70] The two Italian and Albanian officers do not differ in their social standing, and their disguise concerns only their human uniqueness, their privileged status of lover and beloved. The message could perhaps be phrased thus: When there is no master, everybody is just a substitute for the unique subject and is thus interchangeable. For Don Giovanni, all women could be reduced to mere numbers, whereas he was unique and irreplaceable. Now the men seem to turn out to be mere numbers, too.[71]

But if, with the expulsion of the master, we find ourselves in this not particularly enticing universe where everybody is caught where s/he thinks to be free and replaceable where s/he thinks him/herself unique, then the philosopher's message in this predicament is not one of universal hedonism or abandon but rather the contrary. *Così* bears the subtitle *La scuola degli amanti*, The School of Lovers. What the philosopher is aiming at is a process of sentimental education. The school of lovers demands an education about human nature, a disenchantment, a loss of illusions and *amour propre* as the precondition of true love. One has to pierce the blindness and deception that clings to the narcissism of love, and only this can be the foundation of matrimony and reconciliation. The philosopher, despite appearances, defends the institution of matrimony precisely as a defense against the deficits of human nature. One needs to admit one's own limitations, thus breaking the spell of the imaginary, to make allowance for the puppetlike, mechanical part of oneself lurking behind the glorified feelings. This is the sound basis for marriage.

But which love is true love? What does the music tell us about it? Which feelings are genuine, the first ones or the second ones? The answer of Mozart's music may seem scandalous, but I think it is unambiguous: All feelings are true. Mozart puts in a fine dose of irony here and there, but the pain of the farewell is true (the wonderful trio *"Soave sia il vento"* (1.10), where the philosopher himself cannot resist melancholy);[72] Fiordiligi's despaired insistence on fidelity is true, as if written in blood (the brilliant rondo 2.25);

the happiness and exaltation of newly found lovers is true (the two passionate duets 2.23 and 2.29)—or is everything but a delusion? One could see in *Così fan tutte* a musical embodiment of the liar paradox: Where music is sincere, it lies, where it lies, it is sincere. Where we believe, we are deceived, and both are indistinguishable.[73]

The philosopher's conclusion is this: Because uniqueness and genuineness are lost anyway, because love and faith are synthetic social ties, it is best to admit it and to condone the artificial tie of the institution of matrimony, the best protection against the deficiency of human nature. This is also why the recurrent speculations that the final marriages take place between the new couples and not the initial ones are beside the point (see, for example, Hughes 1972: 186–187),[74] though the libretto itself does not explicitly exclude such a possibility. The philosopher is a moralist rather than a cynic. In the final reconciliation that he brings about, he defends the initial order, although it has retroactively turned out to be entirely contingent and not any better than the second one—or rather, not although but *precisely* for that reason. As a philosopher worthy of his status, he defends the negation of negation: the initial position has met with a symmetrical and inverted negation (antithesis), that is, a limited specular negativity. One can transcend the initial state only if one returns to it after the abyss which has opened since, if one sticks to it as to its own negation, the mediated immediacy brought about through the process of *Bildung* (internal formation and education). The existing order is entirely arbitrary, and the story has demonstrated its contingency, but as such it is its own self-negation—and the only remedy against contingency is to embrace it unconditionally.[75] Don Alfonso thus offers one hand to La Mettrie and the other one to Hegel.

Così fan tutte, like *Figaro*, ends with an act of forgiveness, though now subject to an essential displacement that makes it rather a parody of forgiveness. In *Figaro*, the humiliated count asked for forgiveness in front of the countess in maid's clothes, and the woman's forgiveness could reconcile the community. Here, the two women ask for the two men's forgiveness, though the situation should rather be reversed—they should be kneeling before their ladies. The moment of forgiveness lacks sublimity; it is ambiguous and provokes uneasiness—an uneasiness that pervades the entire finale, which seems particularly stumbling and faltering all along, with sixteen changes of tempo and no less than forty-eight fermatas. The promise of a utopian community has vanished, and it does not quite seem that *"tutti contenti saremo*

così." The sincerity of the two ladies' contrition can be genuine only if it is not put to test: "*Te lo credo, gioia bella, / ma la prova far non vo*" (I believe you, my fair one, / but I won't put it to the test).[76]

The ambivalence of forgiveness is demonstrated by purely musical means. When the two ladies assume the attitude of atonement, remorse, and supplication, their motive exactly repeats that of the fake return of the two soldiers (finale, bars 372–382 and 476–479) in the same tonality of B-flat major.[77] If musically all feelings were genuine, then are the remorse, contrition, and forgiveness genuine as well? The thematic repetition casts a long shadow over them and colors them with inauthenticity; remorse repeats deception and disguise. If the canon referred back to the sublime moments and condensed them, then their repentance refers back to hypocrisy. The reconciliation is double edged. This prompts the question, What could be the musical counterpart of the Hegelian side of reconciliation, the part of resignation in it? Can this be put to music with the same passion and sublimity as its optimistic face in *Figaro*? There, the innocence showed its magnanimity in forgiving the sinner, but here nobody is innocent. Maybe this is why Mozart had to place the moment of sublimity amidst the highest deception and to leave the final gesture in ambiguity. The reconciliation does not possess the strength of *Ungeschehenmachen* (retroactive annihilation), which glimmered as a delusive promise in the toast. The finale remains fractured and unconvincing, an anticlimax; "it brings a sudden lowering of the imaginative level" (Kerman 1957: 116), and the music cannot quite sustain it. There is an edge where Mozart lost his ground.

Let us finally consider the curious position of the philosopher in the whole affair. He has started the intrigue, and he is the one who pulls the strings of these puppets. He remains the only one who was not deluded, because even Despina was deceived—she was prepared to push the ladies into the arms of the new lovers but did not realize their exchanged identity. The philosopher acts as the agent of the Other, the universal knowledge; he instigates a scientific experiment to prove a general thesis. But there is a rather dubious part to this: his malevolent neutrality ("It's your own fault, I told you so"), his seemingly objective observation of human deficiencies that he helps to bring about. He presents himself as a mere instrument of the general laws of human nature, but what makes it dubious is his enjoyment and his laughter: "*Tutti quatro ora ridete / ch'io già risi e ridero*" (All four of you can laugh now / as I have laughed and shall do again). He has laughed and will continue laughing because he is above human passions and weaknesses

except for the last and most insidious one, that of enjoying the spectacle of human weakness. His dubious side is ultimately that he is not just a neutral agent of the universality but also the agent of the gaze and the enjoyment of the Other, the absent gaze of the master for whom this spectacle of human deficiencies is finally put on the stage. The puppets exist for the enjoyment of the master, and the philosopher is ultimately the agent of this enjoyment, which he secretly serves—this is precisely the structural position that in psychoanalysis defines perversity. The anecdote that the idea for the play stemmed from the king himself, though probably not authentic, is thus structurally necessary—if it did not exist, one would have to invent it.

The link with the gaze and enjoyment of the Other was still clearly visible in Marivaux; one could still glimpse the vanishing rope that binds the puppets to the king. In *La dispute*, a close kin of *Così fan tutte*, the dispute arises in the royal circle, and its experimental solution is carried out on *enfants sauvages* who stage the matter for the royal enjoyment.[78] In *Così*, the palpable presence of this gaze has vanished. The role of the trial persons is taken by the two men who have wagered and who act as their own ideal representatives, whereas the philosopher takes the role of the director who sees to it that the performance is carried out to the greatest satisfaction of the Other. The absent gaze directs the play with an invisible hand whose extension is the philosopher.[79]

Machine and Enjoyment

What is the use of machines, mechanisms, and automata, this big obsession of the Enlightenment? First of all, they are devices skillfully and meticulously designed to be presented to the gaze of the Other and to serve its presupposed enjoyment. Let us recall Vaucanson, the most famous constructor of automata, who fascinated the Parisian salons in the years 1730–1750, precisely in the period of the vogue of Marivaux's comedies, presenting his *joueur de flûte*, which could play twelve melodies; his *canard digérateur*, the digesting duck; and the automatic model of the circulatory system that was financed and sponsored by Louis XV. Let us recall the pioneering experiments of Leonardo da Vinci, who constructed a moving lion that came to greet—there is no coincidence—Louis XII at his arrival in Milan in 1499 and revealed on his chest the royal emblem, the lily (Fiordiligi, one is tempted to add).[80] Let us recall the mechanical and hydraulic wonders hidden in the gardens of Louis XIV for his particular enjoyment. Later, the automata constructed by

father and son Jacquet-Droz in Switzerland in 1760 through 1773, among them the draftsman that could draw—what else—the portrait of Marie Antoinette.[81] And last but not least, La Mettrie himself, who elevated an ubiquitous fantasy into a philosophical system and who found the refuge from prosecution in the court of Frederick the Great. The great emperor himself wrote *Éloge de La Mettrie*, a panegyric to be placed at the head of his posthumous collected works, just as La Mettrie during his lifetime did not stint any compliments on account of the emperor (whom he called "the Solomon of the north" and a model for an ideal government). The status of monarch's protégé was something that neither Voltaire nor Diderot could forgive him (one can rather suspect jealousy, for they were not much better themselves). So there is an obvious and strong link between the automaton and the Other represented by the monarch.

This necessary bond was pointed out by Foucault:

> The great book of Man-the-Machine was written simultaneously on two registers: the anatomico-metaphysical register, of which Descartes wrote the first pages and which the physicians and philosophers continued, and the technico-political register, which was constituted by a whole set of regulations and by empirical and calculated methods relating to the army, the school and the hospital, for controlling or correcting the operations of the body. These two registers are quite distinct, since it was a question, on the one hand, of submission and use and, on the other, of functioning and explanation: there was a useful body and an intelligible body. And yet there are points of overlap from one to the other. La Mettrie's L'Homme-machine is both a materialist reduction of the soul and a general theory of dressage, at the centre of which reigns the notion of "docility," which joins the analysable body to the manipulable body. A body is docile that may be subjected, used, transformed and improved. The celebrated automata, on the other hand, were not only a way of illustrating an organism, they were also political puppets, small-scale models of power: Frederick II, the meticulous king of small machines, well-trained regiments and long exercises, was obsessed with them. (Foucault 1995, 136)

Let us put it this way: Before machines and automata became useful, before they could serve as the basis of industrial revolution, they inhabited the space of a fantasy, offering themselves to the gaze of the Other.[82] Before they

could yield profit, they could yield the enjoyment of the Other (one can re-member that Lacan based his concept of surplus enjoyment on Marx's con-cept of surplus value). Machines produce enjoyment, but whose? What fas-cinates the gaze and places it in the position of power is above all their disponibility and utter transparence. Machines and automata have no se-crets; their hidden springs and levers are accessible to all. What makes the mechanism a mechanism is the fact that anybody can see through it and any-body can make it.[83] Disponibility and transparence are also the main feature of the puppets in Così. This is the point that Foucault is driving at: There is only a small step from here to the fantasy of the panopticon, this universal-ized gaze of the Other whose place anybody can come to occupy. Once the mechanism of the mechanism sank in, this place ceased to be the privilege of the king; domination can function without a master, that is, it can func-tion precisely as a machine. The procedures of drill, discipline, control, quadrillage, and so on can separate the place of the Other from the place of the master. The place can be disembodied and operationalized as the empty space of power.

On the other hand, the surplus enjoyment that the fantasy ascribed to the Other could gradually get its material and quantifiable counterpart in the measurable profit—it could be economized, canalized, invested, and ac-cumulated. The fantasy assumed a new function, and this could be accom-plished only by amalgamating it with another great Enlightenment theme, utility—let us recall Hegel's analysis of the Enlightenment in his *Phenom-enology*, where it is seen precisely through the universal reduction to util-ity, *Nützlichkeit*, the disponibility for the subject. And that leaves but a small step to another obsessive great theme, that of enjoyment as something to be calculated, *le calcul des jouissances*. Thus, the fantasy, with the gaze and the enjoyment of the Other at its core as its *enjeu*, could with a slight shift entirely change its function. With Mozart, we can still see its vanishing back-ground where it could still underpin the fading ancien régime but could at the same time also become a harbinger of another epoch. Mozart, the great watershed.

Let us now go back to Così. One could say that this opera presents both a step forward and a step back when measured against the conclusion of *Fi-garo*, that is, the utopian moment of *liberté, égalité, fraternité*. It is a step forward insofar as it puts into question the slogans of freedom and equality and discloses their hidden pessimistic side, which truncates the glory of new autonomy and inspires resignation. After the fall of the master, the paradise failed to materialize.

Against the frivolity and free life of the aristocracy, the bourgeoisie proclaimed the purity of feeling, the emotion and, last but not least, morality as the bourgeois virtue. Da Ponte and Mozart not only did not respect it, but actually thoroughly unmasked it. The enlightenment to which the persons on the stage, and thus also the audience, are exposed has rocked the foundations of the new bourgeois society, before they could even be consolidated. (Kunze 1984: 433; my translation)

So what is at stake is not to criticize and shatter the phony high ideals of the old order but rather those that the new order has taken as its basis and that sparked the rise of the bourgeoisie against the lax morals and enjoyment privilege of the nobility. Libertinage was viewed as the usurped part of enjoyment seized by the nobility through their unmerited and abused social status—*Figaro* and *Don Giovanni* incarnated that view. In opposition to that, the bourgeoisie posited true love and genuine morality, a matrimony that would not be just a received convention but would be based on the true intimacy of feeling, an institution springing from human nature—but this is precisely what *Così* has put into question. Its underlying anthropology is entirely different from that of *The Magic Flute*.

It also represents a step back, because the very framework of *Così* is imbued with the fantasy of domination that prevailed throughout the first two centuries of the rise of the opera—the carrying fantasy of the absolutist state. It presents its ultimate and most subtle transformation, the absent gaze of the master, the intangible enjoyment of an elusive Other. The absolute monarchy as the setting of the birth and rise of the opera survives in its most sublimated and distilled form. *Così fan tutte* is thus too much ahead of its time as well as too much behind it. It outpasses its historical moment—precisely and literally the moment of the revolution—as well as lags behind it. Thus, among all Mozart's operas it is the most out of place, the hardest to range, a source of perpetual scandal.

Being at the same time too forward and too backward, it is in some sense a close kin of *Don Giovanni*. There, the hero was also too autonomous for the bourgeois order to swallow, and the play had to go through the motions of a moral fable about just punishment for the trespasser, which is taken care of by powers from the Beyond in the old premodern tradition of Catholic miracles (Brophy even speaks of a "Catholic counter-revolution" after the radicalism of *Figaro*—see Brophy 1988: 203, 232, and so on). This is a step for-

ward that takes the form of a step backward. But if, in *Don Giovanni*, this paradoxical step concentrated on the highly ambiguous figure of the massively present master, then in *Così* we are left with an absent gaze, his philosophical shadow, an elusive form that evades confrontation—he can neither be reconciled with the community, reduced to human measure, nor sent to hell.

The Rationalistic Myth of the Enlightenment

Die Zauberflöte, written one and a half years later as a curious operatic last will, basically poses the same problem—how to deal with the master in the new Enlightenment age—but in a completely different light. It was not written for the court but for the Theater auf der Wieden, a fact immediately apparent both in its dramaturgical structure and musical form. It was intended for a completely different audience, no longer the aristocratic high class and the king. There is no lack of common humor and even somewhat vulgar jokes fitting for the tastes of its intended audience, and neither is there any lack of special effects or of various fairy tale wonders; the story seems rather heterogeneous, even inconsistent, and only barely pieced together. The musical heterogeneity goes hand in hand with this, displaying an unbelievable mixture of different genres and levels, from the lowest to the highest, from church choir hymns to popular hits. It doesn't display uniformity of concept but rather a curious structure of addition (Schulz 1991: 346) and of juxtaposition that almost anticipates Brecht's epic theater. Compared to the three great operas written on the basis of De Ponte's librettos, it belongs to a completely different genre: It is a *Singspiel* written in German, comprising numerous spoken dialogues as was common in popular comedies, it is not part of the strongly codified Italian tradition.

A controversy lasting two centuries also surrounded *Die Zauberflöte*, and once again it primarily concerned the discrepancy between the music and the libretto. In several instances, critical opinions about the music itself were put forward—not concerning the unquestionable quality of many extraordinary moments but rather the considerable heterogeneity and irregularity of the whole.[84] But the majority of critique was directed against the libretto writer Schikaneder, whose libretto was *ein Machwerk* (a real botchwork)—a word stubbornly repeated in many discussions and that stems from nothing less than Hegel's *Aesthetics* (Hegel 1970, 15: 207).

The story is well known. The Queen of the Night asks Prince Tamino to save her daughter Pamina, who is being held captive by the evil tyrant

Sarastro. To boost his courage, the queen gives him a magic flute and chimes as well as the servant Papageno and three boys, who are to show him the way. After arriving in Sarastro's temple, Tamino finds out that Sarastro is the spiritual leader of a community of priests who serve the ideals of wisdom, justice, love, and humanity and that Sarastro is no villain but a wise man who was actually protecting Pamina from her mother's wickedness. Tamino wants to be admitted into the community, but he must first undergo difficult trials. He finally also wins Pamina, who accompanies him on his trials, and at the end he becomes an enlightened and just ruler.

An initial complex of questions concerns the break occurring in the middle of the piece. The apparent good guys turn out to be bad guys and vice versa; good and evil change places. Was this transformation planned at the beginning? Numerous clues indicate that it was not. Three women, the servants of the Queen of the Night, save Tamino's life in the first scene and then appear as the keepers of the truth in the following scene. The Queen of the Night legitimates herself through her suffering as a mother whose child has been stolen from her. Tamino can overcome all obstacles with the help of the gifts—in particular the magic flute—given to him by the queen, who turns out to be the embodiment of the powers of darkness. Now, whom do the three boys serve, who were given to Tamino by the queen and who later, in all decisive moments, save both Tamino and Pamina from great dangers, making possible a happy ending and the queen's destruction? At the beginning there is no sign that would point even vaguely to such a shift, such an unexpected ending. Many interpretations share the opinion that the change in perspective occurred while the piece was being written—indeed, when the major part of the work already was finished—so some of the inconsistency can be attributed to inerasable traces of the first draft. There have been innumerable speculations about the reasons for the change. A frequent suggestion has been that it can be traced back to competition: At the time that the opera was being written, Müller's opera *Kaspar der Fagottist oder die Zauberzyther* (based on Liebeskind's story *"Lulu oder die Zauberflöte"* from *Dschinnistan*, Wieland's collection of Oriental tales) was being performed with considerable success in Vienna. This story was also one of the sources for *Die Zauberflöte*, but it lacks the turn in the middle. Mozart and Schikaneder decided on another ending to outdo the competition and to present something new to the audience. Brophy (1988), who has (along with Jacques Chailly) done comprehensive research on the history of *Die Zauberflöte*, searched for reasons in the Masonic ideological principles of the

opera, which Mozart and Schikaneder, both Freemasons, tried to both retain and hide at the same time. At any rate, a compromise was made that exhibits some contradictions and loopholes.[85]

The extraordinary success of the opera and its rising popularity called up innumerable critics, but one didn't have to wait long for numerous defenders. It is not difficult to criticize *Die Zauberflöte* and to make fun of its frequent cheap tricks, but as Goethe reportedly said, "It requires more education to recognize the value of this opera than to deny it" (see Riehn 1985: 37).[86] The critics may hit their mark without any difficulties, but they miss the essence. In his *Aesthetics* (in connection with treating the relationship between the text and the music), Hegel speaks about many interpreters who consider the text of *Die Zauberflöte* a mere botchwork, "but this botchwork is one of the most praiseworthy librettos. Schikaneder, after many crazy, fantastic and trite productions, hit the right point." And this is not to mention "that, because of the depth, the charming sweetness and soul of the music, everything expands and fills one's imagination and warms one's heart" (1970, 15: 207). Beethoven, too, was charmed (he wrote the famous variations on *"Bei Männern, welche Liebe fühlen"*); Wagner was enthusiastic—he considered it the first German opera, the creation and unsurpassable example of a new genre, the miracle that occurred in the midst of the banality of a suburban theater.

The unusual change of places between good and evil forms only one side of the ambiguity of the whole. If one takes the Egyptian mythological model seriously, then it is not difficult to recognize that the Queen of the Night is characterized by attributes of the goddess Isis. She is only described as the "Queen of the Night" at the end; at the beginning she appears as "the starry queen," as the Queen of the Moon and, hence, as an extension of and not the opposite of the sun deity Osiris. (According to the Egyptian myth, after Osiris was murdered, he was revived by his sister-wife Isis. The cult of Isis later formed the basis for the Eleusinian mysteries, and in a revised form it can also be found in the works of Apuleius, who even calls her *regina coeli*—a designation later reserved for the Virgin Mary). The choir of priests sing the praise of Isis and Osiris (2.10), and when Tamino and Pamina pass all trials, the choir extols their initiation into Isis's secrets *("Der Isis Weihe ist nun dein")*, even though the formerly good mythological queen has been transformed to an evil one. The story of *Die Zauberflöte* can also be interpreted as the combination of two well-known Greek myths: the story of the goddess Demeter (the Greek version of Isis), whose daughter Persephone is

robbed by Hades, the god of the underworld, and above all, the story of Orpheus and Eurydice. Just like Orpheus, Tamino tries to save his beloved Pamina from captivity; just like Orpheus, he can tame the creatures of nature with the power of his music; and just like Orpheus, he is forbidden to turn back toward his beloved. Tamino must not speak a single word to Pamina during the first trial—but unlike Orpheus he succeeds because his heart doesn't fail at the crucial moment. Finally, the name Sarastro comes from the Persian name Zoroaster, that is, Zarathustra (for a more detailed analysis, see Brophy 1988: 131–202).

Although one can find the building materials for every element of *Die Zauberflöte* in elements of different myths (this basis is significantly expanded when the Masonic current of the eighteenth century is taken into account, especially Terrasson's novel *Sethos* of 1732), although one can see in it merely a pieced-together patchwork of different and sometimes contradictory mythological fragments, and although one can always convince oneself that there is nothing new under the sun, one would be missing the essential point. Apart from its extensive mythological pedigree, *Die Zauberflöte* above all represents the attempt at a new, synthetic myth—the myth about the Enlightenment itself. It provides a mythological basis for the Enlightenment, the ancient story of the victory of light over darkness is taken as the immediate model for the victorious campaign of the Enlightenment. Whereas Mozart's previous operas vacillated between a relatively realistic portrayal of the present (*Figaro, Così*) and a faraway mythical past of the *opera seria*, this opera is a strange amalgam of the two: It offers a mythology of reason that was triumphant at that time, a mythological song of praise to mankind no longer in the service of the Other's mercy. If *Die Zauberflöte* is interpreted as a foundational myth of the Enlightenment that was produced at the moment of its triumph, then the Queen of the Night could be viewed as the immediate embodiment of despotism (at that time, associations with Maria Theresa came up immediately) and its demise. "The rays of the sun drive out the night," says Sarastro at the end (one is tempted to add, "Thus spoke Zarathustra"). The new subject began its path in the service of the old order—the Queen—and through a process of *Bildung* it is elevated to the light while the old order is destroyed.

Before we return to the mythical nature of *Die Zauberflöte*, another decisive problem needs to be discussed. When the story of *Die Zauberflöte* is compared with the first of Mozart's operas to be examined here, *Die Ent-*

führung aus dem Serail, numerous parallel features become evident. Both stories are about saving the beloved from captivity and feature two couples, the masters (Tamino–Pamina) and the servants (except that Papageno doesn't get his partner until the end); we once again have the couple of the ruler (Sarastro) and the evil vizier (Monostatos) and the apparent evil again turns out to be good—and just as Pasha Selim, the detested despot who holds Constanze captive, finally shows mercy, so Sarastro also changes from a villain and brute to a noble benefactor. The abduction from the temple, which is supposed to liberate the beautiful Pamina, is thwarted, just like the abduction from the harem, and the fugitives are caught at the end of the first act— here they are returned by Monostatos, just as Osmin returns them in *Die Entführung.* They have to prostrate themselves before the ruler, admit their crime, and beg for mercy. The subject, to be worthy of mercy, must stand in the realm of truth (Papageno: "My child, what shall we say now?"; Pamina: "The truth, even if it were a crime!") and confession (Pamina: "My lord, it is true that I have transgressed!"); the subject must be willing to risk its own life for the truth. Sarastro, in his position as a despot, grants mercy, proves his power, and proves that he deserves the title with which the choir sings his praise—"He is our idol," *Abgott,* God's image.

This structural parallel leads to a surprise: The whole action of *Entführung* has already run out by the middle of *Die Zauberflöte.* The failed escape followed by the act of mercy fills only the first act of the opera; the act of mercy does not conclude the opera but only its beginning. What will happen in the rest? Which dimensions will the second part enter if the first has already run through the standard agenda?

Die Zauberflöte begins in one register and ends in a very different one. Whereas the first part is concerned with saving the beloved from captivity, the classical task of the classical hero, this noble undertaking proves unnecessary halfway through because the tyrant turns out to be on the hero's side. From now on the hero has to master another task: He must prove himself, undergo trials, and show that he is worthy of his status. This he can do only through self-discipline, self-knowledge, mastery over his inclinations and passions, and emancipation from his own nature by attaining autonomy through struggle. He no longer needs to triumph over the tyrant but only over himself. The act of mercy is no longer enough: After mercy has been shown, it is up to the subject to actually prove its worth. Pleading with the Other, expressing humility and supplication, doesn't suffice, and the magnanimity

of the Other is no longer enough either. *The register of mercy is followed by the register of autonomy.* The end of the path has been reached, and the journey begins.

In the trials that need to be undergone, one has to overcome one's own nature. One must prove restraint and renounce one's desires. Tamino must not speak a single word to his beloved Pamina; he must be able to renounce her if he is to be worthy of her. The trial of water and fire is reminiscent of ancient initiation rites: The subject must go through symbolic death to experience rebirth. Some interpretations have pointed out that the initiation performed in the second act of *Die Zauberflöte* has its roots in the initiation rites of the Masonic lodges. One of the principles of the Freemasons was that the candidate has to rid himself of the fear of death in the course of cleansing, to free himself of the fear by which subjects were held in obedience and terror of hell by the old religion. Only those who can overcome death, who accept death, can be free. Thus, Mozart writes in a famous letter to his father, as one Freemason to another:

> As death, when we come to consider it closely, is the true goal of our existence, I have formed in the last few years such close relations with this best and truest friend of mankind, that his image is not only no longer terrifying to me, but is indeed very soothing and consoling! And I thank my God for graciously granting me the opportunity...of learning that death is the *key* which unlocks the door to our true happiness /*den schlüssel zu unserer wahren glückseligkeit*/ (April 4, 1787, one and a half months before his father's death; quoted from Brophy 1988: 201–202).[87]

The two armored men before "the gates of terror" through which Tamino and Pamina have to enter speak the same language: "If he can conquer the fear of death / he will soar from the earth up to heaven!"[88] and Tamino replies, "No fear of death shall stop me."

The second act is filled with proof through trials. Three paths lead through the process. The first one is Papageno's—he is not able to stand the trials, being led as he is by the pleasure principle, which he cannot resist; he likes eating and drinking, and he ardently wishes for a wife, whom he eventually gets in the end. Papageno gains the status of servant who could never compete for any higher position; this is the status that he obtained by his own choice, as it were, justly allotted to him because he was unable to re-

nounce his desires and could not rise above his own nature.[89] Papageno cannot be initiated. Although even he was finally willing to risk his own life, to put it at stake through the planned suicide to win his beloved. Even the simple uninitiated enjoyment cannot be won without risk, even though his willingness to commit suicide was a humorous repetition of Pamina's gesture (here Papageno touches Pamina's G minor).

The second path is Tamino's: straightforward, without doubts or hesitation. This actually turns Tamino into an uninteresting figure, because he stops being a subject. He also—and particularly so—is no longer interesting musically; he is not allotted a single aria in the entire second act. On his path of trials, he becomes a pale and bloodless figure.

The third path is Pamina's. Paradoxically enough, she is the only true subject of experience in the second act. Her mother, the Queen of the Night, forces her to take revenge, literally placing a dagger in her hand, with which she is to murder Sarastro. Tamino rejects her and refuses to speak even a word to her (which is part of his trials, but she doesn't know that). She actually has to give him the last farewell. All this drives her to desperation, to the brink of suicide, which is probably the most sublime musical moment in the whole opera (aria 2.17 in G minor)[90]—in it one can detect the last version of Ariadne's lament, her call to "turn around," the end of the path taken by Monteverdi. On the path of this experience and desperation, Pamina becomes a person who can emancipate herself and emancipate others. She can lead Tamino through the path of the trials: "I myself shall lead you; love will guide me!" This also is one of the key transformations in the second part: The person who is supposed to be saved becomes the savior herself (see Nagel 1985: 92, 102, and passim). She no longer is a passive victim waiting for her prince and lamenting her loss and misfortune but rather attains her own autonomy.[91] "Male" initiation is only possible with the guidance of a woman who, in the final instance, liberates and redeems man.[92]

I have already argued that Mozart's heart is on the side of the women. Just as the female element already enabled the reconciliation of the community in *Figaro*, so in *Zauberflöte* is elevation to universal humanity possible only through the woman—only the female element enables the relationship between (self-)knowledge, reason, love, and happiness; it makes possible the reconciliation that elevates the supposed masculinity of knowledge and reason to love and happiness, the reconciliation of autonomy with nature. Thus, this apparently antifeminist opera leans toward Pamina's side, in terms of both in the libretto and the music. Although the opera is interspersed with

many notorious antifeminist comments ("A woman does little, chatters a great deal," says the temple speaker to Tamino; "Beware of womanly wiles; this is the brotherhood's first duty" [2.11]) Sarastro's brotherhood of initiated men is—like Freemasonry—no doubt extremely male chauvinist. Nevertheless, all sublime moments are on Pamina's side—apart from the aria (2.17) there is also the duet about love (1.7) that she sings with Papageno—which is a strange celebration of love sung with the servant, not with her lover, thus placing love beyond class divides and immediate feelings; their duet with chime accompaniment in the first finale; the quartet with four boys (at the beginning of the second finale), and so on. As far as the music is concerned, Pamina on her own far outdoes the entire male company of priests.

He Is a Man—Even More, He Is a Prince

The path for proving one's autonomy, the path to universal humanity through self-purification, knowledge, and love opens up beyond the ruler's gesture of mercy. The intrigue planned by the Queen of the Night against the monarch is conducted in the name of revenge and passion and turns out to be despotic in itself, the true embodiment of the principle against which it is supposed to be struggling. Contrary to this, the apparent despot opens up the way to universality and humanity, to initiation in the service of mankind, to a "kingdom without subjects" (Nagel 1985: 25). Two arias are particularly indicative in this respect, and following each other immediately, they form the dramaturgical core of the second act. They can be interpreted as manifesto and countermanifesto and are placed in positions of maximum opposition both as regards the text and the music: The aria of the Queen of the Night (2.14) begins with "My heart is seething with hellish vengeance," and Sarastro's aria (2.15) begins with "Within these sacred portals revenge is unknown!" The first aria is placed in D minor; the second, in the harmoniously distant E major. The tempo of the first is a stormy and nervous *allegro assai*, that of the second a slow and dignified *larghetto*. As far as form is concerned, the first aria is a coloratura aria presenting glittering technical brilliancy, a dramatic aria typical of *opera seria*, whereas the second is a simple strophic song typical for *Singspiel*; the first reaches up to the highest tone sung in the opera, and the second plunges down to the lowest.

One could consider the foundation myth of the Enlightenment presented in *Die Zauberflöte* to be an excellent realization of the philosophical program put forth by the young Hegel in a fragment written five or six years

later that became known as *"Das älteste Systemprogramm des deutschen Idealismus"*:

> Here I would first like to speak of an idea which, as far as I know, has never come to any human mind—we must have a new mythology, this mythology must serve the ideas, it must be a mythology of *reason*. Before we render the ideas aesthetic, i.e. mythological, they have no interest for the people; and vice versa, before mythology is made reasonable, the philosopher must be ashamed of it. So the enlightened and the non-enlightened must join hands, the mythology must become philosophical and the people reasonable, and philosophy must become mythological in order to render philosophers sensual. Then the eternal unity will reign among us. (Hegel 1970, 1: 236)[93]

The approach of *Die Zauberflöte* is precisely to unite mythology and reason, that is, to unite the Enlightenment's rationalism with everything that seems to oppose it; to create a myth about the triumph of reason; to reconcile the people with philosophy, reason with love, and sensuality with concept; and to set up a religion of humanity and love. If Mozart stands at the point of intersection of two worlds, two social orders, and even two ontologies that are placed in a fragile and contradictory balance, or in other terms, at the intersection of mercy and autonomy (to use Nagel's most economical terms), then one can consider *Die Zauberflöte* an attempt to make the two compatible in a mythical, utopian point of fusion. In *Figaro* we witness the triumph of the Enlightenment, and then two different attempts at demonstrating its problematic nature, at emphasizing its reverse side, follow in *Don Giovanni* and *Così*; in *Die Zauberflöte* we are concerned with a declared manifesto of the Enlightenment that is no longer persecuted by some reverse side, its reverse is rather disavowed in the myth. The incompatible seems reconciled in the myth, and autonomy joins hands with mercy.

While Tamino is facing his trials at the beginning of the second act, one of the priests has doubts that he will be able to go through the ordeal. "He is a prince," says the priest, and Sarastro refutes him with his famous reply: "Even more. He is a man!" Tamino is more than a prince, he is human[94] After the trials, through which Tamino proves his worth as a human, he finally becomes a ruler who unites the spiritual and secular powers in one person.

The political background of *Die Zauberflöte* is that Sarastro's sect of priests serves only the high goals of wisdom and humanity, and that is

precisely why it excludes any connection with secular powers. The good king, Pamina's father and late husband of the Queen of the Night, was a friend of Sarastro's, and because he did not trust his wife, he bequeathed to Sarastro the power-bestowing Sevenfold Circle of the Sun before his death, which is the key to the secrets of nature and the symbol of royal power. He also entrusted Pamina to Sarastro's care (he left his wife merely the kingdom and a magic flute). As a prince, Tamino is a stranger, an outsider (initial stage instructions prescribe Japanese clothes for him), and as such he can become ruler if he, by his valor, triumphs over the Queen of the Night, who usurped the power and lost its legitimacy. Therefore, *Die Zauberflöte* solves an eminently political problem: how to resolve the crisis of a rule by creating a new rule. The solution offered by the opera, one that would eliminate the danger of such crises in the future, is that the new power must be based on the cult of wisdom, which had been constitutively separated from it until then (and Sarastro has to refute certain misgivings of the priests in this respect). In Lacanian terms, S1 has to unite with S2: the signifier of the master has to unite with the signifier of knowledge. In the last scene, the priests hand over to Tamino the Circle of the Sun.[95]

Tamino legitimated himself by his courage and humanity, and thus he deserves to become king. He raised himself above his particular humanity and, hence, he will be a wise ruler in the name of the universal, a philosopher-king. In the final instance, the statement about how he is "more than a prince, he is a man" becomes transposed to "more than a man, he is a prince." But that is precisely what the logic of mercy aimed for. If the logic of mercy largely determined the action in the first act, then the second act is ruled by something we could call a reverse logic of mercy: From the first perspective (which determined, for example, *Idomeneo, Die Entführung, La clemenza di Tito,* and so on), the monarch (or the deity) was already the Other "by his being" from the beginning, and at the end he proved through his mercy that he had indeed occupied his status all along because of his qualities, his human greatness and dignity. The perspective of the second part of *Die Zauberflöte,* however, is inverse: Someone who first proves his human greatness can eventually become ruler, he elevates himself to the position of the Other. Whereas he, in the first perspective, proved through his courage and sacrifice that he was worthy of the Other's act of mercy, he now proves that he himself is worthy of being the Other who will grant mercy. Therefore, the register of autonomy that develops in the second part above and beyond the register of mercy is nothing else than mercy turned upside down.[96]

The mythical connection between two otherwise inherently incompatible concepts determined the general framework of and probably provided a lot of the general attraction toward the Masonic movement, so widespread at the time and espoused by Mozart with great enthusiasm. Freemasonry tries to enforce ideas of the Enlightenment in an anti-Enlightenment form: on the one hand, the elevation to universal humanity and reason and on the other, secret lodges, sects of the initiated, and clandestine conspiracies—the very opposite of a reasonable and universal public, which Kant described as the most important framework of the Enlightenment. Yet before *liberté, égalité, fraternité* became the slogan of the French Revolution, it was the slogan of a French Masonic lodge (see Riehn 1985: 47–48). Also *l'Être suprême*, the depersonalized concept of deity, belonged to the Freemasons before it was honored by the revolution. Freemasonry was able to unite Catholics, Protestants, Jews, and Deists under the same banner; however, the access to universality was reserved for the chosen and initiated, who tried to maintain their exceptional and privileged position. Secret signs, mystic symbols, invocations, secret codes, codified initiation rites, new Cabbala—all these abound in great quantities. The representatives of the Enlightenment themselves became a secret sect that strove to lead humanity to reason and progress, becoming a self-appointed avant-garde in the service of historic reason. The belief in reason became a new religion organized in the form of a new church[97] (which is also why the Catholic Church opposed the Masonic movement). The difference between form and content, between the universal and particular, could not have been any greater. The Enlightenment was concerned with abolishing the estates, but the Freemasons themselves attempted to become an estate apart, a new nobility and a new priesthood, albeit in the name of reason.

The uninitiated and the unenlightened remain outside, as the very people who were supposed to compose the universal community. In the second act of *Die Zauberflöte*, Papageno remains excluded from wisdom and service in the name of reason by excluding himself—the subordinates assign themselves an inferior status and remain in "minority by their own guilt," *die Selbstverschuldete Unmündigkeit*, as Kant has incomparably put it (Kant 1996:58). Even more, the subordinates are satisfied with their subordination; they occupy a position corresponding to their nature and abilities, from which they don't want to part. That is the inner contradiction of *Die Zauberflöte*, the concealment of the division that the myth wants to bridge over. Mozart wants to hold both threads in his hands at the same time and does not want

to renounce either—he wants a reconciliation of the monarchy and the Revolution in which the prince and reason should rule supreme, hand in hand.

Whereas Papageno's exclusion represents the exact opposite of Sarastro's declarations and the proclaimed ideals of humanity, love, and reason, Mozart takes Papageno's side in musical respects. He sings the first and the last arias; his presence and all the vulgar jokes and the magic of his music are much more convincing than the uplifting words of the priests, who seem bloodless in comparison. Adorno's opinion (1986) that *Die Zauberflöte* represents the last or maybe the unique moment of fusion of high and popular music seems particularly aimed at Papageno. A certain musical ambiguity permeates the whole: One would be hard put to find a music lover who, in the cast of *Die Zauberflöte*, would be particularly fond of Sarastro and his priests. Their "type of average morals which are outstanding in their generality" was already treated ironically by Hegel (1970, 15: 207), who also doubted the significance of their solemn teachings. Another rule of thumb: Morals cannot be put to music; regardless of how praiseworthy they may be, the music will revolt against them.[98] No one was so aware of this as Kierkegaard, the greatest moralist among the music lovers (and the greatest music lover among the moralists): "The proclaimed aim of the development in *Die Zauberflöte* is the ethically determined love, or the love in marriage, and there lies the fundamental error of this work; for whatever else this love may be from the spiritual or the worldly point of view, one thing it is not, it is not musical, it is even altogether non-musical" (1992: 89).

We have seen that in Mozart's earlier operas, the ensembles presented the most subtle and complex musical structures and could be seen as their strongest moments, so their absence is all the more symptomatic in *Die Zauberflöte*. After an initial incomplete quartet (1.1) and quintet (1.5), the ensembles virtually disappear, at least in the form that defined so much of the earlier operas (see. Stricker 1980, 333). We have seen that the fundamental idea of the ensembles was the utopia of a civil society, the maintenance of individuality through the community's inherent conflicts and reconciliations. But here the choir of priests takes over the role of the ideal community, opposed by the individuals and their arias or duets at the most. Both finales, too, are very different from earlier ones. The utopia of the community, in which every individual lives in a state of simultaneous conflict and harmony with the others, gives way to a different idea of the community, the idealized communal fraternity, which keeps individuality outside itself. Individuality is traced back to a negative principle, either as Pamina's

lonely and desperate lament, as Papageno's insistence on worldly pleasures as compared with the ideal, or as the destructive power of the Queen of the Night. The community stands on the other side, de-individualized and supra-individual.

We have seen that the main objective of *Die Zauberflöte* is to mythically unite the logic of mercy and the logic of autonomy, worldly and spiritual power, S1 and S2, the triumph of the revolution, and the form of the old sovereignty. Another foundational myth needs to be added to this, which is the fundamental element of the whole: the creation of the couple. The rise of the Enlightenment and the bourgeois revolution brought about a new unity of man and woman. *Die Zauberflöte* puts to music the ideas of young Hegel but also and especially those of Rousseau. His *Émile* introduces a new paradigm of the couple as a cure for all the diseases of the expiring order and as a motive for renewing social conditions.

> *Émile* is much more than a treatise on education. In it we must read the invention and construction of an object which is unprecedented: *the couple*, the illustration and idea of the possible sexual relationship, happy and all of a piece, because it is founded in nature. In Rousseau's eyes this is the only imaginable revolution, the only serious alternative to despotism. Reinventing man and woman, offering a formula for their relationship, finally showing that this relationship quite plainly produces all others (parents-children, State-citizen, etc.), means a foundation for the double-sided unity which will be *the* political subject as the guarantee of a State preserved, if not from injustice, at least from the risks of despotism. (Grosrichard 1998: 179)

Tamino and Pamina are the musical embodiment of Émile and Sophie, the beginning of a new mankind, a new age, a new harmony. "Man and woman, and woman and man, reach towards the deity" (1.7).

The distance to *Così fan tutte* is enormous, although it is true that even here, rather ironically, love arises mechanically, so to speak: It suffices to merely show a picture of Pamina to Tamino and to describe the good-looking prince to Pamina, and love flares up before they have even seen each other in person—and as soon as they do meet, they immediately realize they are made for one another ("It is he!" "It is she!"). But regardless of that, the ideal can be realized only in such a way that both are absolutely unique and

inexchangeable, the two halves of one ideal whole, and this fusion goes so
far that at the end they are addressed by the choir in the singular: *"Du edles
Paar"* (You noble couple), *"Der Isis Weihe ist nun dein"* (The consecration
of Isis is now yours). Their marriage is completely different from that in *Così*
because it stems from another anthropology: it is a marriage based in human
nature and one with it, not one designed to oppose human nature and coun-
teract its weaknesses. The nature of the couple forms the basis for the new
morals—its true and emphatic nature, proven in the renunciation of natu-
ral inclinations and worldly pleasures. This harmonious union represents
the highest purpose of nature: "There is nothing nobler than woman and
man" (1.7). Whereas all of Mozart's couples up to now had been problematic,
constantly splitting up and reuniting and gnawed by jealousy and doubts,
Tamino and Pamina are elevated to the level of two Platonic halves who have
finally found each other. Just like Mozart's previous couples, Tamino and
Pamina have to undergo the trial of love, but this trial is imposed from out-
side; it is an external affair that doesn't affect their mutual devotion from in-
side. It is precisely this fantasy that will carry the bourgeois invention of the
couple and the new understanding of marriage and morals. We have previ-
ously seen something that could be called the fetishist disavowal of the scis-
sion between the mercy of the Other and the autonomy of the subject, so
here we have a correlative disavowal in the sexual economy.

The unification of the couple, the successful relationship between the
sexes, can be realized only under the guidance and protection of Sarastro,
the good father figure, just as Émile and Sophie could be united only under
the protection of the teacher. The teacher, just like Sarastro, was a substi-
tute father, and Émile was an orphan. Tamino is also a parentless stranger;
in both cases the education, *Bildung,* of a natural subject toward autonomy
is made possible by authority of the father figure. The father's function is
covered by the mythical gesture of disavowal. In contrast to the statue of the
Commandatore, which returned as the terrible figure of the dead father to
punish the rebellious son, Sarastro presents its good and gentle version, the
side that generously allows the son to ascend to the father's throne while his
vengeful shadow is attributed, equally mythically, to the evil mother. The
family romance is raised to a general family myth through the gesture of dis-
avowal.

Two worlds are brought together in Mozart's operas: one just being cre-
ated that now celebrates its victory and another that has not completely dis-
appeared yet—even though it has lost its substance, it has still retained its

brilliant form. In Mozart's operas, both worlds and their basic principles seem to have achieved a utopian reconciliation sustained by the music. They stage the emergence of the bourgeois world with its mythical starting point in the nontotalitarian community as well as the displaced frame of the logic of mercy, which seems to unite or cohabit with the former in a peaceful reconciliation. Already the Enlightenment, still the gesture of mercy— this was the utopian point of European history where the ambivalent reconciliation between the Enlightenment and tradition, the two ontologies and social theories, seemed possible. But at the same time they also show the limit of this reconciliation; they measure its price and point out its contradictory presuppositions.

If *Figaro* is the point of victory of the Enlightenment and *Don Giovanni* and *Così fan tutte* call it into question, then *Die Zauberflöte* represents the transition to the myth in the sense of Lévi-Strauss, a "logical model for solving a contradiction (an unsolvable task if the contradiction is real)" (1974: 254); that is, it represents the attempt to believe in two contradictory theses simultaneously. Thus, the circle is closed in *Die Zauberflöte:* Both worlds, at whose delicate point of contact Mozart stands, find their mythical unity in it.

But if the tension between the subject and the Other found an outlet in the myth, it still extended to the border of the real problem: Does the logic of autonomous subjectivity, which got rid of its Other through the Enlightenment, suffice? If the fantasy of the Other fell to pieces and was debunked as an illusion, is assuming that one could simply construct the new world on the shoulders of the autonomous subject similarly an illusion? Does not this subject require the Other, too, without which it risks falling apart? Do we not lose subjectivity itself when the Other is abolished? What status can be ascribed to the Other now?

Three Continuations

From *Die Zauberflöte* on—Mozart's last will, as it were—three continuations in three different directions can be traced.

The first continuation is historic. In June 1791, when Mozart wrote the first act of *Die Zauberflöte*, the French Constituante discussed whether one should revoke the king's privilege to grant amnesty at his discretion, which elevated the king to an exceptional position above the law and thus violated the principle of equality before the law. Theoretically, this royal right had

already been destroyed by philosophers (in Bentham's view the "objective of every pardon is that the tyrant be praised for his mercy and the laws be rendered less stringent"; Kant shared this opinion), but now the time had come for the practical and political implementation of this stance. Pétion, the main speaker against the king, made his famous statement: *"La clémence d'une nation est d'être juste"* (The pardon a nation can show is that of being just) (Nagel 1985: 107). Two years later Fichte would include the following in his famous manifesto: "No, Prince, you are not our *God*. From *Him* we expect happiness, from you the protection of our rights. You don't need to be *merciful* to us, you just have to be *just*." (Fichte 1971:9)[99] Hence, the king should be stripped of the status enabling him to dispense mercy, this emblematic attribute of his sovereignty. But as soon as the first step was taken, the second had to follow with an inexorable necessity: no more mercy for the king, his royal status being a violation of natural rights. The king would not be treated with the noble magnanimity of Selim Pasha but rather according to Osmin's verdict: "First beheaded, then hung." Mercy was finished; there would no longer be an Other of the Other.

The second continuation is musical. Beethoven wrote Mozart's last opera, as it were: *Fidelio*, Beethoven's only opera, can to a certain extent be seen as a continuation of *Die Zauberflöte*. Pamina transformed herself from the victim to be saved into the savior, and this transformation achieves its full and explicit realization in *Fidelio* where Leonora disguises herself as a man and takes on the post of the jail keeper's servant to save her beloved Florestan from imprisonment. In the decisive moment she reveals her true identity and keeps him from death. Don Pizzaro, the governor of the prison who wanted to take revenge on Florestan, ignoring the law, desiring to usurp the right of the Other of the Other, gets his rightful punishment in the end, while Florestan is pardoned. The act of mercy is no longer performed by the king but by his representative, the minister Don Fernando; however, the stage directions tell us that the act of mercy is played out in front of the king's statue, which dominates the last scene, immovable and silent. In *Idomeneo* the gesture of divine mercy was reduced to a minimum; in *Die Entführung* Selim had only a speaking role—he could no longer sing of mercy; in *Le clemenza di Tito* all that remains is an empty shell of mercy; and finally, the king in *Fidelio* is but a statue, the last stony remains of the Other. *Fidelio* also concludes Mozart's operas as regards their musical aspects, with constant borrowings and quotations. Musically, it is particularly indebted to *Così fan*

tutte, the opera toward which Beethoven showed such indignation. Leonora's famous aria *"Abscheulicher"*—its structure and even the E major key—is modeled on Fiordiligi's aria (*"Per pietà, ben mio, perdona,"* 2.25).[100] The famous quartet *"Es ist so wunderbar"* is inconceivable without the canon *"E nel tuo, nel mio bicchiero"* and so on.

The third continuation is literary. Goethe, while director of the theater in Weimar, did not think much of the libretto of *Die Zauberflöte* and ordered a new one for the same music.[101] Several years later he decided to write a sequel to it himself, but it remained a fragment.[102] In his work we encounter the same characters several years later. The forces of darkness are preparing another conspiracy: In her underground domain, the Queen of the Night is planning to kidnap a child, the son of Tamino and Pamina. Even though the plan is not successful, her helpers do manage to lock the child in a golden coffin where he is still alive but held captive "between two deaths." The forces of light would have to free him from this condition. The final redemption fails to appear; the fragment is interrupted and remains in an anxious ambiguity. A dark shadow has fallen on the triumph of *Die Zauberflöte;* the victory of light does not seem to have brought redemption.[103] It suffices to quote only some of the verses sung by the choir of priests in this sequel:

> Es soll die Wahrheit
> Nicht mehr auf Erden
> In schöner Klarheit
> Verbreitet werden.
> Dein hoher Gang
> Wird nun vollbrarcht,
> Doch uns umgibt
> Die tiefe Nacht.
> *(Goethe 1981: 374)*[104]

The distance that separates Sarastro's rays of sun that dispel the darkness at the end of *Die Zauberflöte* from the verses written by Goethe five or six years later is the distance between the triumph of the Enlightenment and the beginning of modernity. One could even venture a provisional definition of modernity from here: It began at the moment when we became aware that the triumph of the light pushed us into a darkness deeper and more radical

than that which had been dispelled. Goethe's choir seems to speak our own language, and Mozart stands as the final milestone of an age forever gone.

Whereas *Die Zauberflöte* was placed in the context of realization of Hegel's early philosophical program, Hegel himself had to experience the same radical change. In order for him to be able to find a modern basis for his philosophy, he had to give up enthusiasm for the mythology of reason and the hope for a happy unity between both principles. Once again, only seven years have passed between the verse quoted previously and the following words from the manuscript of *Jenaer Realphilosophie*, the beginning of the realization of his system:

> The human being is this night, this empty nothing, that contains everything in its simplicity—an unending wealth of many representations, images, of which none belongs to him—or which are not present. This night, the inner of nature, that exists here—pure self *[reines Selbst]*—in fantasmagorical representations, is night all around it, in which here shoots a bloody head—there another white ghastly apparition, suddenly here before it, and just so disappears. One catches sight of this night when one looks human beings in the eye—into a night that becomes awful....Here the night of the world approaches one. In this night, the Being withdrew. (Hegel 1976: 187)

Notes

1. The disparaging judgments about opera constituted a whole genre, particularly in the eighteenth century: "An opera may be allowed to be extravagantly lavish in its decoration, as its only design is to gratify the senses, and keep up an indolent attention of the public" (Joseph Addison); "Whenever I go to an opera, I leave my sense and reason at the door with my half-guinea" (Lord Chesterton); "One goes to see a tragedy to be moved, to the opera one goes either for want of any other interest or to facilitate digestion" (Voltaire). For all these quotes and many more, see Watson 1994: 319–324.

2. Kafka died on June 3, 1924, in a sanatorium near Vienna. The opening night of *Erwartung* was a couple of days later, June 6, in Neue Deutsche Theater in Prague, Kafka's city. This pure coincidence is highly charged with meaning.

3. *Dafne* was also the first German opera, composed by Heinrich Schütz in 1627. *Capriccio* (1942), the last opera by Strauss, is another but all-too-obvious candidate. With its discussion of the relative value of words and music in the opera and the possibility of a happy marriage between the two, it looks like a self-conscious and contrived last opera, resuming the discussion surrounding opera's birth. Perhaps this is the problem with the entire Strauss opus—that with its attempt at synthesis, he tried all too hard to be the last opera composer.

4. In a survey of 252 opera companies and festivals worldwide conducted in 1988–1989, a list of the 100 most frequently produced operas was established. Only two operas before Gluck made it to the list: Monteverdi's *Poppea* and Handel's *Giulio Cesare*. Four of Mozart's operas made it to the top ten, including *Figaro* as number one. See Lindenberger 1998: 43–44.

5. Part of the secret of Wagner's and Verdi's great success in the nineteenth century lies in the fact that they were able to provide the mythological support to precisely those two nations that had not been able to constitute themselves as national states. The opera assumed the place of the missing state, as it were, and proved extraordinarily helpful in constituting it. The signifier magnanimously offered a helping hand: The name Verdi could be read as an abbreviation of *Vittorio Emmanuelle Re d'Italia*.

6. The cult of authenticity gained gigantic confirmation some years ago in the megalomaniacal television broadcast of Puccini's *Tosca*, which was performed at the very places and the times mentioned in the story and was transmitted live to dozens of countries (the last act, with the early-morning execution on the top of the Angel Castle, took place at 5 A.M.). For this absurd undertaking, one concept of authenticity—the presumed authenticity of high culture—was directly connected to and translated into another quite different one, television's cult of authenticity as promoted by television as its own ideological basis—that of CNN's slogan: "Watch the news as it happens." The very recent lavish production of *Turandot*, performed on location at the Forbidden City in Beijing and again transmitted live, is another massive confirmation of my point for the skeptics.

7. "The opera house is an institution differing from other lunatic asylums only in the fact that its inmates have avoided official certification" (quoted from Watson 1994: 322). Ernest Newman, the author of this quote, wrote some of the best books on the grand operatic repertoire, so he knew very well what he was talking about.

8. However highly Monteverdi may be regarded by the experts, no opera of his has ever been produced at the Met.

9. Jacopo Peri already was fully aware of this. In the introduction to his *Eurydice* (1600), he wrote the following: "Thus I would not dare to claim that the Greeks and Romans already used this style of singing, because I have reached the conclusion that it is rendered possible as such only through our music in order to make it suitable for our language" (quoted from Tomlinson 1990: 8). A little later, Monteverdi, in a discussion with Artusi, would have to defend his right to violate the presumably permanently defined rules if expression forced him to do so.

10. One can again think of Wagner as the most demonstrative case: The supposed recreation of what appear to be the most conservative ancient Germanic myths requires the most daring innovations in music and a revolution in the concept of theater performance.

11. In his "Discorso sopra la musica" (1628), Giustiniano Vincenzo claims that "the music has an enormous effect not only on people, but also on animals, who have no intellect." He also addresses such questions as why one has to sing when catching swordfish (and in Greek at that), the soothing effects of music on silkworm raising, and so on (quoted from Salazar 1980: 50, 53–54).

12. The honor of the last one actually belongs to Haydn's *L'anima del filosofo, ossia Orfeo ed Euridice*. It was written in 1791, the same year as *The Magic Flute*, but it was never completed or staged at the time (the first performance did not take place until 1951). In the nineteenth century, both Berlioz's cantata *Mort d'Orphée* (1827) and Offenbach's satirical operetta *Orphée aux enfers* (1858—to which we owe the famous cancan), although they are at opposite extremes, belong to a differ-

ent world altogether. And this is to say nothing of the twentieth-century elabora-
tions of the theme by Stravinsky, Tippett, and Birtwistle.

13. It is essential that Orpheus accompanies his singing by lyre, placing himself
under the auspices of Apollo. The lyre provides the harmonic footing, the frame-
work, it places his singing within the symbolic. One could say: Orpheus can tame
wild beasts and nature because he has first tamed his own voice, his internal nature.
For once he fails to do this and turns back, Eurydice is lost.

14. *Flectere si nequeo superos, Acheronta movebo* (Virgil, *Aeneid*, 7: 312): "If I
cannot bend the Higher Powers, I will move the Infernal Regions" (quoted in Freud
1976: 769).

15. Darwin, in *The Descent of Man*, tries to live up in this respect to his fame of
Freud's forerunner: "I conclude that musical notes and rhythms were first acquired
by the male or female progenitors of mankind for the sake of charming the opposite
sex" (Quoted from Watson 1994: 350). Let us provisionally call this "the Papageno
theory of music." In this light of the link between the erotic and the religious func-
tions of music, one could reread Lacan's elaboration in *Encore* on "God and the
Jouissance of the Woman" (Lacan 1975:61).

16. "What is the reason for this power of music, that it can awaken passionate
love, especially where women are concerned, who are used to listening to the sere-
nades sung for them? . . . The theologians should explain why music awakens emo-
tions in souls, guiding them to the devotion and fascination of church ceremonies"
(quoted from Salazar 1980: 52–53).

17. On the artistry and the abundance of the echo as a musical expedient in late
Renaissance and early Baroque music, see Sternfeld 1993: 197–226 and passim.

18. It is highly significant that this is not the original ending intended by Strig-
gio and performed in 1607. The original ending actually sticks closer to the Greek
myth: After the second loss of Eurydice, Orpheus swears to never love another
woman and somewhat inconsequentially utters some disparaging comments against
women in general. He is interrupted by Bacchae who do not take his comments
lightly, and they actually have the last word, the final chorus, whereas Orpheus
leaves the scene. This finale, the Bacchanal, was already present in Poliziano's ver-
sion in 1480, the "mother of all Orpheuses" to come. It was only for the printed ver-
sion of 1609 that Monteverdi commissioned a different ending, in tune with his
own convictions, and this is the only extant version of the music.

19. For a detailed comparison of the versions by Monteverdi and Gluck as well
as the shifts that occurred between the two, see the classical work by Kerman
(1957: 25–49).

20. The return to the Rinuccini ending was already instigated by the earlier Or-
pheus versions by Fux in 1715 and Wagenseil in 1750.

21. Apart from the opening lines of the *Twelfth Night*, there is another variation:
"Give me some music; music, moody food / Of us that trade in love" (*Antony and
Cleopatra*, 2.5.1–2). Having chosen one of Shakespeare's sublime utterances on the
powers of music for my purposes, let me give you also a bawdier one: "The sly
whoresons / Have got a speeding trick to lay down ladies. / A French song and a fid-
dle has no fellow" (*Henry VIII*, 1.3.39–41).

22. The equation is, of course, a great commonplace and a cliché, both in poetry
and in music. So here is a musician: "Which of the two powers, love or music, is
able to lift man to the sublimest heights? It is a great question, but it seems to me
that one might answer it thus: love cannot express the idea of music, while music
may give an idea of love. Why separate the one from the other? They are the two
wings of the soul" (Berlioz, *Memoirs*, quoted from Watson 1994: 349).

23. We have Follino's report on the first performance: The lament "was acted with so much emotion and in so piteous a way that no one hearing it was left unmoved, nor was there among the ladies one who did not shed tears at her plaint" (quoted from Sternfeld 1993: 177).

24. The Consort of Musicke, under the direction of Anthony Rooley, produced a wonderful recording of a variety of versions of Arianna's lament in the seventeenth century. In addition to Monteverdi, there are works by Bonini, Pari, Costa, Il Verso, and Rascarini. (See Harmonia mundi GD 77115.) Monteverdi, very significantly, produced three versions himself: As well as the lament *per voce sola*, there is also a five-part madrigal, reminding us of Monteverdi's ambiguous placement, with each foot in a different epoch, and finally the transcription of the original lament for a different Latin text: that of Mary mourning the dead Christ. The highly sexual original lament can be reinterpreted—without changing anything really—into a highly religious one, demonstrating the close link between the erotic and the religious function that inhabits the very core of music.

25. See Clément 1979 for a rather impressive catalogue. Sternfeld points out the change of institutional setting as a factor: "There is no reason why Desdemona (Rossini 1816), Norma, Lucia, Leonora (in *Forza*), Aida, Carmen, Mimi, Tosca, and Mélisande should not die at the end of the opera; there is no court party, no state banquet to follow" (1993: 50).

26. There is no clear evidence whether *Orfeo*, which appeared in print in 1609 and was reprinted in 1615, had any further performances in the course of the seventeenth century after the initial two on February 24 and March 1, 1607. There may have been some. The next performance, its rediscovery, happened in 1904 in Paris through the efforts of Vincent d'Indy, after some excerpts from the score were printed in 1881. Those facts seem incredible and absurd, given the strength of Monteverdi's music.

27. See Kivy's ingenious parallel between the *da capo* aria as a musical form and the psychology presented in Descartes's *Passions de l'âme*, with its view of "emotions as discrete, name-bearing 'set pieces': hard-edged and rather sharply distinguished from one another—so much so that a catalogue...could be made of them" (1999: 101). And the basic Cartesian catalogue contains just six: "wonder, love, hatred, desire, joy, and sadness, and...all the others are either composed of some of these six, or are species of them" (Descartes, quoted by Kivy 1999: 101).

28. Apart from that, Mozart wrote a dozen or so operas, none of which, despite some masterful moments, can quite measure up to the magnificent seven. Lately many attempts have been made at rehabilitating these operas, which gradually have become part of the repertoire and their recordings are now readily available. Of the seven operas listed, *Idomeneo* and *La clemenza di Tito* only gained full recognition during the past thirty years, and in view of the reawakened interest in Mozart, this list may become longer. The most comprehensive overview of all of Mozart's operas is provided by Mann (1977), which mainly concentrates on the objective, both dramaturgical and musical description, and doesn't attempt interpretation. The older great classical reference work is Dent (1947).

29. The same structure can be found in other, lesser-known operas by Mozart, for example, *Lucio Silla* (1772), *Il re pastore* (1775), and so on.

30. I would like to note here that reading Nagel's brilliant work *Autonomie und Gnade* (1985) was the main source of inspiration for this study, although I part company with him on many issues.

31. For the political context of this opera, see Till 1992: 263 ff.

32. This absence can be interpreted against the backdrop of the underlying ideology. As far as merely musical means are concerned, there is certainly some degree of

affinity in many respects. Paradoxically, Bach's music generally exhibits higher dramatic tension than the contemporary opera; in his cantatas and passions, operatic devices are used in a way that surpasses the opera of his day. See Kerman 1957: 65–70.

33. Rossini's opera, composed in 1816, is based on Beaumarchais's *Le Barbier de Séville* of 1775. Thirty years earlier, in 1786, Mozart composed the sequel to the story in *Le nozze di Figaro*, based on Beaumarchais's *Le Mariage de Figaro*, first performed in 1784. This temporal sequence is highly telling. When Rossini composed the first installment of the Figaro story in 1816, with enormous success, it was precisely to inaugurate the Restoration. After years of revolutionary turmoil and Napoleonic wars, Rossini's *Figaro* presented the world as it used to be, when masters and servants were still in their rightful places. Rossini, with his career spanning exactly from 1814 to 1830, was the Restoration composer par excellence, creating some highly successful *serias* and *buffas* that are all to be understood as remakes of those genres. All his operas are informed by the knowledge that they depict a world already gone and no longer possible (just as the Restoration itself was such a remake), a consciousness that could take both burlesque and nostalgic forms. Rossini's musical strategy has to be understood against the backdrop of two other musical strategies of the same period: Beethoven's and Schubert's. Beethoven's late style is a heroic attempt not at a remake but of drawing the classical style to its extreme conclusions, seeing it through to its decomposition. Schubert (who was a great admirer of both Rossini and Beethoven) managed to inaugurate the new paradigm of romanticism, the proper musical setting for the postrevolutionary bourgeois culture. All his operas were failures and were spectacularly overshadowed by the new intimacy of *Lieder*, reflecting a new type of subjectivity. Covering all this in detail would demand a lengthier development that would only sidetrack us from our present, limited goal.

34. A rough translation would read: "After lunch Mrs. Catherine came for a visit. We have played with the tarock cards. At seven o'clock we went for a walk in the garden. There was the most beautiful tempest in the world." Tarock is not tarot but a card game widely spread in the Austrian Empire.

35. This is a happy formula promoted by Kivy (1999: 252 ff.) and also meant as an express criticism of the very title of Kerman's classic *Opera as Drama* (1957).

36. This example has served as a model several times. For a detailed musical analysis, see Rosen 1971: 290–295, and for the analysis of emotional content, see Kivy 1999: 241–251.

37. Till (1992) has another interesting suggestion here: Text involving rational mastery of emotion must be spoken rather than sung because music, especially in eighteenth-century aesthetics, is the language of passions and could never convey rationality convincingly (111). This raises another question: Mercy was originally conceived not as a triumph of rationality over passions but rather as the triumph of love over harsh laws sustained by rationality. But both ways eventually coincide (or rather are made to coincide), because for one to be elevated to demonstrate mercy as an expression of real love, one has to master one's passions. True love demands self-discipline, and the triumph of the heart is the triumph of reason—at least if we are to believe *Die Zauberflöte*. But we will come to that later.

38. The figure of the woman as redeemer was finally used in epic fashion, and rather catastrophically, by Wagner, but this is another issue about which I shall say nothing here.

39. In perhaps the most radical point in the whole text of Beaumarchais's play, Figaro and Suzanne actually repeat the countess's words: They forgive him, too— they take themselves the right to be the subjects who forgive, without asking for

permission, they recognize themselves as subjects who have been wronged and are hence in a position to forgive their master.

40. Musically, there is also the tonal symmetry with the beginning: The short bravura overture in D major is followed by a drop to the subdominant G major for the first duet between Susanna and Figaro—the moment of initial harmony before the conflict arises—and then in the finale, the G major of forgiveness is followed by an upward shift to the dominant D major, the fundamental tonality of the opera, for the short bravura concluding chorus.

41. If we are to believe Jeanne Louise Campan, the idea that the fall of Bastille follows from *Figaro* originated from none less than Louis XVI himself. She received orders from the king to read the play for him privately so that he could see for himself whether censorship was justified. When she came to the monologue, the king allegedly said, "One would have to pull down Bastille if the production of this play is not to be a dangerous error." Then again, Mme. Campan wrote her memoirs after the fall of Bastille. See Beaumarchais 1985:17.

42. In this respect, Pergolesi's *La serva padrona*, which established the model of *opera buffa*, seems to be an anti-opera: Merely a soubrette and a bass suffice for the entire piece.

43. For a long time, it was believed that the Susanna's aria *"Al desio"* (KV 577), which Mozart composed subsequently for the performance of *Figaro* in Vienna in 1789, was written for the countess.

44. Because of his name, Cherubino is logically enough addressed with diminutives; Figaro calls him *"Narcissetto, Adoncino d'amor."* In the same aria, *"farfallone amoroso"* (amorous butterfly) also insinuates his angelic and erotic nature.

45. I cannot discuss here an extremely important sexual ambiguity that accompanied opera throughout the seventeenth and eighteenth centuries, namely, the prominent part played by castrati and the complex interweavings created thereby in the definitions of masculinity and femininity. One of the first decrees of the French Revolution was the prohibition of castrates, who emblematically embodied the monstrous counternature of the ancien régime. Women were not allowed to sing on stages in Rome until 1823. This is magisterially described in Balzac's famous short story "Sarrazine" (made even more famous by Barthes's excellent analysis in *S/Z*), in which a young Frenchman falls passionately in love with a beautiful Roman prima donna, not knowing that "she" is a castrato. For a more detailed discussion of this paradoxical character, see Salazar 1980: 121–133; see also Barbier 1989 and Ortkemper 1993.

46. Brophy (1988: 106) actually suggests that aria 1.6 can be interpreted as a "phallus monologue" (preceding by a couple of centuries the currently successful *Vagina Monologues*): *"Non so più cosa son, cosa faccio, / Or di foco, ora sono di ghiaccio... / Ogni donna cangiar di colore, / Ogni donna mi fa palpitar. / Solo ai nomi d'amor, di diletto / Mi si turba, mi s'altera il petto / E a parlare mi sforza d'amore / Un desio ch'io non posso spiegar! / Parlo d'amor vegliando, / Parlo d'amor sognando /... E se non ho chi m'oda / Parlo d'amor con me."* (I no longer know what I am or what I am doing, / Now I am burning, now I am made of ice... / Every woman makes me change color, / Every woman makes me tremble. / At the very word love or beloved / My heart leaps and pounds, / And to speak of it fills me / With a longing I can't explain. / I speak of love when I am awake, I speak of it in my dreams... / And if I have none to hear me / I speak of love to myself.) His second aria, 2.12, is similar: *"Sento un affetto / Pien di desir, / Ch'ora è diletto / Ch'ora è martir. / Gelo, e poi sento / l'alma avvampar, / E in un momento / Torno a gelar. / Ricerco un bene / fuori di me, / Non so chi'l tiene / non so cos'è. /... Non trovo pace / Notte nè dì, / Ma pur mi piace / Languir così."* (I have a feeling / Full of

desire, / Which now is pleasure, / Now is torment. / I freeze, then I feel / My spirit all ablaze, / And the next moment / Turn again to ice. / I seek for a treasure / Outside of myself, / I know not who holds it / Nor what it is. / . . . I find no peace / By night or day, / But yet to languish thus / Is sheer delight.)

47. In many versions of the Don Juan myth (for example, the two most prominent ones, by Molière and Molina), his father is also part of the cast. Naturally, Don Juan always treats his father without respect or scruples; he violates the ties with his father as consistently as he does all other ties set by the father's order.

48. This was also pointed out by Kerman, who sees it more as a "dramatic error": "If one claims that Don Giovanni's lack of identity is exactly the strongest element of his personality, then this argument is put forth vacuously. In opera, that which is presented convincingly by the music is trusted. Presumably the missing characterization of Don Giovanni attracted particularly the romantic critics. Their dreams and idealizations could have young and grow in Mozart's relative vacuity." (1957: 121). See also Stricker 1980: "When Don Giovanni sings, then he borrows all kinds of styles, from seria to buffa: he speaks to everyone in their language so as to dominate all of them" (251).

49. "The epilogue definitely provides no answers to questions; it merely shows how boring life is without Don" (Kerman 1957: 122). It was common practice throughout the nineteenth century to omit the finale and finish the opera with Don's descent into hell. This was much more in keeping with the vogue of catastrophic endings.

50. Myths originating in modern times, that is, myths that are not a revision of some ancient story, are rare. The myth of Faust was created in parallel to that of Don Juan and can be seen as his supplement and counterpole, and two centuries later *Frankenstein* was created as a strange kind of postscript. For a comparison of Don Juan and *Frankenstein,* see Brophy 1988: 240–241. The best discussion of Don Juan as a myth is probably Rousset 1976.

51. Almost at the same time that Kierkegaard was writing this, the very same Venusberg was set to music and put on stage in Wagner's *Tannhäuser,* which is nothing but Wagner's version of the eminently Kierkegaardian problem of the relationship between Christianity and sensuality. *Either/Or* was published in 1843, and the first version of *Tannhäuser* was first performed in 1845.

52. According to Kierkegaard, that is the fatal flaw of all literary Don Juan figures, from Molière to Byron. There Don Juan reasons, argues, and is forced to constantly talk, philosophize, and reflect. "In the opera there isn't just talk of a seducer, Don Giovanni is a seducer" (1992: 124). Kierkegaard finds Molière's Don Juan "too moralistic" precisely because of his talk; in addition, his flaw is that his seduction originates from envy and jealousy—he desires the object of desire of the other. His desire is not only desire but the desire of desire, the desire of the Other—in other words, it is a desire and no longer a drive as it is supposed to be in music.

53. "What is this force? No one can say. Even if I asked Zerlina before she went to the ball, 'What is this force with which he captivates you?', she would reply, 'No one knows'; and I would say, 'Well said, my child! You speak more wisely than the wise men of India, *richtig, das weiss man nicht;* and the unfortunate thing is that I can't tell you either'" (Kierkegaard 1992: 108).

54. Here I took his theory in a naive way, abstracting from the intricate problems of his textual strategy, which immediately involves each of his theses in a labyrinth of elusive identities. Of course, Kierkegaard published *Either/Or* under the pseudonym Viktor Eremita, who introduces himself as the mere publisher of the papers

written by A and B and found by chance. A and B, of course, argue opposite stand-points. To the theories put forth by A in the first part (amongst these, those about Don Juan), B responds in the second part. Is Kierkegaard's voice the first or the second one, or perhaps both or none? Is this deadly serious and profoundly ironic man pulling our collective leg?

55. Another, actually extremely opposite theory about Don Juan was developed by Felman (1979). For her, he is a being of speech par excellence, a great manipulator of the word who can take speech to the extreme limit. It is the word that binds and creates the social bond, but Don Juan is a person who violates all bonds and obligations, while all the time making use of the binding power of the word. His power is the power of the performative, of promise, and ultimately of love. He catches everybody with this power, while he himself escapes the bonds that he creates, always being somewhere else. The evoked object of enjoyment is an appearance produced by the autoreference of language—by the anticipation, the supposition of the identity and the referent, which his cospeakers are required to provide insofar as they are ensnared by his word. He aims at the point where the words produce the appearance of enjoyment beyond the word. Consequently, Felman considers Molière's version to be the paramount embodiment of the myth. In both cases, the Don Juan myth runs into the lack of reference—in one case outside speech, where he can be evoked only by music, and in the other within speech as its subversion.

56. Translated literally, this title means "That's how all of them do it" (namely, women) and is taken from Figaro, where Don Basilio says in passing: "Così fan tutte le belle" (trio 1.7). Mozart underscores this quotation by repeating the theme accompanying these words in the overture of Così fan tutte.

57. Perhaps one should briefly summarize the plot: Two young men, Guglielmo and Ferrando, boast about the beauty and the virtue of their two fiancées, Fiordiligi and Dorabella. The old philosopher Don Alfonso, skeptical about feminine virtues, proposes a wager for 100 sequins: In the space of one day, the glorified virtues will crumble if the two men are willing to follow his directions. So they undertake an experiment: The two men pretend to leave for the battlefield and quickly return disguised as Albanian officers. With the help of the ladies' maid Despina and under Don Alfonso's supervision, they try to seduce their fiancées, who do not recognize them, with each man wooing the other one's betrothed. After a series of complications, the two ladies yield—they are finally prepared to marry their new lovers. But in the middle of the wedding ceremony, the two soldiers return in their initial identities and demand revenge. The intrigue is finally clarified, and the two shamed ladies ask for forgiveness, which they are granted under some pressure from Don Alfonso. So everything is again in order—or is it?

58. Almost the only one who did not join the chorus was E.T.A. Hoffmann. It was not for nothing that he took Amadeus as his third name.

59. "O how doubly dear and above all honour is Mozart to me, that it was not possible to him to invent music for Tito like that of Don Giovanni, for Così fan tutte like that of Figaro! How shamefully would it have desecrated Music!" (Wagner, quoted by Einstein 1979: 459).

60. A negative clue about its authenticity is the fact that Da Ponte never mentioned it in his memoirs. If it were true, he probably would not have missed the opportunity to boast about it.

61. One can come across the following suggestion about the social structure of Così: "If Don Alfonso ('intelligentsia') is the actual 'perpetrator', he can open the eyes of the deluded couples ('bourgeoisie') only with the help of the maid ('the work-

ing class')" (Mezzocapo de Cenzo and MacGabham 1991: 285). Following this suggestion, we would have here nothing less than the bond between philosophy and the working class that Marx dreamed about.

62. At the first performance, they were quite literally an odd couple, because the two parts were sung by Bussani and his wife. The notorious production of *Così* by Peter Sellars took the bond between the maid and the philosopher as the guiding line, the assumption being that the real drama takes place there, buttressed by erotic and traumatic undertones. The crucial moment for their relationship is the subtle quartet 2.22 *("La mano a me date")*, where Don Alfonso acts as a spokesman for the two men, while Despina speaks for the two women. They both act as interpreters of the desire of the Other and thus enter an ambiguous play of mediation. After the establishment of contact between the two couples, they quickly vanish, but what about their own desires? Is there such a thing as neutral mediation? What do vanishing mediators do after they vanish?

63. In the eighteenth century, a curious and now almost forgotten genre of puppet operas reached a high popularity. *Così fan tutte* presents perhaps its best embodiment: the actors themselves take the role of the puppets.

64. Ovid's story was based on a Greek myth in which Cephalus disguises his identity and seduces his own wife, Procris, and she later plays the same trick on him in revenge.

65. Canon is used here to attain the sublimity of the moment, but Mozart could use it for the very opposite purpose as well, for his compositions on most vulgar and scatological texts invented by himself (for example, K. 231, K. 233, K. 560, and so on). As the most codified form, it presented the greatest contrast with the vulgarity of the contents.

66. This canon's theme is reminiscent of the trio *"Soave sia il vento"* (1.10), the sublime moment of parting in the first act—the moment of reunion glosses over the moment of farewell. One can also hear an echo of both duets (2.23 and 2.29) in which the two ladies succumbed to the charms of their new lovers (or was it the other way round?). Mozart is a master of condensing significant previous moments.

67. Perhaps one should add that Mozart found himself in a somewhat analogous situation before his marriage: After being turned down by Aloysia Weber, he married her sister Constanze. For him, too, love had to do with substitution and interchangeability: Is one sister as good as the other?

68. Groups of comedians commonly performed the so-called *pièces de transformation*, in which the soubrettes frequently changed clothes and assumed different roles, from the socially highest to the lowest; spoke several languages; and so on. (See Goldoni's testimony in Einstein 1979: 460.) The disguise was an ideal mode of expressing the Enlightenment's mechanical psychology: A person can be reduced to the function denoted by his or her clothes, and their relations can be reduced to conditional reflexes provoked by those external marks. The disguise is the beginning of behaviorist psychology.

69. The obsession with disguises started much earlier, and the seventeenth-century fantasy seemed particularly impressed with disguises to cloak sexual identity. Those disguises were all the more ambiguous if one bears in mind the ubiquitous presence of castrati in the opera (see Salazar 1980 and Barbier 1989).

70. In the general enthusiasm for disguises, *Così* also displays two instances of the other common type: Despina, the soubrette, appears disguised as a doctor in the first finale and as a notary in the second. Implicit social parody demonstrates in those scenes how little it takes to assume the privileged place of the bearers of traditional ideological state apparatuses—the clothes and a few sentences in broken Latin.

71. *"Così fan tutte* is a play...about the problem of identity and interchangeability. If love is transferable, if its objects are interchangeable, each individual replaceable—the two lovers are justifiably outraged that it takes only one day for the social world and its fundamental values to be thrown out of joint—if the personal dignity and the unrenounceable demands suddenly turn out to be
an illusion through a ridiculous, but consciously designed experiment, what happens then? Here opens an abyss that Mozart's music cannot heal, but it can nevertheless...build a bridge across it without falling into an utopia of salvation" (Kunze 1984: 453). Nagel probably had this quotation in mind when he laconically commented, "The absence of abyss...is the real abyss in *Così fan tutte*" (1985: 42).

72. "Don Alfonso is well aware that he is witnessing the final farewell...from this century of Enlightenment, being one of its last representatives, at the same time a cynic and a humanist, a frivolous libertine and a resigned wise man in one" (Schalz 1991: 345).

73. This predicament was pointed out in various ways by several perspicuous interpreters, for example: "On the stage, we see two Italian coquettes who laugh and who lie, but in music, nobody laughs and nobody lies" (Hyppolite Taine); "The music is, as so often before, deceitful: it paints the beauty as the appearance of 'goodness'...Mozart wanted us to see him as a 'diabolus ex machina' who gives us deception as beauty" (Hildesheimer 1977: 316); "Emotions are always genuine, this is the message of the music, we can only mistake the person or his/her name" (Wienold 1991: 320); "Is it not embarrassing that from a strictly musical point of view we equally believe the persons whether they be faithful or dishonest, sincere or lying?" (Stricker 1980: 276–277); "Which music is to be believed at all, if not this one?" (Gülke 1991: 262).

74. Some plausible reasons can be given in favor of this hypothesis: the greater compatibility of the exchanged couples' characters and above all the compatibility of voices (Fiordiligi—soprano, Ferrando—tenor; Dorabella—mezzo-soprano, Guglielmo—baritone). "Who has ever heard of a prima donna marrying a baritone?" (Hughes 1972: 187). The dramatic construction, however, offers many reasons against it (see Kerman 1957: 112).

75. This is also why I think one need not worry, as many interpreters do, about the future happiness of the two couples. One could venture a hypothesis that their union will be sounder than those of most of the rest of Mozart's couples who are supposed to live happily ever after, even though—or maybe for that very reason—Mozart cannot quite celebrate their reconciliation.

76. Compare this with the conclusion of Marivaux's *L'épreuve:* "Maris jaloux, tendres amants, / Dormez sur la foi des serments, / Qu'aucun soupçon ne vous émeuve; / Croyez l'objet de vos amours, / Car on ne gagne pas toujours / A le mettre à l'épreuve." (Jealous husbands, tender lovers, / Sleep with the faith in the vows, / Let no suspicion disturb you; / Believe the object of your love, / For one doesn't always profit / From putting it to test.) So we have to do with another commonplace of the eighteenth century.

77. The B-flat major, otherwise generally a tonality of gaiety and trust, displays again its treacherous side. In *Don Giovanni*, Noske (1977) has found some ten instances of the same musical formula in various places, always in B-flat major and always connoted with treason, *tradimento* (68–74).

78. The *enfant sauvage*, another obsessive myth of the Enlightenment, was also a privileged object for the king's gaze. The king transcends the upper edge of society to found his legitimacy in nature, just as the *enfant sauvage* transcends the lower edge as the zero degree of natural subjectivity before the entry into culture. They

delimit the social space from the opposite ends. It is no coincidence that Kaspar Hauser, the most famous *enfant sauvage*, presented a fantastic condensation of the two, given the numerous speculations about his royal descent.

79. The Sellars's production of *Così*, whatever one might think of its extravagances, has radically reinterpreted the philosopher's position. By concentrating on his problematic erotic link with Despina, it deprives him of his excluded and elevated status.

80. Assoun remarks in passing: "Let us bear in mind this symbolic tie between the automaton and the power" (1981: 158), but he does not develop it any further. The fascination with automata is of much older date and stems from antiquity. Heron of Alexandria wrote a treatise on pneumatics in which he explained the principles of their construction. Mechanical toys were much appreciated in Byzantium and in medieval Arabic culture, from whence they have spread across Europe. But it was only with the Enlightenment that they gained the status of a metaphor.

81. It was particularly enticing that the automata could perform highly spiritual functions such as painting, making music, and so on and thus reduce high aesthetic ideals to a mechanical procedure. Consider also Mozart's compositions for mechanical instruments, for example, K. 594, K. 608, K. 616.

82. Jacques de Vaucanson (1709–1782), born the same year as La Mettrie and having died the year of *Die Entführung*, was otherwise an inspector of the royal weaving mill in Lyon. In his free time, when not busy constructing automata, he also invented a weaving machine driven by a water wheel that did much to revolutionize the textile industry. He can be taken as an emblematic metaphorical figure placed at the intersection of the two epochs.

83. "The source of fascination in Vaucanson's automata was the fact that they were creatures without secrets. Everybody who read Vaucanson's descriptions knew how they functioned. Does it come as a surprise, then, that in Spain the Catholic Church threatened the constructors of automata with inquisition and torture? The secrets of life that were taken care of by the church were not to be yielded to mechanicists and philosophers which would allow their demystification" (Wawrzyn 1990: 99).

84. Riehn (1985: 55–59) gives a sufficient number of convincing reasons for the analysis of the work's musical uniformity. This primarily concerns the motifs, because numerous later motifs can be derived from the first theme of the overture. This reflects Mozart's manner of producing different and chronologically distanced motifs on the basis of a series of ordered transformation, which gives the whole a hidden uniformity, invisible at first glance.

85. There is another speculation that Schikaneder was not the only (or not even the most important) libretto writer, because at that time it was common practice for theater groups to write texts collectively. The candidate named most frequently for the co-authorship (or even for the predominant authorship) is Karl Ludwig Giesecke (a Freemason as well), who, after his youthful theater adventures, made a career as a geologist, studying rocks from Greenland and becoming a renowned professor for mineralogy at the University of Dublin. On the occasion of a later visit to Vienna, he supposedly confirmed his authorship. See Hildesheimer 1977: 333–335.

86. Although Riehn showed that it cannot be proven that this frequently quoted phrase actually comes from Goethe and, hence, can be added to the body of Goethe legends, some of Goethe's other comments on this matter tend in the same direction.

87. Mozart became a member of the Freemasons in 1784, probably under the influence of Baron von Gemmingen, whom he met in Mannheim in 1778. His father,

Leopold, followed his son into the fraternal order in 1785. Freemasons were persecuted under Maria Theresa; Joseph II, however, was more tolerant to them.

88. In the motif of two armored men, Mozart, in a highly extraordinary manner, quotes a Lutheran chorale. There are numerous other quotes and adoptions: The theme of the overture is adopted from Clementi; in the great hit *"Ein Mädchen oder Weibchen,"* (2.20) Scandelli's chorale is quoted; the motif of the aria of Monostatos (2.13) is taken from Myslivecek; the first aria of the Queen of the Night is adopted from Benda; and so on. See Riehn 1985: 65.

89. "Fighting isn't my thing. I don't basically want any wisdom either. I'm a kind of child of nature, taking pleasure in sleep, food, and drink; and if it were just possible some time for me to capture a pretty little wife..." (the dialogue with the priests after 2.10).

90. According to the operatic convention that all important persons introduce themselves with an aria and thus define themselves, Tamino is given his (1.3). Pamina is not given such an aria at the beginning; she is, however, doubly rewarded in her "final" aria in which her identity is defined at the threshold of death— *"So wird Ruh im Tode sein!"* (So there will be peace in death.)

91. "Her transcendence gave the dramatic moment clarity as well as uneasiness, but irrespective of whether she is passive or active, she never is the sister of anyone of Mozart's other heroines" (Stricker 1980: 326).

92. The old misogynist Schopenhauer saw the problem and inconsistency in precisely this point: "In *Die Zauberflöte*, this grotesque, yet significant and many-sided hieroglyphic, the fundamental principle would be completely symbolized, if at the end Tamino were rid of his desire to possess Pamina and instead requested and received consecration in the temple by himself, as compared to his necessary opposite, Papageno, who would justly receive his Papagena" (quoted in Riehn 1985: 45). Wagner would follow exactly this idea in his *Parsifal*, which may be read as a transformation of *Die Zauberflöte* about one hundred years later.

93. *"Zuerst werde ich hier von einer Idee sprechen, die, soviel ich weiß, noch in keines Menschen Sinn gekommen ist—wir müssen eine neue Mythologie haben, diese Mythologie aber muß im Dienste der Ideen stehen, sie muß eine Mythologie der Vernunft sein. Ehe wir die Ideen ästhetisch, d.h. mythologisch machen, haben sie für das Volk kein Interesse; und umgekehrt, ehe die Mythologie vernünftig ist, muß sich der Philosoph ihrer schämen. So müssen endlich Aufgeklärte und Unaufgeklärte sich die Hand reichen, die Mythologie muß philosophisch werden und das Volk vernünftig, und die Philosophie muß mythologisch werden, um die Philosophen sinnlich zu machen. Dann herrscht ewige Einheit unter uns"* (Hegel 1970, 1: 236). This famous three-page text was probably written toward the end of 1796 or at the beginning of 1797. It was published the first time in 1917 and, although it is in Hegel's writing, the authorship is still a subject of dispute—most likely Schelling and Hölderlin were involved, too.

94. Riehn contributed two contemporary parallels to this point, namely from two so disparate authors as Schiller and de Sade. See, for example, de Sade: "Your rulers know only how to be king; I have learned to be a human" (*Aline et Valcour*, quoted in Riehn 1985: 53).

95. There is a paradox here: The Enlightenment put the separation of church and state on the agenda; the medicine proposed by Mozart, however, means that they should be united, despite the fact that he had a different church in mind.

96. Here my interpretation parts company altogether with that of Nagel's otherwise very lucid and inspirational analysis (as it does for *Così*, about which Nagel, curiously, has nothing much to say).

97. "The fat Masonic priest Sarastro" writes Engels at the end of *Anti-Dühring*. In eighteenth-century Austria, Freemasonry did not yet include the vehemently anti-Catholic stance it would later exhibit.

98. Also, in *Così fan tutte* Don Alfonso is given only a short aria. Even though his morals are in sharp contrast to those of Sarastro, his moral teaching cannot be put to music.

99. The title of the manifesto is *"Zurückforderung der Denkfreiheit von den Fürsten Europens, die sie bisher unterdrückten"* (Demanding back the freedom of thought from the princes of Europe who have so far suppressed it) (Fichte 1971:9). Place and year of publication are indicated as follows on the title page: "Heliopolis, in the last year of the old darkness (1793)"; Heliopolis was the ancient Egyptian city of the sun.

100. "It is no coincidence that Beethoven imitated this aria in Leonora's aria and, instead of Mozart's two horns obligato, Beethoven naturally used three" (Einstein 1979: 462). The unintended irony is that Beethoven—for the model of "true" virtue—used that aria in which Mozart shows virtue's last efforts before its fall.

101. In the prologue to the new text he wrote: "It proved simply impossible for us to perform *Die Zauberflöte* in Weimar according to the original, which Mozart ennobled by his heavenly music" (quoted from Riehn 1985: 38). He entrusted his brother-in-law, Vulpius, whose poetic skills hardly surpassed those of Schikaneder, with writing the new text.

102. The work on the fragment was abandoned primarily because it proved impossible to find a suitable composer to fulfill such a task. Schiller had already pointed out to Goethe that even the best text cannot make the opera. Owing to the enormous success of *Die Zauberflöte*, numerous imitations quickly appeared during the next years—*Zauberring, Zauberspiegel, Zauberpfeil, Zauberkrone*, and so on (and even after three decades, Schubert still wrote the stage music for *Die Zauber-harfe* and several additional arias for *Zauberglöckchen*). In 1798, Schikaneder himself wrote a sequel of *Die Zauberflöte* under the title *Das Labyrinth oder Der Kampf mit den Elementen*, a piece with an incredible amount of magic, stage tricks, and machines; the music was composed by a Peter von Winter (see the publisher's notes in Goethe 1981: 712–713).

103. Even Papageno and Papagena cannot be happy any longer: "The whole world is no longer beautiful.... What happened to the two of us?" (Goethe 1981: 367). Neither can Pamina: "I stand as though struck by lightning; / How can I depend on you, you gods / If you take away wisdom from us?" (394).

104. "On this earth the truth shall no longer be divulged in beautiful clarity. Your high march is now concluded, but we are surrounded by deep night."

"I DO NOT ORDER MY DREAMS"

━━━━━━━━━━━━

SLAVOJ ŽIŽEK

In the accompanying text to one of the recordings of Mozart's
Così, the partnership of Mozart and da Ponte is proclaimed "as memorable
as those of Verdi and Boito, Gilbert and Sullivan, Strauss and Hofmannstal,
or Wagner with himself."[1] The surprising thing is how one is allowed to enu-
merate Wagner's incestuous self-relationship in a series with other, "nor-
mal," relationships, implying that Wagner was lucky to encounter the right
librettist, that is, *himself*—a formulation that fits perfectly Wagner's un-
abashedly self-centered reading of the previous history of the opera and music
in general: The features he emphasizes as most progressive in previous com-
posers (say, the great finale of the Act II of Mozart's *Le nozze*) are the fea-
tures he is able to read as pointing forward toward himself, toward his own
notion and practice of the "music drama." However, what if Wagner was
right? What if his work effectively marks a unique achievement, a turning
point that enables us to interpret properly and retroactively the ambiguities
and breaks of the previous composers as well as to conceive of what follows
as the disintegration of the unique Wagnerian equilibrium? Borges once re-
marked, apropos of Kafka, that some writers have the power to *create their
own precursors*—this is the logic of retroactive restructuring of the past
through the intervention of a new *point-de-capiton:* A truly creative act not
only restructures the field of future possibilities but also restructures the

past, resignifying the previous contingent traces as pointing toward the present. The underlying wager of the present essay is to endorse the notion that such is the position of Wagner. To put it in a naive and direct way, what if *Tristan* and *Parsifal* simply and effectively are (from a certain standpoint, at least) the two single greatest works of art in the history of humankind?[2]

The proper counterpart to Dolar's essay on Mozart would have been to start with *The Flying Dutchman*, which occupies in Wagner's opus the same structural role as *The Abduction from the Seraglio* in Mozart: It directly renders its elementary matrix. That is to say, although Mozart's operas present a series of variations on the same basic motif (the master's gesture of mercy that reunites the amorous couple), *The Abduction from the Seraglio*, with its uniquely naive assertion of the all-conquering force of love, clearly stands out as—in no way the best, and precisely for that reason—directly embodying this basic motif (the finale of its Act II, with its triumphant "Es lebe die Liebe!" quartet, is unique in its naïveté, in its lack of later, famous Mozartean irony). When, after the low point of *Così fan tutte*, with its uncanny Pascalean conclusion that love is mechanically generated by following the external ritual, Mozart endeavors to reestablish the pure naïveté of the power of love in *The Magic Flute;* this return to origins is already faked, tainted with artificiality, like the parents who, in telling stories to the children, pretend to really believe them.

And it is similar with Wagner: With regard to the purity of *The Flying Dutchman*, one is even tempted to claim that *Tannhäuser* and *Lohengrin*, although (in Wagner's lifetime) his most popular operas, are not truly representative of his style (see Tanner 1997) because they lack a proper Wagnerian hero. Tannhäuser is too common, simply split between pure spiritual love (for Elizabeth) and the excess of earthly erotic enjoyment (provided by Venus), unable to renounce earthly pleasures while longing to get rid of them; Lohengrin is, on the contrary, too celestial, a divine creature (artist) longing to live like a common mortal with a faithful woman who would trust him absolutely. Neither of the two is in the position of a proper Wagnerian hero, condemned to the undead existence of eternal suffering (the closest we come to it is, the hero's long "Rome narrative" toward the end of *Tannhäuser*, the first full example of the Wagnerian hero's protracted suffering that prevents him to die). And is it not that, again, in a similar way, *Meistersinger* is too common with its acceptance of social reality and that *Parsifal* is too celestial in its rejection of sexual love so that the triad of *Tristan, Meistersinger,* and *Parsifal* repeats at a higher power the triad of *The Flying Dutchman,*

Tannhäuser, and *Lohengrin*?[3] However, because I already made an attempt at such a reading,[4] I would prefer to accomplish here a similar move in the *opposite* direction: to read Wagner's *Tristan* as the zero-level work, as the perfect, ultimate formulation of a certain philosophico-musical vision, and then to read the later works (of Wagner himself as well as of other composers) as the variations on this theme, as posts on the path of the disintegration of *Tristan*'s unique synthesis that culminates in the much-celebrated *Liebestod* toward which the entire opera tends as its final resolution.

The Death Drive and the Wagnerian Sublime

We sing for different reasons: At the very beginning of his *Eugene Onegin*, Pushkin presents the scene of women singing while picking strawberries on a field—with the acerbic explanation that they are ordered to sing by their mistress so that they cannot eat strawberries while picking them. So why does Isolde sing? The first thing to note is the performative, self-reflective dimension of Isolde's final song. When Romeo finds Juliet dead in the finale of Prokofiev's ballet *Romeo and Juliet*, his dance renders his desperate effort to resuscitate her. However, here the action takes place at two levels, not only at the level of what the dance renders but also at the level of the dance itself. The fact that the dancing Romeo is dragging around Juliet's corpse, which is suspended like a dead squid out of water, can be read as his desperate effort to return this inert body to the state of dance itself, to restore its capacity to magically sublate gravity and freely float in the air. Thus, his dance is in a way a reflexive dance aimed at his dead partner's very (dis)ability to dance. The designated content (Romeo's lament of the dead Juliet) is sustained by the self-reference to the form itself. And it is homologous with Isolde's singing: In the sublime moment of *Liebestod*, Isolde's singing as such is at stake. Here singing does not simply represent her inner state, her longing to unite herself with Tristan in her death—she dies of singing, of immersing into the song; in other words, the culminating identification with the voice is the very medium of her death.

In what, then, does this *Liebestod* consist? The answer seems to be clear: Wagner's eclectic combination of Buddhist nirvana (mediated through Schopenhauer) and metaphysical eroticism. The structuring opposition is the one between day and night: the daily universe of symbolic obligations and honors versus its nightly abrogation in the *"höchste Lust"* of erotic self-obliteration. No wonder that this sinking into the oblivious night is associated with

Ireland—as Heinrich Böll reports in his marvelous *Irish Diary* (1957), Irish pubs featured small booths, isolated with a leather curtain, with straps by means of which a drunkard could attach himself to the seat and immerse himself in the "night of the world," getting away from the daily world of family, honor, profession, and obligations and swimming in the darkness till he runs out of money and is thus reluctantly compelled to return home. So everything seems clear: the eroticized death drive, the suspension of the symbolic order—but here, however, the first complication arises. Yes, *Tristan* is the story of a lethal passion that finds its resolution in ecstatic self-obliteration, but the very *mode* of this self-obliteration is as far as possible from the passionate violation of all rules—the immersion into night is rendered as a cold, declamatory, distanced procedure. No wonder that perhaps the ultimate staging of *Tristan* in the last decades, the one by Heiner Mueller, Brecht's unofficial heir, emphasized precisely this aspect of an almost mechanically enacted ritual.

A look at the other Wagnerian heroes can be of some help here. Starting with their paradigmatic case, the Flying Dutchman, they are possessed by the unconditional passion for finding ultimate peace and redemption in death. Their predicament is that at some time in the past they committed some unspeakably evil deed, and the price they must pay is not death but condemnation to a life of eternal suffering, of helplessly wandering around, unable to fulfill their symbolic function. This gives us a clue to the exemplary Wagnerian song, which is the complaint (*Klage*) of the hero displaying his horror at having to exist as an undead monster, longing for peace in death; consider the Dutchman's great introductory monologue and the lament of the dying Tristan and the two great complaints of the suffering Amfortas. Although there is no great complaint by Wotan, Brünnhilde's final farewell to him— "*Ruhe, ruhe, du Gott!*"—points in the same direction: When the gold is returned to the Rhine, Wotan is finally allowed to die peacefully.

Wagner's solution to Freud's oppositional placement of Eros and Thanatos is thus the identity of the two poles: Love itself culminates in death, its true object is death, and longing for the beloved is longing for death. Is what Freud called the death drive *(Todestrieb)* the urge that haunts the Wagnerian hero? It is precisely the reference to Wagner that enables us to see how the Freudian death drive has nothing whatsoever to do with the craving for self-annihilation, for the return to the inorganic absence of any life-tension. The death drive does not reside in Wagner's heroes' longing to find peace in death; it is, on the contrary, *the very opposite of dying*—a name for

the undead state of eternal life itself, for the horrible fate of being caught in the endless, repetitive cycle of wandering around in guilt and pain. The final passing away of the Wagnerian hero (the death of the Dutchman, Wotan, Tristan, Amfortas) is therefore the moment of their *liberation* from the clutches of the death drive. Tristan, in Act III, is not desperate because of his fear of dying but because without Isolde he cannot die and is condemned to eternal longing—he anxiously awaits her arrival so as to be able to die. The prospect he dreads is not that of dying without Isolde (the standard complaint of a lover), but rather that of the endless life without her. The paradox of the Freudian death drive is therefore that it is Freud's name for the very opposite of what the term would seem to signify, for the way *immortality* appears within psychoanalysis, for an uncanny excess of life, for an undead urge that persists beyond the (biological) cycle of life and death, of generation and corruption.[5] The ultimate lesson of psychoanalysis is that human life is never "just life": Humans are not simply alive but are possessed by the strange desire to enjoy life in excess, passionately attached to a surplus that derails the ordinary run of things.

Such a striving to experience life at its excessive fullest is what Wagner's operas are about. This excess inscribes itself into the human body in the guise of a wound that renders the subject undead, depriving him or her of the capacity to die (apart from Tristan's and Amfortas's wound, there is, of course, *the* wound, the one from Kafka's "A Country Doctor"); when this wound is healed, the hero can die in peace. On the other hand, as Lear (2000) is right to emphasize, the figure of the balanced ideal life delivered of the disturbing excesses (say, the Aristotelian contemplation) is also an implicit stand-in for death. Wagner's insight was to combine these two opposite aspects of the same paradox: *Getting rid of the wound, healing it, is ultimately the same as fully and directly identifying with it.* Does this insight not concern the very core of Christianity? Is Christ not the one who healed the wound of humanity by fully taking it upon himself? It is here that the originality of Wagner appears: He gave to the figure of Christ an uncanny twist. Although Christ was the pure one who took upon himself the wound (the highest suffering), Parsifal (the Wagnerian Christ) does *not* heal the wound of Amfortas by taking it upon himself; in clear contrast to Christ, he brings redemption by fully retaining his purity, by resisting the temptation of the excess of life (the temptation that brought devastation to the Kingdom of the Grail, when Amfortas's father, Titurel, succumbed to it by excessively enjoying the Grail) and not by assuming the burden of sin. For this reason, Parsifal does not have to

die but can directly impose himself as a new ruler—Gutman is right to claim that *Parsifal*'s "temple scenes are, in a sense, Black Masses, perverting the symbols of the Eucharist and dedicating them to a sinister god (1990: 432).

In the history of opera, this excess of life is discernible in two main versions, Italian and German, Rossini and Wagner—so, maybe, although they are the great opposites, Wagner's well-known private sympathy for Rossini, as well as their meeting in Paris, does bear witness to a deeper affinity. In contrast to Wagner's universe, Rossini's is decidedly pre-Romantic—a universe in which the evil characters feel the need to declare their evil to their victims—even Pizarro, in the great confrontation in Act II of Beethoven's *Fidelio*, declares who he is to Florestan before proceeding to kill him; he wants Florestan to *know* who will kill him. The darker undertone of such self-display can be discerned in de Laclos's *Les liaisons dangereuses*, in which Valmont, the hero, wants to seduce Madame de Tourvel not in a reckless moment of passion but with her full consciousness—he wants her to see herself being humiliated and unable to resist it: "Let her believe in virtue, but let her sacrifice it for my sake; let her be afraid of her sins, but let them not check her."[6] Valmont's plan is thus "to make her perfectly aware of the value and extent of each one of her sacrifices she makes; not to proceed so fast with her that the remorse is unable to catch up; it is to show her virtue breathing its last in long-protracted agonies; to keep that somber spectacle ceaselessly before her eyes" (Laclos 1961: 150). Not until the morning after will awareness of her act catch up with her. The situation here is antitragic: In a tragedy proper, the subject accomplishes the fateful act unaware of its consequences, which catch up with him only afterward; here, however, no temporal gap opens up space for the tragic experience because the act itself coincides with the full awareness of its consequences. This is the sadist's position of transposing onto the Other the subjective split at its purest.

In a homologous way, the two men in Mozart's *Così fan tutte* want to have their fiancées see themselves humiliated. The point is not just to test their fidelity but to embarrass them by way of compelling them to confront publicly their infidelity (recall the finale, when, after the marriage contract with the two Albanians, the two men return in their proper dresses and then let the fiancées know that they themselves had been the Albanians). The enigmatic desire is not the women's (is it stable or fleeting?), but the men's: What kind of imp of the perverse propels the two young gentlemen to submit the women to such a cruel ordeal? What is pushing them to throw into disarray the harmonious idyll of their love relationship? Obviously, they

want their fiancées back, but only after having been confronted with the vanity of their feminine desire. As such, their position is strictly that of the Sadean pervert: their aim is to displace to the Other (victim) the division of the desiring subject; that is, the unfortunate fiancées must assume the pain of finding their desire repulsive.

With the typical late Romantic villain (say, Scarpia in Puccini's *Tosca*), we get a thoroughly different constellation, discernible not only in the supremely obscene finale of Act I but also throughout all of Act II: Scarpia not only wants to possess Tosca sexually but wants to witness her pain and her impotent fury provoked by his acts: "How do you hate me! . . . This is how I desire you!" Scarpia wants to generate in his object a hatred that arises from fury at having been reduced to powerlessness. He does not want her love but rather her giving herself to him as the act of utter humiliation, on behalf of her love for Mario, not for him. His is the hatred of the feminine object: Scarpia's true partner is the man desired/loved by the woman, which is why his supreme triumph is when Mario sees Tosca surrender herself to Scarpia out of love for him and curses/rejects her violently for that. Therein resides the difference between Scarpia and Valmont: Although Valmont wants the woman to hate herself while surrendering herself, Scarpia wants her to hate him, the seducer. (See Braunstein 1986: 91–92.)

Rossini belongs to this same series of self-display—however, with a twist. His great male portraits, the three from *Barbiere* (Figaro's *"Largo il factotum,"* Basilio's *"Calumnia,"* and Bartolo's *"Un dottor della mia sorte"*), plus the father's wishful self-portrait of corruption in *Cenerentola*, enact a mocked self-complaint, wherein one imagines oneself in a desired position, bombarded by demands for a favor or service; the subject assumes the roles of those who address him and then feigns a reaction to it. Let us further consider the father in *Cenerentola:* When his daughter is married to the prince, people will address him for services at the court, offering him bribes, and he will react furiously, overwhelmed by it all. The culminating moment of the archetypal Rossini aria is this unique moment of happiness, of the full assertion of the excess of life; the Rossinian sublime arises when the subject is overwhelmed by demands, no longer being able to deal with them. At the highpoint of his factotum aria, Figaro exclaims: "What a crowd / of the people bombarding me with their demands / —have mercy, one after the other / *uno per volta, per carita*!" referring therewith to the Kantian experience of the sublime, in which the subject is bombarded with an excess of data that he is unable to comprehend. The basic economy is here obsessional; the

object of desire is the Other's demand. This excess is the proper counterpoint to the Wagnerian sublime, to the *"höchste Lust"* of the immersion into the void that concludes *Tristan*. There is, of course, something pre-Romantic, prepsychological, and caricatural in this total self-display, which is why, with the onset of Romantic psychology, Rossini was right to stop composing and to adopt the satisfied stance of a bon vivant—this was the only properly ethical thing to do (his long silence is comparable to that of Sibelius and, in literature, to that of Rimbaud and Hammett). This opposition of the Rossinian and Wagnerian sublimes perfectly fits the Kantian opposition between the mathematical and the dynamic sublime;[7] as we have just seen, the Rossinian sublime is mathematical, enacting the subject's inability to comprehend the pure quantity of the demands that overflow him, whereas the Wagnerian sublime is dynamic, enacting the overpowering force of the one demand, the unconditional demand of love.[8]

The Forced Choice

The reference to this excess of life enables us to account for one of the alleged contradictions in the plot of the *Ring:* In their downfall, gods are supposed to pay the price for having disturbed the cosmic balance (appropriating the gold that should have been left to rest at the bottom of the Rhine); however, because the gold—the ring—is finally returned to the Rhine, why do the gods nonetheless perish? The only way to answer this enigma is to introduce the difference between *two* deaths: the biologically necessary demise and the so-called second death, the fact that the subject died in peace, with his accounts settled and with no symbolic debt haunting his or her memory. Wagner himself changed the text of the *Ring* with regard to this crucial point: In the first version of Erda's warning in the final scene of *Rheingold*, the gods will perish if gold is not returned to the Rhine, whereas in the final version, they will perish anyway. The point is merely that prior to their demise, the gold should be returned to the Rhine so that they will die properly and avoid the "irretrievable dark perdition." The unpaid debt, the original sin of disturbing the natural equilibrium, is that which *prevents* Wotan from dying—he can die and find peace only after he settles his debt.[9]

What we encounter in this uncanny space between the two deaths is the palpitation of a life substance that cannot ever perish, like Amfortas's wound in *Parsifal*. Suffice it to recall Leni Riefenstahl who, in her unending search for the ultimate life substance, focused her attention first on the Nazis, then

on an African tribe whose male members's bodies displayed authentic mas-
culine beauty and vitality, and finally on deep-sea animals—as if it were only
here, in the fascinating world of primitive life forms, that she finally en-
countered her true goal and calling. This underwater life seems indestructi-
ble, like Leni herself: What we fear when we follow reports on how at nearly
100 years of age she is still actively diving to make a documentary on deep-
sea life is that she will never die. Our unconscious fantasy is definitely that
she is immortal. It is crucial to conceive the notion of the death drive against
the background of this second death, as the will to abolish the indestructi-
ble rhythmic palpitation of life beyond death (of the Dutchman, of Kundry
and Amfortas), not as the will to negate the immediate biological life cycle.
After Parsifal succeeds in annihilating the seemingly pathological sexual urge
in himself, this opens his eyes to the innocent charm of the immediate nat-
ural life cycle (the magic of Good Friday).

So, back to Wotan. He wants to shed his guilt to die properly, in peace,
and thus to avoid the fate of an undead monster who, unable to find peace
even in death, haunts common mortals—this is what Brünnhilde has in
mind when, at the very end of *The Twilight of Gods*, after returning the ring
to the Rhine maidens, she says, *"Ruhe, ruhe, du Gott!"* (Rest now, rest now,
you god!). Consequently, the death drive wants to annihilate a certain di-
mension of life; however, this life is not the simple biological life but the
very undead life of eternal longing between the two deaths.

This notion of the second death enables us to locate properly Wagner's
claim that Wotan rises to the tragic height of willing his own downfall: "This
is everything we have to learn from the history of mankind: to will the in-
evitable and to carry it out oneself" (quoted from Cord 1983: 125). His state-
ment is to be taken literally, in all its paradoxicality—if something is al-
ready in itself inevitable, why should we then actively will it and work
toward its occurrence, one might ask? This paradox, central to the symbolic
order, is the obverse of the paradox of prohibiting something impossible (in-
cest, for example), which can be recognized even in Wittgenstein's famous
"What one cannot speak about, thereof one should be silent"—if it is in any
case impossible to say anything about it, why add the superfluous prohibi-
tion? The fear that one would nevertheless say something about it is strictly
homologous to the fear that what is necessary will not occur without our ac-
tive assistance. The ultimate proof that we are not dealing here with futile
logical games is the existential predicament of predestination, the Protes-
tant ideological reference that sustained the extraordinary explosion of

activity in early capitalism. That is to say, contrary to the common notion according to which, if everything is decided in advance, why bother doing anything at all, people's very awareness that their fate was already sealed propelled them into frantic activity. The same goes for Stalinism: The most intense mobilization of Soviet society's productive effort was sustained by the awareness that they were merely realizing an inexorable historical necessity.

At a different level, Brecht gives a poignant expression to this predicament in his so-called learning plays, exemplarily in *Jasager,* in which a young boy is asked to freely go along with what will in any case be his fate (to be thrown into the valley). As his teacher explains to him, it is customary to ask the victim if he agrees with his fate, but it is also customary for the victim to say yes. All these examples are far from exceptional: Membership in any society involves a paradoxical point at which the subject is ordered to embrace freely, as the result of her choice, what would be imposed on her anyway (we all *must* love our country, our parents, and so on)[10] Our point, however, is that all these paradoxes can occur only within the space of symbolization. The gap on account of which the demand to embrace freely the inevitable is not a meaningless tautology can be only the gap that forever separates an event in the immediacy of its raw reality from its inscription into the symbolic network—to embrace freely an imposed state of things simply means to integrate this state of things into one's symbolic universe. In this precise sense, the gesture of willing freely one's own death signals the readiness to come to terms with one's death on the symbolic level as well, to abandon the mirage of symbolic immortality.

This paradox of willing (choosing freely) what is necessary, of pretending (maintaining the appearance) that a free choice exists although really there is not one, is closely connected to the splitting of the law into ego ideal (the public, written law) and superego (the obscene, unwritten, secret law). Because, at the level of ego ideal, the subject wants the semblance of a free choice, the superego injunction has to be delivered between the lines. The superego articulates the paradoxical injunction of what the subject, its addressee, has to choose freely; as such, this injunction has to remain invisible to the public eye if the power is to remain operative. In short, what the subject effectively wants is a command in the guise of freedom, of a free choice: He wants to obey while maintaining the semblance of freedom and thus saving face. If the command is delivered directly, bypassing the appearance of free choice, public humiliation hurts the subject and can induce

him to rebel; if there is no order discernible in the master's discourse, this lack of a command is experienced as suffocating and gives rise to the demand for a new master capable of providing a clear injunction.

We can see now how the notion of freely choosing what is inevitable is strictly codependent with the notion of an empty symbolic gesture that is meant to be rejected. The one is the obverse of the other; that is, what the empty gesture offers is the possibility of choosing the impossible, that which inevitably will *not* happen (in Brecht's case, the expedition turning around with the sick boy instead of getting rid of him by throwing him into the valley). Another exemplary case of such an empty gesture is found in John Irving's *A Prayer for Owen Meany:* After the little boy Owen accidentally kills John's—his best friend's, the narrator's—mother, he is, of course, terribly upset, so to show how sorry he is, he discretely delivers to John as a gift a complete collection of color photos of baseball stars, his most precious possession; however, Dan, John's delicate stepfather, tells him that the proper thing to do is to return the gift. What we have here is symbolic exchange at its purest, a gesture made to be rejected; the point, the magic of symbolic exchange, is that although at the end we are where we were at the beginning, the overall result of the operation is not zero but a distinct gain for both parties, a pact of solidarity. And is not something similar part of our everyday mores? When, after being engaged in a fierce competition for a job promotion with my closest friend, I win, the proper thing to do is to offer to decline the promotion so that she will get it, and the proper thing for her to do is to reject my offer, thus saving our friendship.[11] In short, far from standing for an empty Romantic hyperbole, Wagner's notion of freely embracing the inevitable points toward a feature constitutive of the symbolic order.

However, Wotan's gesture of willing his own destruction to shed his guilt and Tristan and Isolde embracing their disappearance into the abyss of nothingness as the climactic fulfillment of their love, these two exemplary cases of the Wagnerian death drive, are to be supplemented by a third one, that of Brünnhilde, this "suffering, self-sacrificing woman" who "becomes at last the true, conscious redeemer"(quoted in Cooke 1979: 16–17). She also wills her annihilation but not as a desperate means to compensate for her guilt—she wills it as an act of love destined to redeem the beloved man, or as Wagner himself put it in a letter to Liszt: "The love of a tender woman has made me happy; she dared to throw herself into a sea of suffering and agony so that she should be able to say to me 'I love you!' No one who does not know all her tenderness can judge how much she had to suffer. We were

spared nothing—but as a consequence I am redeemed and she is blessedly happy because she is aware of it" (quoted in Donington 1990: 265.) Once again, we should descend here from the mythic heights into everyday bourgeois reality: Woman is aware of the fact that by means of her suffering, which remains invisible to the public eye, of her renunciation for the beloved man or her renunciation to him (the two are always dialectically interconnected, because in the fantastic logic of the Western ideology of love, it is for the sake of her man that the woman must renounce him), she renders possible man's redemption, his public social triumph—like Traviata, who abandons her lover and thus enables his reintegration into the social order, like the young wife in Edith Wharton's *The Age of Innocence* who knows of her husband's secret adulterous passion but feigns ignorance to save their marriage. The possible examples are here innumerable, and one is tempted to claim that like Eurydice who, by sacrificing herself, by intentionally provoking Orpheus to turn his gaze toward her and thus sending her back to Hades, delivers his creativity and sets him free to pursue his poetic mission, Elsa also intentionally asks the fateful question and thereby delivers Lohengrin, whose true desire, of course, is to remain the lone artist sublimating his suffering into creativity. We can see here the link between the death drive and creative sublimation, which provides the coordinates for the gesture of feminine self-sacrifice, this constant object of Wagner's dreams: By way of giving up her partner, the woman effectively redeems him, compelling him to take the path of creative sublimation and perlaborate the raw stuff of the failed real sexual encounter into the myth of absolute love.[12] What one should do, therefore, is read Wagner's *Tristan* the way Goethe explained his *Werther:* By way of writing the book, the young Goethe symbolically acted out his infatuation and brought it to its logical conclusion (suicide); this way, he relieved himself of the unbearable tension and was able to return to his everyday existence. The work of art acts here as the fantasy supplement; its enactment of the fully consummated sexual relationship supports the compromise in our actual social life—in *Tristan,* Wagner erected a monument to Mathilde Wesendonck and to his immortal love for her so that he was able to get over his infatuation and return to normal bourgeois life.[13]

The Disavowal

Tristan is not just an opera: Michael Tanner (1997) was right to point out that if one is to make sense of *Tristan,* one has to approach it not simply as

a work of art but as an ontological statement about the last things, about the meaning of life. The problem here is not the standard postmodern quip about who, in our cynical post-ideological era, can still take seriously big metaphysical solutions such as the Wagnerian *Liebestod* but rather the opposite one, that is, today's ambiguous relationship toward belief (or firm convictions as such). Suffice it to mention two thoroughly different examples. Is it not deeply symptomatic how—in some European countries, at least—priests and right-wing populist politicians are among the most popular guests for roundtable TV debates? What makes them so fascinating is their very naive sticking to firm conditions; the fact that they dare to stick publicly and firmly to their convictions makes them such an easy target. The second example: Why do fans insist on watching a soccer match live, even if it is in front of the TV? Why is this never the same as watching it later? The only honest answer is to help their club, to magically influence the game (which is why, even if they are only in front of the TV screen, they hiss and shout in support of their side). Is this not confirmed by the *opposite* experience: Thirty years ago, when the public was still thrilled by heart transplants, plans for their live TV transmission were rejected on ethical grounds—why? Because the operation could fail and the patient could die—as if the public would somehow be partially responsible for that.[14] The logic at work here is, of course, that of the fetishist disavowal, of "I know very well, but nonetheless," which is operative everywhere in our daily lives (see Mannoni 1969). When we observe a magician in the circus or in a nightclub, we know very well that there is no real magic, that she is just performing a clever sleight-of-hand, but we are nonetheless deeply disappointed if we are able to see through it and discern how it was done—we want it to be perfect.[15] And does something similar not hold for the movie *aficionados* dedicated to the art of discovering small inconsistencies or mistakes that ruin the illusion? The identification of such gaffes brings immeasurable pleasure, especially when they are found in great classics. Recall the most famous case from Hitchcock: In his *North by Northwest,* the kid in the restaurant covers his ears with his hand seconds before Eva-Marie Saint shoots at Cary Grant—obviously, he knew when the bang would occur from previous (and seemingly endless) repetitions of the same take, so he covered his ears in advance to avoid the unpleasant impact of the sound. The magic of such discoveries is that far from disturbing our pleasure and ruining our suspension of disbelief, they strengthen our transferential relationship to the master (in exactly the same way that learning some common weakness about a public person—

that he is, after all, human like all the rest of us—only strengthens our ad-
miration for him, that is to say, his *extraordinary* status). There are, how-
ever, two opposite versions of the "I know very well, but nonetheless" logic
with regard to the distinction between belief *(croyance)* and faith *(foi)*:

• *I do not believe it (that is, I know very well it is not true), but,
nonetheless, I have faith in it!* Is this not the concise formula of Judaism, in
which the question is not that of believing in God but of having faith (belief)
in him, of a symbolic engagement/commitment? Owing to this very feature,
Judaism comes closest to the paradox of the atheistic religion: What really
matters are not your intimate beliefs in God's existence or his goodness but
the fact of honoring the pact with him, of keeping your word and following
the divine commandments. The supreme example is here the well-known
passage from the diaries of Anne Frank, in which she naively and patheti-
cally asserts her faith in the goodness of humanity: "Having to witness the
Nazi bestial crimes, I don't really believe people are essentially good, I am
well aware how evil they can be, but I nonetheless have faith in the essen-
tial goodness of the mankind." And is this not also the most elementary
strategy of an authority figure who wants to pressure on a weak person: "I
know you are wavering, you are not up to the task, you yourself do not be-
lieve you can do it, but I have faith in you!"

• *I do not have faith in it, but I nonetheless believe in it!* According to
Lacan, this was the attitude of the ancient Jews toward pagan gods and spir-
its: They did not have faith in them (their faith being reserved for their jeal-
ous God), yet they nonetheless feared those other deities because their exis-
tence and evil powers were considered very real.

And is Wagnerian metaphysics not caught in the same predicament? The
key feature of Wagner's famous formula about the relationship between art
and religion ("Where religion becomes artificial, art has the privilege to re-
deem the kernel of religion" [Wagner 1972, 6: 211]) is that it turns around
the standard Hegelian notion of the sublation *(Aufhebung)* of art in religion
as the higher form of the expression of the idea. In Wagner, the art saves the
kernel of authentic religious experience that has been ossified in lifeless in-
stitutional rituals. The problem with this solution, of course, is that it sus-
pends religious belief as such, turning the religious experience into an aes-
thetic spectacle that seduces us without obliging us to engage ourselves

seriously in it. In short, the question "How seriously are we to take Wagner's solution today?" is to be turned around: Did Wagner himself take it seriously?[16] Did it not function in the mode of fetishist disavowal?

Perhaps, the deadlock that underpins the Wagnerian aestheticization of religion transpires most succinctly in the following dilemma: If art is a speech that "does not know what it says," does that mean that it says what it does not know? And does the opposite also hold? If I do not say what I know, does this mean that I know what I do not say?

Notes

1. Steven Ledbetter, notes to Charles Mackerras, *Così fan tutte*, TELARC 80399, compact disk, 5.

2. The parallel with Hitchcock, another great Wagnerian, imposes itself here with his two absolute masterpieces, *Vertigo* and *Psycho*. The echoes of *Tristan* in *Vertigo* are a standard topic of Hitchcock studies, and one is tempted to read the great Hitchcockian triad of *Vertigo*, *North-by-Northwest*, and *Psycho* as Hitchcock's version of the triad *Tristan*, *Meistersinger*, and *Parsifal*. In both cases, the weak link in the chain is the middle one (*Meistersinger* and *North-by-Northwest*), a comical and light interlude that encapsulates the story of Oedipal normalization, of subordination to paternal law, which produces a happy ending with a "normal" couple. Finally, like *Parsifal*, *Psycho* ends with a completely insane *Spaltung*: Closure is (re)established, the intrusive outside is cancelled, and the hero is totally taken over by the eternal-maternal feminine, which, to paraphrase Goethe, draws the hero toward itself, into its abyss (in the very last shot of *Vertigo*, Scottie is seen staring down into this abyss, whereas at the end of *Psycho*, Norman is fully swallowed by it). A further, more detailed analysis would have to also discern displacements between these two series—in the same way that the story of *Parsifal* fell into pieces for Wagner once it became clear to him that Kundry the seductress and Kundry the redemptrix are one and the same woman, the story of *Vertigo* falls into pieces once it becomes clear that the sublime Madeleine and the vulgar Judy are one and the same.

3. If one conceives of *Parsifal* as the point of conclusion of Wagner's work, as his version of *The Magic Flute*, one can, of course, discern how many earlier operas point toward it—not only *The Magic Flute* itself, but, surprisingly, Joseph Haydn's neglected masterpiece *Armida* from 1784 (in a garden with flower maidens on the mountain castle, the seat of the enemy king Idreno, the hero, Rinaldo, is being seduced by Armida and has to resist temptation; Armida erupts in fury when he does not succumb to her charms; the garden has the same fantastic status as Klingsor's castle in *Parsifal*—when Rinaldo strikes the myrtle in the middle of the forest with his sword, the forest miraculously disappears). The interest of *Armida* resides in its curiously sinister finale with which Haydn decided to replace the contrived happy ending of Antonio Tozzi's earlier opera on the same topic from 1775; it is not simply that the ending is tragic rather than happy but also that it is open that keeps the tension unresolved: To the sound of martial music, Rinaldo's mixed emotions are clearly rendered (on the way to join the Christians in their decisive battle, he nonetheless declares that, when he has done his duty, he will return to Armida),

whereas Armida remains consumed by vengeance. One is effectively tempted to read the inconsistency, the lack of clear resolution, and the endless repetitive oscillations of Haydn's opera as a sign pointing forward to *Parsifal;* it is only Wagner's radical resolution to thoroughly reject the feminine advances that resolves the tension between love and the call of duty.

4. See Chapter 5 of Žižek 1993. Furthermore, the present volume cannibalizes parts of my other Wagner essay, "There Is No Sexual Relationship," which first appeared in Salecl and Žižek 1996.

5. For a closer presentation of this notion of the death drive, see Chapter 5 of Žižek 1999.

6. Laclos 1961: 33–34. For a close Lacanian reading of *Liaisons* on which I rely here, see Chapter 6 of Zupančič 2000.

7. For another exemplary case of the opposition between the mathematical and the dynamic, recall, from our daily experience, how men tend to misperceive the feminine "Encore!"; during cunnilingus, after gently touching the clitoris with the tongue, a man hears the woman's satisfied "Yes! Yes! More!" but as a rule misreads this admonition as a request for a more aggressive approach. Instead of just going on doing the same, he turns more violent, aggressively sucking and biting the clitoris—with, of course, the catastrophic result of the woman's withdrawal.

8. This "Italian" excess takes another shape in Verdi, say, in the two duos of father and daughter, Rigoletto and Gilda, from *Rigoletto:* in both of them, especially the second, *("Vendetta!"),* it is as if the word singing itself is caught in a mad propelling rhythm of the orchestral music, clearly excessive with regard to its function of expressing what goes on between the characters.

9. The status of suicide in Christianity renders directly palpable this undead dimension; by killing oneself, one commits a mortal sin by way of abrogating the divine gift of life, so one can no longer be buried in hallowed ground and with the proper rituals—biological death can no longer be accompanied/redoubled by the symbolic one, and it is in this space between the two deaths that the undead roam about, haunting the living. Thus, suicide condemns one to eternal life: to the undead existence (or, rather, insistence) of those who are not allowed to find peace in death. By killing myself, I attain immortality—not the immortality of living forever in the historical memory but the obscene immortality of the undead body. (I rely here on Zupančič 2000.)

10. As to this notion of the forced choice that forms the base of our social allegiance, see also Chapter 5 of Žižek 1989.

11. Of course, the problem is this: What if the other to whom the offer to be rejected is made actually accepts it? What if the boy in Brecht's *Jasager* would have said no and refused to be thrown into the valley? What if, upon being beaten in the competition, I accept my friend's offer to receive the promotion instead of her? A situation like this is catastrophic because it causes the disintegration of the semblance (of freedom) that pertains to social order—however, because things at this level are what they seem to be, this disintegration of the semblance equals the disintegration of the social substance itself, the dissolution of the social link. Formerly communist societies present an extreme case of such a forced free choice; in them, the subjects were incessantly bombarded with the request to express freely their attitude toward power, yet everybody was well aware that this freedom was strictly limited to the freedom to say yes to the communist regime itself. For that very reason, communist societies were extremely sensitive to the status of semblance; the ruling party wanted at any cost whatsoever to maintain the appearance of broad popular support for the regime.

12. We can now see the crucial difference between *Ring* and *Parsifal:* In the *Ring,* knowledge is not yet accessible to "the pure fool" Siegfried—he has to die so that Brünnhilde, the woman, can become knowing *("dass wissend wird ein Weib"),* whereas in *Parsifal,* the hero himself, the pure fool, becomes knowing *("des reinsten Wissens Macht, dem zagen Toren gab").* Syberberg was thus fully justified, in his film version of *Parsifal,* to turn Parsifal into a woman after his conversion; the moment he gains access to knowledge, Parsifal effectively occupies the feminine position of Brünnhilde.

13. At the opposite end, Wagner composed *Parsifal,* this hymn to the radical rejection of the sex drive, to be able to pursue his affair with Judith Gautier, the real-life model for Kundry.

14. It is similar to torture in snuff movies: even more unbearable than watching them would have been to watch a live broadcast of someone being tortured—as if our passive stance, our inability to intervene, makes us somehow coresponsible for the horror of what is going on.

15. For most of the examples here, as well as for their theoretical background itself, I am deeply indebted to Pfaller 2000.

16. Recall an interesting detail from the Wachowski brothers' *The Matrix:* When Keanu Reeves has to choose between the red and blue pill, his choice is between truth and pleasure, between the traumatic awakening into reality or persisting in the illusion regulated by the Matrix. Reeves chooses truth, in contrast to the most despicable character in the movie, the informer-agent of the Matrix among the rebels, who, in that memorable scene with Smith, the agent of the Matrix, picks up with his fork a juicy red piece of steak and says: "I know it is just a virtual illusion, but I do not care about it, since it tastes real." In short, he follows the pleasure principle, which tells him that it is preferable to stay within the illusion, even if one knows that it is only an illusion. However, the choice of *The Matrix* is not as simple as that. What exactly does Reeves offer to humanity at the film's end? Not a direct awakening into the desert of the real but a free floating between a multitude of virtual universes—instead of being simply enslaved by the Matrix, one can liberate oneself by way of learning to bend its rules—one can change the rules of the physical universe and thus learn to fly freely and violate other physical laws. In short, the choice is not between bitter truth and pleasurable illusion but rather between two modes of illusion; the traitor is bound to the illusion of our so-called reality, dominated and manipulated by the Matrix, whereas Reeves offers to humanity the experience of the universe as the playground in which we can play a multitude of games, freely passing from one to another, reshaping the rules that fix our experience of reality.

===============

"DEEPER THAN THE DAY
COULD READ"

The What-Ifs

The myth of Tristan and Isolde was the first to give full expression to the
axiom of courtly love: Love is an act of radical transgression that suspends
all sociosymbolic links and, as such, has to culminate in the ecstatic self-
obliteration of death.[1] (The corollary to this axiom is that love and marriage
are incompatible; within the universe of sociosymbolic obligations, true love
can occur only in the guise of adultery.) It is, however, all too simple to re-
duce Wagner's *Tristan* to the fullest realization of this transgressive notion
of love; its greatness resides in the very tension between its official ideolog-
ical project and the distance toward it inscribed into its texture—as Alt-
husser would have put it, Wagner's writing undermines its own explicit ideo-
logical project. The opera seems to celebrate this self-obliterating immersion
into the night—but what does it effectively render? The first attempt at this
self-obliteration (the duet in Act II) is brutally cut short by what is arguably
the most violent coitus interruptus in the entire history of art, Brangaene's
scream. The second attempt succeeds, but in a displaced way: The two lovers
don't die together but one after the other, their death being separated by—
again—the intrusion of external common reality. First, Tristan dies when,
in an act of hysterical precipitation, he "hears the light" of Isolde's arrival;

then Isolde alone dies—or does she? This entire chapter can also be read as a sustained argument in favor of Jean-Pierre Ponelle's Bayreuth staging from 1983,[2] in which it is only Tristan who really dies—Isolde's coming and death is just the vision of the dying Tristan, while Isolde opportunistically remains with her husband. There is thus no full reunion; what we actually get is a failed, interrupted, reunion in Act II, followed (in Act III) by the self-obliteration and release as a lone male fantasy.

The way Tristan tears up his bandage in a gesture of suicidal hysterical precipitation is more ambiguous than it may appear—it can also mean that, being aware of Isolde's imminent arrival, into which he invested so much, he cannot endure the prospect of actually encountering her and prefers to erase himself out of the picture. (Or is it, perhaps, an act of aggressivity aimed at Isolde, the source of his suffering: better to die before she arrives so that she will have to die alone, deprived of the shared lovers' death—we should not forget that, in his long monologue, Tristan *curses* the drink that made him fall in love with Isolde!) Therein resides another asymmetry between Tristan and Isolde: It is Isolde, not Tristan, who, long before the events directly staged in the opera, performed the act that sealed their fatal love link. In her great narrative to Brangaene, the focal point of Act 1, Isolde tells how, after killing her betrothed Morold in a duel, the wounded Tristan took refuge with her, pretending that he was someone else ("Tantris"); out of compassion, Isolde, well known for her magical healing talents, took care of him but then learned from the incision in the blade of his sword (which perfectly fitted the shrapnel piece she recovered from Morold's body) that she was taking care of her betrothed's murderer. When, following the mores of the time, she raised the sword to stab him, their gazes met, and the suffering, helpless surrender discernible in his gaze aroused not only her compassion but also her love, so she let him go. This act of hers was an act of love in the Paulinian sense of suspending the reign of law; by way of helping Tristan, Isolde violated the rules of the ethical substance to which she belonged and that called for revenge to be imposed as a duty. In contrast to Isolde, whose love resulted from a free act of compassion that suspended the predominant moral law, Tristan's love for her is rooted in the disturbances of his family past condensed in the old tune *(die alte Weise)* that haunts him—basically, Isolde is for Tristan a means to work through his traumatic past.

Wagner's explicit ideological project in *Tristan* is radical in its very superficial simplicity. It brings together what his mentor, Schopenhauer, opposed. For Schopenhauer, the only salvation consists in total self-obliteration

of the will to life, whose ultimate expression is sexual craving, whereas Wagner simply combines these two opposites; our very exhaustive surrender to sexual love brings about redemptive self-obliteration. One should thus never forget that (in contrast to, say, *Romeo and Juliet*) Wagner's *Tristan* is not a tragedy but a sacred, aesthetico-religious musical play with a "happy" outcome of attaining the looked-for bliss. However, as we have already emphasized, crucial for *Tristan* is the gap between this opera's official ideology and its subversion through the work's texture itself.[3] This subversion in a way turns around the famous Mozartean irony in which, although the person's words display the stance of cynical frivolity or manipulation, the music renders their authentic feelings. In *Tristan,* the ultimate truth does not reside in the musical message of passionate self-obliterating love-fulfillment but in the dramatic stage action itself, which subverts the passionate immersion into the musical texture. The final shared death of the two lovers abounds in Romantic operas—suffice it to recall the triumphant *"Moriam' insieme"* from Bellini's *Norma;* against this background, one should emphasize how in Wagner's *Tristan,* the very opera that elevates this shared death into its explicit ideological goal, this is precisely *not* what effectively happens—in music, it is as if the two lovers die together, whereas in reality, they die one after the other, each immersed in his or her own solipsistic dream. Along the same lines, one should just imagine how easy it would be for *Tristan* to end three times (at least) before its official ending:

- What if, toward the end of Act I, when Tristan and Isolde discover their love for each other and simultaneously acknowledge the hopelessness of their situation, they were to drink the cup of poison and die embracing, so that the ship would bring to Cornwall two corpses?
- What if, toward the end of Act II, the two lovers were left to consummate their lethal passion in the orgasmic culmination and to "die undivided," as they announce in their song? Or what if Tristan's suicidal gesture of dropping his sword were to succeed so that instead of just wounding him, Melot killed him?
- What if, toward the end of Act III itself, Isolde were to arrive just in time so that the two lovers would be able to resume their orgasmic dialogue from Act II and die together? Or, a last subtle variation, what if the second ship were *not* to arrive so that Isolde would be allowed to finish her final song and die when she first takes that road, immediately after Tristan's death—in short, what if we were to have a kind of *Romeo and Juliet*

scenario in which one lover dies after the other? Many a commentator has noticed that at this point, just prior to Brangaene's arrival, the music could have moved straight into the final transfiguration.

The most interesting is this last interruption, that is, the arrival of the second ship, which accelerates the slow pace of the action in an almost comic way—in five minutes, more events occur than in the entire previous opera (the fight in which Melot and Kurwenal die and so on)—similar to Verdi's *Il Trovatore*, where in the last two minutes many things happen. Is this simply Wagner's dramatic weakness? What one should bear in mind here is that this sudden hectic action does not just serve as a temporary postponement of the slow but unstoppable drift toward orgasmic self-extinction—if we read Isolde's death as Tristan's apparition, this hectic action *had* to occur as a brief intrusion of reality, permitting Tristan to stage Isolde's final self-obliterating act. Without this unexpected intrusion of reality, Tristan's agony of the impossibility of dying would drag on indefinitely.

If, then, each of the three acts of *Tristan* culminates in an attempt to die (the drinking of the potion in Act I, the love duet and then Tristan's suicidal exposure to Melot in Act II, and Isolde's immersion into the trance interrupted by Brangaene's arrival in Act III) and if, each time, this attempt is thwarted by the intrusion of daily reality (the substitution of the potion and the Sailors' Chorus announcing the ship's arrival to Cornwall; the arrival of King Mark, which cuts short the lovers' immersion; and again, the arrival of Brangaene and the king in Act III), where is the Lacanian real here? Is it the night into which the couple wants to disappear or the unexpected intrusion that thwarts the trance of this self-obliteration? Paradoxically, the real is not the abyss of night in which reality disintegrates but the very contingent obstacle that again and again pops up, preventing the smooth run of the ecstatic immersion into the night; this obstacle materializes the inherent impossibility that undermines from within the fantastic immersion into the night.

What Tristan and Isolde are striving for is the shared specular immersion into the thing in which their very difference is cancelled—this is what the long duet in Act II is about, with its (precocious) conclusion: "Thou (I) Isolde, Tristan (I) (thou), no more Tristan, no more Isolde! Ever nameless, never parting, newly learning, newly burning; endless ever joined in joy *(ein-bewusst)*, ever-glowing love, highest love pleasure *(höchste Liebeslust)*." The articulate language itself seems to disintegrate in this process, resembling more and more a childlike mirror inversion with less and less syntax.

Does not the linguistic "regression" that articulates this fusion, this blur-
ring of individual identities, function as a kind of inversion of the famous
lines from *Tarzan*—"Me not Tarzan, you not Jane"? Poizat is justified in
calling this suspension of syntax and meaning *echolalia:* Tristan and Isolde
are more and more just echoing each other's words, regardless of their mean-
ing, which is why the text is here untranslatable (see Poizat 1998: 209). This
irrepressible elevation toward the supreme bliss of self-obliteration is sud-
denly and brutally interrupted by Brangaene (who has already gently re-
minded the lovers that the night will soon be over); as Wagner's stage di-
rections read: "*Brangaene utters a piercing shriek. Tristan and Isolde remain
entranced.*" The reality of the day intervenes: King Mark has surprised the
two lovers. Two features are crucial here. First, the ecstatic rise of the melody
is cut short by the inarticulate scream; second, this scream, although it in-
tervenes in a totally unexpected way as a violent sudden intrusion, is
nonetheless necessary for strictly structural reasons, giving body to the ob-
stacle that inherently prevents the full actualization of the fantasy of self-
obliteration. In other words, as Poizat is right to emphasize, this shriek, al-
though shocking, appears at the place that has been prepared for it by the
entire preceding musical intensification. It could have emerged at no other
place but this, that is, at the very threshold of the couple's approaching the
"highest love pleasure," designating the sudden, inevitable reversal of ex-
cessively intense pleasure into horror. (See Poizat 1998: 210.) This is why,
if we were to listen to the music without knowing who is singing what, we
would tend to attribute Brangaene's scream to Isolde herself, as if, getting
too close to the excessive *jouissance*, bliss has to turn into its opposite. The
true trauma is thus not the intervention of external reality, which interrupts
the blissful immersion, but the inversion of this joy—objective reality in-
tervenes to externalize the inherent impediment, to sustain the illusion that
without its intervention the blissful immersion would have gone on to its
ecstatic climax.

Attentive reading of the text of the long duet in Act II can easily expose
the almost imperceptible but crucial features that distinguish Tristan's po-
sition from Isolde's. Just before the shift from the long reflexive exchange to
the final declamatory ecstasy that begins with the famous *"So stuerben wir,
um ungetrennt,"* after Tristan babbles about how even if he were to find the
death he longs for, the love within him could not perish ("If love will not
die in Tristan, then how can Tristan die in loving?"), Isolde gently but firmly
reminds him that he is not alone in the affair: "But our sweet loving, is it

not Tristan and—Isolde?" When Tristan repeats his claim that death could not destroy their love, Isolde provides the concise formula of their death: "But this little word 'and'—if it were to be destroyed, how but through the loss of Isolde's own life could Tristan be taken by death?" In short, it is only in and through her death that he will be able to die. Does then Wagner's *Tristan* not offer *the* case of the interpassivity of death itself, of the "subject supposed to die"?[4] Tristan can die only by way of transposing/displacing his death onto Isolde, in other words, insofar as she experiences the full bliss of the lethal self-obliteration for him, at his place. In other words, what really happens in Act III of *Tristan* is only Tristan's long "voyage to the bottom of the night" with regard to which Isolde's death is Tristan's own fantastic supplement, the delirious construction that enables him to die in peace.

In his famous analysis of the Being-toward-Death in *Sein und Zeit*, Heidegger emphasizes that one cannot die by a proxy—death is radically one's own, another can die FOR one, but she cannot take away from one one's own death (Heidegger 1977: 240). Is, then, this what takes place at the end of *Tristan*? Not quite—what we see there is the split between the reality of death and the fantasy at its most radical: While Tristan is dying himself, he is experiencing his own (horrible) death as the (blissful) death of another person, of his beloved. (The logic of incorporating an external stimulus into the dream narrative—say, when a sound threatens to awaken me, I prolong my sleep by quickly inventing a scene that includes this sound—is here brought to its extreme.) But what about Lacan's point that we awaken into reality to escape the trauma encountered in the dream? In other words, why does Tristan not awaken when he is being swallowed by Isolde's *Liebestod*? The answer is that in awakening he would have to confront the truly unbearable trauma (Isolde did not arrive, and he is alone); that is, he would have to abandon the ultimate fantasy of the feminine and open himself to the reality of the woman's desire. So again, there is no sexual relationship, no simultaneous orgasmic self-obliteration of a couple (like the triumphant *"Moriam' insieme"* at the end of *Norma*), but the lone man lulled into a false bliss through delirium. As such, Act III of *Tristan* is almost unbearable in its intensity; Wagner was in no way exaggerating when, in April 1859, he wrote these half-joking, half-serious lines to Mathilde Wesendonck: "This *Tristan* is turning into something *terrible*! This final act!...I fear the opera will be banned—unless the whole thing is parodied in a bad performance: only mediocre performances can save me! Perfectly *good* ones will be bound to

drive people mad,—I cannot imagine it otherwise. This is how far I have gone!!" (quoted in Vetter 1992: 153).

Tristan's death seems to be the epitome of the tragic dimension reversing into the comic one: dying as a process of well over an hour of exhausting singing—no wonder that the first Tristan, Ludwig Schnorr von Carolsfeld, actually died of exhaustion after the first performances in Munich in 1865? Is it not significant to what extent Tristan's long monologue in Act III is about him only and not about Isolde? "Act III is centrally concerned with him. Isolde does not enter until he is ready to die, and her *Liebestod* is an amplifying reflection of his more active conversion" (Kerman 1957: 162). The "old tune" *(alte Weise)* that haunts Tristan from the very beginning of Act II and is played by the shepherd who is watching for the arrival of Isolde's ship is a kind of cipher of Tristan's destiny, condensing his relationship to his parental couple and thus staking the coordinates of his desire. In short, this tune stands for the primordial lack that Isolde, endowed with extraordinary healing powers, is expected to remedy. (A feature that unites Tristan and Parsifal is that both their mothers were marked by immense pain—Parsifal also learns that his mother's name is Herzeleide, "the one with the suffering heart.")

Tristan's Journey to the Bottom of the Night

The wounded Tristan's inner journey in Act III occurs in two cycles, each of them structured as the succession of recollection-curse-relapse-anticipation (see Kerman 1957: 162–168). In Act III, Tristan is already a living dead man, dwelling between the two deaths, no longer at home in reality, pulled back into the daily life from the blissful domain of the night and longing to return there; in the first cycle, Tristan blames his love for Isolde for having dragged him from the "boundless realm of endless night" back into the common reality of the day: "Love came to grieve me, love it was that drove me forth and made me seek the daylight." Because of his love for her, it is now only in unification with her that Tristan can find peace again: "I must seek her, I must see her, I must find her, for with her alone united can Tristan find release." This recollection culminates in his cursing the day that disturbed his peace: "Accursed day, you shine again!" After sinking back exhausted, he regains his strength by hallucinating her arrival: "It nears! It nears so bravely and fast. It waves! It waves, the flag on the mast. The ship! The ship! It's rounding the reef! Do you not see? Kurwenal, do you not see?" Disappointed when he learns that there is no ship, Tristan goes into a deeper recollection:

After providing an apt description of his undead predicament ("Though I am yearning to die, this very yearning prevents me to die!"), he identifies his cause in the love potion: "I hoped the draught would wholly cure me, instead a mighty enchantment came over me: that death would never find me, that grief would ever bind me." However, far from simply blaming the drink, he admits that he himself brewed it (that is, concocted his sad fate) from the chain of events that started with his parents' early death: "By me, by me, that potion was brewed. From father's grief and mother's woe, from lover's tears of long ago / ... I have distilled the poison of madness." Consequently, this proto-Freudian self-analysis can end only in Tristan assuming full responsibility for his fate, that is, cursing himself: "I curse you, dark fatal drink! And curse him by whom it was brewed!" This fact of repetition is crucial: One cannot directly acquire the authentic position; the first attempt necessarily ends up in the reifying mystification ("It's Fate, not me!"), and it is only through repeating the cycle of recollection that one can effectively assume one's past.[5]

Apropos of Beethoven's "Great Fugue," op. 133, one is almost tempted to quote the *Pravda* attack on Shostakovich's *Lady Macbeth:* "The music quacks, hoots, pants, and gasps."[6] Is this strange piece the testimony of a heroic, ultimately failed, struggle to master the musical material? It begins with four utterly incongruous themes made out of the same note set, something "like a mnemonic sheet out of a sketchbook, a random series of jottings" (Kerman 1966: 277–278), in contrast to the beginning of the fourth movement of the Ninth Symphony, where Beethoven just recapitulates the first three movements' themes. After two failed attempts to organize the material, we fall back to the same series of jottings—the synthesis disintegrates. One can also think in terms of a comical rather than tragico-metaphysical, a kind of joke in musical technique. Whatever the outcome, the fact remains that the "Great Fugue" is "a controlled violence without parallel in music before the twentieth century and anticipated only by Mozart in the C minor fugue for two pianos (K.426)"(Lam 1986: 109). More precisely, the fugue's uniqueness is that it is not simply an expressionist outburst in the Dionysiaque style but a much more unsettling outburst of violent madness within the confines of reason, which thus renders palpable the madness and violence inherent in reason itself: "The power of this climax comes from its underlying harmonic structure, which is of Bach-like symmetry. Any expressionist can produce an effect of chaotic violence, but Beethoven never lost

touch with the Age of Reason. There is a background of perfectly normal harmonic progression supporting the ceaseless thrills of the first violin, the weird figure of the counter-theme in the second, and the relentless canon of the two lower parts" (Lam 1986: 113). The interest for us resides in the structural parallel between the "Great Fugue" and Act III of *Tristan*; both share the same repetitive structure of the double failed attempt to elevate oneself as well as a similar chromaticism.

It is as if Isolde is allowed to arrive only after Tristan has clarified his subjective position: Tristan's second collapse after the curse is followed by a new anticipatory enthusiasm, which this time proves justified—instead of the sad old tune, the shepherd starts to play a merry song, signaling that Isolde's ship is actually landing. Tristan's reaction to this news is significant; in an outburst of violent hallucinatory madness, he stands up and tears the bandage from his wound, letting his blood freely flow, because he knows that now he can finally die ("Heia my blood! Joyfully you flow now! Dissolve o world, as I hasten to her"), and then, in the final, unique, and precipitating vision that mixes the senses ("What, hear I the light?"), he dies in Isolde's arms. Is this "I hear the light!" not an encounter with impossible real at its purest? That is to say, insofar as the object-voice is that which cannot ever be heard (with our ears), the only way to perceive it is with our eyes, and vice versa, the only way to perceive the visual object (the gaze) is with our ears, to hear it. Maybe this passage is effectively the true birthplace of modernism (as August Everding once claimed): Modernism begins with this criss-cross between different modes of perception, when we "hear with our eyes" and "see with our ears."

The final *Liebestod*—or, rather, ascension, as it was called by Wagner, for in a curious displacement, Wagner's designation of the Prelude as *Liebestod* is now commonly applied to the finale—signals the plunge into the eternal bliss of self-obliteration, which was hitherto repeatedly interrupted. Crucial is here the difference between Tristan and Isolde: Tristan is, up to his death, hysterically nervous; even his death is a jumping forward, not a calm self-obliteration and "letting go"—only Isolde can finally achieve this, and she is, as such, Tristan's fantasy. Isolde's death is thus just the culmination of Tristan's long process of dying; through her self-obliterating immersion in the "highest enjoyment," it is he who finally finds peace. In the final *Liebestod*, Isolde is thoroughly the symptom of man (Tristan)—for this reason, one should listen to Isolde's final "aria" as the conclusion of the *en-*

tire Act III (or even opera) and not fetishize it into a separate seven-minute
piece. Isolated, it is meaningless, because it lacks the background of the
tension that it finally resolves; the usual performance of Isolde's *Liebestod*
as a separate event is totally misleading. What gets lost in this isolation is
its topological aspect, that is, the fact that Isolde's final song is the culmi-
nating point of Tristan's long process of dying—Tristan finds final release
only when he identifies himself with a pure gaze observing the specter of
Isolde. The structural parallel with Syberberg's version of *Parsifal* is here cru-
cial: In the same way that after Parsifal's transferential experience of Am-
fortas's suffering ("The wound! The wound!") and the ensuing rejection of
Kundry's advances, Parsifal I (a young boy) is replaced by Parsifal II (a cold
young woman), after Tristan's completed inner journey of his painful self-
analysis, a woman has to replace him to perform the final act of transfigu-
ration.[7] What this means is that paradoxically, in the opposition between
Tristan and *Parsifal*, it is the latter opera that, in spite (or, rather, because)
of its apparent and misleading misogyny, harbors secret feminist potential
(after his rejection of feminine advances, Parsifal himself assumes a femi-
nine subjective position, extracting himself from the phallic logic), whereas
Tristan's very clinging to the appearance of Isolde as his final redeemer bears
witness to the fact that Isolde herself has been reduced to a male fantasy.

Furthermore, far from being a simple self-obliteration into the night of
the world in which all symbolic links to others are suspended, Tristan's final
delirium involves the reference to the big Other as the *third* element, pres-
ent in the guise of the gaze at which the specter of Isolde is addressing her
plea. In her final song, Isolde starts by echoing Tristan's previous appeal to
Kurwenal ("Do you not see? Kurwenal, do you not see?"): *"Can't you see
how he / Tristan / is smiling?"* The dying Tristan is not fascinated directly
by the vision of Isolde but by the gaze that perceives this vision; the proper
object of fantasy is the fantasized gaze, not the fantastic scene itself.[8] More
precisely, Isolde's *Liebestod* is clearly divided into two parts, the first being
a calm narrative in which the tension is just building up as the Other is ad-
dressed ("See you not? ... See him, friends!"), whereas the second one begins
when Isolde assumes her solitude, conceding that she alone sees Tristan alive
and smiling: "Feel and see you not? Can it be that I alone hear this wondrous,
glorious tone?" (One should note here how Isolde here repeats Tristan's con-
fusion of senses: She also hears what others cannot see.)

It is this assumption of her solitude, this withdrawal from the symbolic
community, that allows Isolde to lose herself in the deadly, orgasmic trance.

This means that in this second part, Isolde fully assumes the Weiningerian position of being nothing but the figure in Tristan's dream: In the hallucination of her orgasmic self-obliteration, Tristan fantasizes his own real death. (Ponelle's staging can be further justified by the fact that, earlier in his narrative, Tristan already had a hallucination of Isolde's ship arriving—Ponelle merely repeats the hallucination.) In this self-obliterating climax, the so-called small death of orgasm coincides with the real "big" death, so what takes place in the Wagnerian *Liebestod* is precisely the conflation of the two deaths. In Lacanian terms, we are dealing with the catastrophic conflation of the impossible thing—*jouissance* with its remainder, the *objet petit a*, the conflation that found its ultimate expression in "Once More," Nietzsche's poem from *Zarathustra* about the depth of the night that eternally wills *jouissance*.[9]

Transgression? No, Thanks!

In the end, it is not enough to point out that the empirical obstacles that pop up in *Tristan* again and again and prevent the final, lethal fusion are structurally necessary. Wagner was well aware that true love is impossible to realize in social reality, so the external (contingent, empirical) obstacles are here to mask an inherent impossibility; it is this very myth of inherent impossibility that has to be abandoned. As *Tristan* itself demonstrates, the truth of such unconditional love is the double Narcissistic fusion, a self-immersion that disavows the Other—the place for post-Wagnerian operatic variations on the Tristan motif is already opened up by these cracks in *Tristan*'s edifice. In what, precisely, does this crack consist? Why is the notion of the adulterous, ecstatic self-obliteration that transgresses the bounds of marriage insufficient? Something in marriage gets lost when we locate it in the opposition between, on the one hand, its legal-economic role (guaranteeing inheritance and so on), and its emotional-psychic role: the symbolic act of publicly declaring the mutual, unconditional attachment of the two persons involved. This act should *not* be reduced to the expression of one's emotions: it in a way declares, "We are committed to each other, whatever the fluctuations of our sentiments!"[10] So when, say, Judith Butler insists, against the demand for the recognition of gay marriages, on the need to dissociate the form of marriage from the actual entitlements that are legally bestowed on the married subjects (health care, child care, inheritance, and the like), the problem is still what remains of *this form itself*, of the formal symbolic act of marriage that

publicly proclaims the most intimate possible commitment. What if, in our postmodern world of ordained transgression in which marital commitment is perceived as ridiculously anachronistic, those who cling to it are the true subversives? One should recall again G.K. Chesterton's perspicuous remark, in his "A Defense of Detective Stories," about how the detective story

> keeps in some sense before the mind the fact that civilization itself is the most sensational of departures and the most romantic of rebellions. When the detective in a police romance stands alone, and somewhat fatuously fearless amid the knives and fists of a thief's kitchen, it does certainly serve to make us remember that it is the agent of social justice who is the original and poetic figure, while the burglars and footpads are merely placid old cosmic conservatives, happy in the immemorial respectability of apes and wolves. [The police romance] is based on the fact that morality is the most dark and daring of conspiracies. (Chesterton 1946: 6)

What, then, if the same goes for marriage? What if marriage is now the most dark and daring of all transgressions? When Lenin's (at that point ex-) mistress Inessa Armand wrote him in 1916 that even a fleeting passion was more poetic and cleaner than kisses without love between man and woman, he replied: "Kisses without love between vulgar spouses are *filthy*. I agree. These need to be contrasted... with what?... It would seem: kisses *with* love. But you contrast 'a fleeting (why a fleeting) passion (why not love?)'—and it comes out logically as if kisses without love (fleeting) are contrasted to marital kisses without love.... This is odd" (quoted in Service 2000: 232.) Lenin's reply is usually dismissed as a proof of his personal petit bourgeois sexual constraint, sustained by his bitter memory of the past affair; however, there is more to it. Marital kisses without love and extramarital fleeting affairs are the two sides of the same coin—they both shirk from combining the real of an unconditional passionate attachment with the form of symbolic proclamation. The implicit presupposition (or, rather, *injunction*) of the standard ideology of marriage is that there should be no love in it; one gets married to cure oneself of excessive passionate attachment, to replace it with boring daily custom (and if one cannot resist passion's temptation, there are extramarital affairs). Consequently, the ultimate subversion is to nominate the love union, to proclaim it publicly instead of concealing it. *Alyosha's Love,*

a Soviet film from the early 1960s (the time of the so-called Khrushchev's thaw), concerns a group of geologists camping near a small town in the middle of the Siberian wilderness. The young Alyosha falls in love with a girl from the town; notwithstanding all the troubles that accompany his love (the girl is at first indifferent toward him, her ex-boyfriend's companions give him a brutal beating, his own elder colleagues deride him cruelly; and so on), Alyosha saves all his free time for long walks to the town so that he can cast a quick and distant glance at the girl. At the end of the film, the girl gives way to the force of his love; she changes from the beloved to the loving one, takes the long walk herself, and joins him in the camp. Alyosha's colleagues who work on the hill above the camp suspend their digging, stand up, and silently follow the girl who approaches Alyosha's tent: cynical distance and derision are done, the big Other itself is compelled to recognize its defeat, its fascination with the force of love—the sublime reversal occurs when the hero's passionate love is finally acknowledged by his peers. No matter how manipulative such scenes can be in commercial films (recall the final scene at the subway station of *Crocodile Dundee* and the restroom reconciliation between Cameron Diaz and Julia Roberts in *My Best Friend's Wedding*), there always remains a minimal utopian emancipatory potential in them. This public proclamation is what marriage is ultimately about: a symbolic commitment, not just an expression of our (fluctuating) emotions—in the marriage ceremony, one makes a vow, one gives one's word. This is why Romeo and Juliet are the very opposite of Tristan and Isolde; their aim is not to conduct a secret affair (they could have done so without provoking war between their respective families) but to proclaim to the public their mutual commitment.

So, although one should, of course, defend the right to divorce, one should nonetheless insist that marriage should be conceived of as valid forever and essentially indissoluble: if divorce occurs, it does not mean that a marriage is simply over but rather and more radically that the marriage never really existed.[11] In his *Me-Ti*, Bertolt Brecht referred to Communism as the "great Order," resisting the fascination with the negative power of revolt, of undermining and transgressing the existing Order, as the ultimate horizon of the revolutionary practice. Following Brecht, one should—today more than ever—reject the seductive celebration of the ecstatic transgressive experience, the experience of going to (and beyond) the limits, as the ultimate, authentic human experience. If the fate of subjectivity in late capitalism has

anything to teach us, it is how such ecstatic transgressive gestures (from Bataille to Foucault and, perhaps, including Lacan himself in his fascination with the figure of Antigone) are in advance "part of the game," not only tolerated but even directly elicited by the capitalist system.

It was Flaubert who made a crucial step in undermining the coordinates of the transgressive notion of love. That is to say, why was *Madame Bovary* dragged to court? Not, as it is usually claimed, because it portrays the irresistible charm of adultery and thus undermines the fundamental assumptions of bourgeois sexual morality. *Madame Bovary* rather *inverts* the standard formula of the popular novel in which the adulterous lovers are at the end punished for their transgressive enjoyment; in this kind of novel, of course, the final punishment (mortal illness, exclusion from society) only enhances the fatal attraction of the adulterous affair, at the same time allowing the reader to indulge in this attraction without penalty. What is so profoundly disturbing and depressing about *Madame Bovary* is that it takes from us even this last refuge—it depicts adultery in all its misery, as a false escape, an inherent moment of the dull and grey bourgeois universe. This is why *Madame Bovary* had to be brought to trial: It deprives the bourgeois individual of any hope that an escape is possible from the constraints of meaningless everyday life. A passionate extramarital liaison not only does not pose a threat to the conjugal love but also functions as a kind of inherent transgression that provides the direct fantastic support to the conjugal link and thus participates in what it purports to subvert. It is this very belief that we can really obtain full satisfaction outside the constraints of marriage, in the adulterous transgression, that is questioned by the hysterical attitude; hysteria involves the apprehension that the real thing behind the mask of social etiquette is itself void, a mere mirage. If one feature serves as the clear index of modernism—from Strindberg to Kafka, from Munch to Schoenberg's *Erwartung*—it is the emergence of the figure of the hysterical woman, which stands for radical disharmony in the relationship between the two sexes. Wagner doesn't yet venture this step into hysteria; the problem with him is not his hysteria (as Nietzsche thought) but rather that he is not hysterical *enough*. Although his dramas provide all possible variations of how love can go wrong, all this takes place against the fantastic background of the redemptive power of full sexual relationships—the very catastrophic outcome of the stage action seems to assert *per negationem* the belief in the redemptive power of sexual love. This Wagnerian fantasy of the sexual relationship offers the framework to interpret the political dimension of his work as well.

Wagner's Sexualized Politics

The debate on Wagner and politics usually centers on the change in the ending of *The Twilight of Gods.* From Feuerbach to Schopenhauer, from the revolutionary assertion of new humanity delivered from the oppressive rule of gods and finally free to enjoy love to the reactionary resignation and disavowal of the very will to life—in a paradigmatic case of ideological mystification, Wagner inflates the defeat of the revolution and his betrayal of the revolutionary ideals into the end of the world itself. However, on closer investigation, it soon becomes clear that the true state of things rather resembles the good old Soviet joke about Rabinovitch: Did he really win a car in the lottery? In principle, yes, only it wasn't a car but a bicycle; besides, he didn't win it, it was stolen from him. So the standard story of the changed ending of *The Twilight of Gods* is also true in principle; however, the ending that we actually have is closer to the original one (people, common mortals, do survive and just stare in mute witness to the cosmic catastrophe of the gods). Furthermore, the early revolutionary Wagner is definitely more protofascist than the late one—his "revolution" looks rather like the restitution of the organic unity of the people who, led by the prince, have swept away the rule of money embodied by the Jews.

It is interesting to note that we find a similar ambiguity in the young Marx when he claims that the full emancipation of Jews (their integration into Western societies) can only occur as the result of emancipation of our societies themselves from Jewishness. The problem here is the interrelationship of these two mentions of Jews: When we speak of Jews not being integrated, we mean the way the Jewish people maintained their identity; when we speak of the emancipation of our societies from Jewishness, we mean the ideological (ultimately anti-Semitic) notion of Jewishness (exploitation, obsession with money, and the like). What is problematic in Marx's formula is the implied identity of these two mentions. Furthermore, does not therein reside the ultimate paradox of the state of Israel? In it, Jews themselves are effectively emancipating themselves of their Jewishness: in its first, ascetic-revolutionary kibbutzim period, during which farmers had Marx's *Capital* and the Torah by their bedsides, the basic goal was precisely to change the very Jewish identity from an unproductive focus on circulation (money and trade) to hard labor and production.

However, the true problem lies elsewhere. In his *Ring*, Wagner addresses the fundamental ethico-political question of German idealism: How is it pos-

sible to unite love and law? In contrast to German idealists whose political vision involved the hope of a reconciliation between the assertion of an authentic intersubjective bond of love and the demands of the objective social order of contracts and laws, Wagner is no longer prone to accept this solution. His apprehension articulates itself in the opposition between Wotan and Alberich, between contractual symbolic authority and the spectral, invisible master: Wotan is a figure of symbolic authority, the "God of contracts." His will is bound by the word, by pacts (the giant Fasolt tells him: "What you are, / you are through contracts only" (Wagner 1977: 24), whereas Alberich is all-powerful because he is an invisible agent not bound by any law: "Nibelungs all, / bow down to Alberich! / He is everywhere, / watching you! / . . . You must work for him, / though you cannot see him! / When you don't think he's there, / You'd better expect him! / You're subject to him for ever!" (40).

Wagner's crucial insight is, of course, that this opposition is inherent to Wotan himself; the very gesture of establishing the rule of law contains the seeds of its ruin—but why? Wagner is here guided by a perception that has been given different theoretical articulations by Marx, Lacan, and Derrida. Equivalent exchange is a deceptive mirage that conceals the very excess on which it is grounded. The domain of contracts, of giving and receiving something in return, is sustained by a paradoxical gesture that provides in its very capacity of withholding—a kind of generative lack, a withdrawal that opens up space, a lack that acts as a surplus. This gesture can be conceptualized as the Derridean gift, the primordial *Yes!* of our openness to dissemination, or as the primordial loss, the Lacanian symbolic castration. (In Wagner's mythical space, this violent gesture of grounding the domain of legal exchange is depicted as Wotan's tearing out the World Ash Tree, from which he then cuts out his spear and inscribes on it the runes containing laws; this act is followed by a whole series of similar gestures: Alberich's snatching the gold, Siegmund's pulling out the sword, and so on.) Wagner is thus well aware that the very balance of exchange is grounded on the disturbance of the primordial balance, on a traumatic loss that opens up the space of social exchange. However, at this crucial point, the critique of exchange becomes ambivalent; it either endeavors to assert the primordial *Yes!*, the irreducible excess of the openness toward the Otherness that cannot be constrained to the field of balanced exchange, of its closed economy, or it aims at restoring the primordial balance prior to this excessive gesture. Wagner's rejection of (the society of) exchange, which provides the basis of his anti-Semitism, amounts to an at-

tempt to regain the prelapsarian balance. Nowhere is this more obvious than in his sexual politics, which asserts the incestuous link against the exogamic exchange of women: Sieglinde and Siegmund, the good incestuous couple, against Sieglinde and Hunding, the bad couple based on exchange; Bruenhilde and Siegfried against two further couples based on exchange (Brünnhilde and Günther, Gutrune and Siegfried).

In dealing with Wagner's anti-Semitism, we should always bear in mind that the opposition of German true spirit versus the Jewish principle is not the original one. There is a third term, modernity, the reign of exchange, a term of the dissolution of organic links and of modern industry and individuality—the theme of exchange and contracts is *the* central theme of the *Ring*. Wagner's attitude toward modernity is not simply negative but much more ambiguous; he wants to enjoy its fruits while avoiding its disintegrative effects—in short, Wagner wants to have his cake and eat it, too. For that reason, he needs a Jew so that modernity—this abstract, impersonal process—is given a human face, identified with a concrete, palpable feature then, in a second move, we can retain its fruits by rejecting the Jew, which gives body to all that is disintegrated in modernity. In short, anti-Semitism does not stand for antimodernism as such but for an attempt to combine modernity with social corporatism, which is characteristic of conservative revolutionaries.[12] So, because the rule of law, the society of contracts, is founded on an act of illegitimate violence, law not only has to betray love but also has to violate its own highest principles: "The purpose of their [the gods'] higher world order is moral consciousness: but they are tainted by the very injustice they hunt down; from the depths of Nibelheim [where Alberich dwells] the consciousness of their guilt echoes back threateningly" (quoted in Dahlhaus 1979: 97).

Aware of this impasse, Wotan concocts the figure of the hero not bound by any symbolic bond and thereby free to deliver the fallen universe of contracts. This aspect of Wagner is to be located within the great ideologico-political crisis of the late nineteenth century, which turned around the malfunctioning of investiture, of assuming and performing the paternal mandate of symbolic authority. This crisis found its most aggravated expression in the fate of Daniel Paul Schreber, whose memoirs were analyzed by Freud: Schreber fell into psychotic delirium at the very moment when he was to assume a position as a judge, that is, as a function of public symbolic authority; he was not able to come to terms with this stain of obscenity as the integral part of the functioning of symbolic authority.[13] The crisis thus breaks

out when the obscene, joyful underside of the paternal authority becomes visible—and is not Alberich the paradigmatic case of the obscene ludic father on account of which Schreber failed in his investiture? The most disturbing scene of the entire *Ring*, the mother of all Wagnerian scenes, is probably the dialogue between Alberich and Hagen at the beginning of the Act II of *The Twilight of Gods:* Wagner put a tremendous amount of work in it and considered it one of his greatest achievements. According to Wagner's own stage indications, throughout this scene Hagen must act as if asleep; Alberich is not there as a part of everyday reality but rather as an undead creature who appears as Hagen's *Alptraum,* literally "elf-dream," or nightmare (another occasion that would fully justify the procedure of staging part of the action as the delirious delusion of one of the characters). We all know the classic Freudian dream in which the dead son appears to his father, addressing him with a horrifying reproach: "Father, can't you see I'm burning?" What we have in this scene from *The Twilight of Gods* is a father appearing to his son, addressing him in similar fashion—he is burning with obscene enjoyment underlying his overwhelming passion to take revenge. When confronted with such a humiliated, ludic, tragicomical dwarf of a father, what can the subject do but assume an attitude of shuddering coldness that contrasts clearly with the father's overexcited agitation—it is here, in the figure of Hagen, that we have to look for the genesis of the so-called totalitarian subject. That is to say, far from involving a repressive symbolic authority, the totalitarian subject rather emerges as a reaction to the paternal authority gone awry. A humiliated father, a father transformed into the obscene figure of ludic enjoyment, is the *symptom* of the totalitarian subject.[14] How, then, are we to resolve this deadlock of legal power that participates in what it officially prohibits, that is, illegitimate violence? the deadlock of property, which is in itself a theft; of contract, which is in itself a fraud? It is the reference to sexual relationships that serves as the ultimate support for Wagner's political project: "The mediator between power and freedom, the redeemer without which power remains violence and freedom caprice, is therefore—love" (quoted in Cooke 1979: 17). "Love in its fullest reality is only possible between the sexes: only as man and woman can we human beings truly love. Every other love is merely derived from this, arisen from it, connected with it, or artificially modelled on it" (18).

In order to grasp how Wagner is able to use the sexual relationship as the paradigm for authentic political order, one has only to bear in mind that for him, woman is the all-embracing unity, the ground that bears man, yet

precisely because of her positive, empirical existence, she must be subordi-
nated to man's "formative power." For that reason, the elevation of and sub-
ordination to the essential woman goes hand in hand with the exploitation
of and domination over actual flesh-and-blood women. Suffice it to recall
here Schelling's notion of the highest freedom as the state in which activity
and passivity, being active and being acted upon, harmoniously overlap.
Schelling gives a specific twist to the distinction between *Vernunft* and *Ver-*
stand, reason and understanding, which plays a crucial role in German ide-
alism: "*Vernunft* is nothing else than *Verstand* in its subordination to the
highest, the soul" (1856–1861, 7: 472) *Verstand* is active intellect, the power
of actively seizing and deciding by means of which we assert ourselves as
fully autonomous subjects; however, we reach our acme when we turn our
very subjectivity into the predicate of an ever higher power (in the mathe-
matical sense of the term); in other words, when we yield to the Other, de-
personalizing our most intense activity and performing it as if some other,
higher power were acting through us, using us as its medium—like an artist
who, in the highest frenzy of creativity, experiences himself as a medium
through which the impersonal Spirit expresses itself. What is crucial is the
explicit sexual connotation of this highest form of freedom; the feminiza-
tion (the adoption of a passive attitude toward the transcendent absolute)
serves as the inherent support of masculine assertion. It is therefore clearly
wrong to interpret the Wagnerian elevation of the feminine as a protest
against the male universe of contracts and brutal exercise of power, as the
utopian vision of a new life beyond aggressive modern subjectivity; the ref-
erence to the eternal feminine toward which the male subject adopts a pas-
sive attitude is the ultimate metaphysical support of the worldly aggressive
attitude—and, incidentally, the same goes for the contemporary New Age
revival of the Goddess.[15]

The Moebius Strip

What, then, is inherently wrong with Isolde's *Liebestod*? In the first of his
Duino Elegies, Rainer Maria Rilke makes his famous claim that "*das Schöne*
ist nichts als des Schrecklichen Anfang" (the beautiful is nothing but the be-
ginning of the horrible)—and in Chapter 2 of his *Seminar on the Ethics of*
Psychoanalysis, Lacan points in the same direction. For him, the existence
of the hostile object (what Freud called "*das feindliche Objekt*," the extimate
foreign body (the "thing from inner space") in the very heart of the subject is

the subject's scream; in other words, in the scream, the veil of beauty dissolves and the subject directly confronts the real. The ultimate fantasy of *Tristan* is that *it is possible to make peace with the thing*, to peacefully immerse oneself into it—which is why Wagner must prevent this reversal of the beautiful to the horrible at any price. As Poizat (1986) puts it succinctly, the scream signals that woman doesn't exist, that the Grail is a void, a place in which one can encounter only an excremental object of horror (274). At the opera's end, Isolde's culminating voice needs the orchestral supplement to fill the void of the silent scream, which would have been the direct embodiment of horrifying real.[16]

Which dimension of the voice is Wagner desperately trying to avoid? Let us recall the expression "the voice of conscience"—why does the ethical agency use a voice to address us? Is this just a(nother) metaphor? One should turn here to Lacan's notion of voice as *objet petit a:* when we talk, our words are always mere babbling—whenever we talk, we talk too much to escape the unbearable silence, and this silence is the voice as object. Consequently, it is only when our words fail that we confront the voice reminding us of our fundamental responsibility.[17] The voice of conscience is the pressure exerted on us by silence itself, its reverberation. Imagine a situation in which one enumerates arguments to rid oneself of the responsibility for some deplorable act: One talks and talks, and when one finally runs out of words, the silence that follows is the voice of conscience. Far from being exceptional, such a situation is basic to human speech. The ultimate image of this silent voice is, of course, Munch's *The Scream*, which renders the utter anxiety of the voice *en puissance*, stuck in the throat and unable to externalize itself. The moment this voice is vocalized, the anxiety is released. And is not all of Wagner an attempt to arrive at this release, to get rid of this anxiety?

One of the best-known anecdotes about Kant concerns his relationship with his faithful servant Lampe. In his old age, Kant was deeply disturbed by the news about Lampe's severe illness; the doctor advised Kant not to think too much about Lampe because this might have been bad for Kant's own health. However, Kant couldn't help worrying about the poor Lampe, so he wrote a reminder on a piece of paper: *"Der Name Lampe muss unbedingt vergessen werden!"* (The name Lampe should be unconditionally forgotten!). Is not something of the same order at work in Isolde's *Liebestod*—the same paradox of the conscious intention to forget everything and sink into the unconscious void? Furthermore, is this paradox not discernible in the Kantian categorical imperative itself? Is it not in a way its concealed

truth, expressly articulated later by Fichte and Schelling, who make it clear that the unconditional/absolute act of self-consciousness itself has to be unconscious? Or, to consider the ethical domain, is it not that every conscious ethical injunction is already minimally pathological, tainted by some particular interests, so that the only actual existence of the purely ethical imperative should be unconscious—we really act ethically only if we follow an injunction whose nature as such we have forgotten, and only such a forgotten injunction can be truly unconditional?

This crack in the Kantian edifice opens up the way for de Sade as the truth of Kant. At first glance, it may seem that de Sade is the very opposite of Kant: Whereas the latter demands that we make the effort to discard our pathological considerations of pleasure and act from universal duty alone, the former enjoins us to ruthlessly exploit all our neighbors, to give way to all our pathological caprices, to obtain maximum pleasure. However, in his very radicalness, Sade comes unexpectedly close to Kant; in his first move, de Sade denounces all ethical considerations as unwarranted limitations of the true natural order: God or morality are parasitical entities that impede the full realization of our natural urges. In a second move, he then turns against nature itself: The order of nature, this complex network of the eternal circular movement of generation and corruption, is also a constraint on our freedom, outlining in advance the scope of our desires and acts. To be truly free, the subject has thus to commit an absolute crime, a radical act of destruction that will undermine the very natural order. The paradox, of course, is that such an excessive act of freedom fits the formal conditions of the Kantian ethical act; insofar as its caprice is absolute, it is not motivated by any pathological motive such as pleasure—in it, a noumenal dimension transpires that introduces a gap in the phenomenal order. Thus, Kant read through de Sade provides the coordinates of the highest pleasure of the *Liebestod.*

Perhaps today's equivalent to de Sade is Peter Singer, the Australian whose books sell in the hundreds of thousands of copies and who needs a bodyguard to protect him from attacks at Harvard, where he now teaches. Singer is not controversial because he adopts some extravagant axioms but because he draws the ultimate, logical conclusions from commonly accepted axioms, ignoring hidden qualifications that might keep us from agreeing with him. (See Singer 2000.) Although Singer is today's utilitarian anti-Kant, he shares with Kant this attitude of fearlessly drawing the consequences of one's premises. Recall not only Kant's definition of marriage in *Metaphysical*

Elements of Justice, which scandalized Hegel ("the binding together of two persons of different sexes for the lifelong reciprocal possession of their sexual attributes" [1999: 88], or in other words, the legitimization of "the reciprocal use that one person makes of the sexual organs and faculties of another person" (87). Later in the same work, Kant even considers legitimizing the infanticide of illegitimate children: "A child born into the world outside marriage is outside the law (for this is [implied by the concept of] marriage), and consequently it is also outside the protection of the law. The child has crept surreptitiously into the commonwealth (much like prohibited commodities), so that its existence as well as its destruction can be ignored (because by right it ought not to have come into existence in this way)" (143).[18]

Like Kant, Singer—usually designated as a social Darwinist with a collectivist socialist face—is also ready to tolerate infanticide in certain specific situations, although his argumentation is the very opposite of Kant's. Singer starts innocently enough, arguing that people will be happier if they lead a life committed to ethical behavior; a life spent trying to help others and reduce suffering is really the most moral and fulfilling one. He radicalizes and actualizes Jeremy Bentham, the father of utilitarianism: the ultimate ethical criterion is not the dignity (rationality, soul) of humanity but the ability to suffer, to experience pain, which we share with animals. With inexorable radicalness, Singer levels the animal/human divide: Better to kill an old suffering woman than a healthy animal. Look an orangutan straight in the eye and what do you see? A none-too-distant cousin—a creature worthy of all the legal rights and privileges that humans enjoy. One should thus extend aspects of equality—the right to life, the protection of individual liberties, the prohibition of torture—at least to the great apes (chimpanzees, orangutans, and gorillas).

Singer argues that speciesism (privileging the human species) is no different from racism because our perception of a difference between humans and (other) animals is no less illogical and unethical than our one-time perception of an ethical difference between, say, men and women or blacks and whites. Intelligence is no basis for determining ethical stature; the lives of humans are not worth more than the lives of animals simply because we display more intelligence (if intelligence were a standard of judgment, Singer points out, we could perform medical experiments on the mentally retarded with moral impunity). Ultimately, all things being equal, an animal has as much interest in living as a human, and therefore medical experimentation on animals is immoral. Those who advocate such experiments claim that

sacrificing the lives of twenty animals will save millions of human lives—
however, what about sacrificing twenty humans to save millions of animals?
As Singer's critics like to point out, the horrifying extension of this princi-
ple is that the interests of twenty people outweigh the interests of one, which
gives the green light to all sorts of human rights abuses. Consequently, Singer
argues that we can no longer rely on traditional ethics for answers to the
dilemmas that our situation imposes on ourselves; he proposes a new ethics
meant to protect the quality, not the sanctity, of human life. As sharp bound-
aries disappear between life and death and between humans and animals,
this new ethics casts doubt on the morality of animal research, while offer-
ing a sympathetic assessment of infanticide. When a baby is born with se-
vere defects of the sort that always used to kill babies, are doctors and par-
ents now morally obligated to use the latest technologies, regardless of cost?
No. When a pregnant woman loses all brain function, should doctors use
new procedures to keep her body living until the baby can be born? No. Can
a doctor ethically help terminally ill patients to kill themselves? Yes.

One cannot dismiss Singer as a monstrous exaggeration—what Adorno
said about psychoanalysis (that its truth resides in its very exaggerations)
fully holds for Singer: He is so traumatic and intolerable because his scan-
dalous "exaggerations" directly render visible the truth of so-called post-
modern ethics. Is not the ultimate horizon of postmodern identity politics
essentially Darwinian—defending the rights of some particular subspecies
of humankind within the panoply of our proliferating numbers (say, gays
with AIDS or black single mothers)? The very opposition between conser-
vative and progressive politics can be conceived of in Darwinian: ultimately,
conservatives defend the rights of those with might (their very success proves
that they won in the struggle for survival), whereas progressives advocate
the protection of endangered human subspecies, in other words, of those los-
ing the struggle for survival.

One of the divisions in the chapter on *Vernunft* in Hegel's *Phaenome-
nologie des Geistes* speaks about *"das geistige Tierreich"*: the social world that
lacks any spiritual substance so that individuals effectively interact as intelli-
gent animals within it. They use reason but only to assert their individual in-
terests, to manipulate others into serving their own pleasures. Is not a world
in which the highest rights are human rights precisely such a "spiritual ani-
mal kingdom"? There is, however, a price to be paid for such liberation—in
such a universe, human rights ultimately function as *animal* rights. This, then,
is the ultimate truth of Singer, but the obvious counterargument to this is, so

what? Why should we not reduce humankind to its proper place, that of one of the animal species? What gets lost in this reduction? The thing, something to which we are unconditionally attached regardless of its positive qualities. In Singer's universe, there is a place for mad cows but no place for an Indian sacred cow. Singer's universe is the positive universe of qualities in which there is no place for what Kant would have called the eruption of the noumenal dimension in the order of phenomenal reality, no place for the dimension beyond the pleasure principle, no place for *love* in the radical sense of the term. When the lover who fears rejection by his or her partner says, "You will not find anyone better than me!" we can be sure that the game is over—the moment one argues in terms of (comparative) qualities, there is no love.

What Kant himself tries to elude is that three elements are at play in his ethical edifice, not just the opposition between pleasures and moral duty: on top of these two is the excessive enjoyment that not only violates the moral law but also threatens our well-being and self-preservation, leading to self-destruction (excessive sexual pleasures, gluttony, drinking, violence). The true tension is not the one between my egotistic-utilitarian concerns and the call of moral duty (as it may still appear in *Tannhäuser*), but the one, inherent to pleasure itself, between moderate pleasure that serves the subject's self-preservation and excessive, self-destructive pleasure *(jouissance)*. Paradoxically, the egotistic-utilitarian calculation of pleasures and the moral duty that obliges me to forgo my striving for pleasures thus find themselves *on the same side,* both of them being a form of defense against the excess of *jouissance*—or is it so? Is it not also that this excessive *jouissance* and the moral duty are brought so close that, at some point, they can no longer be clearly separated? They both suspend the reign of the utilitarian-egotist self-preservation stance. When I put everything, including my life, at risk to attain some *jouissance, jouissance* itself starts to function as a kind of duty. The paradoxical result is thus that sometimes the only way to sustain the reign of the pleasure principle is to sacrifice (some excessive) pleasure; vice versa, the only way to undermine the rule of the pleasure principle is to follow the pleasure to its horrifying, unbearable excess.

Perhaps, disgust is here a more appropriate term than horror or anxiety. In psychoanalysis, the proper opposite of pleasure is not pain but disgust, the most elementary psychic operation, the repulsion of the libidinal object that opens up the space for subjectivity.[19] Disgust occurs when we get too close to the object of desire—consider the well-known courtly love motif of the beautiful lady who, when we get too close to her, turns into an abhorrent

creature, her face full of worms. Pleasure and disgust are therefore related just like the seeming two sides of the continuous Moebius strip; if we proceed far enough on the side of pleasure, all of a sudden we find ourselves in disgust.[20] As such, disgust cannot be explained away as the secondary effect of repression (a turning away in disgust from libidinal objects that are prohibited by the symbolic norms): it is, on the contrary, prohibition itself that should be accounted for as a means to avoid the paradox of disgust, that is, the fact that we turn away in disgust when the very object of desire comes too close. Prohibition transposes this inherent self-blockade into the effect of the external obstacle; were it not for the prohibition that prevents access to it, the object would give full satisfaction.[21]

This structure of the Moebius strip, then, is what Wagner is obfuscating in his ecstatic staging of the *Liebestod:* the fact that when we reach the highest pleasure in which Isolde's deadly trance culminates, we find ourselves on the other side, pleasure necessarily turning into disgust. One is tempted to make the same point even in the poignant terms of a real-life experience. In the "After Words" to Ruth Picardie's *Before I Say Goodbye,* which contains newspaper columns and emails from the last year in the life of the author, a British journalist who died of metastasized breast cancer in 1997, her husband, Matt Seaton, admits how "the fantasy of terminal *tendresse* fell far short of the mark": "The dying person has to break her bonds with the world, to separate herself off: it is the process of alienation I still bitterly regret, but it is also a necessary part of letting go" (Picardie 2000: 128–129). This cruel self-withdrawal of the dying person into absolute loneliness impedes any authentic contact, any empathic shared experience:

> At times I became haunted by something in Ruth's blank expression and uncomprehending, frightened eyes that I had seen somewhere before: they reminded me of nothing so much as some footage of a cow in the final stages of BSE, lurching and stumbling, knowing nothing but its incomprehension and fear. That sounds a terrible way to speak of someone you love, but there is nothing more terrible than to find that person spirited away and a brain-damaged, zombie-like *doppelgänger* usurping her place. (Picardie 2000: 121)

This dimension of dying is utterly obfuscated by the Wagnerian fantasy of the *Liebestod.* What, then, comes—what *can* come—after *Tristan?* Let us try the obvious empirical answer: *Die Meistersinger von Nürnberg.*

Notes

1. The principal reference here is, of course, de Rougement 1995.

2. Conductor, Daniel Barenboim; Tristan, Rene Kollo; Isolde, Johanna Meier; Mark, Martti Talvela; Brangaene, Hanna Schwarz.

3. One should nonetheless bear in mind how even the most tragic endings can be read as providing a satisfying, "happy" outcome at a deeper level. Recall Verdi's *Rigoletto*, which ends with a broken Rigoletto who learns that the murderer whom he paid to kill the duke instead stabbed to death Gilda, his daughter who meant everything to him and for whose seduction he wanted to punish the duke. However, does Gilda's death not provide the only viable outcome to Rigoletto's excessively possessive stance toward her? If she were to stay alive, she would sooner or later abandon him, so the only way to possess her forever is for her to die. Incidentally, *Rigoletto's* most famous aria, the duke's *"La donna e mobile,"* also nicely renders the paradox of characterization: Although the words sung by the duke provide the characterization of women (as flirtatious, unstable, and so on), they expose the character of the duke himself much better than his self-description would have done—in Hegelese, the image of women we get from his aria is a "reflexive determination" of his own attitude toward women and thus of his own character. And does not the same go for anti-Semitism, for the anti-Semitic concept of the Jew? This concept tells us a lot more about the innermost secrets and fears of the subject who perceives Jews in this way than it does about Jews themselves.

4. It is not sufficient to counter these examples of interpassivity by claiming that they are mere exceptions and that, in the large majority of cases, we directly experience what we feel (enjoyment, sorrow, laughter) without attributing it to others. The simple classification of all passive experiences into directly passive and interpassive misses the point, which is that once we admit even one example of interpassivity, this one example compels us to *change the entire field of what passive experience is*—even (what appears as) the "direct" passive experiences of enjoyment, laughter, and so on somehow lose their innocence. It is the same with the Freudian notion of the unconscious; it is not enough to counter it by claiming that the unconscious is marginal, that it plays a minor role—the very fact that there *is* an unconscious formation changes the entire picture. Here we have a nice example of the dialectical relationship between universality and singularity: The question "How widespread is unconscious phenomena (or interpassive experiences)?" is misleading, because a single case is sufficient to legitimize the universal thesis that covers the unconscious and consciousness, passive and interpassive phenomena.

5. And does the same not hold for the great duet of Kundry and Parsifal, which occupies most of Act II of the opera? Here as well, Kundry's first attempt at seduction is false, the game of *femme fatale*, whereas her second attempt is the authentic, desperate plea of a woman in love.

6. "Music Instead of Muddle," *Pravda*, January 28, 1936, quoted in Laurel E. Fay, *Shostakovich. A Life* (Oxford: Oxford University Press, 2000), 88.

7. Strictly correlative to this falsity of the Wagnerian *end* is the falsity of the Wagnerian *beginning*. What is creation, the beginning? Recall from the very beginning of Wagner's *Rheingold* the magical, sudden passage of the brief orchestral prelude into the singing of the three Rhine maidens. What effectively happens here in musical terms is ultimately a simple reversal in the relationship between figure and background, between the main melody and its accompaniment: In the orchestral prelude, the "melody" is the rhythmic repetition of a single tone, and the intricate web of string melodies serves as its background; the moment of creation occurs

when the Rhine maidens enter and their singing takes over (and thus elevates into the main melodic line) what was previously the main *background* line. Creation is nothing but such a reversal that exposes what was previously subdued, contained within the simple, monotonous, repetitive protomelody. However, is this the true beginning? It is interesting to note that when the FBI was laying the siege to the Branch Davidian compound in Waco, Texas, one of the musical numbers that they played again and again through the large loudspeakers to unnerve the people in the compound was the deeply resonating music of Tibetan long horns. How is it that Tibetan Buddhism, a spiritual practice of deep inner peace, is—in the West, at least—musically identified with a horrifying sound that evokes unbearable suffering? Even more than the Jewish shofar, does this music not render the horror of the Freudian primordial crime, the painful cry of the dying *Urvater*? Insofar as David Koresh, the leader of the sect, enforced on the members the fundamental rule of the Freudian primal father (reserving for himself the exclusive right to copulate with women in his group, while sexual intercourse was prohibited for all other male members), was it not in a way quite appropriate for the FBI to play the music that signals the death pangs of this obscene figure? This horror of the true beginning is what is obliterated in the paradigmatic Wagnerian beginning, the Prelude to the *Rhinegold*.

8. It is interesting to note how Ponelle had to resort to the cinematic procedure of fade-out/fade-in to succeed in his staging: After Isolde's last words, the lights dim, and when they return, we are back in the bleak reality of the dead Tristan lying in Kurwenal's arms.

9. "The world is deep, And deeper than the day could read. / ...But joys all want eternity,—Want deep, profound eternity" (Nietzsche 1993: 338).

10. It is easy to be "radical" as regards gay marriage, incest, and so on—however, what about child sex and torture? On what grounds are we justified in opposing them without having recourse to the legal fiction of the adult autonomous subject responsible for his or her acts? (And incidentally, why should marriage be constrained to *two* persons, gay or not? Why not three or more? Is this not the last vestige of binary logic?) More generally, if we adopt the standard postmodern mantra of the autonomous responsible subject being a legal fiction, what are the consequences of this denial for our dealing with, say, child rapists? Is it not deeply symptomatic how the very same theorists who denounce the liberal autonomous subject as a Western legal fiction at the same time fully endorse the discourse of victimization, treating the perpetrators of sexual harassment as guilty (that is, responsible) for their acts? Furthermore, the attitude toward sex between adults and children is the best indicator of the changes in sexual mores: Three or four decades ago, in the heyday of the sexual revolution, child sex was celebrated as a way to overcome the last barrier, the ideologically enforced desexualization of children, while the politically correct ideology of victimization offers the sexually abused child as the ultimate image of horror.

11. The Catholic Church likes to emphasize how sex is not only animal satisfaction but also a higher spiritual act; however, how are we to reconcile this with the church's insistence that the aim of sex must be procreation? Is not procreation the ultimate animal aim of the sexual act? Do not animals copulate only for procreation? And consequently, is sex not spiritual precisely insofar as it surpasses a mere finality of procreation, not (only) in the sense of providing sensual pleasure but (also) in the sense of establishing the most intimate link between two persons, which are in a way most radically exposed to each other, trusting the other, putting themselves in an utterly vulnerable situation?

12. What makes the Jewish reference in Wagner even more complex is the naive but crucial question: Who *is* the Jew in his work? Is not the Flying Dutchman, the first true Wagnerian hero, a figure in the lineage of the Wandering Jew? Is thus not Kundry herself in *Parsifal* the last variation of the Dutchman? Furthermore, what about the crucial transformation of Wotan himself, the supreme god, into the anonymous Wanderer in *Siegfried*, after Siegfried breaks his runic lance, the source of his power? How are we to locate this enigmatic figure of God, the supreme authority, who, after losing his power, turns into a wanderer? (It is interesting to note that Goethe, in his planned sequel to Mozart's *The Magic Flute*, envisaged the same fate for Sarastro: After transferring his power to Tamino, he also turns into a wanderer.) Do we not encounter in this figure of the wanderer a god who, deprived of his symbolic authority, turns into an excremental object lacking its proper place?

13. I rely here on Santner 1996.

14. The proper counterpoint to this uncanny beginning of the Act II of *The Twilight of Gods* is the trio that concludes it, the supreme example of the dialectical notion that the way to universality leads only through its constitutive exception. In this trio of revenge (Brünnhilde, Hagen, and Günther together pledging to take revenge on Siegfried by killing him), Wagner enigmatically violates the most sacred rule of his mature (postoperatic) musical dramas, the prohibition of traditional duos or trios—all of a sudden, at the very peak of his output, we are unexpectedly thrown back into something that resembles the style of the middle Verdi of *Forza del destino* or *Don Carlos*. What was it that compelled Wagner to violate his own fundamental rule? It is the answer to *this* question alone that allows us to articulate the rationale of Wagner's central prohibition.

15. From the Lacanian standpoint, it is easy to identify this reference to the eternal feminine as the disavowal of the "primordial repression of the binary signifier," that is, as a faked return to the premodern mythic universe in which the binary signifier is not repressed. The order of the premodern universe is sustained by the balance of the two signifiers, yin and yang, the feminine and masculine principles, respectively; the modern universe stands under the sign of One, and the repressed Other (the complementary binary signifier) only returns in the series of S2: Instead of the couple S1-S2, we have a radical dissymmetry of the two levels—the One and the series of Others in which returns what the imposition of the One repressed. It is crucial to bear in mind here that the emergence of the modern subject ($) is strictly correlative to this repression of the Other signifier, which is why, on behalf of a truly radical feminism (the assertion of the feminine subjectivity, or even more radically, of subjectivity as ultimately feminine), one should oppose any attempt to articulate the signifier of woman parallel to the male phallic signifier. The subject emerges in the very dissymmetry between S1 and S2; in a way, it is the very lack of the binary signifier ($) that the series of S2 represents for S1, the master signifier.

16. It is worth mentioning here a nice accident from one of the greatest recordings of *Tristan*, Wilhelm Fuertwaengler's from 1952: As Kirsten Flagstad was already past her prime, Elisabeth Schwarzkopf—the wife of Walter Legge, the recording's producer—helped out her elder colleague with the long high C that concludes *Liebestod*. Schwarzkopf's voice thus imperceptibly replaces Flagstad's at this climax, as if it were not possible for one singer to bring *Liebestod* to its conclusion.

17. I rely here on Chapter 3 of Baas 1992.

18. Two paragraphs later, Kant retracts this radical position, proposing a compromise solution; we are clearly dealing with a concession to the pathological spirit of time.

19. Kant himself also relates disgust to excessive enjoyment; for a detailed analysis of Kant's notion of disgust *(Ekel)*, see Chapter 3 of Menninghaus 1999.

20. Why does Lacan refer to the Moebius strip as the topological model of the libidinal closure? Recall that bands of homophobic thugs often gang rape their gay victims to humiliate them, thereby committing the very act for which they (pretend to) despise them.

21. This convolution of pleasure and disgust also accounts for two further paradoxical experiences, that of finding pleasure in disgust and that of finding disgust in pleasure. The first experience refers to the well-known fascination exerted by the object of disgust; we cannot avoid being attracted to it as if by magnetism even while shrinking away from it. Disgust in pleasure, on the contrary, refers to the no less well-known repulsion that overwhelms some (obsessional) subjects when they confront an object that brings them intense pleasure. The agency of censorship allows them pleasure only if this pleasure is kept at bay, filtered, through disgust, in other words, being experienced as something disgusting.

"THE EVERLASTING IRONY OF THE COMMUNITY"

Wagner with Kierkegaard

Nietzsche was right in conceiving Meistersinger as complementary to Tristan. If we are to survive in the everyday world of social reality, we have to renounce the absolute claim of love, which is precisely what Hans Sachs does, thereby enabling the only semblance of a happy ending in Wagner. By adding Parsifal to this list, one obtains three versions of the redemption that follow the logic of the Kierkegaardian triad of the aesthetic, the ethical, and the religious. In all three of these stages, the same sacrificial gesture is at work, each time in a different power/potential (in Schelling's sense of the term).[1] The religious sacrifice is a matter of course (suffice it to recall Abraham's readiness to sacrifice Isaac, Kierkegaard's supreme example), so we should concentrate on the renunciation that pertains to the ethical and the aesthetic:

• The ethical stage is defined by the sacrifice of the immediate consumption of life, of our yielding to the fleeting moment, in the name of some higher universal norm. In the erotic domain, one of the most refined examples of this renunciation is provided by Mozart's *Così fan tutte*. If his *Don Giovanni* embodies the aesthetic (as was developed by Kierkegaard himself

in his detailed analysis of the opera in *Either/Or*), the lesson of *Così fan tutte* is ethical—why? The point of *Così* is that the love that unites the two couples at the beginning of the opera is no less artificial, mechanically brought about, than the love of the two sisters for the exchanged partners dressed up as Albanian officers that results from the manipulations of the philosopher Alfonso—in both cases, we are dealing with a mechanism that the subjects follow in a blind, puppetlike way. Therein consists the Hegelian "negation of negation": First, we perceive the artificial love, the product of Alfonso's manipulations, as opposed to the initial, authentic love, and then we suddenly become aware that there is actually no difference between the two. So because one love counts as much as the other, the couples can return to their initial marital arrangement.[2] This is what Hegel has in mind when he claims that in the course of a dialectical process, the immediate starting point proves itself to be something already mediated, that is, its own self-negation; in the end, we ascertain that we always and already were what we wanted to become, the only difference being that this always-already state changes its modality from in-itself into for-itself. The ethical is in this sense the domain of repetition qua symbolic; if, in the aesthetic, one endeavors to capture the moment in its uniqueness, in the ethical a thing becomes what it is only through its repetition.

• In the aesthetic stage, the seducer works on an innocent girl whom he considers worthy of his efforts, but at a crucial moment just prior to his triumph when for all practical purposes her surrender is already won and the fruits of his labor have only to be reaped, he has not only to renounce the realization of the sexual act but also to induce *her* to drop him (by putting on the mask of a despicable person and thus arousing her disgust). Why this renunciation? The realization of the process of seduction in the sexual act renders visible the goal the seducer was striving at in all its transiency and vulgarity, so the only way to avoid this horror of radical desublimation is to stop short of it, thereby keeping awake the dream of what *might have* happened—by losing his love in time, the seducer gains her for eternity. One must be careful here not to miss the point: The desublimation one tries to avoid by renouncing the act does *not* reside in the experience of how realization always falls short of the ideal for which one was striving, that is, of the gap that forever separates the ideal from its realization; in it, it is rather the ideal itself that loses its power, that changes into repugnant slime. The ideal is, as it were, undermined from within; when we approach it too closely, it changes into its opposite.

In all three stages, the same gesture of sacrifice is thus at work in a different power/potential, and what shifts from the one to the other is the locus of impossibility. That is to say, one is tempted to claim that the aesthetic-ethical-religious triad provides the matrix for the three versions of the impossibility of sexual relationship. What one would expect here is that with the progression (or rather, leap) from one to the next stage, the pressure of prohibition or impossibility gets stronger. In the aesthetic, one is free to seize the day, to yield to enjoyment without any restraints; in the ethical, enjoyment is admitted but on condition that it remains within the confines of the law (marriage), that is, in an antiseptic, gentrified form that suspends its fatal charm; in the religious, finally, there is no enjoyment, just the most radical, irrational renunciation for which we get nothing in return (Abraham's readiness to sacrifice Isaac). However, this clear picture of progressive renunciation immediately gets blurred by the uncanny resemblance, noticed by many a sagacious commentator, between Abraham's sacrifice of Isaac (which, of course, belongs to the religious) and Kierkegaard's own renunciation to Regina (which belongs to the aesthetic dialectics of seduction). On a closer look, one can thus ascertain that contrary to expectations, the prohibition (or rather inhibition) *loosens* with the leap from one to the next stage. In the Aesthetic, the object is completely lost, beyond our reach, owing to the inherent instability of this level (in the very gesture of our trying to lay our hands on the fleeting moment of pleasure, it slips between our fingers); in the ethical, enjoyment is already rendered possible in a stable, regular form via the mediation of the law; and, finally, in the religious...what is the religious mode of the erotic if its aesthetical mode is seduction and its ethical mode is marriage? Is it at all meaningful to speak of a religious mode of the erotic in the precise Kierkegaardian sense of the term? Lacan's point is that this is precisely the role of courtly love, in which the lady suspends the ethical level of universal symbolic obligations and bombards us with totally arbitrary ordeals in a way that is homologous to the religious suspension of the ethical; her ordeals are on a par with God's ordering Abraham to slaughter his son Isaac. And contrary to the first appearance that sacrifice reaches here its apogee, it is only at this point that we finally confront the Other qua thing that gives body to the excess of enjoyment over mere pleasure. If the aesthetical endeavors to seize the full moment end in fiasco and utter loss, paradoxically, the religious renunciation, the elevation of the lady into an untouchable and unattainable object, leads to the trance of enjoyment that transgresses the limits of law.

And is not this extreme point at which radical ascetic renunciation par-
adoxically coincides with the most intense erotic fulfillment the very topic
of Wagner's *Tristan?* One can also see why Nietzsche was right in claiming
that *Parsifal* is Wagner's most decadent work and the antithesis to *Tristan.*
In *Parsifal,* the normal, everyday life totally disappears as a point of refer-
ence—what remains is the opposition between hysterically overexcited chro-
matics and asexual purity, the ultimate denial of passion. *Parsifal* thus of-
fers a kind of spectral decomposition of *Tristan:* In it, the immortal longing
of the two lovers, sexualized and simultaneously spiritualized to extremes,
is decomposed into its two constituents, sexual chromatic excitation and
spiritual purity beyond the cycle of life. Amfortas and Parsifal, the suffering
king who cannot die and the innocent pure fool beyond desire, are the two
ingredients that, when brought together, give us Tristan.

We can see now in what precise sense *Tristan* embodies the aesthetic
solution: Refusing to compromise one's desire, one goes to the end and will-
ingly embraces death. *Meistersinger* counters it with the ethical solution
that true redemption resides not in following immortal passion to its self-
destructive conclusion; rather, one should learn to overcome it via creative
sublimation and to return, in a mood of wise resignation, to the daily life of
symbolic obligations. In *Parsifal,* finally, the passion can no longer be over-
come via its reintegration to society in which it survives in a gentrified form;
one has to deny it thoroughly in the ecstatic assertion of the religious *jouis-
sance.* The triad of *Tristan, Meistersinger,* and *Parsifal* thus follows a precise
logic: *Meistersinger* and *Tristan* render the two opposite versions of the Oedi-
pal matrix, within which *Meistersinger* inverts *Tristan* (the son steals the
woman from the paternal figure; the passion breaks out between the pater-
nal figure and the young woman destined to become the partner of the young
man), whereas *Parsifal* gives the coordinates themselves an anti-Oedipal
twist—the lamenting wounded subject is here the paternal figure (Amfor-
tas), not the young transgressor (Tristan). (The closest one comes to lament
in *Meistersinger* is Sachs's *"Wahn, wahn!"* song from Act III.) Wagner
planned to have Parsifal visit the wounded Tristan in the first half of Act III,
but he wisely decided against it. Not only would the scene have ruined the
act's perfect overall structure, but it would also have staged the impossible
encounter of a character with (the different, alternate reality, version of) it-
self, as in a time-travel science fiction narrative. One can even bring things
to the ridiculous here by imagining the third hero joining the two—Hans
Sachs (in his earlier embodiment as King Mark, who arrives with a ship prior

to Isolde)—so that the three of them (Tristan, Mark, Parsifal), standing for the three attitudes, debate their differences in a Habermasian undistorted communicational exchange.

This triad of *Tristan, Meistersinger,* and *Parsifal* presupposes the notion of woman as the object of exchange between men, whose logic was elaborated by Lévi-Strauss in his *Structures elementaires de la parente* (1949). Already the first truly Wagnerian opera, *The Flying Dutchman* is about the exchange of Senta between her father and the Dutchman—a false exchange, for sure, because instead of the young hunter Erik, her normal partner, Senta gets the incestuous Dutchman about whom she was dreaming and who is more her father's colleague. The final catastrophe occurs because the dream that haunted her is realized; it is as if Eva in *Meistersinger* were to marry Hans instead of Walter.[3] And the three operas on which we focused stage the three versions of how the normal exchange can be disturbed:

- In *Tristan,* the exchange fails, and the mediator takes over the bride. Responsible for this failure is the fact that the exchange itself was wrong: Isolde is given to a wrong man (to the paternal figure); in other words, Tristan *should* have been Isolde's partner in a normal exchange. What, however, would have happened in that case? The answer is simple: If their love were to be left free to realize itself in a marital link, deprived of its transgressive dimension, Tristan and Isolde would have been an ordinary couple, with Isolde engaged in transgressive dreams about whom? About King Mark, of course, which brings us to the next opera.

- In *Meistersinger,* the exchange is normal, and the winner of the song contest gets Eva; however, in her incestuous outburst in Act III, Eva makes it clear that her true love is the paternal Hans Sachs himself (who, in answer to her outburst, compares himself explicitly to the unfortunate Mark!).

- Finally, in *Parsifal,* Kundry is the object of exchange, manipulated by Klingsor. Is Klingsor not a kind of false father who offers Kundry to men not to redeem them but to destroy them? In a kind of mocking synthesis of *Tristan* and *Meistersinger,* Kundry is offered first to the older Amfortas (that is, Mark-Hans) and then to the younger Parsifal (Tristan-Walter). Klingsor, who wins the first time, is vanquished when no exchange takes place, because Kundry's advances are rejected by Parsifal.

This, then, is how we are to interpret Wagner. The meaning of *Tristan* becomes visible when we establish the connection between it and the two

other musical dramas (in short, when we apply to it the structural interpretation of myths elaborated by Claude Lévi-Strauss, himself a great Wagnerian).[4] What really matters is not the pseudoproblem of which of the three solutions reflects Wagner's true position (did he really believe in the redemptive power of the orgasmic *Liebestod*? Did he resign himself to the necessity of returning to the everyday world of symbolic obligations?) but the formal matrix that generates these three versions of redemption. What defines Wagner's position is not any of the three determinate solutions but the underlying deadlock to which these three operas (*Tristan, Meistersinger, Parsifal*) each provide their own solution, the unstable relationship between the ethical universe of socio-symbolic obligations (contracts), the overwhelming sexual passion that threatens to dissolve social links (the aesthetic) and the spiritualized self-denial of the will (the religious). Each of the three operas is an attempt to compress this triangle into the opposition between two elements: between spiritualized sexual passion and the socio-symbolic universe in *Tristan*, between sexual passion and the spiritual sublimation of socialized art in *Meistersinger*, between sexualized life and pure ascetic spiritualism in *Parsifal*. Each of these three solutions relies on a specific musical mode that predominates in it: the chromaticism of *Tristan*, the choral aspect of *Meistersinger*, the contrast between chromaticism and static diatonics of *Parsifal*.

Kundry's Laughter...

Why, then, is Parsifal's ascetic renunciation false? The reference to Nietzsche is crucial here: Nietzsche was not against asceticism as such but against asceticism secretly grounded in envy. That is to say, what Nietzsche and Freud share is the idea that justice as equality is founded on the envy of the Other who has and enjoys what we do not have; the demand for justice is thus ultimately the demand that the Other's excessive enjoyment should be curtailed so that everyone's access to *jouissance* is equal. The necessary outcome of this demand, of course, is asceticism; because it is not possible to impose equal *jouissance*, what one can impose is only the equally shared prohibition. However, one should not forget that today, in our allegedly permissive society, this asceticism assumes the form of its exact opposite, of the generalized superego injunction to enjoy. We are all under the spell of this injunction, with the outcome that our enjoyment is more hindered than ever—consider the yuppie who combines narcissistic self-fulfillment with

the utter discipline of jogging, eating health food, and so on. This, perhaps, is what Nietzsche had in mind with his notion of the Last Man—it is only today that we can really discern his contours in the guise of the hedonistic asceticism of yuppies. Nietzsche thus does not simply urge life assertion against self-denial; he is well aware how a certain asceticism is the obverse of decadent excessive sensuality—therein resides his criticism of Wagner's *Parsifal* and, more generally, of the late Romantic decadence oscillating between damp sensuality and obscure spiritualism.[5]

So what is envy? From the most elementary case of a sibling envying a brother who is sucking their mother's breast (evoked by Saint Augustine at the beginning of his *Confessions*), the subject does not envy the Other's possession of the prized object as such but rather the way the Other is able to enjoy this object. This is why it is not enough for him simply to steal and thus gain possession of the object; his true aim is to destroy the Other's capacity to enjoy the object.[6] As such, envy is to be located in a triad with thrift and melancholy, the three forms of not being able to enjoy the object (and, of course, reflexively enjoying this very impossibility). In contrast to those who envy the Other's possession or *jouissance* of the object, the miser possesses cannot consume it—his satisfaction derives from just owning it, elevating it into a sacred, untouchable, and prohibited entity that should under no conditions be consumed (recall the proverbial figure of the lone miser who upon returning home, locks the doors, opens up his chest, and then takes a secret peek at his prized object, observing it in awe); this very hindrance that prevents the consummation of the object guarantees its status as an object of desire. The melancholic subject, like the miser, possesses the object but loses the cause that made him desire it; this figure, the most tragic of them all, has free access to all he wants but finds no satisfaction in it.

The common topic of leftist (psycho)analysis of fascism is how the people's submission, their renunciation of pleasure, is bought by the perverse pleasure generated by this submission itself: Beneath the totalitarian call "Enough of pleasure! Sacrifice yourself!" one should discern the hidden superego injunction "Enjoy!" Is not the ultimate proof of this Joseph Goebbels's infamous "Total War" speech in Sportpalast, Berlin, on February 18, 1943, culminating in a series of rhetorical questions, to which the gathered crowd answered with a frenzied, stomping "YES!" All his questions ("Do you want theaters and restaurants to be closed [and so on and so on] to achieve total mobilization?") ultimately asked for the same thing—more renunciations: "Do you want a total war—more total and radical than we can

even imagine today?" However, one should also take into account its opposite, that is, the paradox that emerges in our allegedly permissive, hedonist, liberal societies in which subjects are directly called to enjoy (to organize their life around the use of pleasures, to realize the inner potentials of their self). Far from being a spontaneous rule of pleasures, the result is a globalized asceticism; to really enjoy yourself, you have to submit to a strict diet, avoid smoking and drinking, jog regularly, and shun sexual and other harassments so as to not frustrate others in their enjoyment.

The opposition we are dealing with here is, of course, none other than that between *Gemeinschaft* (community) and *Gesellschaft* (society). Because the obvious ideological aim of *Parsifal* is to reinstate community against the alienated society, one should be careful not to accept this opposition as self-evident: What is *Gemeinschaft* as opposed to *Gesellschaft*? When does one belong to a community? The difference concerns the netherworld of unwritten obscene rules that regulate the community's inherent transgressions, the ways we are allowed or expected to violate its explicit rules. This is why the subject who closely follows them will never be accepted by its members as one of the gang: she does not participate in the transgressive rituals that effectively keep the community together. And society, as opposed to community, is a collective that can dispense with this set of unwritten rules—because this is impossible, there is no society without community. This is where the theories that advocate the subversive character of mimicry get it wrong; according to these theories, the properly subversive attitude of the Other—say, of a colonized subject who lives under the domination of the colonizing culture—is to mimic the dominant discourse but with a distance, so that what he does and says is like what the colonizers themselves do...almost...with an unfathomable difference that makes his Otherness all the more palpable. One is tempted to turn this thesis around: The foreigner who emulates faithfully the rules of the dominant culture he wants to penetrate and with which he wishes to identify who is condemned forever to remain an outsider because he fails to practice, to participate in, the self-distance of the dominant culture, the unwritten rules that tell us how and when to violate the written ones. We are "in," integrated in a culture, only when we succeed in practicing this distance.[7] This, then, is how one should perceive the Grail community at Montsalvat: as a closed circle engaged in the obscene ceremony of disclosing their shared secret, a ceremony closer to a Satanist Black Mass than to a Christian ritual—an uncanny opera "midway between Mass and orgy,"

in which the consecration of a theater turns into the desecration of a church (see Conrad 1989: 183).

On the other hand, one should be careful not to succumb to the liberal temptation of condemning all collective artistic performances as inherently totalitarian.[8] Both the *Thingspiel* in the early Nazi years and Bertolt Brecht's learning plays *(Lehrstuecke)* involved a mass ideologico-aesthetic experience (of songs, speeches, and acts) in which spectators themselves served as actors—does this mean that the Left in the 1930s participated in the same proto-Fascist totalitarian experience of the regressive immersion into pre-individual community as Nazism (the thesis of, among others, Siegfried Kracauer)? If not, does the difference reside in the fact that the Nazi *Thingspiel* staged a pathetic-emotional immersion, whereas Brecht aimed at a distanced, self-observing, reflected process of learning? However, is this standard Brecht-ian opposition of emotional immersion and reflexive distance sufficient? Let us recall the staged performance of "Storming the Winter Palace" in Petro-grad on November 7, 1920, the third anniversary of the October Revolution. Tens of thousands of workers, soldiers, students, and artists worked round the clock, living on kasha (the tasteless wheat porridge), tea, and frozen ap-ples and preparing the performance where the event had really taken place three years earlier; their work was coordinated by army officers as well as by avant-garde artists, musicians, and directors, from Malevich to Meyerhold. Although this was acting and not reality, the soldiers and sailors were play-ing themselves—many of them had not only actually participated in the rev-olution but were also involved at that time in the real battles of the civil war that were raging in near Petrograd, a city under siege and suffering from se-vere shortages of food. A contemporary commented on the performance: "The future historian will record how, throughout one of the bloodiest and most brutal revolutions, all of Russia was acting" (Buck-Morss 2000: 144); the for-malist theoretician Viktor Shklovski noted that "some kind of elemental pro-cess is taking place where the living fabric of life is being transformed into the theatrical" (Buck-Morss 2000: 144). We all remember the infamous, self-celebratory May Day parades that were one of the hallmarks of Stalinist regimes—if one needs a verification that Leninism functioned in an entirely different way, are not such performances the supreme proof that the October Revolution was definitely not a simple coup d'etat by a small group of Bol-sheviks but an event that unleashed a tremendous emancipatory potential?

So, back to *Parsifal*: what is wrong with it is not the collective ritual as such but its flavor of an obscene secret ceremony. Like every compulsive

ritual, it is a defense formation—a defense against the real of feminine de-
sire. In his perspicuous Lacanian interpretation, Michel Poizat reads *Parsi-
fal* as telling the story of the closed incestuous community, immobilized by
the *jouissance* of the privileged object-thing (Grail), which is derailed when
Amfortas, its leader, succumbs to feminine seduction; Parsifal's function is
then to heal the wound and thus reestablish the closed circle of the Grail
community.[9] Parsifal and Klingsor, Kundry's master, stand for the two op-
posing ways to avoid the encounter of the desiring woman and its castrative
effect: Parsifal renounces desire, rejects the woman, and closes himself to
the encounter, whereas Klingsor avoids this encounter by literally castrat-
ing himself to be able to resist Kundry's advances and thus to be able to func-
tion as her master, indifferent to her charms. Wagner's admiration of *The
Oresteia* is well known—is it then too daring to suggest that the model of
Parsifal's rejection of Kundry is Orestes' murder of Clytemnestra, his mother?
Here is how Aeschylus renders his words:

> Quickly! Listen to me! One last time!
> It carries me away!
> I sit in a chariot,
> but I do not drive.
> It is the horses
> who hold the reins.
> I have no more power over them,
> I...can...not...think.
> Think? No! Someone else
> Is thinking for me!
> And deep in the heart sits fear
> and sings and begins to dance.
> Therefore, so long as I am in my right senses
> —am I still in my right senses?—
> It was just that I killed my mother,
> the woman abhorred by the god—
> a horror hated by the earth!"
> (Wolf 1988: 222–223)

Is this not the most concise description of an autonomous, free act that
the subject cannot ever assume or subjectivize, which is necessarily experi-
ence as a foreign body, as something in one more than oneself that acts

through one? Do these lines not therefore point toward what Kierkegaard called the *madness* of an actually free decision? In his *Adieu a Emmanuel Levinas*, Derrida tries to dissociate the decision from its usual metaphysical predicates (autonomy, consciousness, activity, sovereignty) and to think of it as the Other's decision in oneself: "The passive decision, condition of the event, is always, structurally, an other decision in me, a rending decision as the decision of the other. Of the absolutely other in me, of the other as the absolute who decides of me in me" (Derrida 1997: 87). The difference between Orestes and Parsifal, of course, is that their respective acts are clearly opposed with regard to their scope; although, in both cases, the feminine is rejected, Orestes's murder marks the rupture with the maternal-feminine, the installment of the paternal law, whereas Parsifal cast off the woman's desire on behalf of the maternal-feminine. For this reason, Orestes has to kill a woman (his mother); in the case of Parsifal, we are dealing with a negative gesture of shirking. For this reason also, it is only Orestes who commits a true act: Parsifal's gesture is ultimately a nonact, a withdrawal from the reality of the Other's desire. What, then, is so threatening in Kundry?

In his *Phenomenology of Spirit*, Hegel introduces his notorious notion of womankind as "the everlasting irony of the community": womankind "changes by intrigue the universal end of the government into a private end, transforms its universal activity into a work of some particular individual, and perverts the universal property of the state into a possession and ornament for the family" (Hegel 1977: 288). These lines fit perfectly the figure of Ortrud in Wagner's *Lohengrin*: for Wagner, there is nothing more horrible and disgusting than a woman who intervenes into political life out of a desire for power. For Hegel and Wagner, in contrast to men, an ambitious woman wants power to promote her own narrow family interests or, even worse, her personal caprice, incapable as she is of perceiving the universal dimension of state politics. How are we not to recall F.W.J. Schelling's claim that "the same principle carries and holds us in its ineffectiveness which would consume and destroy us in its effectiveness" (1946: p. 13; translation quoted from Bowie 1993: 105)? This power, when kept in its proper place, can be benign and pacifying, but it turns into its radical opposite, into the most destructive fury, the moment it intervenes at a higher level, the level that is not its own: the same femininity that, within the closed circle of family life, is the very power of protective love, turns into obscene frenzy when displayed at the level of public and state affairs. In short, it is okay for a woman to protest the state's power on behalf of the rights of family and kinship, but

woe to a society in which women endeavor directly to influence decisions concerning the affairs of state, manipulating and effectively emasculating their weak male partners, (as Ortrud does in *Lohengrin*). And are Isolde and Kundry not the two further versions of this "everlasting irony" that leads to the dissolution of the social link? Isolde is the opposite of Ortrud; instead of operating within the social structure, intervening in the power struggle by way of manipulating the (male) hero, she entices Tristan to step out of this realm of the day into the abyss of the night. Kundry, however, occupies a third position, neither intervening in the edifice of power nor simply longing to step out of it and obliterate herself, but literally functioning as its everlasting irony, mockingly undermining its authority.

The main sign and weapon of Kundry's subversive irony is her laughter, so it is crucial to probe into its origins; the primordial scene of laughter is the Way of the Cross where Kundry was observing the suffering Christ and laughing at him. This laughter then repeats itself again and again apropos of every master Kundry served (Klingsor, Gurnemanz, Amfortas, Parsifal). She undermines the position of each of them by means of the surplus knowledge contained in her hysterical laughter that reveals the fact that the master is impotent, a semblance of himself. This laughter is thus profoundly ambiguous: it stands not only for making a mockery of the Other but also for despair at herself, that is, for her repeated failure to find a reliable support in the master. The question that one should raise here is that of the parallel between Amfortas's and Christ's wound: What do the two have in common? In what sense is Amfortas (who was wounded when he succumbed to Kundry's temptation) occupying the same position as Christ? The only consistent answer, of course, is that *Christ himself was not pure in his suffering:* When Kundry observed him on the Way of the Cross, she detected his obscene *jouissance*, in other words, the way he was "turned on" by his suffering. What Kundry is desperately searching for in men is, on the contrary, somebody who would be able to resist the temptation of converting his pain into a perverse enjoyment.

...and Her Kiss

The unique achievement of *Parsifal* is to unite, in the figure of Kundry, the two traditionally opposite figures (which, in his early *Tannhäuser*, are kept apart): the devastating seductress and the angelic redemptrix—or, as Wagner put it in his famous letter to Mathilde Wesendonck from August 1860:

"Have I already told you that the fabulous, savage messenger of the Grail has to be one and the same as the seductress in the second act? Since that dawned upon me almost everything to do with it has become clear to me" (quoted in Dahlhaus 1979: 152–153). The motto from the finale of *Parsifal*, "the wound is healed only by the spear that smote you," holds also and especially for Kundry.[10] This fact that the identity of Kundry has popped up as a solution is to be taken literally; Kundry's "secret" is that she does not stand for the psychological unity of a real person but for an artificial composite invented to resolve a certain (narrative and, simultaneously, ideological) deadlock. The first to describe this logic in detail was Claude Lévi-Strauss, in his famous analysis of the facial decorations of the Caduveo Indians; he begins by identifying, in purely visual terms, the antagonistic tension of a "complicated situation based upon two contradictory forms of duality, and resulting in a compromise brought about by a secondary opposition between the ideal axis of the object itself /the human face/ and the ideal axis of the figure which it represents" (1971: 176). He then goes on to interpret this visual dynamics as the imaginary solution for the unresolved antagonism and imbalance of their social structure: an attempt to supplant the imbalance of the emerging hierarchical distinctions, insurmountable in their own terms, by displacing them onto "horizontal" division of the tribe into groups—at this level, the imaginary compromise can at least be staged.

And was it not the same with Heidegger in 1933? The primary opposition there was also the class distinction, and the secondary opposition was the one between Heidegger's attachment to the traditional local community and his commitment to Nazism as a modern mass political movement. How, then, did Heidegger try to resolve this double tension? Karl Löwith reports that in 1933, Heidegger attracted the attention of bypassers with the "queerness of his clothes: a kind of Schwarzwald peasant jacket with wide lapels and a half-military collar, accompanied by knickerbockers, both made from a dark-brown cloth...a unique compromise between the ordinary local attire and the S.A. uniform" (1986: 43). Is this not the exact equivalent to the facial decorations of the Caduveo Indians? Did Heidegger not first displace the class antagonism onto the antagonism between folk roots and modern mass movement and then try to resolve their tension by enacting on his body itself their utopian reconciliation in his clownish attire that combined the two dimensions? The figure of Kundry follows the same logic; she had to be invented to provide an imaginary solution that allowed Wagner to bring *Parsifal* to conclusion.

So, when, after receiving Kundry's kiss, Parsifal pushes her away with the cry "Amfortas! The wound!" signaling his compassionate identification with the suffering Amfortas (a scene that, incidentally, cannot but provoke laughter in today's audiences), Poizat is fully justified in conceiving this identification of Parsifal with Amfortas in the moment of Kundry's kiss along the lines of science fiction stories in which, to paraphrase *Hamlet*, the time is out of joint and the hero sets it right by traveling back to the moment when things took the wrong turn (for example, when Hitler was born) (1998: 121). We are thus here as far from Hegel as possible, even if Wagner's "the wound is healed only by the spear that smote you" may sound vaguely Hegelian. When Hegel says that "knowledge heals the wound it itself is"*(Erkennen heilt die Wunde, die es selber ist),* his idea is that the split introduced by knowledge into our being (the loss of innocence, of the immersion into immediate life, that is, the rise of the reflexive distance of consciousness, of the gap between subject and object, between thought and act) is itself its own self-sublation: We overcome the limitation of our knowledge when we become aware of how the wealth of the pseudo-concrete sensual content that we lose in the passage from direct experience to notional knowledge is in itself null, worth losing. Hegel's point is thus not to regain what was lost but *to accept the loss itself as liberating.* In contrast to Hegel, Wagner's Parsifal does not sublate the Fall in a later reconciliation-through-synthesis; rather, he travels back in time to retroactively undo the Fall. In short, the Wagnerian formula "the wound is healed only by the spear that smote you" means that the only way to undo the Fall (the wrong turn of the events) is to return back to the moment of the wrong decision and to *repeat* the choice, this time making the right decision. However, what Wagner does not take fully into account is the very necessity of this repetition: Parsifal's right decision can only take place as a repetition, after Amfortas, in his first choice, made the wrong one. And, perhaps, therein resides the core of the Wagnerian fantasy, Wagner's ultimate retreat from the real: Instead of endorsing the wound, reconciling himself with it, he sticks to the dream of fully undoing it—here is his famous rendering of Tristan and Isolde's predicament:

> Thanks to the potion their passion suddenly flares up and they have to confess mutually that they belong only to each other. And now there were no bounds to the longing, the desire, the bliss and the anguish of love: the world, power, fame, glory, honor, chivalry, loyalty, friendship, all swept away like chaff, an empty dream; only one thing

is left alive: yearning, yearning, insatiable desire, ever reborn—languishing and thirsting; the sole release—death, dying, extinction, never more to wake! (Dahlhaus 1979: 150)

The trouble with this confused Buddhist vision is clear: In it, the *three* levels (the daily world of symbolic obligations, the insatiable desire, and the eternal peace) are squeezed into *two*.[11] The principal tension is not that between the day and the night but that inherent to night itself, between longing and peace; it is the very longing for peace that forever disturbs our daily routine, preventing us from finding peace in our lives. So, in a Hegelian way, one should claim that the day had to be invented for us to sustain the inherent deadlock of the longing for peace. Or, to put it in a slightly different way, the obstacle of the day, of socio-symbolic conventions, is necessary for metaphysical longing to flare up—in reconciliation, "the negative force recognizes in what it fights its own force" (Hegel 1969: 174), that is to say, the night has to recognize its own condition of possibility in the obstacles posed by the obligations of the day.

One should distinguish two phases of Kundry's advances in the great Act II duet: first, Kundry tries to seduces Parsifal from the position of the evil femme fatale who intends to devour her victim. At the end of this first phase, Parsifal resists Kundry by means of his identification with Amfortas's wound: at the very moment of her kiss, he retreats from her embrace, shouts "Amfortas! The wound! The wound!" and seizes his thighs (the site of Amfortas's wound)—this comically pathetic gesture is a clear case of *hysterical* identification, a step into the hysterical theater. (See Bronfen 1996.) The true hysteric of the opera, of course, is Kundry herself, and it is as if Parsifal's very rejection of her contaminates him with hysteria as well. After the kiss and Parsifal's rejection of it, Kundry's second approach is therefore totally different—no longer is she the femme fatale playing cruel games but a real desiring woman desperately in love with Parsifal. Instead of flirting with the incestuous identification with Parsifal's mother, she now opens up to him the very core of her trauma, the original sin that turned her into an undead specter desperately looking for a savior. This is why Kundry's outburst of rage at the end of the duet is in a way justified as the reaction of a loving woman deeply hurt by the cruel and cold rejection of her sincere offer. The parallel with *The Magic Flute* is here crucial: If *Parsifal* were to be a normal Oedipal opera, one rejection would have been enough; that is, Parsifal would have been allowed to accept Kundry the second time because he would be

dealing with a woman who accepted the symbolic law (in the same way that Tamino is allowed to accept Pamina after she sustains the ordeal of his silence and rejection). Parsifal is thus unable to accomplish the normalizing gesture of renouncing the fantasmatic feminine to gain access to the real woman's love. Instead, he immerses himself in the bliss of the fantasmatic feminine by way of rejecting the real of the woman's desire.

The opposition between an actual woman and the feminine is brought to an extreme here: The former drops dead (Kundry is silenced by the end of Act II and reduced in Act III to a half-catatonic mute presence whose only words are "To serve! To serve!" and whose only act is to wash Parsifal's feet with her own hair at the ceremony of his anointment), while the latter triumphs. What is crucial here is the thorough ambiguity of the feminine reference. On the one hand, woman is the external intruder who disturbs the closed circle of male community—the encounter of a woman stands for the encounter of the reality of the Other's desire in all its traumatic opacity; on the other hand, however, breaking the circle, introducing division, is a male act par excellence, whereas the feminine is identified with the harmonious whole of the substantial ground prior to its disturbance by means of the subjective act—when the circle is closed again, when we return to the harmonious balance, is this not equal to the return to the safe protective haven of the feminine?

Wagner's ambiguous relationship toward the feminine—the cause of man's Fall as well as his redemptrix—should, of course, be placed in the context of the long German tradition, which found its supreme expression in the very last lines of Goethe's *Faust*: "*Das Unbeschreibliche / Hier ist's getan; / Das Ewig-Weibliche / Zieht uns hinan*" (a paraphrase: "What cannot be described / Is here accomplished; / The eternal feminine / Draws us up toward itself").[12] In Goethe, this eternal feminine appears in the guise of saintly figures withdrawn from active life, whose very immobility moves men to act, from Iphigenia to Ottilie in *The Selective Affinities*;[13] what is still missing here, what is only implied and not yet explicitly posited, is its destructive dimension.[14] And is this dimension, this excess of life in its connection with death, not the very stuff, the minimal definition, of Romanticism?[15] Novalis had already written "Hymns to the Night," which contains the idea that ultimate fulfillment can be found only in the self-obliterating immersion into the night.[16] This transgressive matrix of love found its first clear expression in the notion of courtly love: the idea that a love relationship inherently tends toward an oblivion that suspends the universe of sym-

bolic obligations. This Romantic notion of love involves the claim that marriage is contrary to truly passionate love and is, in fact, its worst enemy, an institution violently imposed on love by state and church for the purposes of ideological control and transference of private property. The interesting point here is that this celebration of extramarital love, far from involving antireligious hedonism, can experience and present itself as a quasi-religious suspension of the moral link of marriage.[17]

The first to provide the highest philosophical expression to this disturbance in the status of femininity was Schelling (1987), who distinguished between (logical) existence and the impenetrable ground of existence. Schelling's opposition of the proto-ontological real of drives (the ground of being) and the ontologically and fully constituted being itself (which, of course, is gendered in terms of the feminine and the masculine: the feminine protoreality versus the masculine fully constituted real) thus radically displaces the standard philosophical couples of nature and spirit, the real and the ideal, existence and essence, and so on. This notion is crucial not only with regard to the history of ideas but even with regard to art and our daily experience of reality. Recall the protracted stains that make up the yellow sky in the later works of van Gogh or the water or grass in Munch; this uncanny massiveness pertains neither to the direct materiality of the colored stains nor to the materiality of the depicted objects—it dwells in a kind of intermediate spectral domain of what Schelling called *"geistige Koerperlichkeit,"* spiritual corporeality.

No wonder, then, that Schelling was also the first and only to elevate art into the highest expression of the absolute, higher than philosophy, which remains within the confines of the opposition between subject and object. One is tempted to claim that this obsession with the eternal feminine as the dark background of male reason provides the key to German art. From Goethe onwards, the German attitude toward women reflects a perturbation, something stronger than the standard discord that constitutes the impasse of sexual relationship. The eternal feminine enters the stage as the placebo, the abyssal background of male identity, the ambiguous threatening-protective foundation, which then provokes a multitude of reactions, from trusting reliance to paranoiac refusal (in, say, Otto Weininger). Is this eternal feminine not also the support of the specifically German notion of the self-destructive artistic genius? Does it not sustain the German notion of sexual life (or, rather, life itself) as something rotten and sick that finds its culmination in death or outright self-destruction (see Thomas Mann's *Death in Venice*)?[18] Even Bertolt

Brecht, the very opposite of this damp Romantic obsession with lethal sexu-
ality, reacts to this idea in his own way—see, for example, his posthumously
published erotic poems, which present two features of his attitude toward the
sexual act: his opposition to simultaneous orgasm as too close to mystical
self-immersion, his preference for "first I do it to you, then you do it to me";
and his obsessive belief that, after (not before) sexual commerce, one should
take a bath, as if to wash off the filth. And does this reference to the eternal
feminine not also sustain Wagner's scenario of the culmination of love in
Liebestod, a climactic self-obliteration in which all distinctions disappear?

The link between Wagner and Heinrich von Kleist (see Maar 2000) is in-
dicative here, insofar as Kleist brought to its extreme the Romantic notion
of unconditional love to death: Not only is there a direct connection (Wag-
ner's uncle, the crucial influence in his formative years, was a literary critic
who was the only public figure in Germany to defend Kleist after his suicide
and introduced the young Richard to him) and not only do lines in the li-
bretto of *Tristan* repeat verbatim Kleist's suicide note but also the *Liebestod*
in Wagner's *Tristan* could be read as a kind of repetition that attempts to
pacify the truly traumatic dimension of the ultimate Kleistian *Liebestod* in
Penthesilea, arguably Kleist's most unsettling play, even today often avoided
and dismissed as disgusting—the line that separates the beautiful from the
disgusting is here definitely violated.[19] The *Liebestod* in *Penthesilea* gives a
literal twist to the pathetic words of the two lovers about becoming one, im-
mersing themselves in each other; Penthesilea literally cuts Achilles, her
love, to pieces, reducing him to a *corps morcele*; devours the pieces; and then
kills herself.[20] Not only do we thereby make a shift from the Wagnerian ec-
statically hypnotic sublime to the domain of disgust and not only is Achilles,
the object of love, openly asserted as *das feindliche Objekt*; Kleist also clearly
renders the ultimate failure of this Dionysiac reunion: "Even though she
chews him up, she fails, as she must. Penthesilea can never strike Achilles
where she intends to, for to do so would pull the rug out from under her own
feet" (Chaouli 1996: 138). This precise formulation cannot but recall Lacan's
description of Hamlet's predicament apropos of his obligation to kill the king:
how to do it so that his strike will hit also the *objet a*, the thing that is in
the king. The *objet a*, although the remainder of that which is real external
to the symbolic, can emerge as the inherent excess only within the symbolic
field itself, so that when we strike at the reality of the body, we by defini-
tion always miss the thing that eludes us (the same was with Jews in the
Nazi universe: the more their biological bodies were destroyed, the more

powerful remained the specter of the Jew). In short, Penthesilea is the victim of a kind of Kantian transcendental illusion, confusing the reality of the biological body with the real of the thing. This horror, disgust even, and this failure are the truths from which Wagner retreated in his fantasy of the blissful immersion into the night.[21]

The Feminine versus Woman

The fantasmatic feminine, the destructive abyss that threatens to swallow the male subject who succumbs to its siren's voice, is the same as the sublime bliss of the spiritual feminine promising peace eternal—*this* is what Wagner meant when he asserted the identity of Kundry the Seductress with Kundry the Redemptrix, *this* is how "the wound is healed only by the spear that smote you": although the destructive, lethal woman-thing wounds the (male) subject, it is only its own obverse, the pacifying eternal feminine, that can heal the wound. The difference between *Tristan* and *Parsifal* is that in *Tristan*, the real woman also sustains the immersion into the eternal feminine, whereas in *Parsifal*, the eternal feminine is reached through the rejection of the real woman. It is significant that the text on which Wagner was working in the days prior to his death in Venice was "On the Feminine in the Human"—it was while writing it that he was taken by a heart attack and died (at midday on February 13, 1883). The essay's main thesis is a rather conventional one: The oppression of women is a symptom of the history of humanity's degeneration; woman is the victim of power structures determined according to masculine principles and reproduction, of the system of ownership in whose interests marriages are arranged and families founded; female emancipation thus forms part of the regeneration of the human race. What then follows, however, is a specifically Wagnerian twist: first, Wagner refers to Buddha who, in his late years, revoked his exclusion of women from the possibility of sainthood, and then he qualifies this opening toward the feminine with the very last words he wrote, while already feeling the seizure coming: "However, the process of the emancipation of women only proceeds in ecstatic convulsions. Love—Tragedy" (Wagner 1972, 8: 398). Was not what took place at this moment, when the pain of the heart attack made itself felt, the identification of Wagner with Kundry herself, with her "ecstatic convulsions"?

It is here, at this crucial juncture, that Poizat falls short by way of relying on the opposition between the access to the libidinal object mediated by

the symbolic law and the direct confrontation with the real, which is that of the *jouissance* of the incestuous deadly thing; he reduces the passage from fantasy to the real of feminine desire to the passage from the fascination with the fantasized specter (which occludes the real woman) to opening up to the desire of a real flesh-and-blood woman—ultimately, a simple replacement of the delusive fantasy with the real person accessible through the paternal law. This replacement accounts for the motif of the "lady who vanishes," which, perhaps, found its clearest expression in Veit Harlan's *Die verwehte Spuren* (1938). What makes Harlan's film so interesting is its *difference* from the standard storyline, which also served as a model for Hitchcock's *Lady Vanishes* (from 1939) as well as for Cornell Woolrich's *The Phantom Lady* (filmed by Robert Siodmak in 1942)—interestingly, all of them were made in the late same period. The model for all these stories is an event that allegedly occurred during the Paris World Fair in 1867 to a Canadian mother and her daughter. Feeling tired, the mother went to the hotel room, while the daughter stayed out. When she returned to the hotel, not only had her mother disappeared but also everyone denied her existence. What had been the mother's room was now empty, and workers were there repairing the walls; the hotel personal remembered only the daughter; and the ship and hotel registers showed only her name. After a desperate search, authorities disclosed the truth to the daughter: her mother had died of the plague, and to avoid mass panic, they had to deny her existence.

Although in all other versions (inclusive of the original story itself), our—the spectator's or reader's—perspective is limited to that of the young girl, Harlan strangely opted for disclosing the secret of the mother's disappearance (plague) immediately so that the spectator knows the truth all the time and there is no enigma—the question is only when and how the daughter will learn the truth. Why did he do it? Perhaps to accentuate the obvious Oedipal background of the story: The imposition of the paternal Law erases from the picture the obscene, sick, excessive mother; it cuts the daughter's link with her and thus renders her able to enter a "normal" heterosexual relationship. After the mother, this Mozartean Queen of the Night, returns to her hotel, the daughter goes out and engages in a heavily charged flirt with Dr. Moreau, whom they had met earlier in a street parade. Then, in one of the film's most effective scenes, the shots of the couple-to-be making a date across the hotel balcony and then going together to a wild party on the crowded street are interspersed with the shots of the dying mother, her distorted face full of sweat, desperately shouting her daughter's name ("Serafine!")—as if access to the

male partner is to be paid by mother's death. And when Serafine accepts the doctor's invitation to go out with him, we get a cut to the mother crying "Serafine!" as if admonishing her daughter for her transgression, for abandoning her; then, in a nice detail, mother's last words in this shot—"Mein Gott!"—are literally repeated by the doctor when we cut to the couple in a coach.

The second difference concerns the ending. When Serafine learns the truth, the prefect of the Paris police asks her to do the ultimate citizen's sacrifice—because rumors about her mother have already started to circulate, he implores her to sign the document confirming the lie, stating freely that she came to Paris alone, without her mother. After she does this, she and Dr. Moreau stay in the hospital room, confessing their love to each other now that mother has been officially removed from the picture. (This excessive sticking to the lie for the benefit of society points toward Harlan's authoritarian Nazi credentials.) The path is thus clear: To be fully integrated into the symbolic space of mature relations, the girl has to endorse publicly the lie on which social order is based, obliterating the maternal threat—the film is almost subversive in this admission of how public order has to rely on an untruth.[22]

However, the alternative that underlies this narrative—either deadly fascination with the fantasmatic real of the feminine or access to a real woman mediated by the paternal symbolic law—does not cover the entire field of options. Far from presenting a choice, the two poles depend on each other; in other words, the paternal law sustains itself by the specter of the unbridled, devouring woman-thing that would swallow us without its protective barrier. That is to say, far from enabling us to confront and accept the real of the woman as the desiring Other, as the traumatic impact of encountering the Other's desire, the mediation of the symbolic law functions as a protective shield or filter that domesticates or gentrifies its traumatic impact. Poizat is right to emphasize that the abyssal, fantasmatic real of the feminine that threatens to devour the male subject, is, in its very horror, a defense, an escape from the real of the Other's (woman's) desire. When, in this terrifying image, that reality is posited as impossible (as something that can be achieved only by means of self-obliteration, as something whose encounter is forever postponed), what is thereby occluded is the way in which, in our common daily lives, the supposedly impossible *can* happen—in the magic moments of love, we can encounter the real Other's desire.

The real of the woman's desire is thus encountered neither in the fantasy of the eternal feminine nor in woman reduced to an object of exchange

among men regulated by the symbolic law. When Poizat claims that the only access to the real of the (desiring) woman is through the paternal law, through acceptance of the wound of symbolic castration, this mistake of his leaves its trace in an interesting conceptual confusion: He directly equals the imposition of the paternal law as regulating access to women, the acceptance of "symbolic castration" with "traversing the fantasy." This is how he reads Mozart's *The Magic Flute:* In the course of the opera, Tamino "confronts this fantasy [of the woman-thing], taking the risk of a symbolic death, and of the suffering which originates in it, but which he must assume in order to gain access to desire. He can thus 'traverse' the fantasy and encounter the real woman and her desire" (Poizat 1998: 124). In the course of the opera, Tamino thus passes from fascination with the mere image of the woman given to him by the Queen of the Night, this figure of the unbridled, lawless, lethal *jouissance* of the fantasmatic Mother, to subordination to the paternal law, which enables him the access to a real woman. However, one should not forget that this access to the woman is mediated with the subordination to the paternal law; to regain Pamina, Tamino has to abandon her, refusing to answer her desperate entreaties (during the trial of silence) and thus pushing her to the very border of suicide! In other words, he gets Pamina after he demonstrates that he is ready to abandon her.

Of course, Poizat would have pointed out that he is far from confusing fantasy and the real—in his own words, "the function of this fantasmatic elaboration [of the Feminine as the destructive abyss of excessive and unbridled *jouissance*] is precisely to protect the man from encountering the real, desiring, woman" (1998: 119). Or, as he puts it even more concisely a couple of pages later: "*Parsifal* puts together an entire fantasmatic organization of the feminine, whose permanent aim, behind the appearance of the search for the feminine, is to carefully spare us the trouble of 'getting to know' the feminine" (121)—the verb *to know,* of course, is to be read here in its biblical double meaning: having sex with the woman *and* effectively acquainting oneself with her. Is, however, this encounter of the feminine really possible only through the mediation of the paternal symbolic law? Significantly, Poizat oscillates between two notions of the real: the presymbolic real of the excessive, impossible *jouissance,* embodied in the lethal, incestuous woman-thing, and the real of woman as the desiring Other. But does this very opposition not stand for the two ways to avoid the encounter of the real of the Other's (woman's) desire? Here, Poizat's misreading is fatal: Amfortas's wound does not stand for symbolic castration (Poizat 1998: 120) but,

quite on the contrary, for the remainder that resists castration-symbolization, for what Lacan called "lamella," for the real of an undead partial object, of the embodiment of the excessive *jouissance* (*objet petit a* as *plus-de-jouir*) that insists, resisting its integration into the symbolic reality.

Furthermore, this misperception also prevents Poizat from locating the true source of the disturbance in the Grail community: Contrary to the misleading appearances, it is not Amfortas's succumbing to Kundry's advances that sets in motion the catastrophe but Amfortas's horrifying superego father Titurel's excessive attachment to the Grail. Titurel turns into a monstrous undead specter who lives off the rays of the Grail. In short, what goes wrong is not the external intrusion of the desiring Other that introduces a gap into the circle but the internal excess of drive, of its excessive and suffocating fixation on the thing-*jouissance*. Because of this, there is effectively a change at the end of the opera; in contrast to Poizat, who reads the finale as a simple reestablishment of the balance that was disturbed by the intrusion of the desiring Other, one should take note of how Parsifal, when he takes over the Grail community, *changes its rules*, announcing that from now on the Grail will remain forever revealed to the public. And it is also because of this that Poizat's rejection of those stagings that discern in the finale a kind of reassertion of—or, rather, an opening toward—the feminine, falls short: Prior to Parsifal's reign, the Grail community was effectively a self-enclosed male circle, whereas he opens it toward the feminine.[23] Consequently, what one should focus on is rather the relationship between woman and the wound.

Rilke's quote about the beautiful being the beginning of the Horrible goes on: "Because, with indifference, it / the beautiful / delivers us to decay"—a concise characterization of what happens in Mann's *Death in Venice*, in which the blissfully indifferent specter of the beautiful Tadzio drags the narrator toward moral and physical disintegration. What an abyss separates this late Romantic decadent ideology of pleasure-in-decay from, say, the undead wound in "A Country Doctor," Kafka's key story and, for that very reason, definitely not among his best ones. It is all too directly delirious, lacking the cold, austere precision of his great texts, their strange realism that makes his universe all the more uncanny.[24] "A Country Doctor" reads straightaway as a nightmarish dream, which is why it can allow itself to render directly the fantasies underlying Kafka's universe. In deep cold winter, a country doctor and his young maid Rosa are desperately looking for a horse carriage that could take the doctor to a patient at a lone farm.

All of a sudden, the doctor senses a warmth and smell of horses in the abandoned pigpen at his backyard—and, for sure, there is a strong young groom there, ready with two fresh horses. "People don't know what they've got available in their own house," says Rosa with laughter. But then the groom immediately embraces her and shoves his face against hers; after the terrified Rosa withdraws to the doctor, two rows of teeth have left their red marks on her cheek. Against his will, the doctor is dragged away by the horses to his patient, impotently observing how the groom is proceeding to rape Rosa. There, at the lone farm, the family shows him a young boy who at first seems perfectly healthy. "Then, with no fever, not cold, not warm, with expressionless eyes, without a shirt, the boy raises himself up under the feather bed, embraces my neck and whispers in my ear: 'Doctor, let me die.' I look around; no one has heard; his parents are standing in silence" (Kafka 1996: 77). All of a sudden, we thus enter Wagnerian territory: the horror of being condemned to the life of eternal suffering and the longing to find release in death. In what does this suffering consist? Taking a second look, the doctor suddenly becomes aware of a terrible wound on the boy's right hip (the very place of Amfortas's wound):

> On his right side, around the hip, a wound as large as the palm of one's hand has opened up. Pink [in German, *rosa*—the very name of the raped maid!], in many shades, dark as it gets deeper, becoming light at the edges, softly granular, with irregular accumulations of blood, wide open as the surface entrance to a mine. That's how it looks from some distance. But, close up, a complication can be seen, as well. Who can look at it without giving a low whistle? Worms as long and thick as my little finger, naturally rose-colored and in addition spattered with blood, firmly attached to the inside of the wound, with white heads and many legs, are writhing upward into the light. Poor boy, there's no hope for you. I have discovered your great wound; you will be destroyed by this flower on your side. The family is happy. (79)

Why are they happy? Because, as is clear from a series of details, *they cannot see the wound or hear the boy's complaint!* They are here only for the doctor's eyes and ears (in exactly the same way we learn at the end of the parable about "The Door of the Law" in *The Trial* that the door was there only for the man from the country), which means that the status of the

wound is thoroughly fantasmatic. The wound (whose literary model is, of course, Philoktet's stinking wound from the ancient Greek tragedies) is the Lacanian *objet petit a*, the undead partial object—which is why Syberberg was fully justified when, in a true stroke of genius, he filmed Amfortas's wound as a separate object, a round piece of flesh with a vagina-like cut out of which blood is slowly but continuously dribbling. No wonder that the doctor brings relief to the boy by pointing out that the wound is a privilege he enjoys, something for which other people are striving but cannot get: "Your wound isn't that bad. Brought on by two hatchet blows at an acute angle. Many people offer their sides and scarcely hear the hatchet in the forest, let alone having it come closer to them" (Kafka 1996: 89) And who would not like to become infected with the disease of immortality? The boy thus cannot but remain "completely dazzled by the life in his wound" (79): What he sees there is the noncastrated life-substance itself, a little piece of the noumenon, of the thing-in-itself, which tears apart the texture of our phenomenal reality. It is nonetheless difficult and painful to sustain this excess of life, which is why the boy whispers to the doctor with a sob, "Will you save me?" (79)—how? By enabling him to die, of course.

It is, however, crucial to locate this climactic moment in its context; Let us not forget that "A Country Doctor" tells the catastrophic consequences of having the luck to find what one is looking for (the carriage with horses); furthermore, one should follow Kafka's wordplay with "Rosa" and focus on the link between the wound and the raped maid. The wound is not a simple stand-in for the absent maid; the true focal point of the story is not the doctor's impotence, his inability to "pass to the act" in his relationship with his young maid, with his aggression toward the obscene and brutal groom as well as his protective concern about the maid's security just masking its opposite (the fact that the maid might *enjoy* the groom's advances). Although some signs appear to point in this direction (after the doctor discovers the wound, the boy's relatives forcefully undress him and place him in the bed alongside the boy—the doctor thus in a way repeats the groom's sexual experience because he also finds himself naked in bed with Rosa), the boy's disgusting wound is not a mere displacement, a lure destined to obfuscate its true nerve center; rather, it is something primordially repressed that returns in the gaps of sexual relationships. In Freudian terms, we are dealing here with the irreducible tension between sexual relationships and the *jouissance* of partial objects, in which none of the two terms can be derived from the other's failure; on the one hand, the persistence of the partial

objects, these islands of noncastrated *jouissance,* renders sexual relationships impossible, condemning them to the ultimate failure; on the other hand, the specter of sexual relationships sustains a gap that forever prevents the subject from attaining full satisfaction in the imbecilic *jouissance* of partial objects.[25]

One should recall how in "A Country Doctor," the sexual act and the wound are related along the axis of absence and presence: The rape occurs in absentia, with the doctor dragged away from it, so that he can only fantasize about what went on between Rosa and the groom, whereas the wound is intrusive in its exuberant overpresence. What if, then, the doctor secretly prefers the excessive enjoyment of the partial object to the woman? What if his being dragged away from his home conceals the fact of his escape from the scene of the crime? And, mutatis mutandis, the same goes for *Parsifal;* the wound is not a displaced trace of Kundry but something primordially repressed that returns when Kundry withdraws, the partial object that renders a sexual relationship impossible. What, then, if this is the ultimate secret obfuscated by Wagner, *Parsifal*'s ultimate speculative identity: The Grail *is* the wound (the undead partial object), and revealing the Grail equals revealing and displaying the disgusting, obscene wound?

Consequently, the problem with *Parsifal* is not its disavowal of the symbolic law in the fantasy of the self-enclosed Grail community: Wagner is aware that the ultimate source of disturbance is this self-enclosure. Wagner also cannot simply be accused of ignoring the illusory nature of his metaphysical solution—he knew that reconciliation is impossible, that it equals death. The key unanswered question is this: Is the only approach to the real the lethal, transgressive experience of going beyond the (symbolic) limit, or is another approach possible? In order to find an answer to this question, one should look beyond Wagner.

Notes

1. As to Schelling's notion of *Potenz,* see Chapter 1 of Žižek 1997.
2. I rely here on Mladen Dolar's detailed analysis of *Così* in the first part of this book.
3. In *The Twilight of Gods,* the double exchange that would have normalized relations—Siegfried getting Gutrun and Günther getting Brünnhilde—also fails.
4. One is tempted to suggest that the same procedure can also throw a new, more appropriate light on Bertolt Brecht, this great anti-Wagnerian: the key to Brecht's *Jasager,* which also advocates the subject's radical self-sacrifice, is to read it

along with its two later versions (*Neinsager, Jasager*2) as the three possible varia-
tions allowed by the same underlying matrix.

5. This paradox of envy allows us to take a new perspective on the recent con-
flict in Israel: Palestinians envy the Jews not simply for possessing Jerusalem but for
enjoying its possession. In contrast to Jews, Palestinians seem to entertain toward
Jerusalem (and the West Bank in general) a kind of melancholic stance: Their object
(land) is lost, although they in a way possess it (still live there). This is why the so-
lution is not simple (geographic) reunification or division; the fact that there is not
enough room, as it were, in Jerusalem for both Jews and Palestinians is not a simple
fact of urban space; rather, it obeys a different logic—the problem is not scarcity,
because there is *never* enough place (or place at all) for the Other's *jouissance*.
There is no just solution at the level of the distribution of goods (land). (The predica-
ment of the Jews, on the other hand, is an almost symmetrical inversion of that of
the Palestinians: For two millennia, the Jewish identity was sustained by their pas-
sionate attachment to the lost Jerusalem—what to do with it now that they have
it? The recent strengthening of the split between Orthodox and non-Orthodox Jews
in Israel is indicative of this deadlock.) Is, then, the solution a kind of separation
(between the sacred and its geographic location), the dissolution of the attachment
to the particular reality elevated to the sacred thing?

6. The aggressive outbursts of envy toward the Other who does not renounce his
or her excessive and bothersome enjoyment tell a lot about the impasse of political
correctness. For example, those who no longer smoke tend to turn their renuncia-
tion and self-control into aggression against those who continue to do it: Why
should we nonsmokers breathe the same air as them? Because smokers threaten our
health as well (the danger of so-called passive smoking), they should be banned from
public sight and space!

7. Is this notion of the opposition between society and community therefore not
perfect to describe what goes on in today's globalization? We live in a global society,
which is supplemented by multiple (religious, ethnic, sexual) communities, multi-
ple subgroups identified and kept together through their unwritten rules.

8. What we have today in virtual communities is a new collective space that
deconstructs the standard opposition of private and public: When we share our
most intimate fantasies on the Web, when we can observe other people defecating
from the bottom of the toilet bowl courtesy of live webcams, this is no longer old-
fashioned exhibitionism—in these uncanny phenomena, a new space is created, the
paradoxical space of *shared, collective privacy*. This space makes one rather nostal-
gic for the old-fashioned workers' collectives.

9. See "Parsifal on l'illusion tragique" in Poizat 1998: 115–130.

10. Wagner follows here a long tradition that had begun with Euripides. Accord-
ing to the predominant feminist version, prior to her emergence in the classic Greek
tragedy as the murderess of her own children, Medea was presented in popular
mythology as a powerful protective prophetess and magic healer—it was only the
misogynist Euripides who reconfigured her as the ultimate embodiment of destruc-
tive feminine hubris. The problem with this version is, first, that it misrepresents
history: Euripides' Medea was the synthesis of a series of different and unconnected
mythic traditions: that of the powerful protective prophetess and magic healer, that
of the lone evil woman who steals and kills children, and finally, that of a young
princess who helps the foreign prince to achieve his goal (stealing the secret trea-
sure) against her own father. Through a stroke of genius, Euripides magically cre-
ated the fascinating figure of Medea out of what were two (or even three) traditional,

rather flat, and not very interesting, figures. Therein resides the paradox: Even if Euripides effectively repressed the emancipatory feminist potentials of the figure of Medea, he thereby censored not another prepatriarchal tradition but the ethical core of *his own creation.*

11. Not to mention the absent fourth level, the obverse of the day itself: simple human meanness, greed, depravity, and treachery.

12. However, the proof that Wagner *did* retain a sense of irony in all his bombastic rambling is that two years before his death, mockingly alluding to his proclivity to wear expensive velvet and silk feminine clothes, he paraphrased Goethe: *"Das sanft Bestreichliche hat's uns getan, das angenehm Weichliche zieht man gern an."* (What's gently strokable's done for us all, what's pleasantly soft is nice to put on.)

13. See Hans Eichner, "The Eternal Feminine: An Aspect of Goethe's Ethics," in Goethe 1976: 615–624.

14. This destructive dimension is hinted at in *Faust* II: "Goddesses sit enthroned in reverend loneliness, / Space is naught about them, time is less; / The very mention of them is distress" (Goethe 1976: 156).

15. In this precise sense, the ultimate Romantic composer is not Wagner but Robert Schumann, who designated *Humoresque,* his piano masterpiece, as a "variation, but not on a theme," an accompaniment without the main melodic line (which exists only as *Augenmusik,* music for the eyes only, in the guise of written notes). The theme is never actually played; its status is purely virtual, and it can be reconstructed only as the hidden presupposition of what is actually played (as in Freud's "A child is being beaten," in which the middle fantasy scene was never conscious and has to be reconstructed as the missing link between the first and the last scene). Schumann's true antipode is here none other than Eric Satie, whose piano pieces are to be understood precisely as the reaction against the excesses of nineteenth-century Romanticism: His basic procedure is the substitution of motivic juxtaposition for any sort of development. It is this absence of musical development, of variation on the motifs, which is responsible for minimalism that pervades his work.

16. Even the political lineage can be established here: Novalis's paradoxical proto-Fascist solution of a "democratic monarchy" in which the royal family directly represents the organic unity of the people. This solution (strangely echoed even in the *Star Wars* series, where the opposition is between the republic and the bad empire and the key persons of the republic have royal titles, such as Princess Leia) is the very one adopted by the revolutionary Wagner in 1848.

17. In the history of Christianity, we have, in the unique spiritual moment of the twelfth century, two interconnected subversions of this opposition between eros and agape: the Cathar version of Christianity and the emergence of courtly love. No wonder, then, that although opposed, they are part of the same historical movement—they both involve a kind of short circuit that, from a strictly Christian standpoint, has to appear as illegitimate. The basic operation of courtly love is to retranslate agape back into eros, that is, to redefine sexual love itself as the ultimate, unending ethical duty, to elevate eros to the level of the sublime agape.

18. About a decade ago, an international sociological study comparing the actual quality of life (not just in terms of income but also of health and human rights, etc.) of people around the globe came to the conclusion that the Federal Republic of Germany rated the highest in the world. How does this fit the result of another more recent study, which compared the level of (subjectively experienced) satisfaction with life of individuals in different countries: Germans experience themselves as the *least* happy people in the world, whereas the happiest are the people of Bangladesh? The question, of course, is this: How exactly do we understand happiness? What

does it mean to different people, up to the paradox of the unhappiness itself providing a deeper satisfaction? How not to recall here the well-known answer of a German émigré to the United States to the question if he was happy in his new home: "Yes, I am happy, *aber gluecklich bin ich nicht*, but I am not *gluecklich!*" Does this German lack of satisfaction have something to do with the disturbance in the status of femininity that characterizes Germans (and some other Nordic nationalities, such as Swedes and Norwegians)?

19. I rely here on Chaouli 1996.

20. It is interesting to note that among the Amazons, the castrative dimension that sustained their position of social power was cutting off one of their breasts.

21. The subversive nature of Kleist's work resides in its utter ideological ambiguity—let us just recall the denouement of *Prinz von Homburg*, when the father-king bestows mercy on the prince and cancels the death penalty demanded by the prince himself. Is this denouement really a kind of happy ending, the token of the reconciliation between the individual (the prince) and society? Is it not rather (as the Freudian readings of the drama claim) that this very salvation amounts to a kind of second spiritual murder, depriving the prince of his autonomous decision to choose capital punishment for himself? The royal bestowing of mercy prevents the prince's self-fulfillment in the suicidal act.

22. In a further comparative analysis, one should first note how only in Harlan's version does the girl have to publicly admit the lie as a condition of the social order; in both Hitchcock and Woolrich, the logic of demasking is pursued to the end, because the forces that organized the disappearance of the lady are evil and not a benevolent state apparatus. On the other hand, the lady who disappears in Woolrich is not the mother (or an older maternal figure) but a femme fatale double of the hero's murdered wife; also, the victim of the plot, the one who saw the lady whose existence is denied by all others, is here a man, not a woman.

23. The parallel with *Parsifal* also tells us why Antigone is not a tragic figure: Does the couple of Creon and Antigone, of the tragic acting hero and the passive pure figure, not prefigure that of Amfortas and Parsifal?

24. In a letter to Max Brod, Milena Jesenska wrote about Kafka: "Above all, things like money, stock-exchange, the foreign currency administration, typewriter, are for him thoroughly mystical (what they effectively are, only not for us, the others)" (Cerna 1993: 174). One should recall here Marx's analysis of commodity fetishism: The fetishist illusion resides in our real social life, not in our perception of it—a bourgeois subject knows very well that there is nothing magic about money, that money is just an object that stands for a set of social relations, but he nevertheless acts in real life as if money were a magic thing. This, then, gives us a precise insight into Kafka's universe: Kafka was able to experience directly these fantasmatic beliefs that we "normal" people disavow—Kafka's magic is what Marx liked to refer to as the "theological freakishness" of commodities.

Another way to make the same claim would be to say that Kafka observes the same reality in which we all live but from the impossible-real subjective position of someone who is not yet fully born, who still hesitates, not yet sure if he should take the risk and plunge himself into external reality—somehow like the famous scene toward the beginning of Günther Grass's *The Tin Drum*, in which the not-yet-born hero looks from inside the womb through the vaginal opening, not quite attracted by the prospects of what we sees there (see Safranski 1999: 242). Is the Kafkaesque hero therefore not to be placed in the progression that begins with Edvard Munch's paintings: Is he not the very terrified asexual figure of *The Scream* or the figure squeezed between the two frames in his *Madonna*, the same fetuslike figure floating among

the droplets of sperm? Or Georg Trakl's Elis, this undead pale-faced ethereal boy who is properly monstrous, one of the figures of evil itself? What this figure is retracting from is, of course, the overripe and overblown feminine body that threatens to seduce him, involving him in the filth of reality. This brings us back to Wagner: Is Wagner's Parsifal not the first model in this series?

25. For a detailed reading of Kafka's "A Country Doctor" with regard to the notion of disgust, see Chapter 7 in Menninghaus 1999.

═══════════════════

THE FEMININE EXCESS

Most of us know by heart the famous chorus from *Antigone* celebrating the uncanny, excessive, and out-of-joint position of humanity in the midst of all beings, constrained only by the ultimate limit of mortality "There exists much that is strange, yet nothing / Is more strange than mankind: / For this being crosses the gray sea of Winter / Against the wind, through the howling sea swell . . . "); however, in *The Oresteia*, written a couple of decades previously, we find a parallel celebration that passes directly from the human race in general to women as the site of the radical excess:

Marvels, the Earth breeds many marvels,
terrible marvels overwhelm us.
The heaving arms of the sea embrace and swarm
with savage life. And high in the no man's light of night
torches hang like swords. The hawk on the wing,
the beast astride the fields
can tell of the whirlwind's fury roaring strong.

Oh but a man's high daring spirit,
who can account for that? Or woman's
desperate passion daring past all bounds?

She couples with every form of ruin known to mortals,
Woman, frenzied, driven wild with lust,
twists the dark, warm harness
of wedded love—tortures man and beast!
 (Aeschylus 1977, lines 572–585)

If one is to trust the German translation to which Christa Wolf refers in her *Cassandra* (which I translated into English here), the passage from man to woman at the beginning of the second strophe is to be read as the step from the general excess ("daring spirit") that characterizes humanity to its highest and worst expression, that of feminine excess: "And then, / worst of all, / the inordinate desire, / the lust of the woman" (Wolf 1988: 222). Far from being gender neutral, the uncanny excess of life that condenses the utmost characteristic of humankind (and which, as we have already seen, is the ultimate topic of psychoanalysis) is therefore feminine: Sexual difference is ultimately not the difference between the two species of humankind, men and women, but between man ("human being") qua species and its (feminine) excess. Consequently, one should resist the temptation to historicize this disparaging of the feminine, reading it as the expression of the passage from the old matriarchal order (in which the ruling divinity itself was feminine) to the new patriarchal order, from which what was before elevated into the sublime feminine figure appears as the abyss of the feminine excess threatening to swallow the male subject; more than ever, one should insist that the two, the elevation and the condemnation of the feminine, are two sides of the same strategy of coming to terms with feminine excess. It is rather history itself that should be conceived as the series of attempts to come to terms, through temporal displacement, with the unbearable, eternal antagonism of the feminine; the history of literature (and of real life) from antiquity onward offers a series of figures that endeavor to normalize this excess.

In the universe of Greek tragedy, there are two ways for a woman to break out of the private domain and penetrate the public space otherwise reserved for men. The first is unconditional self-sacrifice for the husband or father. Iphigenia and Polyxena both insist on assuming freely the sacrificial slaughter that is imposed on them by the male warrior community—in this purely formal act of freely willing (of assuming as one's own free act) that which is brutally imposed on the individual as an inevitable necessity, resides the elementary gesture of subjectivization. In both cases, the woman accomplishes

it for the gaze of the big Other—she readily sacrifices the pleasures of her young life for her posthumous fame, that is, for the awareness that she will survive in the memory of Greece. The counterpoint to these two sacrificed virgins is Alcestis, who sacrifices herself for her husband, Admestos. Her act is effectively a free choice—she assumes his place and dies (goes to Hades) instead of him. Prior to her act, she extorts from her husband the promise that he will not remarry but indulge in eternal mourning for her. Admestos accepts this condition and even tells her that he will keep a stone statue of her in his bed to remind him of her loss and to make it easier to endure (an ambiguous gesture, because this fetishistic substitute in a way makes it easier for him to survive her loss). The story then turns to comedy: Heracles brings Alcestis back from Hades, veiled as an unknown woman, and offers her to Admestos as a guest's gift. On behalf of his fidelity to his wife's memory, Admestos resists the guest's gift, although the woman uncannily reminds him of his dead wife; finally, after accepting the gift, he is glad to discover that the unknown woman is none other than his beloved Alcestis—to repeat the Marx Brothers' joke, no wonder she looks like Alcestis because she *is* Alcestis. We enter here the domain of the uncanny, of the undead and the double: The paradox is that the only way for Admestos to get back his beloved wife is to betray her memory and break his pledge to her.

This domain of the double provides the answer to this question: What is so unsettling about the possibility that a computer might really think? It's not simply that the original (me) will become indistinguishable from the copy but that my mechanical double will usurp my identity and become the original (a substantial object) while I will remain a subject. It is thus absolutely crucial to insist on asymmetry in the relationship of the subject to his or her double: They are never interchangeable—my double is not my shadow; on the contrary, its very existence reduces *me* to a shadow. In short, a double deprives me of my being. My double and I are not two subjects; we are I as a (barred) subject plus myself as a (nonbarred) object. For this reason, when literature deals the theme of the double, it is always from the subjective standpoint of the original subject persecuted by the double—the double itself is reduced to an evil entity that cannot ever be properly subjectivized.

This is what the fashionable critique of binary logic gets wrong: It is only in the guise of the double that one encounters what is real—the moment indefinite multitude sets in, the moment we let ourselves go to the rhizomatic poetry of the simulacra of simulacra endlessly mirroring themselves, with

no original and no copy, the dimension of the real gets lost. This real is discernible only in the doubling, in the unique experience of a subject encountering his double, which can be defined in precise Lacanian terms as myself plus that "something in me more than myself" that I forever lack, the real kernel of my being. The point is thus not that if we are only two, I can still maintain the nondeconstructed difference between the original and its copy—in a way, this is true, but in the *obverse* way: What is so terrifying in encountering my double is that its existence makes me a copy and it the original. Is this lesson not best encapsulated in the famous scene from *Duck Soup*, in which one of the brothers (the burglar) tries to convince the other (Groucho, the President of Freedonia) that he is just his mirror image, that is, that the door frame into the next room is really a mirror. Because they are both dressed in the same way (the same white nightgown with a nightcap), the intruder imitates Groucho's gestures, with the standard Marx Brothers' radicalization of this logic ad absurdum (the two figures change sides through the supposed mirror frame; when the double forgets to follow closely one of Groucho's gestures, Groucho is for a brief moment perplexed, but when, after a delay, he repeats the gesture, as if to test the fidelity of the mirror image and this time the double copies it correctly, Groucho's doubts are put to rest). The game is ruined only when the third Marx Brother arrives, dressed in exactly the same way.

Back to Greek tragedy: The other series, in opposition to this line of self-sacrificing women, is that of the excessively destructive women who engage in a horrifying act of revenge: Hekabe, Medea, and Phaedra. Although they are first portrayed with sympathy and compassion because their predicament is terrible (Hekabe sees her entire family destroyed and herself reduced to a slave; Medea, who sacrificed all—her country—for the love of Jason, a Greek foreigner, is informed by him that due to dynastic reasons, he will marry another young princess; Phaedra is unable to resist her all-consuming passion for Hippolytus, her stepson), the terrible act of revenge these women concoct and execute (killing their enemies or their own children, etc.) is pathologically excessive and thus turns them into repulsive monsters. That is to say, in both series, we begin with the portrayal of a normal, sympathetic woman caught in a difficult predicament and bemoaning her sad fate (Iphigenia begins with professing her love of life and so on); however, the transformation that befalls them is thoroughly different: The women of the first series find themselves interpellated into subjects, in other words, they abandon their love of life and freely assume their death, thus fully identifying

with the paternal law that demanded this sacrifice, whereas the women of the second series turn into inhuman avenging monsters undermining the very foundations of the paternal law. In short, they both transcend the status of mortal, suffering women, prone to human pleasures and weaknesses, and turn into something no longer human; however, in one case, it is the heroic free acceptance of one's own death in the service of community, whereas in the other it is the evil of monstrous revenge.[1]

There are, however, two significant exceptions to this series: Antigone and Electra. Antigone clearly belongs to the first series of women; however, the nature of her act is such that it doesn't fit the existing public law-and-order scheme, so her no-longer-human insistence does not change her into a hero to be worshipped in public memory. On the other side, Electra is a destructive avenger, compelling her brother Orestes to kill their mother and her new husband; however, she does this on behalf of her fidelity to her betrayed father's memory. The destructive fury is thus here placed in the service of the very paternal law, whereas in the case of Antigone, the self-sacrificing sublime gesture is accomplished in resistance to the law of the city. We thus get an uncanny confusion that disturbs the clear division: a repulsive avenger for the right cause, and a sublime, self-sacrificial agent for the wrong cause. The further interesting point is the psychological opposition between Antigone's inner certainty and calm, and Electra, indulges in exaggerated, theatrical self-pity and thereby confirms that this indulgence is her one luxury in life, the deepest source of her libidinal satisfaction. She displays here inner pain with neurotic affectation, offering herself as a public spectacle. After complaining all the time about Orestes' delay in returning and avenging their father's death, she is late in recognizing him when he does return, obviously fearing that his arrival will deprive her of the satisfaction of her grievance. Furthermore, after forcing Orestes to perform the avenging act, she breaks down and is unable to assist him.

In the case of Antigone and Medea, the radical act of the heroine is opposed to a feminine partner who compromises her desire and remains caught in the ethics of the good: Antigone is contrasted to gentle Ismene, a creature of human compassion unable to follow her sister in her obstinate pursuit (as Antigone herself puts it in answer to Ismene: "Life was your choice, when mine was death"); Medea is contrasted to Jason's young new bride (or even herself in her role as a mother). In the case of Iphigenia, her calm dignity, her willing acceptance of the forced choice of self-sacrifice on behalf of her father's desire, is contrasted to the furious outbursts of her sister Electra,

hysterically calling for revenge yet fully enjoying her grief as her symptom, fearing its end. Why, in this triad of the radical heroines (Iphigenia, Antigone, and Medea), do we tend to prefer Antigone, elevating her to the sublime status of the ultimate ethical hero(ine)? Is it because she opposes the public law not in the gesture of a simple criminal transgression but on behalf of another law? Therein resides the gist of Judith Butler's reading of *Antigone:* "The limit for which she stands, a limit for which no standing, no translatable representation is possible, is . . . the trace of an alternate legality that haunts the conscious, public sphere as its scandalous future" (2000: 40).

Antigone formulates her claim on behalf of all those who, like the *sans-papiers* in today's France, are without a full and definite socio-ontological status; as Butler emphasizes through a passing reference to Giorgio Agamben (2000: 81), in our era of self-proclaimed globalization, they—the non-identified—stand for true universality. This is why one should pin down neither the position from which (on behalf of which) Antigone is speaking nor the object of her claim; in spite of her emphasis of her brother's unique position, this object is not as unambiguous as it may appear (is Oedipus himself also not her [half-] brother?); her position is not simply feminine, because she enters the male domain of public affairs. In addressing Creon, the head of state, she speaks like him, appropriating his authority in a perverse, displaced way; and neither does she speak on behalf of kinship, as Hegel claimed, because her very family stands for the ultimate (incestuous) corruption of the proper order of kinship. Her claim thus displaces the fundamental contours of the law, what the law excludes and includes.

Butler develops her reading in contrast to two main opponents, not only Hegel but also Lacan. In Hegel, the conflict is conceived as *internal* to the socio-symbolic order, as the tragic split of the ethical substance: Creon and Antigone stand for its two components, state and family, day and night, the human legal order and the divine subterranean order. Lacan, on the contrary, emphasizes how Antigone, far from standing for kinship, assumes the limit-position of the very instituting gesture of the symbolic order, of the impossible zero-level of symbolization, which is why she stands for death drive: Although still alive, she is already dead with regard to the symbolic order, excluded from the socio-symbolic coordinates. In what one is almost tempted to call a dialectical synthesis, Butler rejects both extremes (Hegel's location of the conflict *within* the socio-symbolic order, and Lacan's notion of Antigone as standing for the going-to-the-limit, for reaching the outside of this order); Antigone undermines the existing symbolic order not simply

from its radical outside but also from a utopian standpoint of aiming at its radical rearticulation. Antigone is a "living dead" not in the sense (which Butler attributes to Lacan) of entering the mysterious domain of *ate*, of going to the limit of the law; she is a living dead in the sense of publicly assuming an uninhabitable position, a position for which there is no place in the public space—not a priori but only with regard to the way this space is structured now, in the historically contingent and specific conditions.

This, then, is Butler's central point against Lacan: His very radicality (the notion that Antigone locates herself in the suicidal domain outside of the symbolic order), reasserts this order, the order of the established kinship relations, silently assuming that the ultimate alternative is the one between the symbolic law of (fixed patriarchal) kinship relations and its suicidal, ecstatic transgression. What about the third option: that of rearticulating these kinship relations themselves, in other words, of reconsidering the symbolic law as the set of contingent social arrangements open to change? And does the same not also hold for Wagner? Is the obliteration of the law of the day in *Tristan* not the obverse of the inability to envision its radical rearticulation? Is then Lacan—in his celebration of Antigone's suicidal choice of ecstatic death—the ultimate and last Wagnerite, if not the perfect one, as George Bernard Shaw might have put it? It is here that we encounter the crucial dilemma: Can that what Lacan calls *ate* really be historicized, as the shadowy spectral space of those to whom the contingent public discourse denies the right to full public speech, or is it the other way round so that we can rearticulate the symbolic space precisely insofar as we can, in an authentic act, take the risk of passing through this liminal zone of *ate*, which only allows us to acquire the minimum of distance toward the symbolic order? Another way to formulate this dilemma is with regard to the question of purity; according to Butler, Antigone speaks for all the subversive, pathological claims that crave to be admitted into the public space, whereas for Lacan, she is precisely the pure one in the Kantian sense, bereft of any pathological motivations—it is only by entering the domain of *ate* that we can attend the pure desire. This is why Antigone is, for Lacan, the very antipode of Hegel's notorious notion of womankind as "the everlasting irony of the community"(Hegel 1977: 288).

Butler was right to emphasize the strange passage from the (unique) individual to the universal that takes place at this point of Hegel's *Phenomenology* (2000: 38); after celebrating the sublime beauty of Antigone, her unique naive identification with the ethical substance, the way her ethical

stance is part of her spontaneous nature itself, not something won through the hard struggle against the egotistic and other evil propensities (as is the case with the Kantian moral subject), Hegel all of a sudden passes into general considerations about the role of womankind in society and history, and, with this passage, the pendulum swings into the opposite extreme: Woman stands for the pathological, even criminal perversion of the public law. We can see how, far from bearing witness to an inconsistency in Hegel's argumentation, this reversal obeys an inexorable logic: The very fact that a woman is formally excluded from the public affairs allows her to embody the family ethics as opposed to the domain of public affairs, that is, to serve as a reminder of the inherent limitation of the domain of public affairs. (Today, when we are fully aware of how the very frontier that separates the public from the private hinges on political rapport of forces, one can easily perceive women as the privileged agents of the *repoliticization* of private domains: not only of discerning and articulating the traces of political relations of domination in what appears to be an apolitical domain but also of denouncing the very depoliticization of this domain, its exclusion from the political, as a political gesture par excellence.)

Is this, however, the ultimate scope of feminine political intervention? It is here that one should consider the break that separates modernity from antiquity: already in the late medieval era, a new figure appeared who was not taken into account by Hegel: Joan of Arc. On behalf of her very *universal* exclusion from the domain of politics, a woman can, *exceptionally,* assume the role of the direct embodiment of the political as such. Precisely as woman, Joan stands for the political gesture at its purest, for the community (universal nation) as such against the particular interests of the warring factions. Her male attire, her assumption of male authority, is not to be misread as the sign of unstable sexual identity: It is crucial that she does it as a woman, because only then can she stand for the political cause in its pure universality. In the very gesture of renouncing the determinate attributes of femininity (remaining a childless virgin and so on), she stood for woman as such. This, however, was simultaneously the reason she had to be betrayed and only then canonized; such a pure position, standing directly for the national interest, cannot translate its universal request into a determinate social order. It is crucial not to confound this Joan's feminine excess (a woman who, by way of renouncing feminine attributes, directly stands for the universal political mission) with the reactionary figure of Mother Nation or Mother Earth, patient and suffering, who stands for the substance of her com-

munity, and who, far from renouncing feminine attributes, gives body to the worst male ideological fantasy of the noble woman.[2]

The charges against Joan at her trial can be summed up in three points: To regain mercy and be readmitted into the Catholic community, she should (1) disavow the authenticity of her voice, (2) renounce her male dress, and (3) fully submit herself to the authority of the church (as the actual terrestrial institution). These three points, of course, are interconnected: Joan did not submit to the authority of the church because she gave priority to the divine voices through which God addressed her directly, and this exceptional status of her as the warrior directly obeying God, bypassing the customs of ordinary people, was signaled by her cross-dressing. Do we not encounter here yet again the Lacanian triad of the real-imaginary-symbolic: the real of the hallucinated voices, the imaginary of the dress, the symbolic of the ecclesiastic institution?[3] Therein resided the core of Joan's subversion, ultimately intolerable for church and state alike: Although she firmly stood for hierarchy and order, she claimed for herself the right to decide who was the legitimate bearer of this order—her direct contact with the divine voices allowed her to bypass the mediation of the social institution. In short, her very position of enunciation was that of an exception to the order, contradicting her message of order. This exceptional position grounded the massive effect of transference, of which Joan was fully aware and which she deftly manipulated—when, in Orleans, a delegation of citizens told Joan that they wanted to fight although the captain (an official commander of the French army) was opposed to it and formally requested her to lead them, Joan answered: "In God's name, I will do it, and he who loves me will follow me" (Lucie-Smith 2000: 116).[4] The main insignia of this exceptional position was Joan's insistence on wearing men's attire. The judges at Rouen blackmailed Joan, who desperately wanted to make a confession and attend a mass; she was allowed to do it only if she changed her male clothing for clothing appropriate for a Christian lady—yet she rejected this condition, persisting in her choice to the very end. This very obstinacy regarding cross-dressing was also what triggered her downfall; her relapse into heresy after the brief abjuration and admission of guilt was signaled by her changing back into men's clothing.

However, the very fact of Joan's short-lived abjuration demonstrates that she "had none of the masochism which has often marked the temperament of martyrs. She never embraced suffering for its own sake, and she seems, indeed, to have had unusual sensitivity to physical pain" (Lucie-Smith 2000: 278.) This abjuration, when she publicly signed the document proposed to

her and thus got her excommunication lifted, and her death sentence exchanged for perpetual imprisonment, was accomplished in a peculiar way: She spoke her words laughing, and one can interpret this eerie laughter either as a case of *fou rire*, as a sign of an approaching psychic breakdown after such prolonged suffering, or as a sign that she had not really committed herself, in other words, that from her standpoint, her signature was void, "performatively invalid" as we would have put it today. What is even more interesting is the almost Pascalean/Althusserian nature of her relapse, which followed a couple of days later: according to the most reliable sources, men's clothing was initially forced upon her by her guards (they stripped her naked and then left near her bed, to which she was chained, only men's clothing, thus compelling her to use them to avoid the sexually embarrassing situation of being exposed to her guards, who taunted her all the time with obscene remarks and threats of rape), without doubt in accordance with the English authorities, who wanted her relapse to justify her public burning. However, as the next day's interrogation suggests, men's clothing was soon internalized, turned into a matter of her deliberate choice. Her own account of this choice is ambiguous; on the one hand, it coincides with the return of her voices and her belief in her mission; on the other hand, knowing that this meant certain death, she opted for it to put an end as soon as possible to her miserable situation: "She said that she preferred to do her penitence once and for all, that is to say by dying, than to endure longer her pain in prison" (Lucie-Smith 2000: 275.) What was first imposed from without, as an enforced social custom, thus paradoxically enabled Joan to regain the fortitude of her inner conviction.

As to the status of this conviction, one should reject as impertinent the boring psychiatric questioning of the nature of Joan's voices. Of course, they were not real, and, of course, she was not really mandated by Christ; however, although self-posited, that is, authorized by no external authority but only by her own act of declaration, her mission was no less authentic. (One is tempted to repeat here Lacan's formula of the analyst: Joan *ne s'autoriserait que d'elle-meme—authorizes herself.*) So was Joan a psychotic (hearing voices) or a pervert (perceiving herself as the instrument of a divine agenda)? What about hysteria (recalling Lacan's formula of the hysteric's desire in answer to Freud's notorious *Was will das Weib?*: The woman wants a master but a master whom she could dominate)? Was Joan's troubled relationship with the proverbially irresolute Charles VII not that toward a master whom she effectively wanted to dominate? It is this reference to hyste-

ria that perfectly accounts for the curious ritual that Joan succeeded in imposing upon the king, the ritual that cannot but appear as unworthy of royal dignity: "One day, the Maid asked the king for a present. The prayer was granted. She then asked for the kingdom of France itself. The king, astonished, gave it to her after some hesitation, and the young girl accepted. She even asked that the act be solemnly drawn up and read by the king's four secretaries. The charter having been written and recited, the king remained somewhat astonished when the girl said, showing him to those who were by: 'Here you see the poorest knight in his kingdom.' And a little later, in the presence of the same notaries, acting as mistress of the kingdom of France, she put it [the kingdom] into the hands of all-powerful God. Then, at the end of some moments more, acting in the name of God, she invested King Charles with the kingdom of France; and she wished a solemn act to be drawn up in writing of all this" (Lucie-Smith 2000: 67).

This is hysteria at its purest: I take it (the symbolic authority) from you *only to give it back to you immediately*, thus asserting myself as the one who rules over the ruler himself. Do we not encounter here again the structure of the offer made to be rejected? Joan did not really want to rule France; she wanted the king to give her the kingdom so that she could give it back to him (on behalf of God). This hysterical knot forms the very core of Joan's fantasy, to which she holds to the end. Asked to swear to tell the truth, she replied to her judges: "I do not know about what you wish to interrogate me, and perhaps you will ask me things that I will not tell you." The following dialogue then ensued:

> 'Swear to tell the truth concerning whatever will be asked you had to do with the Catholic faith and with anything else that you know.'
>
> 'About my father and mother, and everything that I have done since I took the road to come to France, I shall willingly swear; but never have I said or revealed anything about the revelations made to me by God except to Charles, my king. And even if you wish to cut my head off, I will not reveal them, because I know from my visions that I must keep them secret.' (Pernaud and Clin 2000: 109)

Finally, she consented to take a limited oath to tell the entire truth about reality (her military-political activity and the like) as well as matters concerning religious belief, maintaining her silence about the messages she claimed to receive from God, especially about the secret message that she

revealed to the king. This is the true fidelity: not to the facts but to one's innermost fantasmatic kernel that the subject refuses to share. One should recall here that for Lacan, one cannot "say it all," not because we cannot ever know it all, only approaching it indefinitely, but because the field of truth is in itself non-all, inconsistent—and it is precisely these gaps of inconsistency that are filled in by fantasy. So the point of Joan is not simply "I will not tell you everything I know" but "I will tell you all I know, I will not keep from you any truth known to me—I just refuse to share with you what I *don't* know, the way I try to come to terms with the abyss of what I don't know." And is it not that after Antigone and Joan, Wagner's Kundry stands for the third sociopolitical version of the feminine excess: neither the defiance to the male public sphere on behalf of the family and kinship (Antigone) nor a direct claim to the leading position in the political struggle itself (Joan) but the ironic undermining of the sphere of power, the denunciation of its fake, through hysterical laughter? It is in Kundry that the feminine excess arrives at its truth: that of the hysterical inconsistency, of not wanting what one claims to want. With Kundry, woman is no longer a substantial force opposing itself to the male subject but the pure nonsubstantial excess of subjectivity itself—or, as Lacan put it, "I ask you to refuse what I offer you because that's not it" (1998: 111) The male dread of woman, which so deeply branded the zeitgeist at the turn of the century, from Edvard Munch and August Strindberg up to Franz Kafka, thus reveals itself as the dread of feminine inconsistency. Feminine hysteria, which traumatized these men (and which also marked the birthplace of psychoanalysis), confronted them with an inconsistent multitude of masks (a hysterical woman immediately moves from desperate pleas to cruel, vulgar derision). What causes such uneasiness is the impossibility of discerning behind the masks a consistent subject manipulating them. Behind the multiple layers is nothing or, at most, nothing but the shapeless, mucous stuff of the life substance. Suffice it to mention Edvard Munch's encounter with hysteria, which left such a deep mark upon him. In 1893 Munch was in love with the beautiful daughter of an Oslo wine merchant. She clung to him, but he was afraid of such a tie and anxious about his work, so he left her. One stormy night a boat came to fetch him; the report was that the young woman was on the brink of death and wanted to speak to him for the last time. Munch was deeply moved and without question went to her place, where he found her lying on a bed between two lit candles. But when he approached her bed, she rose and started to laugh; the whole scene was nothing but a hoax. Munch turned and started to leave; at

that point, she threatened to shoot herself if he left her, and drawing a re-
volver, she pointed it at her breast. When Munch bent to wrench the weapon
away, convinced that this, too, was only part of the game, the gun went off
and wounded him in the hand (see Hodin 1972: 88–89). Here we encounter
hysterical theater at its purest: The subject is caught in a masquerade in
which what appears to be deadly serious reveals itself as fraud (dying) and
what appears to be an empty gesture reveals itself as deadly serious (the threat
of suicide). The panic that seizes the (male) subject confronting this theater
expresses a dread that behind the many masks, which fall away from each
other like the layers of an onion, there is nothing, no ultimate feminine se-
cret.[5]

And insofar as this feminine excess is another name for subjectivity, we
can also see in what precise sense subjectivity as such, at its most radical, is
feminine. The parallel with Marx is instructive here; in a first approach, one
can, of course, claim that in the class antagonism between capitalists and
proletarians, capitalists are the subjects who dominate proletarians, the lat-
ter being reduced to objects manipulated, put to use, by the capitalists. How-
ever, as Marx repeatedly emphasizes, the point of pure (substanceless) sub-
jectivity is here the proletarian whose productive efforts are continually
frustrated, who is unable to attain a satisfied, substantial being, because she
is compelled to sell her innermost, productive capacity as a commodity on
the market. When we find ourselves totally alienated, externalized, reduced
to something that can be bought for a piece of money, deprived of all sub-
stantial content, at that point only do we experience ourselves as subject.
And, mutatis mutandis, a woman stands for radical subjectivity insofar as
she is reduced to an object of exchange between men. Or to put it in a dif-
ferent way, women are subjects precisely insofar as their identity consists in
layers of masks with no true substantial content beneath them. Therein re-
sides the key feature of the properly Hegelian dialectic of the subject-object:
the couple subject-object is never a simple duality because one of its terms
(subject) is structurally split into subject as opposed to object (the subject in
the common sense, the agency that mediates, dominates, and forms the ob-
ject) and subject insofar as it emerges in the domain of objectivity itself as
the void of negativity, as the radical frustration of all endeavor to attain ob-
jective existence: I am effectively a subject when I fail to find any objective
correlative, any content in which I can fully recognize myself, apropos of
which I can say "That's me!" Hysteria is the name for this frustration, for
the question "Is that really me?" that arises apropos of every identification.

So, in a strict homology to the identity between the sublime and the dreadful feminine, women's objectivization equals the birth of feminine subjectivity: the historical narrative of how women were deprived of their voice by the victory of the patriarchal warrior society and are now endeavoring to regain this stifled voice is an attempt to escape the debilitating synchronicity of this antagonism. Therein resides the problematic nature of Christa Wolf's *Cassandra*, which "plumbs to the depths of what it means to be turned into an object exploited by others" (Wolf 1988: 264). She constructs the historical background of Cassandra's fate as the narrative in two movements: first, the downward movement of alienation ("The woman is deprived of her living memory, and an image which others make of her is foisted upon her in its place: the hideous process of petrification, objectification, performed on living flesh. Now she is classed among the objects, among the *res mancipi....* The recipient... has the right to *manu capere*, grasp her with the hand, lay his hand on her " 298]), followed by the upward movement of the painful effort to regain one's voice ("Do people suspect, do *we* suspect, how difficult and in fact dangerous it can be when life is restored to an 'object'? When the idol begins to feel again? When 'it' finds speech again? When it has to say 'I,' as a woman?" [298]). What gets lost in this narrative is the zero-level of overlapping between the two processes, the unbearable point at which being reduced to a helpless object already is free subjectivity. In a way, Wolf was nonetheless aware of this paradox, namely of the fact that the first act of freedom is therefore the free acceptance of the inexorable fate—or, as she puts it at the very beginning of *Cassandra:* "Here I end my days, helpless, and nothing, nothing I could have done or not done, willed or thought, could have led me to a different goal" (3).

This attitude of radical impassivity, of the helpless witness who can only observe the inexorable run of things, unable to affect its course with her intervention, is the zero-level of subjectivity: I can only experience this inexorable fate as an unbearable dread *insofar as I subtract from it my subjective position of enunciation, insofar as I am not fully immersed into it.* So, paradoxically, when Wolf claims that "Cassandra is one of the first women figures handed down to us whose fate prefigures what was to be the fate of women for three thousand years: to be turned into an object" (227), this statement is strictly equivalent to the claim that "Cassandra is one of the first women figures handed down to us whose fate prefigures what is to be a subject." We find speech only by finding it again, after being reduced to muteness: At the beginning, we are deprived of what we never possessed.

Notes

1. As to these two series, see Rabinowitz 1993.

2. However, even here, one should bear in mind that there are mothers and there are mothers. The continuing reference to the figure of mother in Brecht's work, from the "learning plays" to *The Caucasian Chalk-Circle*, the epic play about the antagonism between the biological mother and the actual, emotional mother, is as a rule passed over in silence by the commentators. In *Jasager*, the first in the series of learning plays, it is on behalf of the mother, in order to bring medicine to her, that the small boy joins the expedition over the mountains in the course of which he loses his life. The reference to mother then disappears in *The Measure Taken*, the key learning play, only to return even more directly in *Mother*, the ultimate learning play and at the same time the first of Brecht's epic dramas, based on Maxim Gorky's classic revolutionary novel. This figure of the mother is not the standard oedipal mother who keeps her child in the closed incestuous link but the revolutionary mother who is educated by her son and, at the end, supports and takes over the son's social engagement. This mother is to be opposed to a series of other mother figures: the passive-aggressive mother of silent self-sacrifice for her family and children, the conservative mother standing for the stability of home, as well as the postmodern feminist mother who raises her children in a tolerant spirit while pursuing her career or the deep-ecology earth mother. Crucial in Brecht's *Mother* is the song "In Praise of the Third Thing" (*Lob der dritten Sache*) (Brecht 1980: 60). The mother keeps (or rather, regains) her son in the very act of losing him "through the third thing"; they are close to each other by way of being close to the third thing (in this case, of course, their common struggle for communism). This paradox of maintaining proximity in the loss itself is, of course, that of symbolic castration, so it is the mother herself who is here the bearer of castration, that is, of the replacement of herself as thing *(das Ding)* with the common symbolic cause *(die Sache)*.

3. The parallel is clear between the triple accusation against Joan and the three dimensions of the royal authority mentioned by Louis Marin (1987) in his outstanding *Le portrait du roi*: the real (Is he the true king, the child of his parents, and not a false pretender?), the imaginary (the splendor of the king's public appearances, destined to mesmerize his subjects), and the symbolic (the official titles with which the king is endowed).

4. Did not Lacan implicitly refer to the eminent status of this phrase in the French national memory when, after dissolving *l'Ecole freudienne de Paris* in 1979, he addressed his call for the new organization with *"A tous ceux qui m'aiment"*? In both cases, the transference is directly mobilized. This love is not psychological in the usual sense, not an affair of emotions, but objective, inscribed into the very texture of sociosymbolic relations: The Leader is by definition, irrespective of his or her actual properties, beloved.

5. For a more detailed elaboration of this feminine inconsistency, see Chapter 6 of Žižek 1995.

CHAPTER 3

RUN, ISOLDE, RUN

The Cyberspace Tristan

As Walter Benjamin noted long ago, old artistic forms often push against
their own boundaries and use procedures that, at least from the standpoint
of the present, seem to point toward a new technology that will be able to
serve as a more natural and appropriate objective correlative to the life ex-
perience that the old forms endeavored to render by means of their excessive
experimentations: "The history of every art form shows critical epochs in
which a certain art form aspires to effects which could be fully obtained only
with a changed technical standard, that is to say, in a new art form. The ex-
travagances and crudities of art which thus appear, particularly in the so-
called decadent epochs, actually arise from the nucleus of its richest histor-
ical energies" (Benjamin 1969: 237).

While Benjamin himself evokes the case of Dadaism, one is tempted to
go much further back: A whole series of narrative procedures in nineteenth-
century novels announce not only the standard narrative cinema (the intri-
cate use of flashbacks in Emily Brontë or of cross-cutting and close-ups in
Charles Dickens) but sometimes even modernist cinema (the use of off-space
in *Madame Bovary*)—as if a new perception of life was already here but was
still struggling to find its proper means of articulation until it finally found

it in film. What we have here is thus the historicity of a kind of *futur anterieur:* Only when cinema had developed its standard procedures could we really grasp the narrative logic of Dickens's great novels or of *Madame Bovary.*

And is it not that we are approaching a homologous threshold? A new life experience hangs in the air, a perception of life that explodes the linear-centered narrative and renders existence as a multiform flow—even and up to the domain of hard sciences (quantum physics and its theories about mul-tiple realities or the utter contingency that provided the spin to the actual evolution of life on earth—as Stephen Jay Gould (1989) demonstrated in his *Wonderful Life,* the fossils of Burgess Shale bear witness to how evolution may have taken a wholly different turn)—we seem to be haunted by the chanciness of life and the alternate versions of reality. Either life is experi-enced as a series of multiple parallel destinies that interact and are crucially affected by meaningless contingent encounters, the points at which one se-ries intersects with and intervenes into another (see Altman's *Shortcuts*), or different versions/outcomes of the same plot are repeatedly enacted (the parallel-universe scenarios—see Krzysztof Kieslowski's *Chance* and Peter Howitt's *Sliding Doors;* even serious historians themselves recently produced a volume entitled *Virtual History,* a reading of the crucial events, from Cromwell's victory over the Stuarts and the American Revolution to the dis-integration of communism, as hinging on unpredictable and sometimes even improbable chances). This perception of our reality as merely one of the pos-sible—often even not the most probable—outcomes of an open situation, this notion that other possible outcomes are not simply canceled out but continue to haunt us as a specter of what might have happened, conferring on our reality the status of extreme fragility and contingency, implicitly clashes with the predominant linear narrative forms of our literature and cinema—its seems to call for a new artistic medium in which this paradigm would not be an eccentric excess but its proper mode of functioning. One can argue that hypertext *is* this new medium in which this life experience will find its natural, more appropriate objective correlative so that, again, it is only with the advent of cyberspace that we can effectively grasp what Alt-man and Kieslowski were effectively aiming at. Do not Brecht's three ver-sions of his first great learning play, *Der Jasager,* also point forward toward such a hypertext/alternate-reality experience; in the first version, the boy freely accepts the necessary, subjecting himself to the old custom of being thrown into the valley; in the second version, the boy refuses to die, ration-ally demonstrating the futility of the old custom; in the third version, the

boy accepts his death but on rational grounds, not out of the respect for mere tradition. (There is an unexpected ideological link between Brecht and Wagner here: For both, the highest, true freedom is the freedom to freely assume and accept what is necessarily imposed on us, that is, the freedom to choose the inevitable.)

A more recent and better-known example from popular culture is, of course, Tom Tykwer's *Run, Lola, Run* (*Lola rennt*, Germany, 1998), which presents three outcomes of the tense situation in which Lola, a Berlin punk girl, has to get 100,000 deutsche marks to save her boyfriend from certain death: (1) her boyfriend gets killed, (2) she gets killed, (3) she succeeds and her boyfriend finds the lost money he owed to his drug-dealing boss so that they end up happy together with a huge profit. We are here in the world of alternative realities in which, as in a cyberspace game, when one choice leads to the catastrophic ending, we can return to the starting point and make another, better, choice—what was the first time a suicidal mistake can be the second time done in a correct way so that the opportunity is not missed. The interest of *Lola* resides precisely in its tonality: not only the fast rhythm, the rapid-fire montage, the use of stills, the pulsating exuberance and vitality of the heroine, and so on but, above all, the way these visual features are embedded in the soundtrack—the constant techno soundscape whose rhythm stands for (renders) Lola's—and, by extension, ours, the spectators'—heartbeat. One should always bear in mind that, notwithstanding all the dazzling visual brilliance of the film, its images are subordinate to the musical soundscape, to its frenetic, compulsive rhythm that goes on forever and cannot be suspended even for a minute—the film can only explode in an outburst of exuberant vitality, in the guise of Lola's uninhibited scream, which occurs in each of the story's three versions. This is why a film like *Lola* can appear only against the background of MTV music-video culture. One should accomplish here the same reversal that Fred Jameson accomplished apropos of Hemingway's style: *Lola*'s formal properties do not adequately render or express the narrative; rather, the film's narrative itself was invented to be able to practice its specific style. The first words of the film ("the game lasts ninety minutes, everything else is just theory"—from Sepp Herberger, Germany's legendary soccer coach) provide the proper coordinates; as in the usual survival video game, Lola is given three lives. Real life itself is thus rendered as a fictional video-game experience.[1]

This, then, is what this chapter's title means: *Run, Isolde, Run*... to Tristan, with different possible results. She runs to Cornwall, arriving there just

in time to catch the dying Tristan's last words, and then dies herself (the standard outcome); King Mark, who also runs after her to Cornwall, forgives the two lovers their passion so that they can live happily thereafter; upon arriving in Cornwall, Isolde takes a cue from Lady Macbeth, convincing Tristan that they should murder King Mark, which they actually do when, shortly thereafter, he arrives; after Isolde reaches Tristan, they discover with horror that they cannot find fulfillment in the shared death—they are condemned to live forever; and, finally, in what is arguably the most depressing option, Isolde simply *doesn't run* but stays with her husband, so Tristan dies alone. The point, of course, is not to play empty mental video games; such variations often reveal hidden presuppositions of the official storyline and its repressed alternatives; as such, they can generate a powerful effect of truth.

Another, symmetrical possibility would have been to take Wagner's *Tristan*, its metaphysical notion of the *Liebestod*, as the point of culmination of a long operatic tradition. Is the lovers' duet when they await Pasha Selim's verdict in Mozart's *Seraglio* not the premonition of the Wagnerian scene of the lovers willingly accepting death? The next stage here is Beethoven: not *Fidelio* but *Leonore*, the first (1805) version of *Fidelio*, in which the "*O namenlose Freude*" duet of the reunited Florestan and Leonore plays an entirely different role than in *Fidelio*. The couple in the dungeon hears the angry, threatening sounds of the crowd from above; however, unaware that the minister is already there, they misperceive these shouts and cries as meaning that the mob, instigated by Pizarro, is getting ready to lynch them—in this situation, they sing the duet, signaling their readiness to accept death now that they are reunited. In short, what we get in *Leonora* is a kind of *Liebestod avant la lettre*, pointing toward "*So stuerben wir ungetrennt*" from *Tristan*. It is only in the reworked *Fidelio* that this same duet loses this dimension of the Wagnerian *Liebestod*, of voluptuously embracing death, and in an exemplary case of what Stephen Jay Gould calls *ex-aptation*, it is transfunctionalized into an expression of the simple joy at being reunited in triumph over the forces of evil. However, I think it is more interesting and productive to take *Tristan* as a starting point and to elaborate the multiple ways in which this unique, fantasmatic moment of full satisfaction is denounced as a fantasy and disintegrates into its incoherent ingredients. After dealing with the three later operas that can be read as the alternate versions of *Tristan*, I will return to *Tristan* and propose a fourth solution, a rewriting of *Tristan* itself. These three later operas stage the various outcomes of the disintegration of the impossible Wagnerian resolution enacted in *Tristan:* Richard Strauss'

Rosenkavalier, Dmitri Shostakovich's *Lady Macbeth of the Mtsentsk District*, and the least known of them, Erwin Schulhoff's *Flammen*. *Rosenkavalier* restores the rights of the day, the world of etiquette, manners, and obligations, against the fatal attraction of the night in *Tristan*; *Lady Macbeth* renders the raw unsublimated sexuality, bereft of its cosmic-metaphysical baggage; and in what is perhaps the most subversive move, *Flammen* asserts the death drive at its purest, opposed to the nirvana principle.

So why exactly *these* operas? Why not also, at least, Strauss's *Salome* and Berg's *Lulu*, the two other great post-Wagner "sex operas"? Is not *Salome* yet another version of the possible outcome of *Tristan*? What if, at the end of Act II, when King Mark surprises the lovers, he were to explode in fury and order Tristan's head to be cut off? The desperate Isolde would then take her lover's head in her hands and start to kiss his lips in a Salomean *Liebestod*. There is nonetheless a precise reason to exclude *Salome* and *Lulu*: they are not hypertext variations on *Tristan* but, clearly, on *Parsifal*. Salome is Kundry gone wild, having Parsifal killed and fondling his head after he rejected her seduction; Lulu, on the other hand, is an uncanny, perverted reincarnation of *Parsifal himself* (as direct ironic references to *Parsifal* in *Lulu*'s libretto amply indicate).

It was often noted that the closing scene of Richard Strauss's *Salome* is modeled on Isolde's *Liebestod*; however, what makes it a perverted version of the Wagnerian *Liebestod* is that what Salome demands, in an unconditional act of caprice, is to kiss the lips of John the Baptist (called Jokanaan in the opera)—not contact with a person but with the partial object. Salome is first fascinated by another partial object, John's voice—throughout most of the opera, we just hear him singing, and her first comment is "Whose voice is that?" Thus, one can conceive of Salome's fixation on John's head (more precisely, on his lips) as the fixation on a bodily fragment which materializes John's voice. This capricious obsession is emphasized when, after the famous dance of the seven veils, Herod is horrified and dismisses Salome's demand; he offers her all manners of riches and valuables in exchange, even the curtain of the Holy Sacrament, but she stubbornly rejects this substitution, insisting that her wish be fulfilled, repeating seven times "I demand the head of Jokanaan!" as a kind of perverted Antigone who cannot be talked out of properly burying her brother. This demand, although formulated only after her dance, resonates in a simple orchestral motif made up of a third and a triton, first heard after Jokanaan brusquely rejects Salome's advances and then frequently repeated until, thirty-four minutes after it was first played

by the orchestra, it finally acquires a text: "I demand the head of Jokanaan!"—the unconscious desire finally explodes into an open demand.

This reading of Salome's revengeful demand to Herod as a mere death sentence is wrong—what she asks for is his head on a silver plate, the partial object that she starts to kiss once she gets it. (One cannot but recall here the very first sentence of Patricia Highsmith's acerbic, Kafkaesque short story "The Hand" from her *Little Tales of Misogyny:* "A young man asked a father for his daughter's hand, and received it in a box—her left hand" [1980: 7]). One should contrast the dance of the seven veils to Salome's final ecstatic immersion into the *jouissance* of the partial object; the first is the spectacle staged for the male gaze, the slow revealing of the feminine mystery concealed beneath the veils, whereas the second is the enjoyment of the woman herself, Richard the Second's perverted version of Richard the First's *Liebestod.* This is what horrifies Herod so much: her ecstatic pleasure taken in the partial object (the head), with music fully rendering her sexual fervor; it is to this excess that he reacts with his order: *"Man toete dieses Weib"* (This woman should be killed). (Significantly, this order is impersonal—the Heideggerian *Man* is employed here to avoid the more direct *"I* order this woman to be killed!") The ensuing slaughter of Salome is simultaneously the death of a woman and of music—in *Salome,* "Herod has a final *word"* (Leppert 1995: 150). What follows Herod's spoken words is no longer melody but something *"more noise than music...* the traditional sonoric inscription of male authority, the military sounds of brass and percussion, rhythmically punctuated at the loudest possible volume" (150–151)—as if the male word is not enough to stifle the outburst of the woman's sexualized musical *jouissance* but has to be sustained by the violent flare-up of the crashing noise.

The shift from Kundry to Salome is clearly discernible here: Although Kundry still plays the standard game of corruptive seduction, all Salome wants is to enjoy her partial object. At the level of *Salome,* Kundry would have to kiss and embrace Amfortas's wound itself (appropriately staged by Syberberg as a vagina-like object disposed on a pillow carried by the pages in front of the Fisher King). As such, *Salome* rather fits into a triad with *Lulu* and, perhaps, Schoenberg's *Moses und Aaron;* both Salome and Lulu are extreme child-vamp figures in which utter corruption overlaps with youthful innocence (Strauss himself emphasized that Salome is not a nymphomaniac but a chaste virgin). The obvious feature shared by *Moses* and *Lulu* is that they are the two *unfinished* masterpieces, the two supreme candidates for

the title of the "last (true) opera." On the other hand, both in *Moses* and in *Salome*, the male word interrupts the orgy of images and music (the dance of the golden calf and of the seven veils).[2]

What, then, about the third unfinished piece from the 1920s, Puccini's *Turandot*, which seems to fit perfectly our frame? The impoverished Tatar prince Calaf, accompanied by Timur, his blind father and the deposed king, and the faithful servant maid Liu, enters Beijing to challenge Princess Turandot, the emperor's daughter. Turandot is an ice-cold femme fatale. Her suitors have to answer her three questions; and if their answers are correct, they get her hand, and if not, they are beheaded (and there is a long row of heads displayed on the wall of her palace). After Calaf answers correctly, Turandot explodes in an impotent fury and wants to renege on her terms; to break this dramatic deadlock, Calaf then remembers *Lohengrin* and makes Turandot an additional offer: If she divines his name by the next morning, she can behead him; otherwise, she has to marry him. In despair, Turandot orders the faithful Liu (who was seen with Calaf) to be tortured so that she will betray the contestant's name; however, Liu loves Calaf so much that she stabs herself to death to avoid supplying the information. Although the observing crowd is shocked and experiences fearful guilt, Turandot remains cold; Calaf is mad at her, but the faithful Liu's death makes him desire her even more, so he simply grabs her and violently kisses her. The male touch works wonders—Turandot suddenly melts, discovers her feminine tenderness, and agrees to marry Calaf.

This story of Turandot is, of course, rooted in old Asian tales—with the significant exception of the figure of Liu, which was invented by Puccini and his librettist. Perhaps the only way to describe what happens in the last scene of *Turandot* is via reference to the Freudian notion of isolation; it can happen that the traumatic experience "is not forgotten, but, instead, it is deprived of its affect, and its associative connections are suppressed or interrupted so that it remains as though isolated and is not reproduced in the ordinary process of thought" (Freud 1979: 276). Although Liu's suicide is not directly obliterated, it has to be "deprived of its affect" if we are to have the happy ending, that is, if Calaf is to pursue Turandot *as if nothing happened*. The counterpoint to this isolation is the uncanny, nonpsychological character of Turandot herself; rarely do we encounter the fantasy of a woman-thing in such a pure form. Turandot is a pure fantasy, "less a character than a complex: a vagina dentata" (Conrad 1987: 200). No wonder her symbol is the moon, described as a bloodless, pale severed head in transit across the sky—

the monstrous specter of a detached partial object freely floating around. The libretto itself suggests that she "exists only in the haunted minds of men," that "there is no such person, that she is only the void in which Calaf will be annihilated—or the vacancy in which he sexually spends himself" (201)— is this not a succinct definition of the lady in courtly love, of this "feminine object...emptied of all real substance" (Lacan 1992: 149)? This abstract character of the lady has nothing to do with spiritual purification; it rather points toward the abstraction that pertains to a cold, distanced, inhuman partner— the lady is in no way a warm, compassionate, understanding fellow creature: "By means of a form of sublimation specific to art, poetic creation consists in positing an object I can only describe as terrifying, an inhuman partner.... She is as arbitrary as possible in the tests she imposes on her servant" (150). The relationship of the knight to the lady is the relationship of the subject-bondsman, the vassal, to his feudal master, who subjects him to frustratingly capricious ordeals.[3]

The lady is thus as far as possible from any kind of purified spirituality; she functions as an inhuman partner in the sense of a radical Otherness that is wholly incompatible with our needs and desires. As such, she is simultaneously a kind of automaton, a machine that utters random, meaningless demands. This coincidence of absolute, inscrutable Otherness and of pure machine is what confers on the lady her uncanny, monstrous character: The Lady is *not* our fellow creature, and no relationship of empathy is possible with her—this traumatic Otherness is what Lacan designates by means of the Freudian term *das Ding* (the real thing). A further coincidence of opposites characterizes the Lady: Precisely as a cruel, inhuman partner who obeys no rules, with whom no compromise is possible, who is totally oblivious of the suffering she causes, with whom no shared compassion is possible, who never shows any consideration, whose wishes are unconditional orders on which she all the more insists, the more they express her pure caprice—in short, as a monstrously perverted version of a Kantian ethical machine, whose message to us is "You can, because you must!"—the lady is purely fantasmatic, a spectral entity without substance, a mirror onto which the subject projects his narcissistic ideal. In other words—those of Christina Rosetti, whose sonnet "In an Artist's Studio" speaks of Dante Gabriel Rosetti's relationship to Elizabeth Siddal—the lady appears "not as she is, but as she fills his dream."

The structural counterpart to Turandot the woman-thing is Liu, the woman of suffering flesh and blood, the faithful and compassionate servant,

the vanishing mediator whose sacrifice renders possible the happy end. It is, however, precisely this ending that is problematic—what does it actually amount to? Let us imagine the same story in a contemporary noir setting, with the hero split between the icy femme fatale and the silent compassionate friend for whose profound unobtrusive love he is blind. The compassionate woman sacrifices herself for the hero, tortured by the accomplices of the femme fatale on her command; after her death, the hero, although shocked by this act of utmost fidelity, simply goes on to seduce the frigid femme fatale (who is set on revenge against all men because of a past trauma: her best friend was raped and killed in front of her eyes). He violently embraces her, half-raping her, and she is magically cured, turned into a warm, loving woman—is Kerman not right when he defines *Turandot* as "depraved, and the adjective is carefully chosen" (1957: 205)? The problem that Puccini wasn't able to resolve is this: How should the thing subjectivize itself? His solution is a sordid one: Beneath the icy appearance, there is an ordinary sentimental woman who surrenders herself before potent male advances: "The inescapable central message of the piece, then, is that the way to proceed with a frigid beauty is to get your hands on her" (206).

It is thus easy to mock the stupidity of *Turandot*'s ending as well as the total lack of justification for the final normalization of its title character; it is much more difficult to tackle the underlying deadlock. The surprising element is here the very fact of the happy ending. What compelled Puccini to opt for such a ridiculous and unconvincing denouement, for a worst-case deus ex machina? Because he was no stranger to tear-jerking, pathetic finales (from *La Bohème* to *Tosca*), why did he not choose one of the tragic options? The obvious one would have been to have the specter of Turandot disintegrate: When it is already too late, after Liu's death, the broken Calaf could have become aware of how he had already had in Liu what he had been looking for in the elusive Turandot. Or perhaps the shattering experience of Liu's death could have broken Turandot down, compelling her to rediscover her humanity... or after Liu's suicide, Calaf could have exploded in rage, killing Turandot and himself, so that at the opera's end, Timur remained alone on the stage, a blind and embittered Oedipus-at-Colonus figure. In short, the opera should have ended with *Turandot herself* singing Liu's pathetic *"Tu che di gel sei cinta,"* which announces her suicide, assuming this designation of herself in the first person singular ("I who was made of ice...").

The musical-dramatic problem of *Turandot* is that the scene of Liu's suicide already is a climactic Puccini finale—what follows is worthless stuff

not even composed by Puccini himself. This failure of *Turandot* is dramatic ("Drama is entirely out of the question," as Kerman put it with his usual ruthlessness [1957: 207]) as well as musical; for today's listener, the combination of a couple of overexploited good melodies with uninventive, mechanically composed material that merely fills in the space between the hits cannot but evoke the name of Andrew Lloyd Weber. However, the ultimate paradox is that Puccini was right to abandon the pathetic-tragic finale that served him so well in his earlier works—let us not forget that *Turandot* was composed in the early 1920s, when Puccini already heard the music of Schoenberg and Stravinsky, when Freud's discoveries were already exerting their impact. Within these coordinates (which do leave their trace in the very figure of Turandot—there is no place for such a ghastly femme fatale in the late Romantic universe), the standard Puccini finale is structurally impossible. The only way to avoid the happy ending would have been to accomplish the fateful passage into the properly modern posttragic universe, a universe whose horror undermines the very possibility of tragic dignity and in which monstrous figures like Lulu and Salome abound—a step Puccini was not ready to take.

Character is not something that goes by itself in the opera; it emerged with Mozart and disappeared with the modernist break.[4] This is the reason why a figure such as Turandot belongs to the space of modernism: it is already a postpsychological entity. The unfinished status of *Turandot* thus obeys a deeper necessity: Puccini's unexpected death was a godsend that enabled him to save face, that is, to avoid the acknowledgment of a humiliating defeat, by way of letting his pupil Franco Alfano orchestrate the lackluster final scene. *Turandot*'s happy ending is simultaneously a sign of Puccini's artistic failure and integrity: the very obvious ridiculousness of the last scene signals that something else should have been there, something Puccini didn't dare to encroach upon but whose absence he was nonetheless honest enough to render palpable.

The Morning After

Let us then begin with the proper variations on *Tristan*. The first crack in *Tristan*'s edifice becomes visible if we simply read *Tristan* together with *Meistersinger*, its counterpoint (indicated already by the fact that in the key moment of all opera, the violent outburst of the true passion between Hans Sachs and Eva, Sachs himself refers to the sad fate of King Mark in *Tristan*,

implying that he wants to avoid this position). The opera that realized this scenario is Strauss's *Rosenkavalier*, which displays clear parallels between *Meistersinger:* In both cases, we have a renunciation after the outburst of incestuous passion (*die Marschallin* is usually referred to as "the female Sachs"). In an ultimate gesture of loving sacrifice, the older figure (Hans Sachs, *die Marschallin*) surrenders her younger partner to another; this gesture is then followed by the great musical ensemble of reconciliation (the quintet in *Meistersinger*, the trio in *Rosenkavalier*). And it is crucial to perceive how this gesture has the structure of forced choice; at the end of *Rosenkavalier*, when the Marschallin relinquishes her claim to Octavian, she commits the empty gesture of freely choosing the inevitable (the passage of time).

These ensembles of reconciliation provide the only truly sublime moments in Mozart, Beethoven, Wagner, and even Richard Strauss—the moments in which time seems to reach a kind of transient standstill: the course of action is suspended, the subjects enjoy a precious, prolonged moment of a timeless *stasis* that provides blissful inner peace. The following are (the most conspicuous of) these moments, best encapsulated by the words from Beethoven's *Fidelio, "Welch'ein Augenblick":* In Mozart, the count's plea for forgiveness and the ensuing ensemble from the finale of *Le nozze,* just before the opera's joyous last notes *("Contessa, perdona"),* as well as the trio *"Soave il vento"* from *Così; Fidelio* alone boasts three such moments, the canon-quartet in Act I, the sudden suspension of frantic action in the underground cell when the trumpet announces the arrival of the minister, and Leonora's unlocking of Florestan's chains in the opera's finale. In Wagner, such moments of stillness signal the hero's repose and gathering of strength before the decisive ordeal (the quintet in *Meistersinger* before the song contest, the "forest murmurs" in *Siegfried* before Siegfried's struggle with Fafner the dragon, the Good Friday music in *Parsifal* before Parsifal's redemption of Amfortas and unveiling of the Grail).[5] Finally, there is, of course, the final trio in Strauss's *Rosenkavalier*. These moments of magic tranquility, whose function is a kind of mirror reversal of the strange necessity that regulates the sudden, unexpected outbursts of precipitous stage action just before the end of Wagner's *Tristan* (the arrival of two ships, the multiple killings) or Verdi's *Trovatore* (after seeing that Leonora poisoned herself, thus betraying him, the count orders Manrico's execution just to learn immediately afterwards that Manrico is his half-brother), have nothing to do with the blissful peace toward which the Wagnerian heroes strive. One is almost tempted to

claim that they stand for its exact opposite; the magic stillness renders the precious moments when the subject is able to withdraw from the crazy rotary movement of the drives that pulls him or her toward the final (self-) annihilation, whereas Wagnerian ecstatic self-obliteration designates the willing surrender to the pull of the death wish.

The action of *Rosenkavalier* begins "the morning after," with the onset of daylight after a passionate night of love: a clear countermovement with regard to *Tristan*, whose end finally brings to completion the full immersion into the night. No wonder, then, that like Hans Sachs in *Meistersinger*, the Marschallin is the figure of wisdom about the inexorable effects of the passing of time and about how the common necessities and obligations of daily life finally win over the unconditional, dark passion of love. This anti- (or, rather, post-) Wagnerian thrust is nicely rendered in the opposition between Octavian and the Marschallin in the very first scene: While, in a mockingly Wagnerian mood, Octavian babbles about the dissolution of the frontier between subject and object during sex, about his wish to remain immersed in the night and avoid the day ("What does 'you' mean? What 'you and I'? Does it make any sense? /.../ I am that desires you, but the 'I' is lost in 'you'... /.../ Why must there be day? I want no day! What good is day? Then you belong to them all! Let it be dark!"), the Marschallin gently castigates him about his manners and tells him to hide behind the Chinese screen when they hear the commotion outside—we are back in the universe of rococo love confusions and hide-and-seek à la Beaumarchais. So although Strauss claimed that he wanted to compose "a Mozart opera" in *Rosenkavalier* and although the beginning of *Rosenkavalier* can be read as a version of the third installment of the Figaro trilogy, in which the Countess Rosina has an affair with Cherubino, it is a nostalgic Mozart that comes *after Wagner*—in the Mozartean universe, such a direct reference to the sexual act as hits us in the very first lines of the opera (*"Wie du warst! Wie du bist! Das weiss niemand, das ahnt keiner!"*—which simply means "How good you were in bed!"—a direct reference to the exquisite love-making talents of the Marschallin, musically rendered a minute before in the orchestral prelude) would have been thoroughly out of place.[6]

The feature that *Rosenkavalier* shares with Mozart, in clear contrast to Wagner, is cross-dressing: Does the charm of the final trio in *Rosenkavalier* not reside in the fact that we have a trio of *women* singing? The secret libidinal message is therefore that of a feminine community, an extension of the famous duo *"O rimembranza"* from *Norma*. It is interesting to note how

Le nozze, Fidelio, and *Rosenkavalier* raise cross-dressing to the second power; in *Le nozze* and *Rosenkavalier,* the woman singing as a man (Cherubino, Octavian) has, within the narrative content, to cross-dress again for the reasons of concealing her identity to the intruders so that we encounter a woman portraying a man dressed up as a woman. Even in *Fidelio,* where the situation is more straight (Fidelio really is Leonora, that is, the sexes of the singer and the narrative person coincide), we have a woman playing a woman who dresses up as a man. Perhaps, in this politics of sexual difference, it is worth noticing the shift in the title of Beethoven's opera from *Leonora* to *Fidelio*—is this shift not somehow related to the restructuring of the opera's content, best rendered by the changed status of the *"O namenlose Freude"* duet? Furthermore, one is tempted to speculate that at a deeper libidinal level, Marzellina loves Fidelio because she is secretly aware that "he" really is a woman. Typically, Beethoven rejects the frivolous idea of a woman singing as a young, attractive man—in his opera, cross-dressing is fully justified by the narrative necessity (Leonora has to dress as Fidelio to gain access to her imprisoned husband); however, the fact that Mozart—and others—were doing what Beethoven rejected is far from frivolous but rather obeys a deep, libidinal necessity: Can one imagine a more vulgar gesture than the logical and realistic staging that would have the role of Cherubino (or Octavian) sung by a young tenor?

The gap that nonetheless separates Strauss from Mozart concerns the status of the sexual act. It's not that people do not make love in Mozart—on the contrary, all his plots turn around it—the point is, rather, that the reference to the sexual act itself is wholly abstract, lacking earthly substance, somehow like the fade-in after the couple's embrace in the good old days of Hayes Production Code Hollywood. It is only with Wagner that the musical texture itself becomes directly sexualized: The point about the orgasmic structure of the overtures to *Lohengrin* and *Tristan,* although commonplace, nonetheless hits the mark so that one can effectively claim that Wagner "investigates the secrets of orgasm" (Conrad 1989: 181). However, one is tempted to argue here that even in this rendering of the orgasmic acceleration, Wagner is male oriented. As is well known, when a woman is approaching orgasm, the acceleration progresses in two steps (two jumps from quantity into a new quality, to put it in terms of dialectical materialism). First, there is the point of no return, the *rhythmic* movement of hips, which signals that the woman is no longer in control, that she is already sliding (being drawn) toward the climax, and then the arrival of the climax itself is

announced by the breakdown of this regular rhythm, by the onset of irregular seizures. What is missing in the Wagnerian musical rendering of the orgasm is this last stage of chaotic, disordered convulsions: in a typically male way, he (mis-) perceives orgasm as a gradual, linear movement toward completion.

Perhaps, in spite of his proverbial aversion to coarse sexuality, the missing link between Mozart and Wagner is Beethoven himself: Does the gap between the *"O namenlose Freude"* duet and the finale of *Fidelio*, usually filled in by the Leonore overture (with, again, its all-too-obvious double orgasmic structure), not mark the nondepicted passionate lovemaking of the reunited couple? The act is here for the first time inscribed, although (to use the old structuralist jargon) in the mode of absence, as a gap in the musical texture— in Mozart, its absence doesn't even cause a gap. Shostakovich's *Lady Macbeth* makes a radical step further in this graphic musical depiction of the sexual act. With regard to this depiction, it would be interesting to compare *Lady Macbeth* with *Tristan* and *Rosenkavalier*. What predominates in Wagner is the raising of inner tension and its orgasmic resolution (the end of Act II has the most shocking coitus interruptus in the history of the opera, whereas the finale finally brings the orgasmic resolution); the most notorious feature of Shostakovich's *Lady Macbeth* is the graphic orchestral depiction of the first violently passionate sexual exchange between Katarina and Sergei in Act III: the "external" mickeymousing (the close imitation of bodily movements by the music, as in the cartoons) of the gasps and thrusts of the act of copulation, inclusive of the trombone slides providing a half-comic rendering of the postorgasmic reprieve. The brief orchestral prelude to *Der Rosenkavalier*—which also renders a scene of exuberant lovemaking, complete with an imitation of the thrusting moves, the climax mimicked by whooping horns, and luxurious afterglow—is somewhere in between, an outburst of raw sexual passion muffled by affected rococo manners, in accordance with the half-imaginary, half-real mode of opera itself.

In what, then, does this opening love encounter in *Rosenkavalier* differ from the immersion into the night of *Tristan*? It is not only that *Rosenkavalier* goes through *Tristan*'s path, as it were, in the opposite direction, starting with the nightly bliss of the love encounter and then returning to the universe of the day with its formal social obligations; it is not only this morning-after effect that spoils the Wagnerian solution—the immersion into the bliss of the sexual act itself is already disturbed. While the Marschallin and Octavian chat drinking hot chocolate in the morning, she

in passing informs the surprised Octavian that while they were making love during the night, she thought of the Marshal, her absent husband who was at that time hunting wild boars in Croatia—the gap that separates the real of the sexual act from its fantasmatic support is thereby confirmed (it is the whole point of *Tristan* that, at the highest ecstatic bliss, this gap is suspended and the real and fantasy coincide). To the angry Octavian, who asks her: "How could you dream about HIM while we were . . . ," she promptly replies: "I do not order my dreams."[7] Usually, Freud's alleged pansexualism is taken to mean that "whatever we are doing and saying, we are ultimately always thinking about *that*"—that reference to the sexual act is the ultimate horizon of meaning. The Freudian notion of fantasy points in exactly this direction: The problem is not what we are thinking when we do other, ordinary things but what we are thinking (fantasizing) when we actually *are* doing that—the Lacanian notion that "there is no sexual relationship" ultimately means that while we are engaged in the sexual act itself, we have to think (fantasize) about something else. We cannot simply "fully immerse ourselves into the immediate pleasure of what we are doing"—if we do that, the pleasurable tension gets lost. This point is made clear in *Rosenkavalier*: It is not that while making love with her boring husband, the Marschallin dreams of the young, virile Octavian, but the other way round—while making love to Octavian, the specter of her boring and pompous husband haunts her imagination.

"It quacks, hoots, pants, and gasps"

The passage from *Rosenkavalier* to Shostakovich's *Lady Macbeth* is the passage from refined aristocratic etiquette to the vulgar reality in which we are not only sadly aware of how things pass but in which people actually beat up and poison each other—and copulate. The spirit of this passage was nicely captured by Anthony Burgess who, in his retelling of *Rosenkavalier* as a novella, ended it up with this: "Octavian lost a leg and an eye in the War of Austrian Succession. Sophia died bearing her second child. The widowed *Marschallin* entered a nunnery. Baron Ochs married the richest heiress of all Austria and died at ninety-one in his bed" (1982: 68). In such a universe, of course, sex is neither a mystical reunion nor a scintillating affair. Listening to the orchestral depiction of the sexual act in *Lady Macbeth*, one is almost tempted to agree with Comrade Stalin who, after leaving the Bolshoi theater in fury after this very scene, in his infinite wisdom ordered the anonymous

article "Muddle Instead of Music" to be published in the January 28, 1936, issue of *Pravda*. As this article stated, "The music quacks, hoots, pants, and gasps in order to express the love scenes as naturally as possible"—Prokofiev himself ironically designated Shostakovich's *Macbeth* music as the next step in the progress from monophony to polyphony—"pornophony." However, the lesson of this mickeymousing is a Hegelian one: Pure tautological repetition is the greatest contradiction. We (wrongly) think that the music merely follows visual movements, whereas it actually strongly colors, even distorts, our visual perception, giving an exaggerated comical twist to gestures on the stage (or screen). We are all familiar with the comical effect that occurs when, while watching an opera on TV, the sound is suddenly cut off; deprived of their vocal ground, the singers' dignified gestures change into ridiculous gesticulating. What we get in *Lady Macbeth*'s sexual scenes is the obverse effect: the very *addition* of music, although it only slavishly echoes sexual gestures, "extraneates" the passionate quasi-animal coupling into a clownish performance, transforming the lovers into puppets who blindly follow the rhythm set by the music.

Shostakovich's redemption of Katarina's two murders as the justified acts of a victim of patriarchal oppression is effectively more ominous than it may appear; the price for this justification, the only way to make the murders palpable, is the derogation, dehumanization even, of the victims (her husband's father is portrayed as an old lecherous ruffian, whereas the son is an impotent weakling without any clear characterization, a deliberate omission because having him presented strongly might give rise to sympathy for him in the murder scene). In a complementary way, Katarina herself is purified of any ethical ambiguity (there are no hints of an inner struggle while she commits the murders or of any pangs of conscience afterwards); she is portrayed not so much as a fighter for personal freedom and dignity against patriarchal oppression but as a woman totally enslaved to her sexual passion, ready to ruthlessly smash everything that stands in the way of its gratification—in this sense, she is also dehumanized so that, paradoxically, the only human element in the opera is a collective one: the convict's chorus with its two laments in the last act. Furthermore, Taruskin was right to emphasize the historical context of the opera: the years of the ruthless terror against the kulaks—are the murdered father and son not two exemplary kulaks? In the first two years of the opera's triumphant performance, before Stalin's ban, was it possible for the public not to perceive how its violent content echoes the violence of dekulakization? The opera's official condemnation should

thus not blind us to the fact that it is a deeply disturbing *Stalinist* work that served to legitimize the murderous antikulak campaign. Taruskin's conclusion is thus that *Lady Macbeth* is "a profoundly inhumane work of art": "If ever an opera deserved to be banned it was this one, and matters are not changed by the fact that its actual ban was for wrong and hateful reasons" (1997: 509).

And does the same not go for another prohibited (in this case, literally destroyed) Soviet masterpiece from exactly the same period, Sergei Eisenstein's *Bezhin Meadow* from 1934–1936, of which the negatives themselves were burned, the veritable missing link (or rather, vanishing mediator) between Eisenstein I (of the intellectual montage and brilliant dialectical use of formal antagonisms) and Eisenstein II (of *Nevsky* and *Ivan*, of the pathetic rendering of large historical frescoes in an organic form), which was partly based on the story of Pavlik Morozov, the young village hero who was killed by his relatives in the northern Urals in 1932 because he had denounced his father to the village soviet for speculating (after his death, Morozov was elevated to a cult figure all around the Soviet Union). In the film, Stepok, a young village boy, organizes the local Young Pioneers to guard the harvest of the farm collective each night, thereby frustrating his own father's plans to sabotage it. In the film's climax, the nightly confrontation between father and son, the father kills Stepok. Next morning, a typical Eisenstein scene celebrating the exuberant orgy of revolutionary violence (what Eisenstein himself called "a veritable bacchanalia of destruction") takes place, when the frustrated Pioneers force their way into the local church and desecrate it (recall the similar scene from *October*, in which the victorious revolutionaries, after penetrating the wine cellars of the Winter Palace, indulge there in smashing thousands of the expensive wine bottles): "On one level, the audience is encouraged to sympathize with the peasants robbing the church of its relics, squabbling over an icon, sacrilegiously trying on vestments, heretically laughing at the statuary—while Eisenstein's profound admiration and knowledge of religious art creates a parallel revulsion at the vandalism. A young girl is framed in a mirror as if in a picture of the Virgin Mary, a young child is a cherub, a statue of the crucified Christ is held as in a Pieta" (Bergan 1997: 287).

When Boris Shumyatsky, the official head of the Soviet film industry (until he was, only two years later, accused of being an English spy, arrested, and shot), vetoed the film on March 17, 1937, he explained his reasons in an interesting article in *Pravda*. His main reproach was that instead of locating

the conflict in the concrete circumstances of the class struggle in the coun-
tryside (the dekulakization), Eisenstein staged the conflict in an almost bib-
lical, atemporal mythical space, as an abstract fight between good and evil
as elementary cosmic forces. Stepok is presented in pale and luminous tones,
a pale boy in his white shirt, as if wrapped in a halo, as a kind of spectral, in-
nocent saint whose fate was already sealed by a supernatural destiny. (In the
self-criticism that, of course, followed, Eisenstein himself claimed that the
father's killing of the son was "reminiscent of Abraham's sacrifice of Isaac"
[1997: 283]). Connected with this reproach were the standard charges of for-
malism, of indulging in eccentric framing, lighting, and cuts instead of pre-
senting the story in a direct, psychologically realistic way that would allow
an easy emotional identification for the viewer. From today's perspective, of
course (and bearing in mind Eisenstein's fascination with and detailed knowl-
edge of psychoanalysis), it is easy to identify this eternal, mythic space as
the scene in which the underlying libidinal economy of the father/son con-
flict (the inverted Oedipus in which the obscene, corrupted father kills the
innocent, asexual son) is played out. Far from being simply too intellectual
and thus prohibiting the viewer's empathy, *Bezhin Meadow* was so disturb-
ing because its very formalist excess allowed this repressed libidinal tension
to be directly articulated.

The film had to be prohibited because such a direct rendering of under-
lying sexual tensions, such a direct celebration of ecstatic and destructive
sacrilegious revolutionary violence, was not admissible under the new con-
ditions of so-called socialist realism—why not? Because Stalinist ideology
functioned only on condition that it did *not* directly display this hidden li-
bidinal economy. (No wonder Eisenstein was enthusiastic about Alexander
Medvedkin's *Happiness* of 1935, in which similar revolutionary obscenities
abound: In an extraordinary moment, a priest imagines he sees the breasts
of a nun through her habit.) And, back to Shostakovich, what if his *Lady
Macbeth* was also prohibited for similar reasons: not because of the openly
depicted sexuality but also because this open depiction, as well as the open
support of the killing of the kulak patriarchal oppressors, had to be publicly
disavowed. And this also enables us to see why Taruskin's accusation against
Lady Macbeth as a legitimization of the mass murder of the kulaks, of their
"liquidation as a class" (as Stalin put it), misses the point: The directly vio-
lent aspect of it *had* to be publicly disavowed, which is why its direct ren-
dering was unacceptable. The explicit depiction of sex and violence were the

two sides of the same coin (which openly coincide in the erotically charged, orgasmic character of the church desecration in *Bezhin Meadow*).

It is at this precise point concerning political terror that one can locate the gap that separates Leninism from Stalinism:[8] In Lenin's time, terror was openly admitted (Trotsky sometimes even boasted in an almost cocky way about the nondemocratic nature of the Bolshevik regime and the terror it used), whereas in Stalin's time, terror's symbolic status had thoroughly changed into the publicly unacknowledged shadowy supplement of public official discourse. It is significant that the climax of terror (1936–1937) took place after the new constitution was accepted in 1935—this constitution was supposed to have ended the state of emergency and to have marked a return to normalcy: the suspension of the civil rights of whole strata of the population (kulaks, ex-capitalists) was recalled, the right to vote was now universal, and so on. That constitution's key idea was that now, after the stabilization of the socialist order and the annihilation of the enemy classes, the Soviet Union was no longer a class society; the subject of the state was no longer the working class (workers and peasants) but the people. However, this does *not* mean that the Stalinist constitution was a simple hypocrisy concealing the social reality—the possibility of terror is inscribed into its very core: Because the class war had now been proclaimed over and the Soviet Union was conceived of as the classless country of the people, those who (were still presumed to) oppose the regime were no longer mere class enemies in a conflict that tears apart the social body but enemies of the people, insects, worthless scum, which were to be excluded from humanity itself.

Katarina Izmajlova is a kind of Madame Bovary gone wild, reacting to her unsatisfying marriage with a wild explosion of murderous violence in the long tradition that reaches from the naturalism of Zola's *Theresa Raquin* to American film noir (not so much *Double Indemnity* but rather *The Postman Always Rings Twice*). Within this tradition, misogyny is inextricably linked to the feminist potential (it is the desperate patriarchal condition that drives a wife to such outburst of violence).

The Separated Flames

The next and last work is Erwin Schulhoff's half-forgotten but outstanding *Flammen (Flames)* from 1932, a modern reworking of the Don Juan myth (now available in the London "Entartete Musik" series). (As a curiosity, one

should remember that the other great work of this follower of Schoenberg is a large-scale oratorio based on the text of the *Communist Manifesto*.) It is only with Schulhoff that we pass to radical atonal expressionism. What, exactly, does this mean? Here is Charles Rosen's perspicuous description of "the secret of the continuous and violent expressivity of Schoenberg's music": "The expressive force, finding no outlet in a large 'homophonic' harmonic structure, pervades the melodic line of all the different instruments and voices.... This radical expressivity, congenial to Schoenberg's temperament, and obviously closely related to the movements in other arts of his time, is therefore also a logical development of his extension of the musical language. Technically speaking, it may be described as a displacement of the harmonic tension to the melodic line" (1976: 54).

Brecht's well-known sarcastic remark that Schoenberg's atonal music is "all too melodic" thus inadvertently hits the mark: The melodic line has to take upon itself the burden of harmony. One should put to Brecht's credit that he perceived the error of the usual reproach according to which atonal music lacks melody—it's the opposite that holds because in atonal music, the excessively expressive melody pays the price for the thereby limited harmonic possibilities, and it is this lack of harmony that creates the unpleasant experience for the common listener.[9] The further thing to do here is to introduce the rather obvious link between harmony and melody and two other couples: space and time and synchrony and diachrony. In Schoenberg, the prohibited synchrony (harmony) returns in (is displaced on) the diachronic melody—or space returns in time (and is it necessary to add that the term *displacement* (*Verschiebung*) acquires here its whole Freudian weight?). This means that to comprehend Schoenberg properly, one has to *temporalize (translate into a melodic line) space itself.* Schoenberg is here antimythical: if, as Levi-Strauss claimed, the most concise definition of the myth is Wagner's designation of the Grail domain in *Parsifal* (*"Zu Raum wird hier die Zeit"*—Here time becomes space), in Schoenberg, space itself becomes time. It is here that the term *expressionism* acquires its proper place; it is only when the direct, natural (harmonious) expression of the subject is prohibited that this barred subject can effectively express itself in a gesture in which expression is forever linked to its inherent failure. In other words, the paradox of expressionism is that it emerges at the very point when the direct, organic expression of the subject's inner essence is barred—no wonder that the ultimate icon of expressionism in painting is Munch's *Scream,* this paradigm of the alienated individual unable to connect with the world.

Although the immediate and obvious reference of *Flames* is Mozart's *Don Giovanni*, its hidden reference to Wagner's *Tristan* is more crucial. Schulhoff submits the Don Juan myth to a series of displacements; his hero is not just confronted with the series of conquered women—central is his more fundamental attachment to La Morte, a woman in the guise of death. The true attachment that cannot ever be consummated is between the two of them, which is why all the passionate pleasure cries of the seduced women cannot satisfy him. When the statue of the Commendatore appears, it condemns Don Juan not to death but to eternal life—here is the crucial dialogue between Don Juan and La Morte (and incidentally, the libretto was cowritten by Max Brod!):

DON JUAN *(in a paroxysm):* How beautiful, how enticing, to suck love out of your empty eye-sockets, lust from your arid lips and the balsamic scent of fleshless breasts!

LA MORTE *(stretches her arms out):* So you do not recoil, the only man to endure the test!

DON JUAN: And no Commendatore from hell can deny me this happiness! Give yourself now, give yourself utterly! Now is the time!

(Here the statue appears and raises his fist against Juan.)

LA MORTE *(to Juan):* Futile striving, you may not join the dance of death! Juan, don't you see how the stony fist pronounces judgment upon you, eternal judgment—you are Juan, who can never die.

(Juan presses a Browning to his temple and shoots himself, but he immediately reawakens in a cabaret with a jazz band playing.)

DON JUAN: I have to be like this for ever, ever and ever! (Schulhoff 1995, 54–55)

So although we do have here the oedipal constellation, inclusive of the fourth impossible-real partner, Death itself, the function of the paternal figure is to prohibit contact with Death itself, more precisely: the consummation of *jouissance* in death. Here are the last lines of the opera:

LA MORTE: Flames of love and death, when will they finally join together...
SHADOWS: Passionate breathing intensifying...and red light from the window!...Intoxicated moaning!...The light dies down.

LA MORTE: The star so near, drowning in night, that which would bring us salvation *[Erloesung]* is so distant again, so distant. (57–58)

In short, what is prohibited here is precisely the climactic salvation of the Wagnerian *Liebestod*, the unity of the "flames of love and death"; the two dimensions, that of the undead flames of sexual desire that follow Juan like the fire that walks with one in David Lynch's films and that of final peace in death, remain forever separated. This separation can be put in very precise theoretical terms as that between the death drive proper (the Freudian name for *immortality*, for the undead passion that persists beyond the cycle of life and death, of generation and corruption) and so-called nirvana, the extinguishing of the life drive, the entry into eternal peace—the separation of these two dimensions that were confused not only by Wagner but also by Freud himself.

One is tempted to add here another version, a kind of subspecies of Schulhoff, the one enacted in Leoš Janáček's *The Makropulos Case*: What if only Tristan dies, while Isolde survives and, in order to cope with the trauma of her love's death, turns into an undead monster, a cold, cynical seductress destroying men's lives? *Makropulos* is a grotesque comedy about Emilia Marty, the extraordinarily beautiful opera diva and femme fatale who, at the end, turns out to be the 337-year-old Elina Makropulos. The action takes place in Prague during the 1920s: Having survived thus far on an elixir of life, Emilia engages in a legal battle to get back the secret formula for this elixir, which got lost among the papers of one of her deceased relatives—she needs more of it to stay alive. At the beginning of the last act, we see her together with Baron Prus ,with whom she had spent the night to get the formula from him. Although he complains that her lovemaking was cold and passionless, the baron fulfills the bargain and hands over the envelope with the formula. After obtaining it, Emilia at last tells her full story to the other protagonists. However, in telling her story to the gathered community (the "big Other"), she realizes that she has lived all too long, because life is precious and meaningful only when it is finite. A cynical predator ruthlessly exploiting and destroying men, she is now overwhelmed by disgust at herself and gradually slides into drunken despair and panic at the utter meaninglessness of her life. Finally, she gives the formula to her young colleague-singer Krista (who immediately burns it) and is ready to calmly accept and even welcome death as a release from the intolerable burden of life.

The last half hour of the opera provides a kind of negative correlative to Wagner's *Liebestod*, in which Isolde also finds release in death; it displays

the painful process of the disintegration of the exploitress as she goes through self-disgust, hysterical despair, and utter panic until she finally embraces death. One is tempted to claim that this is the truth about Isolde's death repressed by Wagner. The opposition of *Flames* and *Makropulos* (both operas composed in the same decade in the Czech republic!) runs along the lines of sexual difference: Don Juan is condemned to live eternally, whereas Emilia nonetheless finds peace in death.

No More Running

So, perhaps, in the digitalized future one will be able to choose between different endings of *Tristan* or to watch them consecutively: Wagner's standard ending (first Tristan dies and then Isolde dies); then *Tristan* translated into *Rosenkavalier* (Mark comes and forgives the lovers their betrayal, and his forgiveness has a miraculous effect on Tristan's wound, so all three finish up with a resigned trio in which the old Mark, like Sachs or Marschallin, quotes the very words of Marschallin—"I chose to love her in the right way, so that I would love even her love for another!"—and cedes Isolde to Tristan, while they both sing a praise to Mark's benevolent forgiveness and then stay together, living happily thereafter); then the *Lady Macbeth* version (Tristan and Isolde plot to kill King Mark after they are discovered at the end of Act II—this would have been the true *Tristan* noir); and finally, the *Flames* version: Unable to die, Tristan, like a new incarnation of the Flying Dutchman, is condemned to endlessly wandering around in search of Isolde.

We have here four attitudes toward sexual love: the Wagnerian deadly immersion into the unremitting *jouissance* of the night; the *Meistersinger-Rosenkavalier* resigned wisdom, the acceptance that time passes, rendered in a half-imaginary, half-real dreamy Mozartean mode; Shostakovich's brutal naturalism of the vulgar daily life—"just the story of an ordinary quiet Russian family whose members beat and poison each other," as Shostakovich himself put it sarcastically; and finally, Schulhoff's assertion of the undead spectral compulsion as the ultimate dimension of sexual love. However, there is effectively a kind of internal displacement at work within each of these four attitudes:

- In his endeavor to render the ecstatic deadly immersion, Wagner effectively resorts to etiquette, to a customized ritual—say, when the love duet in Act II, after the long psychological self-ruminations, catches up for

the coital finale, is it not as if the two singers all of a sudden drop their psychology, change into a declamatory mode, get caught in ritualized compulsion, and sing/act like automatized puppets, their passion turning into a cold, self-propelling mechanism?

• In his endeavor to render the gentle Mozartean world of etiquette, Strauss effectively brings forward insipid daily life. Therein resides the fundamental tension and paradox of *Rosenkavalier:* the very attempt to render the realistic lesson of daily life (getting old and dying) has to be done in the mode of the idealized lost world of the old aristocratic etiquette.

• While trying to render the oppressive vulgarity of the daily life, Shostakovich's depiction of Katarina's unconditional passion effectively generates the sublime effect.

• Finally, Schulhoff, in his very modern, post-Wagnerian, turn to the banality of the nightclubs with jazz bands, distills pure, lethal eroticism. What changes from Shostakovich to Schulhoff is the nature of the unconditional sexual drive: no longer the earthly erotic drive constrained and thereby perverted by the boring provincial life but the spectral, undead passion.

We thus encounter here a quadruple tension: between the message of the lethal erotic drive to self-obliteration in the depth of the night and its ritualized, declamatory mode of expression; between the message of the realistic acceptance of the obligations of the common daily reality and its dreamy, nostalgic mode of expression; between the message of the horror of boring frustration of provincial daily life and the effect of the sublimity that its expression engenders; between the decadent, undead, spectral drive and its objective correlative in cheap contemporary night life. It is, however, clear that these four attitudes do not move at the same level: *Tristan* is the exception, the point of impossible fantasmatic unity, and the three other operas are the outcomes of this unity's disintegration. One should thus raise here the reflexive question: How are we to rewrite Wagner's *Tristan* so that we could inscribe him into this series of the outcomes of its disintegration? In Hegelese: Where and how, in this series, can *Tristan* encounter *itself* in its oppositional determination?

It is in Ponelle's staging, which we analyzed in the first chapter, that we get this *Tristan* in its oppositional determination. Far from being guilty of the retroactive projection into Wagner of a contemporary sensibility, Ponelle's intervention hits the mark because it brings forward a certain gap that is already there in the first great Wagnerian love dialogue, that of the

Dutchman and Senta from *The Flying Dutchman:* The two lovers seem to
ignore each other's physical presence, not even looking each other in the face
but simply engaging in their respective, intimate, fantasmatic visions of the
other—for both of them, the Other whom they finally find is simply the ma-
terialization of their dream image (when Senta first encounters the Dutch-
man, it is literally as if he steps out of his portrait, which Senta is admiring).
For this reason, the third gaze for whom the act is staged is needed—which
gaze? Most of the James Bond films close with the same strangely utopian
sexual scene, which is at the same time intimate and a shared collective ex-
perience: while Bond, finally alone and united with the woman, makes love
to her, the couple's activity is observed (listened to or registered in some
other—say, digital—way) for the big Other, who is here embodied by Bond's
professional community (M, Miss Moneypenny, Q, and so on); in the most re-
cent Bond movie, *The World Is Not Enough* (1999), this act is nicely rendered
as the warm blot on the satellite image—Q's replacement (John Cleese) dis-
creetly turns off the computer screen, preventing others from satisfying their
curiosity. This same third gaze, to which Isolde appeals in her death song,
finds its vulgar culmination in the recent slew of so-called reality TV shows.

Our thesis is thus that Ponelle's version is not just one in the series of
variations that render the disintegration of Wagner's impossible fantasmatic
resolution; rather, it occupies the exceptional place of the repressed truth of
Wagner's *Tristan* itself—to put it in all naïveté, Ponelle stages what effec-
tively happens in Wagner's *Tristan*, unmasking the full fusion of reality and
fantasy in the blissful love encounter as a male fantasy. The path that we
covered is thus a kind of proto-Hegelian triad: first the thesis, Wagner's *Tris-
tan;* then the antithesis, the subordinated triad of its variations/negations;
and then, finally, the return to Wagner's *Tristan* itself, reflexively transformed
through its subsequent variations in such a way that the fantasmatic third
gaze is directly rendered visible.

Is it possible to escape this gaze, to suspend the need for it? The history
of modern music provides an answer. That is to say, why is Wagner not yet
properly modern? To put it in dogmatic Lacanian terms, he is not because for
him, the big Other still exists—as we already pointed out, in her *Liebestod,*
Isolde still refers to this Other in the guise of the ideal witness supposed to
register what is going on ("Can't you see that he [Tristan] is smiling?"). Not
even Schoenberg fully abandons this reference: The true break occurs be-
tween Schoenberg and Webern. Although Schoenberg, already totally resigned
to the fact that no actual public can directly respond to his work, still counted

on the symbolic fiction of the one purely hypothetical, imagined listener, which was needed for his composition to function properly, Webern renounced even this purely theoretical supposition and fully accepted that there is no big Other, no ideal listener for him. Sibelius and Shostakovich were unable to accomplish this step—significantly, Shostakovich's attacks on Western musical modernism were more ambiguous than they may seem. Although they were often written under the pressure of the official cultural bureaucracy and as such simply expressed the party line, they nonetheless at the same time undoubtedly gave voice to Shostakovich's sincere conviction that today's music must remain accessible, must continue to aim at generating a public response. The need for live communication with the ordinary public was a constant in Shostakovich's life.

One often hears the cliché that, even before the Holocaust, Schoenberg's music had already rendered its horror—perhaps one should introduce a slight change in this cliché by replacing Schoenberg with Webern. That is to say, in his classic *If This Is a Man*, Primo Levi recalls how he discovered with amazement that most of the inmates at Auschwitz shared the same dream: After miraculously surviving the camp, they are at home, describing their horrible experiences to their friends and family when, all of a sudden, they notice that their listeners are either completely indifferent, bored, and speaking among themselves as if the survivor were not there or simply leave the table—does this "ever-repeated scene of the unlistened-to story" (1987: 60) not render the fact that the big Other doesn't exist, that there is no ideal witness ready to register our experience? It is interesting to note that in the very last paragraph of *The Truce*, Levi reports of a dream that haunted him long after the war and that, although it starts with the same scene as the Auschwitz dream (sitting at home and relating his terrifying experiences to friends and family), follows a different twist. What disturbs this scene of reconciliation is not the indifference of the listeners but the emergence of a dream within a dream: All of a sudden, everything starts to collapse and disintegrate around him, and he is alone in the center of a grey and turbid nothing—he is in the concentration camp once more, aware that the family scene had been a mere deception, a dream, and anxiously awaiting the voice of the Kapo pronouncing the feared foreign word: *"Wstawach!"* (Get up!) (1987: 379–380). This is what Lacan meant when he claimed that within a dream, the real appears in the guise of a dream within the dream. The link between the two denouements is easy to discern; they ultimately amount to two versions of

the same outcome: the obscene superego voice is precisely the foreign intruder that causes the disintegration of the big Other.[10]

Such a heroic acceptance of the nonexistence of the Other is, perhaps, the only thoroughly radical *ethical* stance today, in art as well as in real life. Not only Wagner but also Nietzsche himself, his most bitter critic, was not able to persevere in this stance—witness his final madness, which is structurally and strictly homologous to the suicidal *passage a l'acte:* in both cases, the subject *offers himself as the object to fill in the constitutive gap of reality's symbolic order,* in other words, the lack of the big Other. That is to say, the key enigma of Nietzsche's final madness is this: Why did Nietzsche have to take recourse to what cannot but appear to us as ridiculous self-aggrandizing ("Why I am so brilliant?")? This is an inherently philosophical deadlock that has nothing whatsoever to do with any private pathology: his inability to accept the nonexistence of the big Other. (Within these coordinates, suicide occurs when the subject perceives that the megalomaniac solution doesn't work.) And it is only within this horizon that Isolde will no longer have to run.

Notes

1. When, in Jane Austen's *Mansfield Park*, Sir Thomas, the mansion's master, goes to West India on a business trip (the shady reference to the slave trade on which his wealth is based), the young people in the castle take advantage of the master's absence and engage in preparing the theatrical performance of *Lover's Vow*, a risqué play that, of course, serves as a kind of virtual screen onto which they can project and thus act out their own half-acknowledged libidinal undercurrents. This is the dispositive of virtuality at its purest: When the paternal presence (which guarantees the subject's firm anchoring in social reality) withdraws, the space is open for playful indulgence in multiple fantasmatic scenarios—all of a sudden, the repressed fantasies that lurked beneath the surface explode, transforming reality itself into the playground for obscene games.

2. I will also not consider other modern parodies of *Tristan*, such as Benjamin Britten's *Albert Herring*, the story of an innocent village boy terrorized by a protective mother: During a spring festival, his more experienced fellows try to initiate him into sensual pleasures, with rum-spiked lemonade standing for Wagner's love potion, and so on.

3. To emphasize the nonspiritual nature of these ordeals, Lacan quotes a poem about a lady who demanded that her servant literally lick her ass; the poem consists of the poet's complaints about the bad smells that await him down there (one knows the sad state of personal hygiene in the Middle Ages) and about the imminent danger that, as he is fulfilling his duty, the lady will urinate on his head—*this* is sublimation at its purest. For a more detailed account of the role of the lady in courtly love and its later vicissitudes, see Chapter 4 of Žižek 1995.

4. For example, in what is arguably Mozart's single supreme achievement (although being able to appreciate and enjoy it fully calls for an acquired taste), Act II of *Così fan tutte*, the moment where a true psychological character emerges is Fiordiligi's unsurpassable rondo-aria *"Per pieta, ben mio, perdona,"* her last desperate attempt to defend herself against the desire for Ferrando dressed up as the Albanian. Two features are crucial here: First, *"Per pieta"* is Fiordiligi's *second* attempt to assert her firm stand against the temptation—the first one is *"Come scoglio"* from Act I, in which she proclaims her intention of remaining as firm as a rock buffeted by stormy seas of seduction. Mozart's genius resides in the way he turns around the standard logic of repetition (first the seriousness of tragedy, then comedy): The first aria *("Come scoglio")* is an exemplary case of pathetically comic exaggeration, whereas *"Per pieta"* renders a true tragic tension. The second feature is that Fiordiligi fully subjectivizes herself, that is, emerges as a full character, not in directly assuming the irresistible passion that already consumes her but in the course of a desperate attempt to suppress its explosion; the depth of subjectivity proper involves an inherent tension, a struggle against one's innermost desire. So, in a way, one is justified in claiming that Fiordiligi is the *only* true character in *Così*—all other persons are just a bundle of one-dimensional stereotypes: Despina, the earthy and opportunistic servant; Dorabella, the spoiled flirting lady; and so on.

5. The paradox of *The Magic Flute* is that the *Augenblick*, the moment of peaceful suspension of time that usually precedes the final test, here coincides with the (water and fire) test itself, rendered as a moment of peaceful withdrawal.

6. One should, of course, mention Strauss's other direct musical depiction of the sexual act: the blustering prelude that accompanies Matteo's deflowering of Zdenka in *Arabella*.

7. And, incidentally, her dream was very Freudian: First, it included the noise from reality that threatened to disturb their lovemaking (servants doing their job outside the room), interpreting them as the noise caused by the unexpected return of the husband; secondly, in the dream, the *Marschallin* repeats a previous real-life scene, as she hints that her husband had once unexpectedly returned home when she was with another lover.

8. One is tempted to question the very term *Leninism:* Was it not invented under Stalin? And does not the same go for Marxism (as a school of thought), which was basically a Leninist invention, so that Marxism is a Leninist notion and Leninism is a Stalinist one?

9. For a cogent example of this transposition of vertical harmony into horizontal melody (and vice versa), see the first movement *("Maessig")* of Schoenberg's *Three Piano Pieces* (Op. 11) from 1909, which mark his decisive break with tonality.

10. A further difficult theoretical question concerns the relationship of this modernist break to psychoanalysis. On the one hand, the connection between psychoanalysis and the rise of modernism is clear: It is clearly more than a coincidence that Schoenberg's *Erwartung*, the first true masterpiece of atonal music, set to music the poem commissioned by Schoenberg from Marie Pappenheim, a minor poetess who belonged to Freud's inner circle (any connection to Bertha Pappenheim?), and written following Schoenberg's detailed instructions. On the other hand, not only Schoenberg was indifferent (if not outright opposed) to psychoanalysis, and—like Kandinsky—identified with an intense spiritual stance; Freud himself had no great understanding for modern art and limited his interpretive ventures into the artistic domain to traditionalist works (da Vinci, Shakespeare, Goethe, Dostoyevsky), basically psychoanalyzing the characters and the authors themselves. Perhaps, it is only with Lacan that psychoanalysis reaches the level from which ac-

cess to modernist art is possible. At least circumstantial evidence for this thesis is provided by Lacan's reliance on the Saussurean, purely differential notion of the signifier (a signifier has no substantial identity; its identity resides in *nothing but* its differences from other signifiers); unknowingly, without doubt, Schoenberg had recourse to precisely the same terms when he claimed that his atonal break was based on the insight that each tone is nothing but its difference from the other tones.

BIBLIOGRAPHY

Adorno, Theodor W. *Einführung in die Musiksoziologie*, Gesammelte Schriften 12. Frankfurt: Suhrkamp, 1986.

Aeschylus. *The Oresteia*. Translated by Robert Fagles. Harmondsworth: Penguin Books, 1977.

Assoun, Paul-Laurent. "Présentation." In La Mettrie, *L'homme-machine*, Paris: Denoël/Gonthier, 1981.

Baas, Bernard. *Le désir pur*. Leuven: Peeters, 1992.

Barbier, Patrick. *Histoire des cástrants*. Paris: Grasset, 1989.

Beaumarchais. *Le mariage de Figaro*. Paris: Bordas, 1985.

Benjamin, Walter. "The Work of Art in the Age of Mechanical Reproduction." In *Illuminations*. New York: Schocken, 1969.

Bergan, Ronald. *Sergei Eisenstein: A Life in Conflict*. London: Warner Books, 1997.

Böll, Heinrich. *Irishes Tagebuch*. Köln: Kiepenheuer & Witsch, 1957.

Böttinger, Peter. "Stets verwirrend neu: Zur musikalischen Gestaltung in Mozarts *Le Nozze di Figaro*." In *Mozart—Die Da Ponte-Opern*, edited by Metzger and Riehn, 1991. München: edition text + kritik, 1991.

Bowie, Andrew. *Schelling and Modern European Philosophy*. New York and London: Routledge, 1993.

Braunstein, Nestor A. "Le désir de Scarpia," in *Analytica*, Volume 46. Paris: Navarin, 1986.

Brecht, Bertolt. *Die Mutter*. Frankfurt: Suhrkamp Verlag, 1980.

Bronfen, Elisabeth. "Kundry's Laughter," in *New German Critique* 69, 1996.

Brophy, Brigid. *Mozart the Dramatist*. New York: Da Capo Press, 1964 (rpt. 1988).

Buck-Morss, Susan. *Dreamworld and Catastrophe*. Cambridge: MIT Press, 2000.

Burgess, Anthony. "The Cavalier of the Rose." In Richard Strauss, *Der Rosenkavalier*. Boston: Little, Brown, 1982.

Butler, Judith. *Antigone's Claim*. New York: Columbia University Press, 2000.

Cerna, Jana. *Kafka's Milena.* Evanston: Northwestern University Press, 1993.

Chaouli, Michel. "Devouring Metaphor: Disgust and Taste in Kleist's *Penthesilea,*" in *The German Quarterly* 69.2, 1996.

Chesterton, G.K. "A Defense of Detective Stories." In *The Art of the Mystery Story,* edited by H. Haycraft. New York: The Universal Library, 1946.

Clément, Catherine. *L'opéra ou la défaite des femmes.* Paris: Grasset, 1979.

Conrad, Peter. *A Song of Love and Death.* London: The Hogarth Press, 1987.

Cooke, Deryck. *I Saw the World End.* Oxford: Oxford University Press, 1979.

Cord, William O. *An Introduction to Richard Wagner's "Der Ring des Nibelungen."* Athens: Ohio University Press, 1983.

Dahlhaus, Carl. *Richard Wagner's Music Dramas.* Cambridge: Cambridge University Press, 1979.

Dent, Edward J. *Mozart's Operas.* Oxford: Oxford University Press, 1947.

De Rougement, Denis. *Love in the Western World.* Princeton: Princeton University Press, 1995 (rpt. ed.).

Derrida, Jacques. *Adieu à Emmanuel Lévinas.* Paris: Galilée, 1997.

Dolar, Mladen. "The Object Voice," in *Gaze and Voice as Love Objects,* edited by Renata Salecl and Slavoj Žižek. Durham: Duke University Press, 1996.

Donington, Robert. *Wagner's "Ring" and Its Symbols.* London: Faber and Faber, 1990.

Einstein, Alfred. *Mozart: His character, His Work.* London: Granada, 1946 (rpt. ed. 1979).

Felman, Shoshana. *Le scandale du corps parlant.* Paris: Seuil, 1979.

Fichte, Johann Gottlieb. *Werke.* vol. 6. Berlin: de Gruyter, 1971.

Foucault, Michel. *Discipline and Punish.* New York: Vintage Books / Random House, 1975.

Freud, Sigmund. *The Interpretation of Dreams,* Pelican Freud Library, vol. 4. Harmondsworth: Penguin Books, 1976.

——. "Inhibitions, Symptoms and Anxiety," in *On Psychopathology,* Pelican Freud Library, vol. 10. Harmondsworth: Penguin Books, 1979.

Goethe, Johann Wolfgang. *Faust:* A Norton Critical Edition. New York: Norton, 1976.

——. *Berliner Ausgabe,* vol. 4. Berlin (DDR): Aufbau-Verlag, 1981.

Gould, Stephen Jay. *Wonderful Life.* London: Hutchinson Radius, 1989.

Grosrichard, Alain. *The Sultan's Court.* London: Verso Books, 1998.

Gülke, Peter. "Das schwierige Theaterspielwerk," in Metzger & Riehn, 1991.

Gutman, Robert. *Richard Wagner.* New York: Harcourt Brace Jovanovich, 1990.

Hegel, G.W.F.. *The Science of Logic.* London: George Allen & Unwin, 1969.

——. *Theorie Werkausgabe* I-XX. Frankfurt: Suhrkamp Verlag, 1970.

——. *Jenaer Systementwürfe* III, edited by R.-P. Horstmann & J.H. Trede. Düsseldorf: Rheinisch-Westfälische Akademie der Wissenschaften, 1976.

——. *Phenomenology of Spirit.* Oxford: Oxford University Press, 1977.

Heidegger, Martin. *Sein und Zeit.* Tübingen: Max Niemeyer Verlag (14th reprint, 1977).

Highsmith, Patricia. "The Hand." In *Little Tales of Misogyny.* Harmondsworth: Penguin Books, 1980.

Hildesheimer, Wolfgang. *Mozart.* Frankfurt: Suhrkamp Verlag, 1977.

Hodin, J.P. *Edvard Munch.* London: Thames and Hudson, 1972.

Holland, Dietmar. "Il resto nol dico." In Metzger & Riehn, 1991.

Hughes, Spike. *Famous Mozart Operas.* New York: Dover, 1958 (rpt. ed. 1972).

Kafka, Franz. "A Country Doctor." In *The Metamorphosis and Other Sto-*

ries. New York: Dover Publications, 1996.

Kant, Immanuel. "An Answer to the Question: What is Enlightenment?" In *What is Enlightenment?*, edited by James Schmidt. Berkeley and Los Angeles: University of California Press, 1996.

———. *Metaphysical Elements of Justice.* Indianapolis: Hackett Publishing Company, 1999.

Kerman, Joseph. *Opera as Drama.* London: Oxford University Press, 1957.

———. *The Beethoven Quartets.* New York: Norton, 1966.

Kierkegaard, Søren. *Either/Or—A Fragment of Life.* London: Penguin Books, 1992.

Kivy, Peter. *Osmin's Rage.* Ithaca: Cornell University Press, 1988.

Kloiber, Rudolf, & Konold, Wulf. *Handbuch der Oper.* 2 vols. München/Kassel: DTV/Bärenreiter, 1985.

Kunze, Stefan. *Mozarts Opern.* Stuttgart: Eugen Dietrichs Verlag, 1984.

Lacan, Jacques. *Encore* (Le séminaire, livre xx). Paris. Seuil, 1975.

———. *The Ethics of Psychoanalysis (The Seminar, Book VII).* London: Routledge, 1992.

———. *On Feminine Sexuality (The Seminar, Book XX).* New York: Norton, 1998.

Laclos, Choderlos de. *Les liaisons dangereuses.* Harmondsworth: Penguin Books, 1961.

Lam, Basil. *Beethoven String Quartets.* London: BBC Publications, 1986.

La Mettrie. "Présentation." In *L'homme-machine.* Paris: Denoel/Gonthier, 1981.

Lear, Jonathan. *Happiness, Death, and the Remainder of Life.* Cambridge: Harvard University Press, 2000.

Leppert, Richard. *The Sight of Sound.* Berkeley: University of California Press, 1995.

Levi, Primo. *If This Is a Man. The Truce.* London: Abacus, 1987.

Lévi-Strauss, Claude. *Mythologiques I: Le cru et le cuit.* Paris: Plon, 1964.

———. *Tristes tropiques.* New York: Atheneum, 1971.

———. *Anthropologie structurale.* Paris: Plon, 1974.

Lindenberger, Herbert. *Opera in History.* Stanford: Stanford University Press, 1998.

Löwith, Karl. *Mein Leben in Deutschland vor und nach 1933.* Stuttgart: Cotta, 1986.

Lucie-Smith, Edward. *Joan of Arc.* Harmondsworth: Penguin Books, 2000.

Maar, Michael. "Deadly Potions," in *The New Left Review* 4, July/August, 2000.

Mann, William. *The Operas of Mozart.* London: Cassell, 1977.

Mannoni, O. "Je sais bien, mais quand même...," In *Clefs pour l'imaginaire.* Paris: Editions du Seuil, 1969.

Marin, Louis. *Le portrait du roi.* Paris: Editions de Minuit, 1987.

Marivaux, Pierre. *Théâtre choisi.* Paris: Robert Laffont, 1958.

Menninghaus, Winfried. *Ekel.* Frankfurt: Suhrkamp, 1999.

Metzger, Heinz-Klaus, and Riehn, Rainer, editors. *Ist die Zauberflöte ein Machwerk?* Musik-Konzepte 3. München: edition text + kritik, 1985.

———. *Mozart—Die Da Ponte-Opern.* Musik-Konzepte Sonderband. München: edition text + kritik, 1991.

Mezzacapo de Cenzo, Paolo, and MacGabham, Liam. "...vi voliamo davanti ed ai lati e dal retro..." In Metzger & Riehn, 1991.

Montesquieu. De l'Esprit des lois, vol. 1. Paris: Garnier, 1961.

Nagel, Ivan. *Autonomie und Gnade: Über Mozarts Opern.* München/ Wien: Carl Hanser Verlag, 1985.

Nietzsche, Friedrich. *Thus Spake Zarathustra.* Buffalo: Prometheus Books, 1993.

Noske, Frits. *The Signifier and the Signified: Studies in the Operas of Mozart and Verdi.* The Hague: Martinus Nijhoff, 1977.

Ortkemper, Hubert. *Engel wider Willen.* Berlin: Henschel, 1993.

Osborne, Charles. *The Complete Operas of Mozart: A Critical Guide.* London: Victor Gollancz, 1978 (rpt. ed. 1986).

Pernaud, Régine, and Clin, Marie-Véronique. *Joan of Arc: Her Story.* London: Phoenix Press, 2000.

Pfaller, Robert. "Die Einbildung für Andere," lecture at the Kulturwissenschaftliches Institut in Essen, November 29, 2000.

Picardie, Ruth. *Before I Say Goodbye: Recollections and Observations from One Woman's Final Year.* New York: Henry Holt, 2000.

Poizat, Michel, *L'opéra ou le cri de l'ange.* Paris: Editions A.M. Métailié, 1986.

——. *Variations sur la voix.* Paris: Anthropos, 1998.

Rabinowitz, Nancy Sorkin. *Anxiety Veiled: Euripides and the Traffic of Women.* Ithaca: Cornell University Press, 1993.

Riehn, Rainer. "Machwerk = Werk-Stück—Stück-Werk = Lehr-Stück, oder Mozart, der dialektische Komponist." In Metzger & Riehn, 1985.

Rosen, Charles. *The Classical Style.* London: Faber and Faber, 1971.

——. *Schönberg.* Glasgow: Fontana/Collins, 1976.

Safranski, Rüdiger. *Das Böse.* Frankfurt: Fischer Taschenbuch Verlag, 1999.

Salazar, Philippe-Joseph. *Idéologies de l'opéra.* Paris: Presses universitaires de France, 1980.

Salecl, Renata, and Žižek, Slavoj. *Gaze and Voice as Love Objects,* SIC Series, Volume 1. Durham: Duke University Press, 1996.

Santner, Eric. *My Own Private Germany.* Princeton: Princeton University Press, 1996.

Schelling, F.W.J. *Sämtliche Werke.* Stuttgart: Cotta, 1856–1861.

——. *Die Weltalter: Fragmente. In den Urfassungen von 1811 und 1813,* edited by Manfred Schröter, Munich: Biederstein, 1946 (rpt. ed. 1979).

——. "Philosophical Investigations into the Essence of Human Freedom and Related Matters." In *Philosophy of German Idealism,* edited by Ernst Behler. New York: Continuum, 1987.

Schulhoff, Erwin. *Flammen,* cd 444 630–2. New York: Decca 1995.

Schulz, Nicolas. "Mozart oder die Intuition der Modernität." In Metzger & Riehn, 1991.

Service, Robert. *Lenin.* London: Macmillan, 2000.

Singer, Peter. *The Essential Singer: Writings on an Ethical Life.* New York: Ecco Press, 2000.

Starobinski, Jean. *1789: Les emblémes de la raison.* Paris: Flammarion, 1979.

Sternfeld, F. W. *The Birth of Opera.* Oxford: Oxford University Press, 1993.

Stricker, Rémy. *Mozart et ses opéras: fiction et vérité.* Paris: Gallimard, 1980.

Tanner, Michael. *Wagner.* London: Flamingo, 1997.

Taruskin, Richard. *Defining Russia Musically.* Princeton: Princeton University Press, 1997.

Till, Nicholas. *Mozart and the Enlightenment.* London: Faber and Faber, 1992.

Tomlinson, Gary. *Monteverdi and the End of the Renaissance.* Oxford: Clarendon Press, 1987 (rpt. ed. 1990).

Vetter, Isolde. "Wagner in the History of Psychology." In *Wagner Handbook,* edited by Ulrich Müller and Peter Wapnewski. Cambridge: Harvard University Press, 1992.

Wagner, Richard. *Prose Works.* London: K. Paul, 1972.

——. *The Ring of the Nibelung.* New York: Norton, 1977.

Watson, Derek. *The Wordsworth Dictionary of Musical Quotations.* Edinburgh: Wordsworth, 1994.

Wawrzyn, Lienhard. *Der Automaten-Mensch.* Berlin: Wagenbach, 1978 (rpt. ed. 1990).

Wienold, Hanns, and Hüppe, Eberhard. " 'Cosi fan tutte' oder die hohe Kunst der Konvention." In Metzger and Riehn, 1991.

Wolf, Christa. *Cassandra: A Novel and Four Essays.* New York: Farrar, Straus and Giroux, 1988.

Žižek, Slavoj. *The Sublime Object of Ideology.* London: Verso Books, 1989.

———. *For They Know Not What They Do.* London: Verso Books, 1991.

———. *Tarrying With the Negative.* Durham: Duke University Press, 1993.

———. *The Metastases of Enjoyment.* London: Verso Books, 1995.

———. *The Indivisible Remainder.* London: Verso Books, 1997.

———. *The Ticklish Subject.* London: Verso Books, 1999.

Zupančič, Alenka. *Ethics of the Real.* London: Verso Books, 2000.

Index